THE HISTORY OF

British Art

David Bindman (*General Editor*)

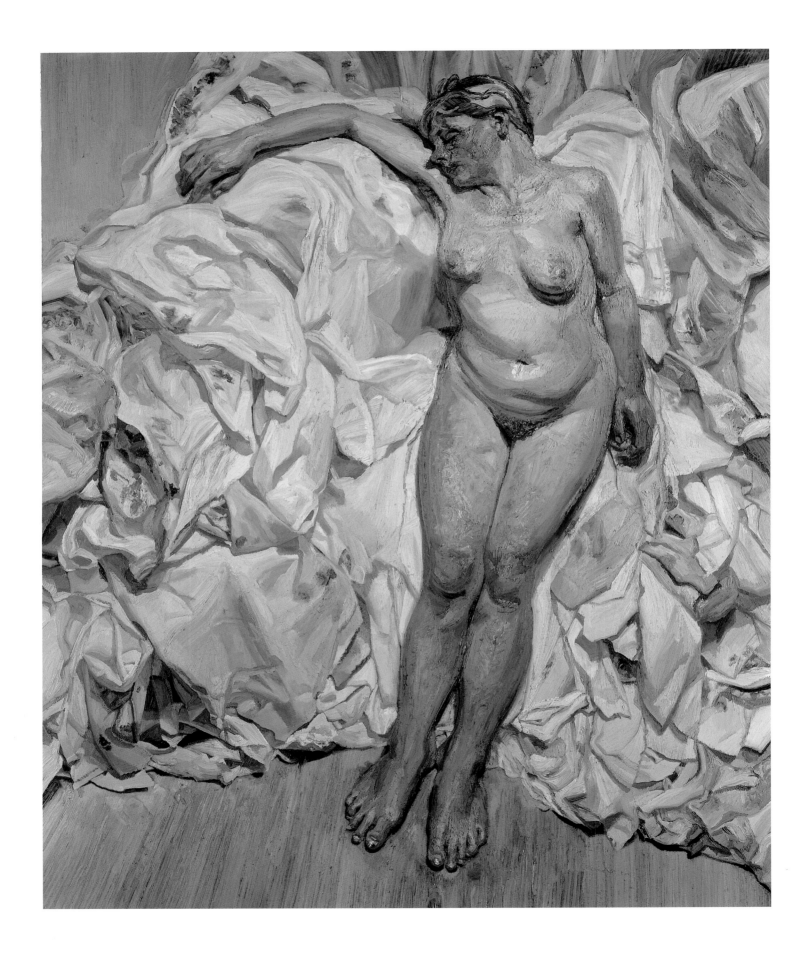

THE HISTORY OF
British Art
1870–Now

Edited by Chris Stephens

Yale Center for British Art
Tate Britain

Distributed by Yale University Press

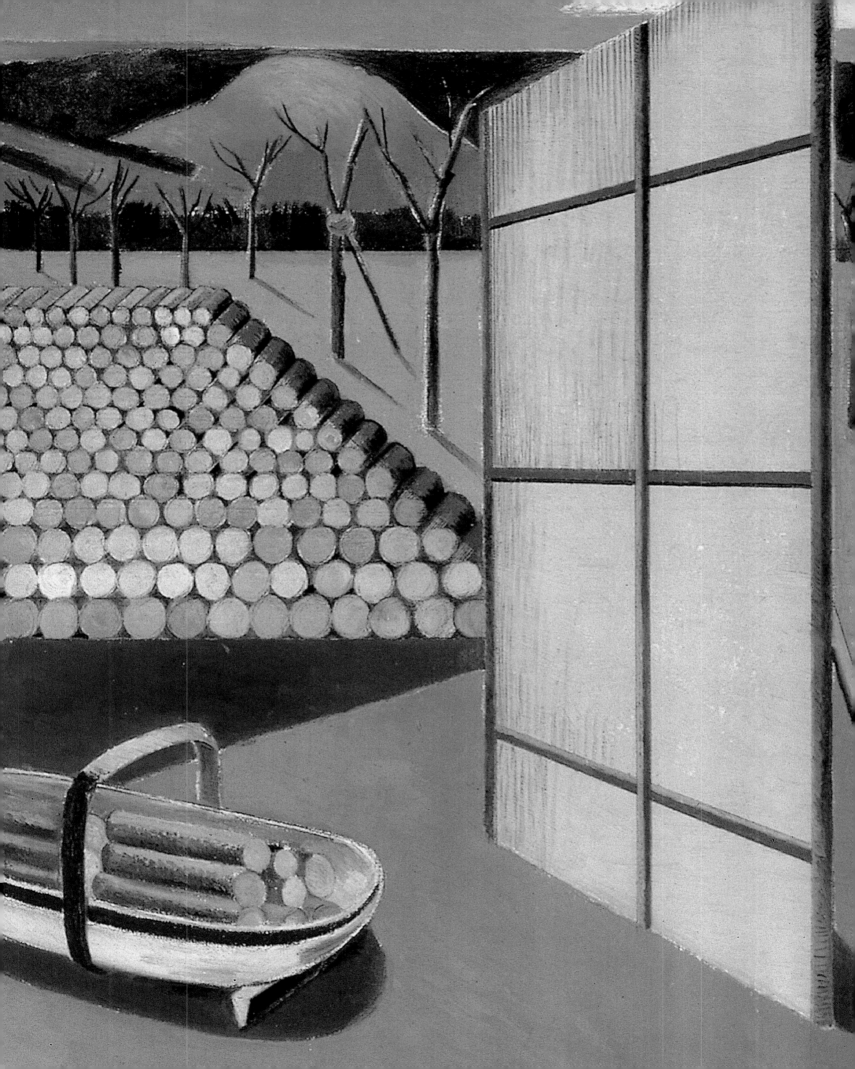

Contents

1

2

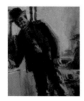

Contributors

Rasheed Araeen is an artist, writer and founding editor of Third Text.

Nicolas Bourriaud is Curator of Contemporary Art at Tate Britain, London.

Robert Burstow is University Reader in History and Theory of Art at the University of Derby.

Virginia Button is Course Leader, MA Curatorial Practice at University College Falmouth.

Eddie Chambers, a curator and writer of art criticism, is currently a Visiting Professor, History of Art at Emory University, Atlanta.

Barry Curtis is Professor Emeritus of Visual Culture at Middlesex University, Fellow of the London Consortium and Tutor at the Royal College of Art.

Penelope Curtis is Curator of the Henry Moore Institute, Leeds.

Emma Dexter is Director of Exhibitions at Timothy Taylor Gallery, London.

Martina Droth is Research Coordinator at the Henry Moore Institute, Leeds.

Alicia Foster is Senior Lecturer in Fine Art at the University for the Creative Arts.

Matthew Gale is Curator of Modern Art and Head of Displays at Tate Modern, London.

Ann Gallagher is Head of Collections (British Art) at Tate, London.

Martin Hammer is Reader in History of Art at the University of Edinburgh.

Charles Harrison is an independent writer on art.

Richard Humphreys is Curator of Research at Tate, London.

Timothy Hyman is an artist and writer.

Carol Jacobi is Leverhulme Fellow in the History of Portraiture at the National Portrait Gallery, London.

Sarah Lowndes is a writer and a lecturer in the Historical and Critical Studies Department at Glasgow School of Art.

Sheila McGregor is a freelance curator, writer and museums consultant.

Sue Malvern is Senior Lecturer in History of Art at the University of Reading.

David Alan Mellor is Professor of Art History at the University of Sussex.

Catherine Moriarty is Principal Research Fellow, Faculty of Arts and Architecture at the University of Brighton.

Neil Mulholland is Reader and Director of the Centre of Visual and Cultural Studies at Edinburgh College of Art.

Gill Perry is Professor of Art History and Head of Department at the Open University, Milton Keynes.

David Peters Corbett is Professor of History of Art at the University of York.

Elizabeth Prettejohn is Professor of History of Art at the University of Bristol.

Julian Stallabrass is Reader in Art History at the Courtauld Institute of Art, London.

Chris Stephens is Curator of Modern British Art and Head of Displays at Tate Britain, London.

Andrew Stephenson is Subject Director of Visual Theories and Research in the School of Architecture and the Visual Arts at the University of East London.

Colin Trodd is Lecturer in Art History at the University of Manchester.

Robert Upstone is Curator of Modern British Art at Tate Britain, London.

Clarrie Wallis is Curator of Contemporary British Art at Tate Britain, London.

Hester R. Westley is Artists' Lives Interviewer, National Life Stories at the British Library.

Andrew Wilson is Curator of Modern and Contemporary British Art at Tate, London.

Paul Wood is Senior Lecturer in the Department of Art History at the Open University, Milton Keynes.

William Wood is Assistant Professor of Art History, Visual Art and Theory at the University of British Columbia, Vancouver.

Acknowledgements

Modern British art has not been well served by art history. A perception of its inherent conservatism and marginality to international developments was, until the late 1970s, generally supported by its own chroniclers. Since Dennis Farr's *English Art 1870–1940* (1978) and Charles Harrison's *English Art and Modernism 1900–1939* (1981) considerable work has been done to investigate and open up different areas of Britain's modern art history. There have been few attempts, however, at broad surveys and even fewer that extend to the present day and that engage with the complexity of British identity. This complexity is perhaps the reason for the paucity of such ambitious projects.

Tate Britain and the Yale Center for British Art have been at the forefront of the research and exhibition of British art and to oversee the compilation of such a broad history under the auspices of those two great institutions is both an honour and a huge responsibility. I am immensely grateful to Stephen Deuchar at Tate Britain and Amy Myers at Yale for inviting me to do so. I am especially indebted to the series editor David Bindman for the invitation and for his encouragement and advice throughout. His vision for the series has strongly marked the emphases evident in this volume. Its shape and tone were also formed at an early stage by stimulating exchanges between David, me and our fellow editor Tim Ayers and I am pleased to thank both for that experience.

It is a reflection of the book's importance that so many leading specialists in the field readily agreed to contribute. I would like to thank the authors of the longer essays – Charles Harrison, Sue Malvern, Julian Stallabrass and Paul Wood – not only for their contributions but also for the discussions we had individually and collectively which strongly influenced the choice of shorter essays. I also benefited from discussions with a number of colleagues both within Tate and the British Art Center and beyond, and for those I would like to thank Tim Barringer, Ann Gallagher, Michael Hatt, Julia Marciari Alexander, David Mellor, Alison Smith, Clarrie Wallis and Andrew Wilson. Though all have influenced the thinking behind this volume its overall structure has been my responsibility.

It is, I believe, the range and varying texture of the whole that will be one of this book's strengths. I am delighted that all of the authors were able to make their important and original contributions and thank them for that and for the efficiency with which they delivered despite, on occasion, apparent lack of contact from their editor. To manage thirty-five contributors, their texts and illustrations is an enormous task and I am sorry to say that I let much of that responsibility fall to the project editors; like the other two volumes, this book would not have seen the light of day but for the commitment, focus and hard work of Rebecca Fortey and Katherine Rose, assisted by Beth Thomas. They have been brilliantly supported by Tim Holton, Production Manager, and Picture Researchers Jessica Harrington and Anna Ridley. Also at Tate Publishing Celia Clear, Roger Thorp and James Atlee have been supportive of the project and offered sound advice at various junctures. Finally, I am grateful to Philip Lewis at LewisHallam Design for his most attractive design for the book.

CHRIS STEPHENS

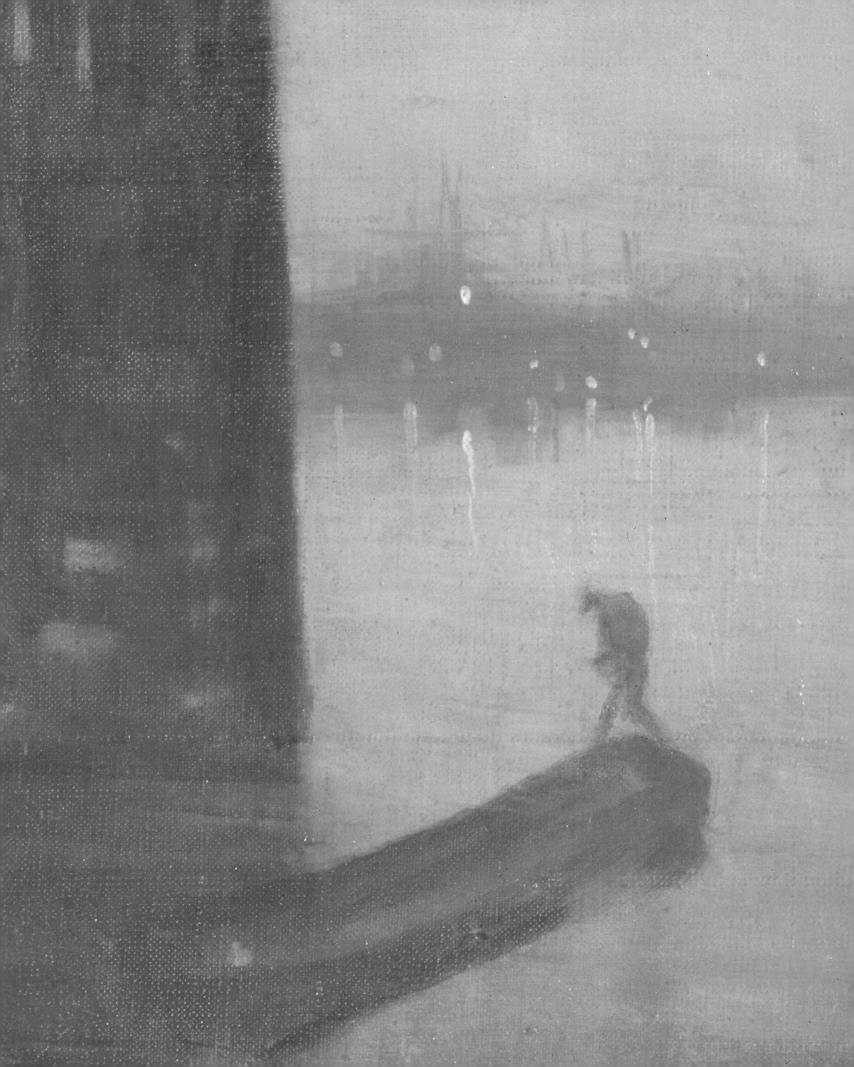

Foreword

Tate Britain in London and the Yale Center for British Art in New Haven, Connecticut, are the only major public museums in the world solely devoted to the collection, display, preservation and interpretation of British art. Together our resources and our programmes constitute an extraordinary gateway to a rich field, serving the needs of both scholars and the general public in our respective countries. As institutions we collaborate regularly – on exhibitions and on the loan of works of art, for example – and this History of British Art series reflects our ongoing wish to promote the cause of British art, together, to as wide an audience as possible.

There have been exciting advances in art history over the past several decades. Whereas the appreciation of art was once conceived only in terms of taste and connoisseurship, confined implicitly to the privileged few, it is now viewed in natural relation to its historical and cultural contexts. Since this has begun to be properly reflected and articulated in exhibitions and displays worldwide, we thought it was time for some of these relatively new ways of thinking to be applied to a general overview of British art's history from its beginnings to the present day. The resulting volumes lay no claim to be comprehensive in their coverage; they aim rather to pose some current questions about British art and to shed fresh light on sometimes familiar ground.

David Bindman kindly took on the task of setting the criteria for the books and organizing the volume editors. Chris Stephens worked with David to shape this volume, as well as coordinating the authors and editing the text. To both of them, to the many distinguished contributors, and to all those who have worked on seeing the books through to publication, we extend our grateful thanks.

STEPHEN DEUCHAR
Director, Tate Britain

AMY MEYERS
Director, Yale Center for British Art

Opposite:
JAMES MCNEILL WHISTLER
Nocturne: Blue and Gold – Old Battersea Bridge c.1872–5
(detail of fig.16, p.34)

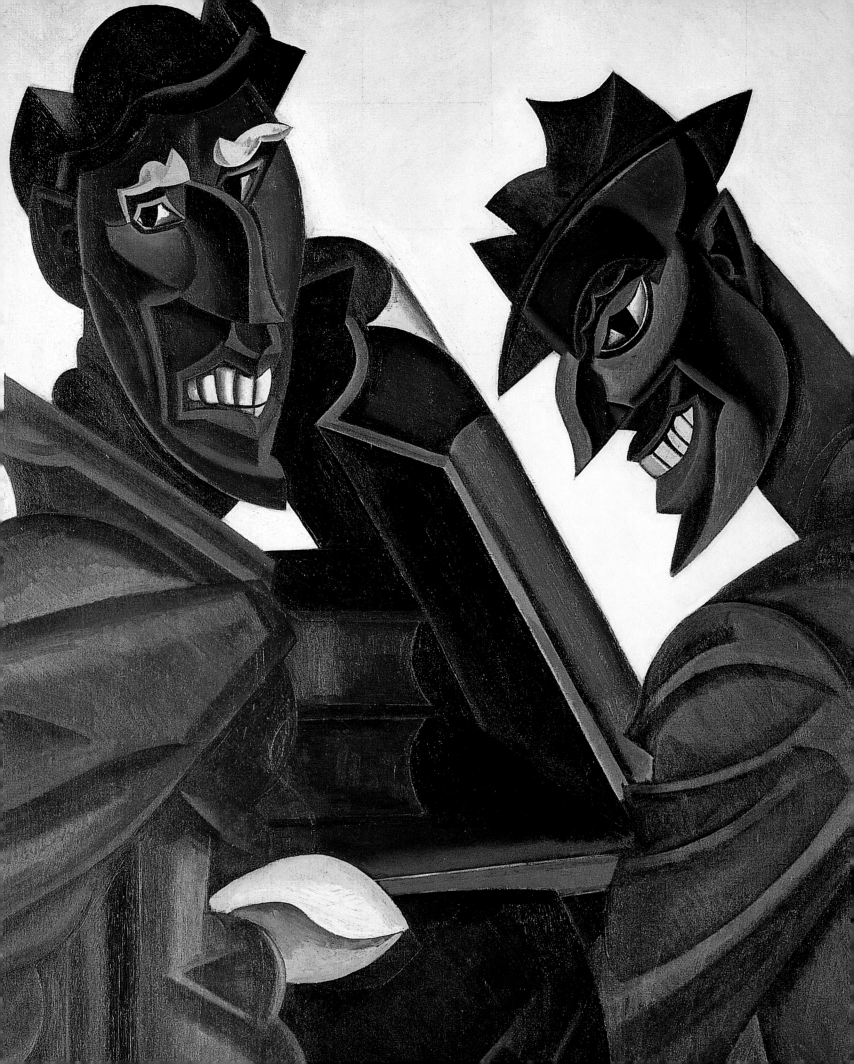

Introduction to *The History of British Art* Series

DAVID BINDMAN

This volume is one of a series of three, covering British art from around AD600 until the present day. The series is best seen not as a linear history of British art but as a number of separate though interconnected histories of its ever-changing relationships with the idea of Britain, and of Europe, and of the world beyond Europe. The series also encompasses art's relationship with political, intellectual and social histories and, where possible, with the lives of artists themselves. These histories reveal a British art that is not inward looking but open to the world beyond, to external events and social pressures. One of the chief aims of these volumes is to reinterpret British art in the light of Britain's inherent instabilities of identity, which still define it in a global world. British art is not, therefore, limited to artists born in Britain, but encompasses art made in Britain or made abroad by artists resident in Britain or its colonies.

The limits of what constitutes art are inevitably contentious and vary from volume to volume. In the medieval volume architecture and what we would now call the applied arts play an important part, while for the other two volumes they only appear as part of the background to painting and sculpture. This was essentially a practical rather than an intellectual decision, based on the amount of space available. The divisions between periods also led to much discussion because of the political implications of choosing a particular date. The beginning date of the series, now c.600, was particularly thoroughly argued over, as were the beginning and end dates of the second volume. In the end it was agreed to leave them fluid, and though volume two technically runs from c.1600–c.1870, some essays begin and end both before and after those dates for reasons that should be clear in each case.

The long essays in each volume run parallel to each other chronologically, each following its theme broadly from the beginning to the end of the period. In addition, there are short essays that pick up aspects of that theme for more detailed consideration, and allow for a particular focus on works of art and key episodes.

Though the volumes have been initiated by Tate Britain and the Yale Center for British Art, they are in no sense an 'official' version of British art; the editors of each volume and I have been given complete freedom to choose the topics and the authors, most of whom come from the academic world, though museums are well represented. The volumes do not claim to be encyclopaedic – you are bound to find that some important artists or issues have barely been considered – but they do show the broader concerns of scholars working in the field, the gains in knowledge over the last few years, and indications of future directions for research. Above all they should convey some of the excitement that scholars feel in pushing back the intellectual boundaries of the study of British art.

Opposite:
WYNDHAM LEWIS
A Reading of Ovid (Tyros) 1920–21
(detail of fig.3, p.21)

Overleaf:
RACHEL WHITEREAD
Ghost 1990
(detail of fig.150, p.231)

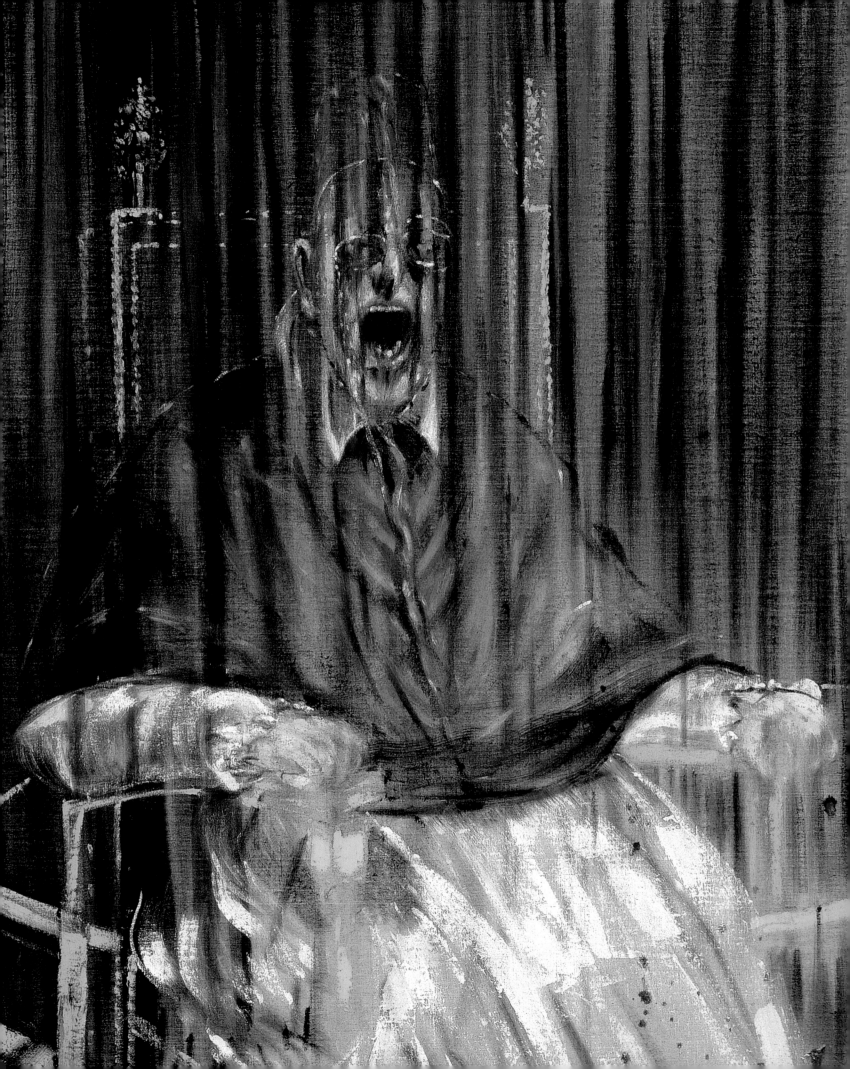

Introduction to
The History of British Art
1870–Now

CHRIS STEPHENS

IN COMPARISON WITH the other two volumes in this series, this book covers a short period of time, the reason being that during the 137 years under scrutiny here, art changed more, and more rapidly, than ever before. To some extent this reflected an era of equally far-reaching and rapid change in social, political, cultural and techno-logical realms. In the attempt to develop a form of visual expression that stayed in tune with its time, innovation became a key criterion of quality in much of the art produced from the late nineteenth century onwards. The subjects, styles and purposes of art were repeatedly questioned and revised. Ultimately, indeed, the very definitions of art, the artist and the work of art were re-evaluated.

In 1870 Britain's industry was at its height, as was the British Empire. That is to imply that subsequent years would witness the decline of both. In the end ours is a period, generally, of liberalization, which saw universal suffrage established along with the acceptance of a basic right to education, decent housing and basic provision. The power of the aristocracy – already in decline – was firmly displaced by the rise of the middle classes, while conditions for the working classes also changed radically. The imperial project survived largely intact until the middle of the twentieth century when the Second World War was followed by a period of rapid decolonization. This was accompanied by large-scale immigration from the Commonwealth, which in a short period of time radically changed the ethnic make-up of metropolitan Britain. Unquestionably, the quality of people's lives changed for the better but this was also a period of great collective suffering. We might see our near century and a half divided by a period of far-reaching conflict that began with the First World War in 1914 and finished with the dropping of the atomic bomb on the

Japanese cities of Hiroshima and Nagasaki in 1945 and the end of the Second World War. Both wars, not to mention the revelation of the Holocaust that accompanied the end of the Second, cast a lingering shadow on the years that followed each of them. The decline of religious observance and growth in a secular belief in the importance of the individual, which had been in train since the early modern period, continued. The shift from a spiritual to a materialist view of life was reinforced by the theories of evolution, genetics and psychoanalysis that came to the fore in the late nineteenth and early twentieth centuries.

So, the constantly changing, the transitory and the contingent displaced continuity and certainty and came to define the nature of modernity. While much of this change brought undoubted progress it soon became clear that such progress was not unqualified. Modernity might be most readily identified in its more material and visible forms – in industrialization, for example, or the growth of the city – but it could also be understood in terms of individual and collective consciousness, played out in social interactions, subjectivities and psychologies. The dominant histories of the art of this period are of the art that engaged with these ideas of modernity. They might be affirmative or critical of these historical circumstances or seek some sort of escape into an anti- or pre-modern fantasy but they could not ignore it. Where one draws the defining boundaries around those responses or around what can justifiably be called modernist remains subject to debate.

An idea of modernism's beginnings became securely attached to the work of Edouard Manet and the Impres-sionists due to their painting of modern life – modern places and modern modes of behaviour – and because of their use of innovative ways of painting and of represent-ation. The dominant history of modernism privileged

the latter, seeing an evolution of the avant-garde that moved from one technical innovation to another (Post-Impressionism, Cubism, Futurism and so on through to Abstract Expressionism, which thus became modernism's zenith). In this formulation almost all serious modernist art was made in or around Paris or, later, New York. As we will see, association with those centres was seen at various times as a badge of a British artist's modernity. By extension, as Charles Harrison touches upon in this volume (see p.40), a problematic relationship was perceived to be set up between an artist's claim to modernism and any suggestion of specifically British or English qualities to their work: between, in artist Paul Nash's formulation, 'going modern and being British'.

This last issue becomes, perhaps, less pressing if a more inclusive idea of modernism is considered. In recent decades the resurgence of a social history of art has allowed for a re-engagement with the idea of modernism being determined by subject matter as well as by innovative modes of production. In the context of British art this goes some way to reincorporate works that are clearly not traditional in approach or appearance and yet do not fit the dominant model or would be unfairly judged if set against Continental or American equivalents with no consideration for local issues. For example, studies have explored ways in which ideas of native tradition were appropriated as part of artists' responses to the conditions of modernity. These revisionist approaches have reinstated whole periods of British art that had been virtually written off by a modernist approach that marginalized anything other than those works in keeping with international formalist modernist forms and values.[1]

In fact, historians of modern British art had been so slow that the period when those modernist accounts were dominant was relatively short-lived. Dennis Farr's groundbreaking, formalist account of *English Art 1870–1940* (1978) was followed by Harrison's more heavily theorized *English Art and Modernism 1900–1939*, published in 1981 though based on postgraduate research from the late 1960s. This kind of approach also shaped the important 1987 exhibition *British Art in the Twentieth Century: The Modern Movement* at the Royal Academy, the subtitle offering an apology, perhaps, to those forms of art excluded by the organizing committee's approach. In the catalogue for that exhibition, the committee's chair proposed that the modern movement began in Britain with Roger Fry's two Post-Impressionist exhibitions of 1910 and 1912, which, he wrote, remade 'an art that was both rudderless and demoralized'. That British art around 1900 was 'enfeebled' was, he suggested, 'beyond question'. In a similar vein these modernist histories ignored or, at best, wrote apologetically about the art of the 1920s and 1940s, which appear as embarrassing moments of weakness when British art was not in step with that of Paris. In such a narrative the history of modern British art leaps from one isolated moment of international involvement to another: Walter Sickert and Edgar Degas; Bloomsbury and the Post-Impressionists; Vorticism and Futurism; 1930s Constructivism.

Revisionist approaches have recuperated periods, artists and movements that had previously featured in earlier histories determined by the arbitrariness of an historical span rather than by ideology. Two such accounts were prompted by the celebration of the centenary of the Great Exhibition of 1851 with the Festival of Britain in 1951. While artist and designer Hesketh Hubbard made something of a virtue of the randomness of that temporal frame, art historian Anthony Bertram found a logic within it. He argued that, though the art of the period was highly

diverse, the date 1851 – the year in which Turner died –
marked a dividing line between the Romantic Age and
another epoch that began with the inception of the
Pre-Raphaelite Brotherhood in 1848.[2] As those accounts
happened to embrace the Pre-Raphaelites, so some
recent authors have asserted that group's modernity.[3]
Some will argue that this volume's periodization reaffirms
Pre-Raphaelitism as not modernist. It is certainly the case
that an argument could be made for the Pre-Raphaelites'
avant-gardism in so far as their work confronted academic
conventions with its emphasis on realism and medieval
revivalism. Their romantic, historical fantasies of past times
and what came to be seen as a mawkish sentimentality
epitomized everything about Victorian culture against
which later, self-conscious modernists set themselves
(fig.1). This is not to say, however, that from our perspec-
tive and in terms of a more broadly defined cultural
engagement with modernity their work might not contain
modernist elements. Certainly this argument has been
proposed in the case of Frederic Leighton (1830–96) whose
style could be seen as academic (see Trodd, p.32) and
whose subject matter was equally based on romanticized
imagined pasts, in his case of classical and Renaissance
cultures.[4]

One of the problems with the classic modernist
accounts of British art is not only that between the
moments of international modernist connection occur
works of art of great aesthetic and theoretical merit but
also that they fail to accommodate British artists or
moments in British art that were widely recognized as
of international import; Francis Bacon (1909–92), the
sculptors who found fame at the 1952 Venice Biennale

2 LUCIAN FREUD
Girl with Kitten 1947
Oil on canvas 41 × 30.7 (16⅛ × 12⅛)
Tate. Bequeathed by Simon Sainsbury
2006

3 WYNDHAM LEWIS
A Reading of Ovid (Tyros) 1920–1
Oil on canvas 165.2 × 90.2 (65 × 35½)
Scottish National Gallery of
Modern Art, Edinburgh

such as Reg Butler (1913–81) and Lynn Chadwick (1914–2003), and even, at times, Henry Moore (1898–1986) struggle to find a place in such histories. This has often caused modern British art to be seen, from an international perspective, either as a series of eccentric individuals operating beyond the bounds of the main narrative of modernism or as accomplished practitioners of an out-moded figuration. Instead, one might discern a different kind of modernism – one that is played out not through the technical qualities of the artwork, nor through the painting of modern subjects such as the city or the crowd but through the human body as its subject. Changes in ideas of existence, spirituality and psychology inevitably impacted upon human subjectivities and upon discourses around those subjectivities such as those about identity and sexuality. These in turn affected how the body was understood and how it might be represented in art to express those modern identities. For example, the early works of Lucian Freud (b.1922) sit uncomfortably in standard modernist histories. Not only figurative but often suggestive of narrative, they might even seem the diametric opposite of formalist modernism. Yet, they are undeniably modern; it is impossible to imagine their existence before the twentieth century and its insights into human psychology (fig.2).

A helpful way into thinking about this may be Hal Foster's proposal that modernism drew upon two 'fictions of origin' – one primordial and tribal, the other futuristic and technological.[5] The two are complementary; both are, in a sense, concerned with human subjectivity in the context of modernity's flux and materialism as opposed to the perceived stability and spiritualism of the pre-modern age.

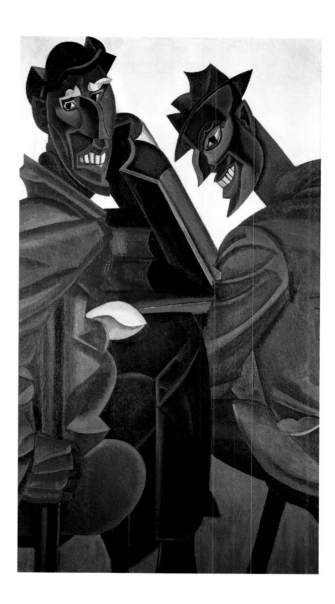

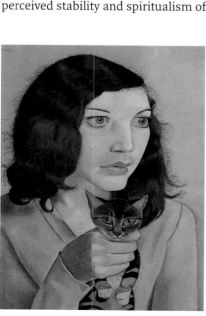

The tribal and a sense of the primordial are most obviously seen in modernism's and, in particular, modernist sculptors' predilection for the arts of early – and what were seen as less developed – 'primitive' cultures. Jacob Epstein (1880–1959), Henri Gaudier-Brzeska (1891–1915), Henry Moore and Barbara Hepworth (1903–75), along with colleagues in Britain and Europe, all drew upon the great ethnographic collections of London and Paris. African carvings, the sculptures of Polynesia, pre-Columbian Mesoamerica and early Cycladic culture were all sources of inspiration. This urge towards the primordial also inhabits Wyndham Lewis's (1882–1957) theory of the 'wild body'. An idea of the body driven by basic physical urges and the comic absurdity of mankind's ambition to gain knowledge and understanding underpinned much of the fiction by Lewis and emerged in his 'Tyro' paintings

of the early 1920s (fig.3). The tyro is a complete novice, an ingénue. There is also a sense of the wild body underlying Lewis's conception of the Vorticist. For him Vorticism was not a celebration of modern technology and automotive speed in the same way that Futurism was. Lewis wrote of the modern world as a vortex, a swirling flux, at the still centre of which was the Vorticist observing – but presumably unaffected by – the chaos spinning around him.

In the early work of Lewis and his contemporaries such as David Bomberg (1890–1957) and Christopher Nevinson (1889–1946) one might see the human figure represented in a way that brings together both the primordial and the technological impulses. In works such as Lewis's *The Crowd* (see Stallabrass, fig.83, p.128) and Bomberg's *Mud Bath* (fig.4) the impact of modernity is registered in the figures, which are reduced to simple geometric forms.

5 JACOB EPSTEIN
Venus 1917
Marble 235.6 × 43.2 × 82.6
(92¾ × 17 × 32½)
Yale University Art Gallery,
Gift of F.C. Guest

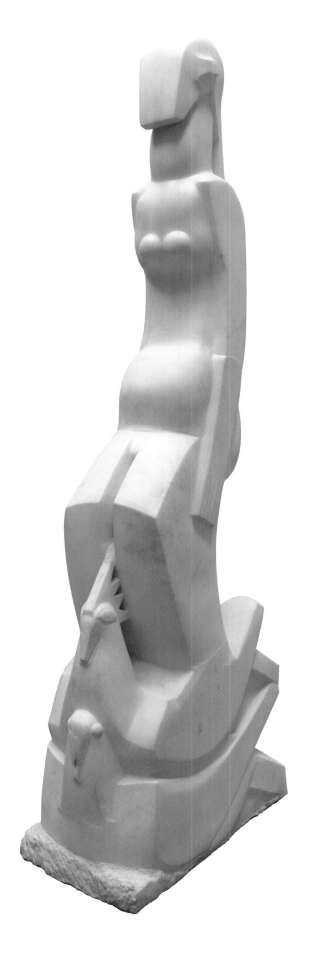

Like the African carvings with which both artists were
familiar, they remain recognizably figurative despite the
abstraction of the body, while the angular nature of their
description imbues them with a mechanistic quality that
alludes to the industrialization that has changed their
subjectivity. The extension of this style (or something close
to it) into the representation of the First World War adds
a poignant coda to this imaging of the human body as
reduced by technology and the uses to which it is put.

It was in the wake of the Second World War that
another representation of the body as both constructed
by modern technologies and, at the same time, subject to
basic primordial impulses appeared. It came from a gener-
ation that had witnessed in the Holocaust the barbarity to
which human beings could descend and who lived under
the shadow of the atomic bomb's potential for techno-
logically enabled mass destruction. In the discussions,
exhibitions and artworks of the Independent Group,
images from other cultures, natural forms and the products
of modern technology were brought together. Nigel
Henderson's (1917–85) photomontaged *Head of a Man* (see
Mellor, fig.104, p.160) presents humanity as an assembly
of multifarious images from a variety of sources. This
conglomeration creates the appearance of a surface
scarred and fragmented. A similar aesthetic appeared in the
sculptures of Eduardo Paolozzi (1924–2005). Produced by
pressing a range of found objects into clay and assembling
the resulting moulds into quasi-representational human
figures, heads and animals, these again presented a vision
of humankind as scarred, fragile and fragmented (fig.6).

Though Paolozzi's figures appear to bear the marks of
technology's intervention into their being, the obsessive
attention to surface – the definition of body and subject

through its skin (a common feature of sculpture in the 1950s) – related his sculpture to the contemporaneous work of Francis Bacon. In his painting – particularly that of the late 1940s and 1950s – Bacon forged a new image of the human body for art. It is this achievement that singles him out above all the other artists discussed in this book as contributing a fundamental innovation to the history of art. Enthusiastically embracing atheism, Bacon painted humankind as nothing more or less than another animal – violent and violated, proud and pathetic, vicious and abject. Setting solitary figures – bare-skinned athletes, transformed copies of Velázquez's portrayal of Pope Innocent X (fig.7), abject dogs and hieratic business men – in empty or claustrophobic spaces, Bacon's painting came to be seen as the art of the post-war existential movement. In their animalism the figures are highly eroticized, as Bacon, for example, depicts pairs of male figures who may be wrestling or engaged in sexual coupling. This artist established an equation between his medium and his subject that becomes one of the major contributing factors to the understanding of his vision of humanity as visceral and frankly nihilistic. The power of these works, and their subject matter, and the expressive eloquence of Bacon's handling of paint ensured that he continued to tower over the British art world throughout the 1960s and beyond.

Though aspiring to universal truths in a way comparable to the Greek tragedies from which he drew inspiration, Bacon's work also engaged with modernity's technological transformation of human existence. Almost all his work drew upon photographic or filmic sources. His figures and their settings were the results of the transformation and conglomeration of photographs of human and animal

7 FRANCIS BACON
*Study after Velázquez's Portrait of
Pope Innocent X* 1953
Oil on canvas 15.3 × 11.8 (6 × 4¼)
Collection of the Des Moines Art
Center. Purchased with funds
from the Coffin Fine Arts Trust;
Nathan Emory Coffin

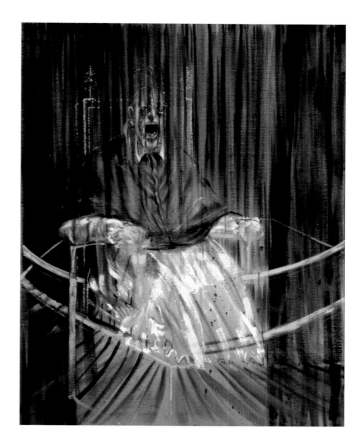

motion by Eadweard Muybridge (1830–1904), images from medical text books, stills from films (most famously Sergei Eisenstein's *Battleship Potemkin* of 1925), news photographs and so on. Through his use of these formal resources Bacon's works also came to be about the mediation of imagery and the consequent construction of identities. A physical manifestation of T.S. Eliot's 'heap of broken images', the photographs also become a kind of matrix of images that together construct a fractured history of modern violence and anxiety that underpins Bacon's claim that he was trying to paint 'a history of my time'.[6]

Bacon's appropriation of photomechanical sources makes his work as much about the mediation of images as it is about anything else. In this he belongs to a lineage of British artists who explored the impact of photography and its mediation on society and modern life. The exploration of photography's potential relationships with painting was a recurring feature of the art of the second half of the nineteenth century. In his late years, Walter Sickert (1860–1942) painted from photographs in a manner that not only used the photographic moment to create a sense of time and immediacy (as his old friend Degas had many years before) but as a consequence seemed to return to the subjects of the image a sense of their humanity and fragility (fig.8). Among his sources, Sickert frequently turned to news photographs. In so doing he seemed to produce an art that highlighted the theatrical aspect of modern life as seen through the mass media and that explored the point at which individual human beings become public personae in the world of celebrity that those media were creating. In the 1960s this became the dominant subject for such Pop artists as Derek Boshier (b.1937), Gerald Laing (b.1936) and

Joe Tilson (b.1928). Next to Bacon, the other great British master of the appropriation and transformation of found photographs has been Richard Hamilton (b.1922). Echoing Sickert, he has made an art that uses news photographs or television footage to imbue public figures with a lost pathos or dignity (fig.9).

Bacon's other legacy in British art was his destabilizing of the traditional, contained, even chaste representation of the human body, replacing it with an idea of an eroticized body defined by its contents, its processes and its urges. This is not simply to set the frankness of the modern nude, as painted by Stanley Spencer (1891–1959) or Freud, against that of academic tradition. The figures those artists painted remain defined by their outer appearance, whereas Bacon managed to articulate a sense of the body's visceral make-up without losing the element of representation. He achieved this through an equation of paint to subject and his contemporary, Roger Hilton (1911–75), also managed a similar feat through his use of his media. Hilton's art around 1960 was essentially abstract: close to French painting of the 1950s but also seen as part of Britain's variation on Abstract Expressionism. In fact, his greatest works allude to the human body, not simply through the forms described by his scraggy charcoal lines and smeared oil paint but also through their evocation of bodily fluids and sexual and excremental functions. This same aspect, the body as a fluid repository of erotic urges and its rendition through

handling of paint and the drawn line, appeared around the same time in the overtly gay love paintings of David Hockney (b.1937; see fig.119, p.188). The erotic, visceral and excremental would persist as themes in representations of the body, becoming especially dominant in the work of Gilbert & George (b.1932 and 1933) and among the generation of artists that emerged at the end of the 1980s. Tracey Emin (b.1963) addressed the theme of sex and sexuality in a variety of ways, ranging from neurotic-looking drawings and monotypes that recall, stylistically, Hockney's drawings to the filmed, embroidered and written narratives of her own sexual history. The work of her colleague Sarah Lucas (b.1962) repeatedly addresses themes of sex and scatological abjection. Jake and Dinos Chapman (b.1966 and 1962) also draw together the themes of violence, sex, death and excrement in their mannequins of hideously distorted figures with truncated limbs, penises substituted for noses and anuses for mouths. This combination is especially potent in their small-scale figure groups such as their 1993 three-dimensional reworking of Francisco de Goya's *Disasters of War* of 1810–14 (figs.10 and 11).

So one may trace running through British art of the twentieth century a theme of the body as the expressive vehicle for the experience of modernity, understood as an amalgam of attitudes and behaviours as much as of material things. This offers an alternative historical strand to run parallel to the more conventionally modernist one

set out in this volume by Charles Harrison. It is one of the main ambitions of this book, however, to treat the art made in Britain or by Britons between 1870 and 2007 with more breadth and diversity than these alternative modernist narratives perhaps allow. The four other longer essays address aspects of the art of the period or the circumstances within which it was made across those 130 years. Each author has been encouraged to take a strongly subjective line, reflecting a belief that, in any event, any history will be shaped by its author's own point of view. In taking this approach, each writer may cover art that falls outside conventional histories of British modernism. The same is true of the shorter essays, each of which examines a movement, a group of artists, a key exhibition or a single work.

The range of these essays has been chosen to some extent, though not completely, to reflect this series's broader concern with ideas of British identity and the relationship of British art to the wider world. We would not, however, want to claim this book to be in any way definitive or comprehensive. The shorter essays do not relate directly to the longer ones. Rather, they form a separate thread, chronologically arranged, that complements those broader accounts. Each piece can be read in isolation, but the whole – both longer and shorter essays – adds up to a substantial history of British art in our period and its relations to the wider world.

Of the authors of the longer pieces, I will examine where British art was made and consumed in the period, and the relationships between those locations and the art itself.

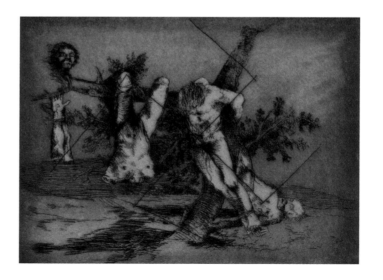

Extending the metaphor of a geography of British art, I will then consider the way artists' work registered the impact of migration and of dual heritage. If nothing else the essay demonstrates that the question over the use of the terms 'British' and 'English' that often arises in such a context is wildly over-simplistic as we see British art encompassing makers from every continent on earth working in Britain and abroad. Radicalism in art has often been associated with political radicalism. Julian Stallabrass asks to what extent this link is valid and, conversely, explores a conservatism that inhabits British modernism as well as academic art. Not unrelated to that theme, Sue Malvern charts the infrastructure of the art world and its development from an era of private patronage through state support to return to a period of privatization and corporate sponsorship. As she points out, to address the question of patronage is also to look at how art was mediated to its publics. Paul Wood considers the history of one of the fundamental aspects of artistic production: art education. In charting changes in pedagogy, Wood also charts changes in ideas of the status and purpose of art and, by implication at least, the definition of the artist.

A key aspect of art between 1870 and 2007 is the extent to which definitions of art and artistic practice changed. Firstly, as has been suggested, a fundamental characteristic of modernism is that the criteria by which a work of art is judged aesthetically or technically are continually reviewed and redefined. Nevertheless, for the first ninety years of our period the objects that tended to be considered 'fine art' were paintings (and related drawings and prints) and sculpture, and the characteristics that defined them as such remained stable. Since the 1960s, however, what art might be has expanded as artists have used installation, photography, sound, film, video and the internet to make art. It is not simply that different types of objects are now considered fine art but that, in this post-medium age, individual artists are likely to range from one type of activity to another, giving their work a heterogeneity that would have been considered a failing in earlier times. In the light of this change in practice, historians and curators have recuperated into histories of art the histories of these other media. If photography is an essential part of artistic practice but still cannot be divorced from the history of photography, the history of photography is part of the history of art. Each author of a longer essay was invited to include other media where relevant to their thesis, but the decision was taken that in a book of this scale and scope attempts to incorporate histories of those other media were neither possible nor desirable. This approach at least has the merit of reflecting the position of the historical moment under discussion.

As this might suggest, what follows may cover a relatively brief period of time but it is a convoluted and complex history of that period's art. Inevitably, with such a diverse and ideologically charged art history to tell, this account can only sit as one amongst many.

Narrative Painting

CAROL JACOBI

Narrative art was the successor of Old Master mythological, religious, history and genre painting. Nineteenth-century subject pictures were often bought for the nation but they achieved a new scale of exposure through commercial forms of publicity and exhibition. In 1857 *Derby Day* by William Powell Frith (1819–1909) earned £1500 from solo shows and engravings. This pioneered a form of mass marketing that brought artists international celebrity and made many millionaires. Transferring financial dependence from the single patron to a broader audience encouraged a range of figurative styles: classical, oriental, historical and realist, and subjects extending from religious scenes, chivalric romances and costume dramas to modern themes: dramatic and anecdotal, domestic and rural. In all of these, virtuoso renderings of detail and light effects provided a poignant immediacy, while literary devices were astutely entwined with contemporary vocabularies, enthusiasms and concerns.

The 1878 Ruskin-Whistler trial (see Prettejohn, pp.34–5) became a symbol of art's independence from anecdote, and by the twentieth century it became a commonplace to assert that literary reference undermined aesthetic value. In a letter to Alfred Tennyson,

however, Ruskin suggested a more creative relationship, writing that good pictures are never mere illustrations but 'always another poem' (Nelson 1985, p.15). Frank Bramley's social realist *A Hopeless Dawn* (fig.12), for example, synthesises ideas from Ruskin's *The Harbours of England* and many other sources to create something new and distinctly visual. Here is only part of the proto-Proustian sentence that contains the title:

> the sense of unfathomable danger, and the human effort and sorrow going on perpetually from age to age, waves rolling forever, and winds moaning forever, and faithful hearts trusting and sickening forever, and brave lives dashed away about the rattling beach like weeds forever; and still at the helm of every lonely boat, through starless night and hopeless dawn, His hand, who spread the fisher's net over the dust of the Sidonian palaces, and gave into the fisher's hand the keys of the kingdom of heaven. (Ruskin 1856, p.4.)

Bramley (1857–1915) describes the fisherman through his absence, drawing on imagery of women waiting by water that was common in poems, plays and paintings. Conventional

motifs, bread as a symbol of salvation and a flame representing the spirit or love, are used in a new way: a burnt-out candle holder on the sill, the remnant of the light that was meant to guide the fisherman home, answers the beautiful rendering of a guttering candle on the table, illuminating the meal in a last, golden burst. The resonances of these objects do indeed act like 'another poem'. The failing flame and the icy line of dawn are not mechanical repetitions of literary motifs. Their reconfiguration and realization as image transforms familiar icons of hope – candle and dawn – into estranged objects of loss in a way that echoes the emotional experience of the figures.

A Hopeless Dawn is typical of the dialogic inventiveness of narrative pictures. The use of dramatic attitudes and lighting draws on the conventions of the theatre as well as literature and art. Bramley is one of many who developed the poetry of gesture explored by the Pre-Raphaelites and their circle. The shadowy arm of the younger woman falls across the white Bible, its *pietà*-like limpness contrasts with the tense sinews of the mother's grasp of her shoulder. Beneath the apparently careless naturalism of the asymmetric scene there is also a taut and complex composition. The anchoring horizontal

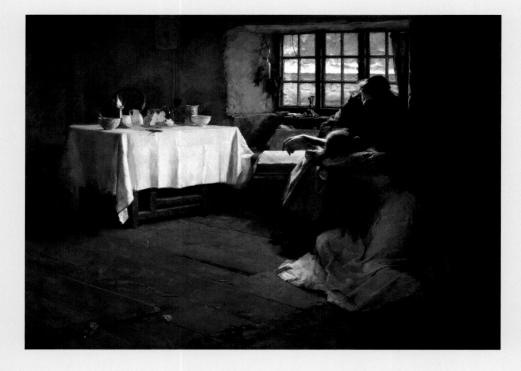

12 FRANK BRAMLEY
A Hopeless Dawn 1888
Oil on canvas
122.6 × 167.6 (48¼ × 66)
Tate. Presented by the Trustees of
the Chantrey Bequest 1888

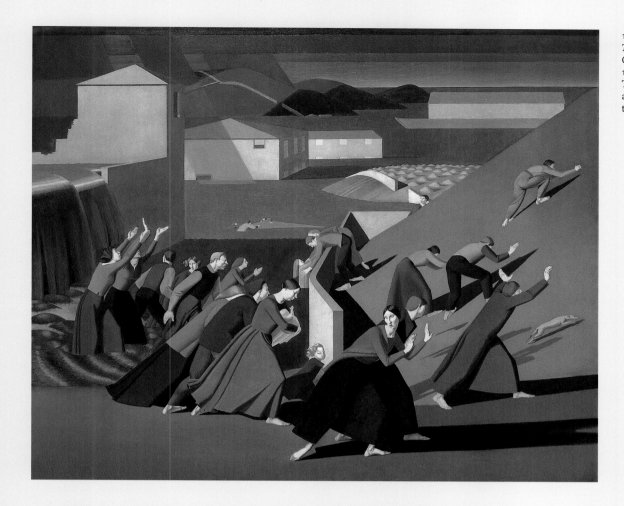

13 WINIFRED KNIGHTS
The Deluge 1920
Oil on canvas
152.9 × 183.5 (60¼ × 72¼)
Tate. Purchased with
assistance from the Friends of
the Tate Gallery 1989

of the holy book is subverted by the pessimism of the empty line of the sea and the neat folds of the altar-like cloth by the barred window. The awful stasis of these competing certainties counterpoints the instability of the floor, riven by diagonals that continue within the folded forms of the women and their inner tempests. The artist R.B. Kitaj (1932–2007) has argued that the ability of narrative pictures to articulate meaning in 'strokes which compose the image' pre-empted the experiments of Vincent van Gogh (1853–90) and later artists (Kitaj 1999). That this formal suggestiveness proceeds from the entanglements with iconography and story, described above, is clear from van Gogh's enthusiasm for English narrative artists, expressed in a letter to his brother in 1889, and his lifelong devotion to the reformist illustrated newspaper in which their work often appeared, *The Graphic*.

Martin Meisel reminds us that 'there is no reason to assume that narrativity in art is always the same, or that its means are always the same' (Meisel 1986, p.67). Story-telling continued to generate striking iconographical and formal innovations in the twentieth century: for example, in the impossibly congested contours of Stanley Spencer's The *Resurrection, Cookham*

1924–7 (see fig.59, p.89). In her existential take on the biblical scene of *The Deluge* (fig.13), Winifred Knights (1899–1947) focuses, like *A Hopeless Dawn*, on the people left behind. Their panic as the waters rise is articulated by the oppressive repetition of diagonals cutting to the right against the distant horizontal of the ark. Its style and story respond to a new set of resonances, the machine apocalypse of the First World War.

The essentially dialogic and synthetic nature of subject pictures provided a persistent alternative to the totalizing tendency of modernist art. Narrative painting evaded its obscure specialized discourses and reliance on non-reproducible media. It should be seen as part of a network that interfaces not only with religious, historical or fictional texts but also with news, theatre, fashion, advertising and communications technology on urban and global scales. Frith is exemplary, an early adopter of photographic sources in his work and the first artist to adapt the mass appeal and marketing techniques of serialized novels and plays to art. Major Victorian narrative painters were also prolific illustrators, and important Victorian paintings toured England and the world accompanied by the sale of repro-

ductions, brochures and merchandise. Their display, often top-lit in a darkened room, had as much in common with the exhibition of a relic or a film as a painting. Herbert von Herkomer (1849–1914) went further, moving from painting to directing theatre and pioneering narrative movies. Eric Hobsbawm's argument that cinema is the mainstream art of modern times, might also be applied to the works we have discussed: the 'revolution in the twentieth century arts was not by the avant-gardes or modernism ... It was achieved by the combined logic of technology and the mass market, that is to say the democratisation of aesthetic experience.' (Hobsbawm 1999, p.30.)

FURTHER READING

E. Hobsbawm, *Behind the Times:The Decline and Fall of the 20th-century Avant-Gardes: Thirteenth Walter Neurath Memorial Lecture*, London 1999.
R.B. Kitaj, 'My Vincent', in *LA Weekly*, 28 April 1999.
M. Meisel, 'Seeing It Feelingly: Victorian Symbolism and Narrative Art' in *Huntington Library Quarterly*, vol.49, no.1, Narrative Art Issue, Winter 1986.
E. Nelson, 'Tennyson and the Ladies of Shalott', in *Ladies of Shalott: A Victorian Masterpiece and its Contexts*, Providence 1985.
J. Ruskin, *The Harbours of England*, London 1856.

Late Victorian Academic Painting

COLIN TRODD

'Academic' is one of the most problematic terms in art history, particularly with regard to the evaluation and understanding of nineteenth-century painting. It is usually a negative title referring to something 'mechanical' rather than 'organic', an attitude popularized by the famous modernist critic Clement Greenberg, who once claimed 'all kitsch is academic; and conversely, all that's academic is kitsch'. However, a more balanced reading of late Victorian painting reveals the inadequacy of this proposition.

What has been called Victorian academic art is at once a continuation and critique of inherited models of history painting, the key academic system based on the principle that pictorial composition expresses rational and dignified norms through the ordering of spaces and planes to create a unified, logical design. Major British artist-theorists upheld such ideas:

Joshua Reynolds, James Barry, Henry Fuseli, Henry Howard, Benjamin Robert Haydon and Charles Lock Eastlake defined painting as the combination of human expression (sensible and elevated values) and formal skills (the organization and clarification of units of visual design). Significantly, none of these figures were particularly interested in 'narrative' as a separate category of expression.

In the final decades of the nineteenth-century these concerns found their most fruitful realization in the work of Frederic Leighton, George Frederick Watts (1817–1904), Edward Burne-Jones (1833–98) and Albert Moore (1841–93). All were aware of Romantic models of art, particularly the Blakean notion that painting must commit itself to the realization of the cultural authority of the imagination, as well as broader anthropological debates where cultural

development was defined as conflict and struggle. Appropriately, these twin pressures resulted in a series of fascinating works where the traditional academic pursuit of pictorial balance gave way to an interest in exploring different states or sites of experience through imposing, subject-centred compositions. Consequently, the human form was reinvented as a colossus at once pictorially dominant yet physically vulnerable.

The association of the body with sensation rather than nature allowed artists to see the human form as a meeting place between different accounts of freedom, action and identity. Such matters are particularly noticeable in Leighton's *Flaming June* (fig.14) and Watts's *Hope* (fig.15), both of which seem to exist in a universe of pictures, a special and unique chamber of art where the subject is at once self-absorbed and emotionally remote. Naturally, this strange combination of artifice and naturalism intrigued many of the more perceptive commentators of the period, such as Arthur Symons, G.K. Chesterton, Laurence Binyon and R.E.D. Sketchley, all of whom found in late Victorian 'academicism' the immobilization of traditional academic notions of compositional order.

Flaming June and *Hope* are concerned with questions of agency: the relationship of the world of the self to the external world. Specifically, both works make the body express the reality of organic processes, and both are more interested in exploring the nature of mental life than in repeating the academic or Raphaelesque tradition of treating painting as a relationship between volumetric forms and compositional motifs. Just as Watts transforms the classical body into a bundle of sensory-nervous energies, so Leighton treats the body as a magical solar entity.

Finally, Watts can be distinguished from Leighton, Burne-Jones and Moore in that most of his figures are divorced from an environment of aesthetic pleasure; his images tend to preserve the unsettling realization of the origin of human value in the physical reality of life.

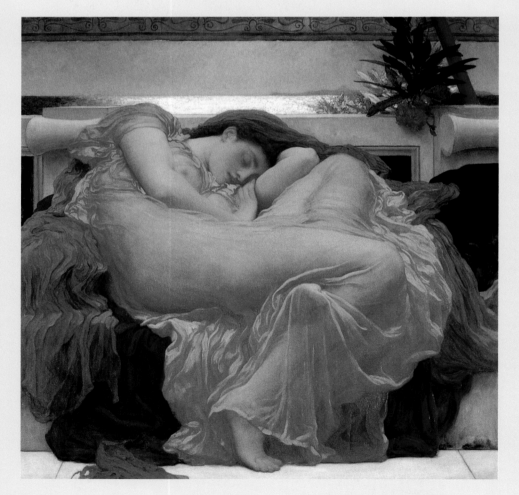

14 FREDERIC LORD LEIGHTON
Flaming June c.1895
Oil on canvas 119 × 119 (47 × 47)
Museo del Arte de Ponce,
Puerto Rico. The Luis A Ferré
Foundation Inc. 1996

In the combination of bleached surface, iridescent pigment and incandescent form, Watts finds an analogue of the relationship of sun to nature, a model of an engulfing presence, a condition of being that both enlivens the world and its objects, and reduces them to flickering, kinetic images. Of course, *Hope* is a frail evocation of this process as Watts transforms the colossus into an agnostic subject who cannot represent her epithet. Instead of dominating her environment, she is confined to the world of material phenomena, an environment unknowable beyond the realm of sensation and feeling. What is represented, then, is a vision of the world as the confrontation between consciousness and a pre-human or non-human system of forces. Tellingly, hope takes one of two forms. It is either a 'scientific' belief that mental life originates in sensation and that the body evolves by distancing itself from its physiological and neurological origin in pain; or it is a 'disciplinary' art, where the subject learns to become a self-governing agent by attempting to perfect a *technique* of hope in terms of bodily resistance to nature. In both cases the Wattsian design has a therapeutic goal rather than a narrative purpose, as the restive, submissive subject hopes for a level of human agency beyond human biology. In sum, Watts makes his figure enact a central moral dilemma of modernity: the existential dread that the material life of the world does not promote or preserve the rationality of human values, and that such values are cultural rather than natural.

FURTHER READING

D.P. Corbett and L. Perry (eds.), *English Art 1860–1914*, Manchester 2000.

R.C. Denis and C. Trodd (eds.), *Art and the Academy in the Nineteenth Century*, Manchester 2000.

E. Prettejohn (ed.), *After the Pre-Raphaelites*, Manchester 1999.

C. Trodd and S. Brown (eds.), *Representations of G.F. Watts*, Aldershot 2005.

A. Wilton (introd.), *The Age of Rossetti, Burne-Jones & Watts: Symbolism in Britain, 1860–1910*, London 1997.

15 G.F. WATTS AND ASSISTANTS
Hope 1886
Oil on canvas 142.2 × 111.8 (56 × 44)
Tate. Presented by
George Frederic Watts 1897

Aestheticism

ELIZABETH PRETTEJOHN

Towards the end of the 1860s, art critics began to note a new development among a small minority of English painters: a shift away from the previous generation's concerns with nature, story-telling and morality, and towards a new emphasis on beauty for its own sake. In 1868 the poet Algernon Charles Swinburne, the critic Walter Pater and the journalist Tom Taylor introduced the motto 'art for art's sake' in contexts closely connected with two interlocking circles in the London art world: those centred around Dante Gabriel Rossetti (1828–82) in Chelsea and Frederic Leighton in Holland Park. Artists in these circles were alert to recent developments in Continental painting and art theory; the phrase 'art for art's sake' is a translation of the French *l'art pour l'art*, associated with the poets and critics Théophile Gautier and Charles Baudelaire, and the ideas discussed in London art circles were heavily influenced by German philosophical aesthetics.

But what does 'art for art's sake' entail? It is simple enough to claim that a work of art does *not* exist for the sake of preaching a moral lesson, of supporting a political cause or of making a fortune. But to say that a work of art exists 'for art's sake' is merely to repeat oneself; the phrase identifies an artistic problem without proposing a definitive solution to it. From the start there were two strongly differentiated approaches. Should art for art's sake mean an art of purely formal perfection, divested of any reference to ideas beyond the picture frame? Or should it mean an art that involved the human subject's experience of beauty in the fullest sense, including passionate sensuality? While divisions among the artists were never entirely clear-cut, the first approach was particularly associated with Leighton, Albert Moore, and James McNeill Whistler (1834–1903), the second with the artists of the Rossetti circle, including Simeon Solomon (1840–1905) and Edward Burne-Jones. The parallel development in the poetry of the Rossetti circle, including the work of Algernon Charles Swinburne and William Morris (1834–96) as well as that of Rossetti himself, came under attack in Robert Buchanan's article of 1871, 'The Fleshly School of Poetry' (Buchanan also castigated the visual art of Solomon). But the apparent amorality of the 'pure art' approach could also attract critical censure, and the phrase 'art for art's sake' was quickly abandoned by its original proponents. After 1870 it was used more often in hostile

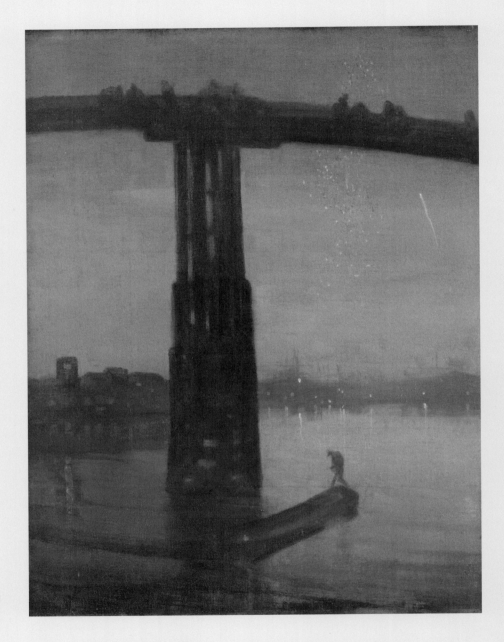

criticism, and the designations 'Aestheticism' and 'Aesthetic Movement' emerged as the standard labels for the movement.

These artistic controversies erupted into public debate with the opening in 1877 of the Grosvenor Gallery, a new exhibiting venue widely seen as a forum for Aestheticism. In a passing comment on the first Grosvenor exhibition, the critic John Ruskin (1819–1900) attacked Whistler for mannerism and eccentricity, while praising the painstaking execution of Burne-Jones; when

16 JAMES MCNEILL WHISTLER
Nocturne: Blue and Gold – Old Battersea Bridge c.1872–5
Oil on canvas
68.3 × 51.2 (26⅞ × 20⅛)
Tate. Presented by The Art Fund 1905

17 EDWARD BURNE-JONES
The Golden Stairs 1880
Oil on canvas 269.2 × 116.8 (106 × 46)
Tate. Bequeathed by Lord Battersea
1924

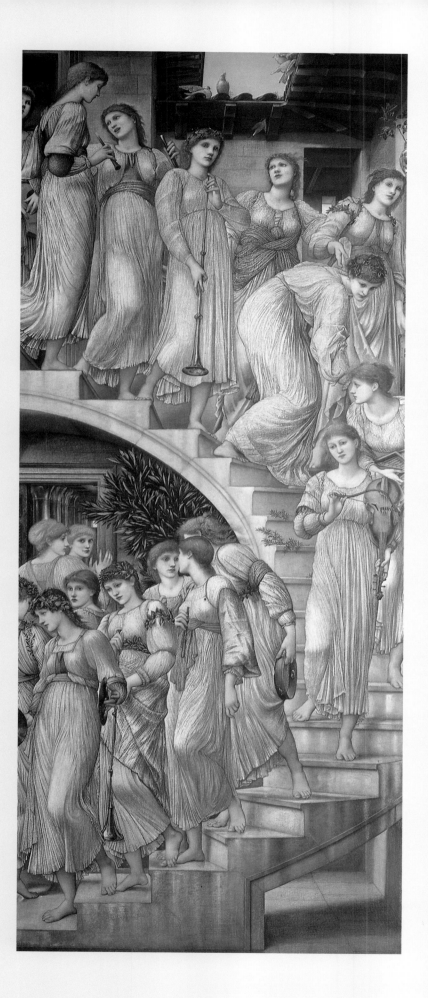

Whistler sued Ruskin for libel, the artistic controversy moved into the courtroom, with Burne-Jones testifying on Ruskin's side and Moore on Whistler's. In an important sense, though, the trial merely brought into public debate the differences of opinion that had been present in artistic circles since the beginning, and the paintings of both Whistler and Burne-Jones can be seen as cogent explorations of what art might be, if it is not for the sake of anything else. Whistler's *Nocturne: Blue and Gold – Old Battersea Bridge* (fig.16) presents a scene of urban modernity, on the Thames at night; Burne-Jones's *The Golden Stairs* (fig.17) creates a fairy-tale world where beautiful maidens, alike as sisters, cycle in endless procession down a staircase that leads nowhere in particular. Yet Whistler transforms the industrial Thames into a luminous world of nocturnal serenity, miraculously purged of daytime strains and stresses. The tiny human figures on the bridge are poised as delicately as the pinpoints of light that barely describe a firework, bursting in the night sky; sweeps of liquid colour, barely graduated in hue and tone, dimly suggest the lapping of the waters into a distance that is impossible precisely to measure. In the stillness of night, forms are muted and blurred, and the scene's modernity gives way to the suggestion of eternity. Burne-Jones gives us, instead, utmost precision in the intricate delineation of drapery folds, of limbs turning in space as the figures descend, of delightful minor details such as the birds on the roof, the archaic musical instruments or the brazen pillars glimpsed through the doorway at bottom left. The procedures of the two painters may be seen as opposite: Burne-Jones gives material specificity to forms of the imagination, while Whistler makes poetry of modern realities. Yet in their different ways both paintings explore a central issue of modern art and art theory: the complex transaction by which the work of art both places itself in relation to, and opens a liberating distance from, the 'real' world in which we necessarily live.

FURTHER READING

D. Peters Corbett, *The World in Paint: Modern Art and Visuality in England, 1848–1914*, Manchester and New York 2004.

E. Prettejohn, *Art for Art's Sake: Aestheticism in Victorian Painting*, New Haven and London 2007.

K.A. Psomiades, *Beauty's Body: Femininity and Representation in British Aestheticism*, Stanford, CA 1997.

The New Sculpture

MARTINA DROTH

The sculptors we now associate with the label 'New Sculpture' emerged as a loosely connected circle of artists who rapidly established their careers during the 1880s and dominated British sculptural aesthetics into the early twentieth century. Despite their varied oeuvres, their over-lapping artistic concerns were recognized as 'new' and indeed oppositional to that of the classicizing practice of earlier generations. That the New Sculpture brought a fresh and revitalized approach to an art that had come to be seen as tired and clichéd was a view almost unanimously accepted in contemporary art criticism.

The major artists of the New Sculpture, and those who have attracted most attention from art historians, include Alfred Gilbert (1854–1934), Hamo Thornycroft (1850–1925) and Edward Onslow Ford (1852–1901), although it was the painter Frederic Leighton, whose work includes a small number of sculptures, who was credited with producing the inaugural work of the movement, with *An Athlete Wresting with a Python* 1877 (Tate, London). As the poet Edmund Gosse wrote in 1894, with Leighton's bronze statue 'a wholly new force made itself felt', which 'gave the start-word to the New Sculpture in England'. Gosse, whose article gave the New Sculpture its name, thereby acknowledged not only Leighton's aesthetic affinity with contemporary sculpture but also his profoundly influential role in fostering its exponents. Under Leighton's presidency of the Royal Academy from 1878 to 1896, the crucial flowering period of the New Sculpture, not only were the conditions for the display of sculpture greatly improved, but an unprecedented number of sculptors were elected Academicians.

The recognition that a radical transformation was taking place in sculptural practice stimulated a considerable wave of interest in the discipline, which was reflected in a marked increase both in the visibility of sculpture in exhibitions and public spaces and in the critical responses it generated in the illustrated press. Although it remained a relatively marginal field in art criti-cism compared to painting and decorative art, within this small corpus of writing significant new theoretical positions about the direction and condition of sculptural aesthetics were forged. The key critical voices included Edmund Gosse, Walter Armstrong, Marian [MacMahon] Hepworth Dixon, Claude Phillips and Marion Spielmann, who collectively not only identified

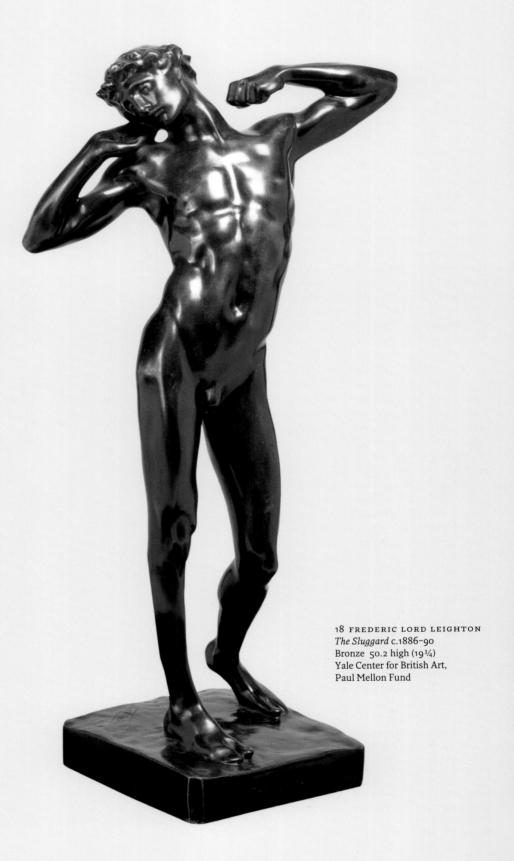

18 FREDERIC LORD LEIGHTON
The Sluggard c.1886–90
Bronze 50.2 high (19¾)
Yale Center for British Art,
Paul Mellon Fund

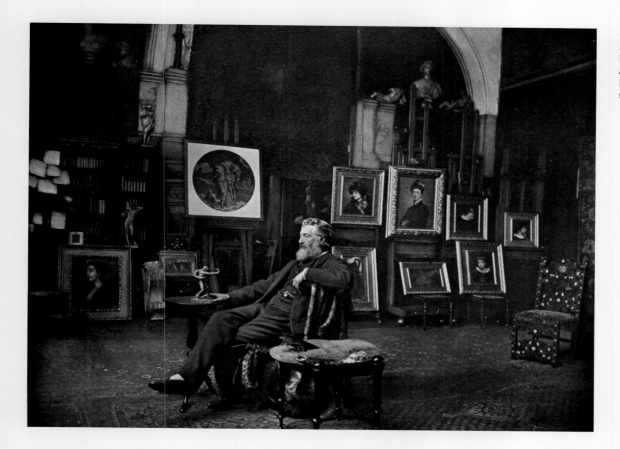

19 Frederic Leighton in his studio at his home in London. In the background is his sculpture *The Sluggard* and on the table next to him is his *An Athlete Wrestling with a Python.* London 1884

the specific stylistic concerns of the new generation, but engaged with the work on a profoundly analytical level, acknowledging its aesthetic intent, its material import and the psychological effects of its physical presence. In a marked departure from earlier evaluations of Neoclassical sculpture, which were largely concerned with the idealization and transcendence of material form, the discourse became focused, as Gosse put it, around 'a theory of execution', in which aesthetic intent and sculptural effects converged on the question of how sculpture was made.

A significant feature of the New Sculpture was its liberal use of forms and materials more typically associated with the decorative arts, including richly wrought ornamental details, symbolic and abstracted forms alongside figurative conceptions, the preference of cast or beaten metal over carved marble, and the introduction of polychromy through enamelling, patination, precious metals and coloured stones. Aspects of this decorative language were visible in all forms of the work, including statuary and public monuments, for example in Ford's statue of General Gordon on a camel of 1890 (Institution of Royal Engineers, Chatham), bedecked with tassels, ornate accessories, and an elaborately rendered oriental saddle-blanket.

But it was in the smaller, more intimate works that the New Sculpture's decorative character was most expressively asserted. Statuettes and *objets d'art* began to be regularly exhibited in the Royal Academy alongside the more traditional format of statues and busts. Far from being seen as minor or auxiliary, such objects came to be viewed as serious and vital elements of sculptural practice. Alfred Gilbert, for example, established his reputation through a series of statuettes, including *Icarus* 1884 (National Museum of Wales, Cardiff), which was commissioned by Frederic Leighton, while Leighton himself, in 1886, exhibited his diminutive *Needless Alarms* (Tate, London) alongside the life-size *Sluggard* (fig.18).

That such smaller, often decorative works were specifically intended for private ownership and display in domestic interiors was widely remarked upon in the art press. Notably, while many bronze reproductions, particularly those imported in large numbers from Paris, were often condemned as commercially debased, the New Sculptors escaped such censure, partly on the grounds of the crafts-ethic seen to underpin their practice, and on the contrary were praised for making their work a relevant and accessible part of modern living. Thornycroft, for example, issued circulars inviting potential patrons to his home to view small casts of his *Mower* and

Teucer, which had previously been exhibited to acclaim at the Royal Academy. Like successful painters, sculptors also invited journalists and critics into their homes, and depictions of their interiors and studios emerged as a major subject of public interest in the illustrated press (fig.19). The New Sculptors' strategic alignment to a domestically orientated set of criteria was important not only for selling work, but for enabling them to determine the aesthetic context in which their sculpture would be viewed and critiqued. Thus, while the Royal Academy provided a critical arena that ensured status and reputation, it was the image of the artist's private interior that established the notion of an exemplary aesthetic environment in which to view and contemplate sculpture.

FURTHER READING

S. Beattie, *The New Sculpture*, New Haven and London 1983.

J. Edwards, *Alfred Gilbert's Aestheticism: Gilbert Amongst Whistler, Wilde, Leighton, Pater and Burne-Jones*, Aldershot 2006.

D. Getsy, *Body Doubles: Sculpture in Britain, 1877–1905* New Haven and London 2004.

E. Gosse, 'The New Sculpture', in *Art Journal*, 1894, in four parts, pp.138–42, 199–203, 277–82, 306–11.

1 Going Modern

CHARLES HARRISON

Introduction

The content of this chapter is framed by three broad questions. Firstly, how does a work of art qualify for the description 'modern'? Secondly, given the nature of the restriction placed on the scope of this volume, on what grounds might a work be thought of as specifically British – which I take to mean not simply produced in Britain but somehow *representative* of a national culture? And thirdly, how far do the possible answers to the first two questions converge? To ask this last question is to straddle two areas of controversy: on the one hand the kinds of difference of opinion that attend on evaluative judgements about works of art, on the other the different values and investments that the category 'British' represents for various individuals and constituencies.[1] It cannot be stated strongly enough that use of this essentially administrative and coercive category is always liable to misrepresent – and indeed to offend against – the work of those whose embarrassment it ignores and whose various distinct identifications, loyalties and intentional *dis*loyalties it tends to co-opt.

In view of my own inevitable partiality, both in the matter of judgements about works of art and where arguments about the distinctness and integrity of the national culture are concerned, I can make no claim to objectivity in what follows. My primary concern is with the relationship of artists working in Britain to modernism, here conceived as a necessarily cosmopolitan value. I shall have nothing to say about a number of widely celebrated artists – Stanley Spencer, Francis Bacon, Lucien Freud, David Hockney, Gilbert & George – whose standing in the history of British art may be undeniable, but whose work I consider of peripheral or negative import where the problems of 'going modern' are concerned. (While I make no apologies for my understanding of modernism, it should be clear that a different theorization of the concept might be used to support a very different set of judgements on the art under review [see Stephens. p.76].) Since I shall largely be concerned with work produced by artists based in England and exhibited in London, I shall use the terms Britain and British with some circumspection.

Inquiry into the relations between the modern and the British is certainly not a novel enterprise. My title makes reference to an article, 'Going Modern and being British', published by the painter Paul Nash in 1932, at a time when a relatively small group of artists in England was attempting to come to terms with recent developments abroad.[2] During the period covered by this volume there have of course been great changes in the field of art to be surveyed, while there have been attendant variations in the plausibility of claims for London as a metropolitan centre of modernist development. It remains the case, however, that significant priorities in the criticism of art can still be measured in terms of the respective qualifications that Nash's conjunction invokes.

To talk of qualification is to imply the application of some kind of standard. Given that it is works of art we are talking about, should we assume that what is required in each case is a primarily *aesthetic* qualification? Many influential theorists of the late nineteenth and twentieth centuries understood modernism as a historical and technical condition that it was incumbent on the artist to confront, and assumed, therefore, that there was some necessary connection between a work's modernism and its aesthetic merit. In other words, a work needed to be modern to be good *as art*. In Edouard Manet's often quoted prescription, 'Il faut être de son temps.' If we assume that a work needs to be good to be taken as representative of the national culture, does it follow that only modernist art will qualify? If so, does this mean that local considerations are in the last resort of no real critical interest except in so far as they provide access to larger concerns? In the words of Herbert Read (1893–1968), 'The artist always has loyalties that transcend the specific political divisions of the society in which he lives.'[3] Or, in the words of a group of modernist artist-signatories to a letter to the *Sunday Times* in June 1963, 'Any painting which will not stand on equal terms with the best painting produced anywhere in the world is not worth bothering about.'[4] This raises the interesting possibility that the nation's most uncompromisingly modernist artists might in the end necessarily be recognized as the best representatives of its culture, from whatever

constituency they may actually have emerged, and however strong the local opposition to them may have been.

The alternative possibility is that there may be some separate virtue attached to qualification as 'British' (or as 'English'), such as to cast a critical light on the value of modernism. Both Read and the artist-signatories to the letter to the *Sunday Times* understood modernism as a cosmopolitan value supervening national interests. But for Robin Ironside, writing in 1947 in the influential survey *Painting since 1939*, the kind of modernist abstract art that Read supported at the time smacked of a new and alien professionalism that was hostile to the interests of the national culture (as conceived by those accustomed to speak for it). Citing the most determinedly cosmopolitan of English artists at the time, he wrote, 'The barrenness that [Ben] Nicholson has cultivated has no pictorial interest.' As Ironside saw it, the specific virtue of British art lay in its closeness to literature and in its 'essentially amateur impulse', both properties explicitly derogated in modernist criticism and theory. Each of the painters of whom he most approved – Stanley Spencer, John Piper (1903–92), Graham Sutherland (1903–80) – remained attached to an idiosyncratic repertoire of personal, topographical and naturalistic motifs. That this limited their receptiveness to such mainstream modernist developments as Cubism and abstract art was in Ironside's view a positive benefit. It is perhaps significant that his study was commissioned by the British Council, that it had something of the flavour of a policy document, and that it was the kind of moderate modernism represented by Piper and Sutherland that received the Council's most wholehearted support over the ensuing decade.

Impressionism, Post-Impressionism, Vorticism

Modernism is a difficult concept to pin down. In discussion of art it is employed to refer both to a property identified in certain works rather than others and to a specific evaluative tendency in criticism and theory by which that property is represented. Historically, modernism is associated not only with the technical modernization of industrialized societies since the late eighteenth and nineteenth centuries, but with the rise of the bourgeoisie to economic and cultural

dominance, which occurred over a still longer period. (To say that the rise of the middle class was a condition of the emergence of modernism is of course *not* to suggest that all modern artists have emerged from the middle class.) In England and much of Continental Europe during the nineteenth century and at least until the last third of the twentieth, that class tended to be uneasily composed both of those whose claim to established status was under-written by heredity and education, and of those who had gained their social position through the fruits of industry and entrepreneurship. Among the symptoms of this division are the numerous terms deployed by the former in the attempt to keep the latter in their place, and thus to preserve their own priority: 'lower-middle class', 'nouveau riche', 'petit-bourgeois', and so on (see Stallabrass, pp.120–151).

Controversy over the meaning and relative value of modernism was largely driven by the consequently contested self-imagery of that divided class, and was increasingly coloured by the different problems and prospects that capitalism and socialism presented to those variously involved. Following the Russian Revolution of 1917, and in the light of Fascist opposition to expressionist and abstract art, a broad modern movement in art, design and architecture was strongly associated in the 1920s and 1930s with the practical imagination of a positively trans-formed and universal social order. Since the late 1960s, on the other hand, the need for recognition of differences – sexual, cultural, racial and economic – has been widely theorized in the name of *post*modernism.

Though arguments between 'Ancients' and 'Moderns' had first been made explicit in published texts in the late seventeenth century, the emergence of a specifically artistic modernism is conventionally associated with the growth of a faction among artists and writers in France in the mid-nineteenth century who were identifiable by their interest in the representation of modern life and by their commitment to principles of realism and naturalism. This commitment served to distinguish their priorities and technical concerns from those grounded in respect for the classics that were still generally upheld in academic training (see Jacobi, pp.30–1) and in the exhibitions of the official Salon. In the view of the artists and writers in question, sentimental emotional investment in debased classical styles and motifs was characteristic of a regressive 'bourgeois' culture from which they meant to distinguish their own

productions – even though it was bourgeois capitalism that they depended on both for economic support and for a wider superstructural context. (It could be said that in so far as modernism virtually requires the critique of sentimentality, its continued pursuit has tended to be incommensurable with nationalism.)

The emergence of this self-consciously different disposition among French artists was noticed by artists in Britain with effect from the late 1870s onwards. A few among them responded positively to the novel styles and techniques – variously realist, naturalist and impressionist – by which that disposition was made manifest, committing themselves so far as they were practically able to making the difference tell on home ground. The presence in London of James McNeill Whistler was a significant factor. Not only was this American painter a veteran of the Salon des Refusés held in Paris in 1863, he had attracted more local attention fifteen years later through his libel action against the critic John Ruskin (see Prettejohn, pp.34–5), defending his practice in terms typical of the advanced modernist theory of the time. Taken together, these two events serve as public markers of a deep rift that had opened between traditional and modernist views on art, and on its proper technical characteristics and expressive purposes.

A clear if paradoxical sign of cosmopolitan intent was given in the foundation of the New English Art Club in 1886 – though not quite as clear as the 'Society of Anglo-French Painters' might have been, had this first suggestion for a title not been rejected. According to the testimony of Albert Thornton, the members of the NEAC were 'in utter revolt against the prettiness and anecdotal nature of the work at home, and enthusiastic for the impressionism of Monet, as well as for Manet.'[5] Claude Monet's American friend John Singer Sargent (1856–1925) was among the founder members. A few were French expatriates. Others had studied in Paris. Notable among those who exhibited with the NEAC at the turn of the century was the Welsh painter Gwen John (1876–1939; see Foster, pp.70–1), who had briefly studied with Whistler in Paris in 1898. From 1903 until her death she lived and worked in France, supporting herself initially as an artist's model, principally for the sculptor Auguste Rodin, who was her lover. Her pictures of single female figures, still lifes and interiors are typically painted with a dry and even touch and a narrow tonal range. For all the careful formality of their composition, the effect they tend to generate is of moments of self-effacing

absorption, casually registered. They are among the most quietly distinctive figurative works produced by any painter working during the first two decades of the twentieth century. Gwen John's brother Augustus (1878–1961) also exhibited with the NEAC. Though he remained a much more widely celebrated figure than his sister, he was altogether the lesser artist, as he himself acknowledged.

The NEAC could hardly have been called an avant-garde. But it was the first in a long series of groupings formed by artists in Britain with a common interest in the modernization of 'the work at home', and with a common perception that the relevant measures of aesthetic interest and achievement were set by art and artists from abroad. So far as concerns the technical character of painting in Britain at the time, it is evident from works exhibited with the NEAC in its first two decades that the main force driving this first modernizing wave was response to the naturalistic aspect of Impressionism. This involved an exploration of *plein air* subjects and techniques, with a consequent move away from tonal composition towards a heightened chromatic range, and the cultivation of relative informality in composition – which in most cases meant avoidance of any noticeably classical formats. The French Impressionists' virtual prohibition on anecdote was somewhat less rigorously observed among the New English painters, as was the French painters' tendency to avoid the kinds of subject matter that Walter Sickert encapsulated as 'the auguste-site motif, and . . . the smartened-up-young person motif'.[6]

The son of a Danish painter and a half-English, half-Irish mother, Sickert himself was an exceptional and exceptionally cosmopolitan figure among artists in England at the turn of the century, with a broad acquaintance among French painters, an appreciation of the urban repertoire of Impressionism, and a highly developed understanding of Edgar Degas's work in particular (see Corbett, pp.66–7). He spent much of his time out of the country between 1883 and 1905, in the last seven years of that period living in Dieppe with long visits to Venice. In 1905, a working friendship with the younger painter Spencer Gore (1878–1914) initiated a remarkable series of pictures of undressed women, seen against the light in dingy interiors. They are rigorously unclassical, not simply in their compositions but in the tones and textures of their surfaces, intentionally redolent as these are of the sapid and the grubby. In subsequent works combining nude women with clothed

20 VANESSA BELL
Studland Beach c.1912
Oil on canvas 76.2 × 101.6 (30 × 40)
Tate. Purchased 1976

male companions, Sickert drew on a dark and risky aspect of the realist tradition that was not easily accommodated even by recent modernist developments in the rest of Europe. Any claim that these works were in some sense specifically British would certainly have been opposed by those of the artist's contemporaries and former associates who found them sordid and obscene.[7] At the same time, it may be acknowledged that Sickert's obstinate attachment to a long tradition of pictorial illustration distinguished him from those other English artists of his generation who were interested in recent French painting. It also disqualified him from sharing his younger colleagues' admiration for the work of Paul Cézanne and thus from joining the London art world's converts to Post-Impressionism.

Promotion of the *idea* of Post-Impressionism was principally the work of the critic Roger Fry (1866–1934) and his younger colleague Clive Bell (1881–1964), effected through two large exhibitions of recent art held at the Grafton Galleries in London in 1910 and 1912. In the first of these, *Manet and the Post-Impressionists*, the naturalism

of the Impressionists was circumvented and a kind of formal progression established, with Cézanne, Vincent Van Gogh and Paul Gauguin providing the platform from which the work of Pablo Picasso and Henri Matisse was launched. By the time of the *Second Post-Impressionist Exhibition of English, French and Russian Artists*, staged two years later, Cézanne was firmly established as 'the Christopher Columbus of a whole new continent of form',[8] Matisse was identified as the foremost exponent of the 'decorative unity of design'[9] characteristic of an entire new school, and a cohort of home-grown Post-Impressionists was assembled.

Impressionism could be understood as an important technical and stylistic category with clear implications where subject matter was concerned. Post-Impressionism was not so easily delimited or so practical. Its principal significance was as the label under which diverse aspects of modern art theory were homogenized and a specific and influential interpretation of modernism was purveyed in Britain. Among the axioms that emerged were that

authentically modern art achieves its significant effect not through the imitation of appearances but through the creation of form; that it has a natural kinship in this respect with so-called 'primitive' art (a category that was seen at the time as uniting the productions of pre-classical and tribal cultures with those of pre-Renaissance Europe); that it is by the feeling aroused in its spectators, rather than by what it represents, that the work of modern art should be judged; and that the feeling in question is dispassionate and disinterested – and thus, of course, representative of the responsible, liberal leadership of the cultured middle class.

While it might be argued – and indeed has been – that these axioms are applicable to art universally, the practical effect of the vogue for Post-Impressionism was to discredit illustrative and descriptive work from all periods and to encourage interest in the decorative and the haptic. A specifically English mode of Post-Impressionism may be identified with the lumpy and simplified modelling of certain pictures and sculptures produced between 1912 and the late 1930s – comparable to the broad range of work in

France that resulted from attempts to cope with the legacy of Cubism while holding on to the possibility of modelling and figuration. Those whose work was selected for the *Second Post-Impressionist Exhibition* included Stanley Spencer and Edward Wadsworth (1889–1949), members of a group of self-styled 'Neo-Primitives' at the Slade School that was dominated by Mark Gertler (1891–1939). Among the others included were Vanessa Bell (1879–1961; fig.20) and Duncan Grant (1885–1978), both members of the social group centred on Bloomsbury to which Fry and Clive Bell belonged. Gore was the sole artist to be included from the nucleus of younger painters that had assembled around Sickert and Lucien Pissarro, London-based son of the Impressionist (1863–1944). Notable among these was Harold Gilman (1876–1919), in whose work a powerful realism in the choice and interpretation of motifs and a modernist intensification of colour are combined in the production of vivid, workmanlike paintings (fig.21).

For a short while – between 1910 and 1913 – no young British artist with modernist aspirations minded being

22 SPENCER GORE
The Beanfield, Letchworth 1912
Oil on canvas 30.5 × 40.6 (12 × 16)
Tate. Purchased 1974

called a Post-Impressionist, with many of them joining the Omega Workshops, an organization set up by Fry, with the avowed aim of improving the quality of design in household goods. By the autumn of the latter year, however, the collected representatives of advanced art in London had already split into distinct factions. A walk-out from Omega had been led by Wyndham Lewis, who identified himself in quick succession as the spokesman for a group of Cubists working in England,[10] as an advocate for Italian Futurism, and as the energizing spirit and theorist of Vorticism, a specifically London-based movement indebted to Cubism and to Futurism but intentionally distinct from both (fig.24). A Vorticist manifesto was published in June 1914 in the first issue of *Blast,* a journal edited by Lewis. This and the 'War number' published the following autumn count among the few indispensable documents of modern art in the twentieth century that were published in Britain (see Humphreys, pp.74–5).

The emergence in 1913–14 of an avant-garde faction with declared interests in French Cubism and Italian Futurism was a clear indication that the time lag between Continental and local developments was closing fast. At a time of political instability in Europe and of marked transition in the character of government in England, it was also significant of a tendency to polarization among those engaged with modern art. On the one hand were the 'traditional' modernists, represented in theoretical terms by the Bloomsbury writers, who conceived of all art as united by the disinterested aesthetic response that its

formal and decorative properties elicited in the sensitive spectator, and who regarded Post-Impressionism as standing for a manifest reliance on the properties in question. The painters of a traditional modernist disposition tended to concentrate on the well-established genres of still life, landscape, portraiture and figure studies, though Grant and Vanessa Bell each produced a few well-mannered abstract compositions during the First World War.

On the other hand were the 'radical' modernists, who were impatient for social change – if by no means agreed as to the direction that change should take. Where the traditional modernists tended to be drawn from the cultured southern upper-middle class, the radical faction was composed in significant measure of individuals with quite different class and cultural affiliations. The dominant figure was Lewis, whose father was a wealthy Canadian. David Bomberg was the son of an immigrant Jewish leather-worker from Birmingham, Frederick Etchells (1886–1973) the son of an engineer from Newcastle, and Edward Wadsworth the son of a mill-owner from Cleckheaton. William Roberts (1895–1980) had commenced an apprenticeship before gaining a scholarship to the Slade. Of the sculptors briefly associated with the loose radical group, Jacob Epstein was an American Jew of Polish extraction, while Henri Gaudier-Brzeska was the son of a French carpenter. A measure of theoretical support was provided by the philosopher-critic T.E. Hulme (1883–1917), who drew heavily on the work of the French philosopher Henri Bergson, by which the Futurists had been much affected, on Wilhelm Worringer's

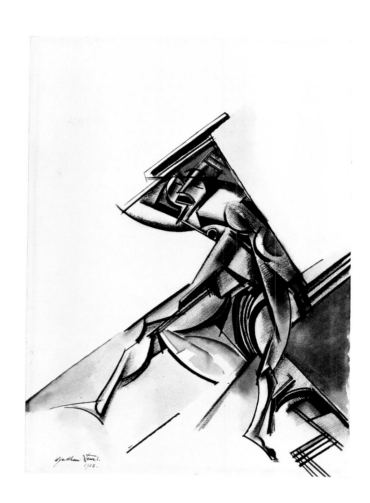

Abstraction and Empathy (1908), and on other recent
German work in aesthetics and the theory of art. The
repertoire of the radical modernists was dominated by
studies of the human figure in action and interaction, by
scenes of urban and industrial life, and by experiments
in energetic abstract design. In the rhetoric of Vorticism,
still life was anathematized.

In the years 1913–14 each of the artists cited in the
previous paragraph produced original and interesting
work of a kind that could not have been envisaged without
the purgative effect of Cubism and to a lesser extent of
Futurism. To register this dependence is not to disparage
the work in question, the best of which – some of Lewis's
works on paper, and the sculptures of Epstein (fig.23)
and Gaudier-Brzeska – would properly be included in any
international survey of the avant-garde art of the period
1910–15. What I have called the radical tendency was
effectively extinguished by the Great War, however, at least
as a possibility for collective endeavour. It is in the nature
of war that it tends to increase nationalist fervour and to
depress the spirit of cosmopolitan adventure. 'You would
think . . .', Lewis wrote in 1915, 'that the splendid war army
of England were fighting to reinstate the tradition of
Sir Frederick Leighton, to sweep away the fancy of the
Russian ballets, or revive a faded Kiplingesque jingoism.'[11]
Gaudier-Brzeska was killed in action in 1915, Hulme two
years later.

A majority of the remaining radicals saw action in
one role or another before being seconded as official war
artists. Christopher Nevinson was reported to the effect
that the war would be 'a violent incentive to Futurism,
for we believe that there is no beauty except in strife,
no masterpiece without aggressiveness'.[12] In the event,
however, it was the artists most strongly committed to
modernist styles who tended to suffer the greatest prob-
lems in responding to a brief that stressed the importance
of documentary record. In England the most considerable
body of work on war-related themes was produced by
Paul Nash (1889–1946), who went to the front in 1917 as an
enthusiast for the work of William Blake, Samuel Palmer
and the Pre-Raphaelites, and whose rapid development
over the next two years set in train one of the most diverse
and interesting bodies of work by any English painter
during the first half of the century.

Between the Wars

Had Gore and Gilman survived through the period between
the wars, the strain of modernist realism associated with
the Camden Town Group might have continued to furnish
strong material for development. But Gore had died from
pneumonia in 1914 and Gilman succumbed to influenza in
the epidemic of 1919. In so far as a cosmopolitan modernism
could be countenanced in the aftermath of the First World
War, it was the traditional tendency that largely dominated.
During the 1920s both Sickert and Lewis were relatively
isolated figures. Of the various factions supportive of
modern art in the pre-war years, the Bloomsbury coterie
had been least depleted and demoralized, and now exercised
a measure of domination over the limited marketing and
exhibiting opportunities for modernist art. Younger artists
emerging during the 1920s were faced with the necessity
to re-establish connection with the history of art as it had
been revised by the largely French modernist practice and
theory of the previous fifty years, and it was not until the
early 1930s that anything like a new avant-garde tendency
emerged among artists in England. The principal individuals
involved were those who had come to terms with the revi-
sions that Cubism had made to the artistic repertoires of

25 CHRISTOPHER WOOD
La Plage Hotel, Ty-Mad, Treboul 1930
Oil on board 46 × 56 (18⅛ × 22)
Sheffield Galleries and Museums Trust

pictorial space and sculptural form, who had absorbed the modernist doctrine of the kinship of so-called primitive art, who had come to entertain the possibility of an altogether abstract art, and who had finally shown some degree of practical interest in aspects of the Surrealist movement. Paul Nash alone among these artists was old enough to have established a reputation with his wartime work. The other major figures were the painter Ben Nicholson (1894–1982) and the sculptors Henry Moore and Barbara Hepworth.

Each of these artists was involved alongside others in one or both of two overlapping groupings, those involved being united in the years 1933–6 by their commitment to the development of a cosmopolitan modernist avant-garde. The first grouping was represented by the 7 & 5, founded in 1919 as the Seven and Five Society. Following the recruitment of Ben Nicholson in 1926, what had commenced as a relatively traditionalist grouping of ex-servicemen was gradually transformed into a significant showcase for moderate modernism in still-life and landscape painting and in figure sculpture. In the 7 & 5 exhibition of 1929 there was a notable showing of work on Cornish themes by Ben and Winifred Nicholson (1893–1981), by their friend Christopher Wood (1901–30) and by the untaught Cornish fisherman Alfred Wallis (1855–1942), whose 'primitive' paintings the three artists had discovered on a visit to St Ives the previous summer. Wood's suicide in 1930 at the age of twenty-nine marked an end not only to a quite

distinctive individual career, much of it pursued in cosmopolitan circles in Paris, but also to the brief phase of cultivated modernist innocence in English painting that the 7 & 5 represented (fig.25). Two years later, Moore and Hepworth were among a group of four new members. Each had recently established a kind of vernacular modernist style in carved figure sculpture that was indebted to Cubist painting and sculpture, to the artefacts of pre-classical and non-European cultures as represented in the British Museum (interest in which was an indirect legacy of Cubism), and to the thematizations of both that were prevalent in the writings of modernist critics. (Moore read Fry's *Vision and Design* [1920] while a student in Leeds. Looking back in 1947, he acknowledged, 'Fry opened the way to other books and to the realisation of the British Museum. That was really the beginning.'[13]) By then the character and direction of Nicholson's work were clearly established by the late-Cubist repertoire that he had first tentatively tried out in 1924. The nucleus of a new avant-garde was now assembled.

The second grouping was the initiative of Paul Nash, who had begun in December 1930 to write regular reviews of exhibitions and publications, and who had been deliberating in public on developments in England with an eye to the European modern movement in art, design and architecture. By late in 1932 he was planning a home-grown contribution to that movement, with artists and architects united to form a common modernizing front.

The composition of Unit One was finally decided early the following year: besides Nash himself the painters were Ben Nicholson, John Armstrong (1893–1973), John Bigge (1892–1973), Edward Burra (1905–76), Frances Hodgkins (1869–1947; almost immediately replaced by Tristram Hillier [1905–83]) and Edward Wadsworth (the one veteran of the pre-war avant-garde); Moore and Hepworth represented sculpture, and Wells Coates and Colin Lucas architecture. Introduced as a friend of Moore, Herbert Read encouraged the group to produce a book of statements and photographs, which he would edit. The resulting volume, *Unit 1*, was published to coincide with the group's first and only London exhibition, held at the Mayor Gallery in 1934. In his introduction Read represented the group as the expression of a 'consciousness . . . international in its extent . . . a coherent movement of world-wide scope'.[14] It should be borne in mind that for those who had broader interests than art in view in 1934, the principal candidate for a 'coherent movement of world-wide scope' was Communism (where it was not Fascism). Among those who responded in print to the initial announcement of Unit One, there were those who noticed 'a Soviet-like flavour, savouring of mass production, the collective man and the like'.[15]

In fact, for all Nash's overt commitment to the objectives of the European modern movement, he was himself quite untouched either by the spirit of 'transcendental socialism', by which that movement had been fired in the early twentieth century, or by the utopian dreams of post-revolutionary planning, by which it was largely maintained during the 1920s. In so far as his very substantial competence as a painter of English landscapes had been complicated and extended, it was principally by his enthusiastic response to the work of the Italian Giorgio de Chirico, which he saw on exhibition in London in 1928, and by an ensuing interest in the politer aspects of Surrealism. (Nash was particularly impressed by an exhibition of the work of Max Ernst, held at the Mayor Gallery in London in June 1933.[16]) His friend Burra is best known for gamey and slightly satirical illustrations on urban themes, redolent of the German work of George Grosz and Otto Dix, but quite at odds with the design-and-architecture aspect of the modern movement (see Stephenson, pp.114–5). Otherwise, Nicholson apart, the painters Nash recruited to Unit One

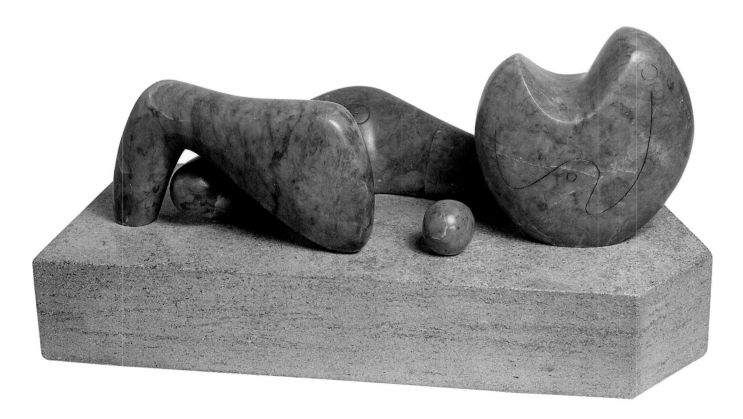

27 BARBARA HEPWORTH
Discs in Echelon 1935
Padouk wood 31.1 × 49.1 × 22.5
(12¼ × 19⅜ × 8⅞)
The Museum of Modern Art, New York

28 BEN NICHOLSON
1935 (white relief)
Painted wood 101.6 × 166.4
(40 × 65½)
Tate. Purchased with assistance from
the Contemporary Art Society 1955

were selected from among those whose own interests were compatible with his own, and none of them was able to make as much of them as he had himself.

For some years previously, the European avant-garde had tended to divide between abstract artists and Surrealists, each of the respective factions being sufficiently broad and internally diverse to sustain a measure of complexity and vitality. Unit One was an incoherent grouping from the start and, especially given an increasing commitment to abstraction on the part of Nicholson and Hepworth, liable to fragment. This it did following the closure of the exhibition in London, while a selection from the work of the group was toured to Liverpool, Manchester, Hanley, Derby, Swansea and Belfast, shown in each case under the sponsorship of the municipal authorities.

In 1935 a greatly reduced 7 & 5 under Nicholson's chairmanship staged the first mixed exhibition of all-abstract work to be held in Britain. Nicholson showed the white

reliefs he had been carving since the previous year and Hepworth the abstract carvings that she had been making over the same period (figs.27 and 28). The highly refined work these two artists made in the years between 1934 and 1938 represents a certain presence in the international abstract art of the period between the wars. Moore's *Four-Piece Composition* (fig.26) was also shown in the 1935 exhibition. It was based on the reclining figure, as its subtitle declared, but would certainly have been regarded as 'abstract' according to the criteria generally applied in English criticism at the time.[17] Though this was the last exhibition to be staged by the 7 & 5, a number of the final membership – Nicholson, Moore, Hepworth, Eileen Holding, John Piper and Arthur Jackson (Barbara Hepworth's cousin A.J. Hepworth [1911–2003]) – were included in the following year in the international exhibition *Abstract and Concrete*, alongside Alexander Calder, César Domela, Hans Erni, Naum Gabo (1890–1977), Alberto

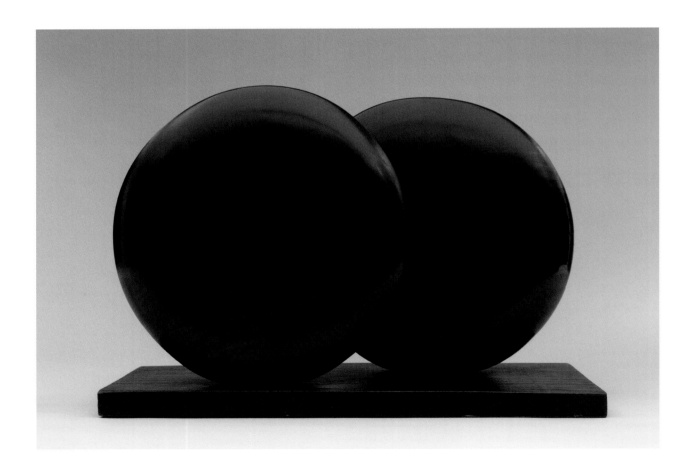

Giacometti, Jean Hélion, Fernand Léger, Joan Miró, László Moholy-Nagy (1895-1946) and Piet Mondrian (1872-1944).

Also in 1936 an International Surrealist exhibition was staged at the New Burlington Galleries (see Gale, pp.116-7). Nash and Moore were among the English members of the organizing committee, together with Read, and were both represented in the exhibition. Among the other British artists included were Roland Penrose (1900-84), Humphrey Jennings (1907-50), Julian Trevelyan (1910-88), Stanley Hayter (1901-88), John Banting (1902-71) and Eileen Agar (1904-91). Neither Nash nor Moore was seriously committed to Surrealism's intellectual and political programme, which drew on the theories of Sigmund Freud and Karl Marx in pursuit of a pointed critique of modern social life and of its representative modes of consciousness. Nevertheless, response to the work of European artists associated with the Surrealist movement had an animating effect on the formal repertoires of both artists, neither of whom was inclined to pursue the alternative course of an altogether abstract art. In Nash's case the consequence was to strengthen the sense of animism he associated with elements in the English landscape, and to increase the possibility of interpretive readings of his pictures. Moore was reinforced in his tendency to exploit the many ways in which the human form might be represented, and in his conviction that there are 'universal shapes to which every-body is conditioned and to which they can respond if their conscious control does not shut them off'.[18]

As the thirties had proceeded, growing numbers of artists and intellectuals – and particularly Jewish artists and intellectuals – had been driven westwards from the Soviet Union and from Germany, many of them to Paris, where their presence served both to enlarge and to diversify the community of those engaged with modern art and design. On a trip to Paris in 1933, Hepworth and Nicholson were invited to join the Association Abstraction-Création, founded early in 1931 for the organization of displays of non-figurative art. By 1935 the association could list 416 'members and friends'. Although only 11 of these were based in Britain, as against 209 in Paris and 33 in the US, London was nevertheless now more closely connected to the centre of the wider modern movement than it had ever been. By the same token, when the Surrealist travelling circus crossed the Channel in 1936, it came to a ready reception and was joined by a number of eager recruits. In the latter part of the decade, as it became clear to those with eyes to see that Paris was no longer a safe haven, many members of the Continental avant-gardes continued their migrations to England, in many cases en route to a final destination in America. Among those in England in the years 1938-9 were Piet Mondrian, Naum Gabo, the artist and designer László Moholy-Nagy, and the architects Walter Gropius, Eric Mendelssohn, Berthold Lubetkin and Serge Chermayeff. In the words of Barbara Hepworth, 'Everywhere there seemed to be abundant energy, and hope, and a developing interest in the fusion of all the arts

to some great purpose.'[19] By September 1939, however, Hepworth and Nicholson had decamped to Cornwall with their five-year-old triplets as it became clear that war was imminent. 'Just when we felt the warmth and strength of this new understanding it eluded us.'[20]

High Modernism

While the outbreak of war was clearly inhibiting to further avant-garde activity, it should be stressed that an internal opposition to what was seen as the modernist extremism of abstract art had been gathering force since at least the autumn of 1936, when John Piper and the writer Geoffrey Grigson had asserted the priority of 'England's Climate', in the name of a Romantic Revival.[21] British art's littérateurs perhaps shared a perception with Herbert Read, who had claimed in 1935 that abstract art was a practical pointer to the 'art of the new classless society'.[22] Unlike Read, however, they welcomed neither the abstraction nor the prospect of classlessness. During the war, with Nicholson and Hepworth relatively isolated in Cornwall, it was the troika of Piper, Moore and Graham Sutherland that received most whole-hearted endorsement from the constituency that Grigson and Piper represented.[23] In 1947, in the publication already cited, Robin Ironside could affirm, 'It has become a naturally accepted convention to link the names of John Piper, Graham Sutherland and Henry Moore as the chief protagonists of the contemporary school, especially in so far as British painting now exhibits neo-romantic tendencies . . . There is at present no likelihood of the alternative of a reaction towards abstraction.'[24]

Within a few years Ironside was proved wrong in this last assertion at least. The next substantial contribution to the literature of modern art in England was to be the small volume *Nine Abstract Artists*, published in London in 1954, with a spirited introduction by the young Lawrence Alloway. In fact, as Chris Stephens has argued,[25] a current of commitment to the cosmopolitan modernist tendency had been kept alive during the war through publications and contributions to mixed exhibitions. For many of the generation of artists who emerged during the late 1940s and early 1950s, Cornwall was an important focus of interest precisely – if paradoxically – because it was associated, through the presence of Nicholson and Hepworth (and

until 1946 of the Russian émigré Gabo), with resistance to the insular, the literary and the Neo-Romantic. Several of those represented in *Nine Abstract Artists* had worked or stayed in Cornwall during the previous decade.

The nine were Robert Adams (1917–84), Terry Frost (1915–2003), Adrian Heath (1920–92), Anthony Hill (b.1930), Roger Hilton (1911–75), Kenneth and Mary Martin (1905–84 and 1907–69), Victor Pasmore (1908–98) and William Scott (1913–89). Of these, Adams, Heath, Hill, the Martins and Pasmore were involved in a 'Constructionist' recapitulation of the Constructivist tradition that had its origins in the art of the Russian revolution of 1917 (fig.29). Pasmore was the leading figure, having been persuaded of the necessity of abstract art by a selective recapitulation of the modernist tradition and by the 'Structurist' theories of the American artist Charles Biederman.[26] Pasmore's was a principled development, but the abstract reliefs he made from 1951 onwards seem curiously vacant – lacking the kind of resonance with potential social change that had enlivened the art of the Constructivists (fig.31). His most interesting works are the paintings of the 1940s that mark his gradual transition from a figurative Whisterlian mode.

Similar judgements may be made concerning the work of the other English 'Constructionists' in the 1950s and

30 PATRICK HERON
Vertical Light: March 1957 1957
Oil on canvas 55.9 × 121.9 (22 × 48)
Collection of the Artist's Family

31 VICTOR PASMORE
*Abstract in White, Black, Indian
and Lilac* 1957
Painted wood 106.7 × 116.8 × 3.2
(42 × 46 × 1¼)
Tate. Purchase 1958

after. During his time in England Gabo had been an influential exponent of the belief that the social and the aesthetic could be brought into harmonious correspondence through recourse to 'underlying structures.' But while this belief might have sustained the European modern movement in the period between the wars, it was already coming under pressure from the course of events by the time Gabo arrived in London in 1936. In the 1950s subscription to the same body of ideas was a rationale for anachronism. What was effectively the dominant modernist theory of the immediate post-war period issued not from Europe but from New York, where the tendency of artists and writers was to associate programmes for the unification of the arts not with a 'possible . . . universal freedom',[27] but rather with a disastrously failed utopianism. In 1945 the American painter Mark Rothko had written, 'If previous abstractions paralleled the scientific and objective preoccupations of our times, ours are finding a pictorial equivalent for man's new knowledge and consciousness of his more complex inner self.'[28] In the same year, Rothko's fellow artist Barnett Newman deliberated on the nature of the 'new knowledge and consciousness' to which abstract art was now answerable. 'The war has robbed us of our hidden terror. We now know the terror to expect. Hiroshima showed it to us . . . No matter how heroic or innocent or moral our individual lives may be, this new fate hangs over us.'[29]

In describing the work of the remaining 'nine abstract artists', Alloway referred to 'a stylistic gamut from expressionistic action painting to a kind of sensual impressionism without things.' That the terms were derived from recent American writing about American painting was indicative of the transfer of initiative that had taken place during the war, and of the different critical criteria that would consequently be applied by those with an interest in the conjunction of the British with the modern. The term 'Middle Generation' was coined by the painter and writer Patrick Heron (1920–99; fig.30) – himself just too young and too late in his own move to abstraction to have been included among the nine – in order to designate those caught in mid-career by this transfer.[30] Though it was far from the implication he intended, the terms in which Heron represented his first impressions of the work of the Americans in 1956 were revealing of the technical conventions by which it seemed that the English artists were restricted.

I was instantly elated by the size, energy, originality, economy and inventive daring of many of the paintings. Their creative emptiness represented a radical discovery, I felt, as did their flatness, or rather, their spatial shallowness. I was fascinated by their constant denial of illusionistic depth, which goes against all my own instincts as a painter. Also, there was an absence of relish in the *matière* as an end in itself, such as one never misses in the French.[31]

Of the Middle Generation artists, much the strongest case for the contrasting virtues of English painting is made by the work of Roger Hilton, whose early training in the pre-war Ecole de Paris was followed by a period of internment during the war. When Hilton re-engaged with French painting in the late 1940s it was the brushy, semi-abstract work of Roger Bissière, Albert Manessier, Jean Bazaine and others that appeared to represent advance on familiar terms. His emancipation from the stylistic mannerisms that such work encouraged occurred in 1952 following contact with the Dutch artist Constant (1920–2005) and direct experience of the work of Mondrian. From that point on Hilton tended to combine a relatively informal and spontaneous technique with a robust and concrete approach to the painted surface. The works that he made from 1953 until his death in 1974 were sustained by his conviction that a painted composition could be the plastic form of an idea or emotion. This was a notion that was good for its time, pursued by many of the strongest and the weakest artists on both sides of the Atlantic. What particularly distinguishes Hilton's paintings is that, while they may be interpreted as redolent of the complex kinds of physical contact and interaction that characterize human relationships, the most remarkable of them also admit marks of ironic detachment and self-deprecation rarely discoverable in the works of other painters of abstract pictures (fig.32). In a significant statement of 1961 he proposed that post-abstract painting and architecture were now alternative pursuits rather than mutual complements. If this belief was incommensurable with the position of the English Constructionists, it was entirely in line with the American revision of modernist theory that was now in the ascendant.[32]

The development of abstract and semi-abstract painting and sculpture in Britain during the 1950s can be assimilated to a contemporary European current of more-or-less

32 ROGER HILTON
February 1961 1961
Oil on canvas 66 × 66 (26 × 26)
Private collection

expressionistic, more-or-less painterly painting and textural sculpture that emerged after the war, that claimed a kind of continuity with previous developments in the respective media and that may be linked in that respect to what I have labelled the traditional tendency of pre-war modernism. An alternative 'radical' current in European art advanced under the banners of new techniques, new materials and new subject matter for 'a society in flux'.[33] Its inheritance from Dada and Surrealism was updated by the exploitation of new technologies, and by recourse to the iconography of popular culture. For certain members of the post-war generation of artists who had reason to dissociate themselves from a class-based tradition of 'Fine Art', resources such as these provided the means to de-stabilize the category itself and to highlight by contrast the system of values within which its virtue was assumed.

A distinct contribution to this second tendency was made by the Independent Group that first gathered at the Institute of Contemporary Arts in London in 1952 (see Mellor, pp.160–1). The artists principally involved were Eduardo Paolozzi, whose parents were Italian and who had spent the years 1947–9 in Paris; William Turnbull (b.1922), a Scot who followed war service in the RAF with a period in Paris from 1948 to 1950; and Richard Hamilton, whose various periods of training in fine art had been interspersed by work in commercial design. Alloway was also among those involved in the discussions of the Independent Group over the ensuing three years. In an essay published in 1958 he concluded: 'The new role for the fine arts is to be one of the possible forms of communication in an expanding framework that also includes the mass arts.'[34] This position was representative of the Pop art movement that first came to public attention as such in 1956 with the exhibition *This is Tomorrow*, staged at the Whitechapel Art Gallery by a combination of forces largely drawn from the Independent Group and the English Constructionists.

The contributors to British Pop art – Hamilton in particular – looked to America as the dominant point of distribution for a modernized consumer culture (see Stephens, p.83). Early in the year of *This is Tomorrow* the exhibition *Modern Art in the United States*[35] had made clear to those with a relatively untransformed sense of High Art that the initiative in this respect also had passed to America during the war. (It was this exhibition that prompted the encomium from Heron, quoted above.) This observation was amply supported by a more substantial showing of Abstract Expressionist work in *New American Painting*, staged at the Tate Gallery three years later. Whether regarded with a traditional or radical modernist disposition, the work of the Americans – specifically of Jackson Pollock, Rothko, Newman, Clyfford Still and Willem De Kooning – made the great majority of contemporary art exhibited in London look fussy and small-town. The effect of this work, and of the very different American art of the later 1950s that was rapidly sought out in its wake, was to drive a virtual wedge between Heron's 'Middle Generation', whose careers were grounded in the assumption that Paris was the 'fountainhead' of modernism (as Clement Greenberg had called it as late as 1946),[36] and those younger artists for whom New York was now the unquestionable centre of development.

In 1960 a constituency of the latter gathered to exhibit their paintings at the Royal Society of British Artists Galleries in London under the title *Situation*. As represented in Roger Coleman's introduction to the catalogue, the conditions of inclusion set by the organizing committee were that work should be 'abstract (that is, without explicit reference to events outside the painting – landscape, boats, figures) and not less than thirty square feet'.[37] The qualification made clear the terms on which those involved saw

themselves as distinct from the painters of the Middle Generation, with their links to St Ives, as did Coleman's reference to 'a new conception of space in painting and with it a new conception of the spectator's relationship to a painting'. In referring also to the concepts of painting as 'event' and of the work of art as 'a real object' Coleman made clear that it was to American modernist theory that visitors should look for explanation of the work on view rather than to the legacy of the European modern movement. Alloway was explicit: 'American art . . . is the mainstream of modern art, which used to run through Paris.'[38]

The exhibitors in *Situation* included Gillian Ayres (b.1930), Bernard and Harold Cohen (b.1933 and 1928–87), Robyn Denny (b.1930; fig.33), William Green (1934–2001), John Hoyland (b.1934), Bob Law (b.1934), Henry Mundy (b.1919), John Plumb (b.1927), Ralph Rumney (1934–2002), William Turnbull and Marc Vaux (b.1932). (Richard Smith [b.1931] was listed in the catalogue as an exhibitor, but he was already working in New York and his paintings were not returned in time to be shown. Gwyther Irwin [b.1931] exhibited but was not listed.) A year later a further exhibition was held at the commercial New London Gallery under the title *New London Situation*. This included a large sculpture in welded and painted steel by Anthony Caro (b.1924). Before 1960 Caro had been making modelled and cast work based on the human figure. His conversion to an improvisatory, constructive way of working had occurred following a visit to America (fig.34), where he had spent time with Clement Greenberg and the painter Kenneth Noland and had been introduced to the work of the sculptor David Smith.

Though the term Middle Generation was initially coined to refer to a group of painters, it is extensible to those sculptors in the same age range – Robert Adams, Kenneth Armitage (1916–2002), Reg Butler (1913–81), Lynn Chadwick (1914–2003), Bernard Meadows (1915–2005) – whose postwar careers had been established in the shadow of Henry Moore and in relation to European art. For younger sculptors emerging in London around 1960, whatever virtues there may have been in the work of this generation – which was generally modelled and cast – they were almost wholly eclipsed by the American painting that engaged the attention of their contemporaries among the painters in London. In preserving some sense of continuity between these generations, Caro's role was a crucial one. It was to a significant extent the categorical change in the means of his work that made the art of the American painters practically accessible to these younger sculptors, and that subsequently served to introduce the virtues of David Smith's welded and constructed sculpture.[39] Largely as a consequence of Caro's presence as a part-time teacher between 1953 and 1963, a relatively homogeneous group

33 ROBYN DENNY
Baby is Three 1960
House paint on canvas 213.4 × 365.8
(84 × 144)
Tate. Purchased 1973

34 ANTHONY CARO
Sculpture Three 1961
Painted steel 299.7 × 443.2 × 129.5
(118 × 174½ × 51)
Raymond and Patsy Nasher
Collection, Dallas, Texas

35 PHILLIP KING
Rosebud 1962
Fiberglass and wood, painted,
in three parts 148.5 × 167 × 158.7
(58½ × 65¾ × 62½)
The Museum of Modern Art, New York

36 JOHN HOYLAND
'28. 5. 66' 1966
Acrylic on canvas 199.4 × 365.8 × 26
(78½ × 144 × 26¼)
Tate. Purchased 1966

of sculptors emerged from St Martin's School of Art in the early 1960s (see Westley, pp.190–1), their work offering a match with on the one hand the colourful abstract paintings of some of the exhibitors in *Situation* and on the other the synthetic and urban imagery favoured by a second generation of Pop artists coincidentally emerging from the Royal College of Art.

A substantial exhibition of Caro's abstract constructions was held at the Whitechapel Art Gallery in 1963. The catalogue introduction was written by the American critic Michael Fried, confirming a transatlantic interest in the sculptor's work already fostered by his contacts with Greenberg and Noland. Two years later the same gallery showed the 'New Generation' sculptors associated with St Martin's: David Annesley (b.1936), Michael Bolus (b.1934), Phillip King (b.1934; fig.35), Tim Scott (b.1937), William Tucker (b.1935) and Isaac Witkin (1936–2006). Between 1965 and 1966 Annesley, Bolus, King, Tucker and Witkin all had one-man shows in New York galleries. In 1966 Alan Bowness wrote: 'It seems to me more than likely that we are witnessing in this country, here and now, one of the great epochs in the history of the art.'[40] That this was no mere case of insular delusion was apparently confirmed two years later when Greenberg gave voice to similar effect: 'I think certain younger Englishmen are doing the best sculpture in the world today – sculpture of originality and character.'[41] When Caro's *Prairie* was exhibited at Kasmin's Gallery in the autumn of 1967, Fried described it as 'one of

the great works of modern art and a touchstone for future sculpture'.[42] To those sympathetic to the work in question it seemed at that moment that American painting and British sculpture had come together with the blessing of academic and critical authority, to define the advanced modernist art of the time. If painters based in London were attracting less attention from abroad, there were at least those – Gillian Ayres, John Hoyland and the slightly younger Jeremy Moon (1934–73) – whose work not only seemed to fit with the sculptors' but was also inviting analysis on the same terms as the late high-modernist abstract painting from America that was currently being shown in the West End galleries (figs.36 and 38).

Ideas of the Postmodern

As it transpired, however, for all the achieved coherence of late-modernist abstract art as it appeared in the years 1965–7, the achievement was terminal. Though the values of expression, sensation, spontaneity and integrity of effect were still supported by a dominant critical order, the relevant practical resources were not themselves suitable for indefinite refinement or renewal – as they needed to be if abstract painting and abstract sculpture were to continue evolving under the same protocols.[43] Various broad developments served to undermine the notion of a continuing

37 JOHN LATHAM
The Bible and Voltaire 1959
Books, metal fittings, wires, plaster,
paint on canvas on hardboard
198 × 160 × 38 (78 × 63 × 15)
Lisson Gallery, London

high-modernist mainstream. Already by 1960 the reductive tendency in modernist theory – the notion that each medium was destined progressively to purge itself of its inessential aspects – had itself been subject to a kind of *reductio* in the blank canvases of the French Yves Klein, the American Frank Stella and others less notable. It would shortly thereafter be further confronted in the 'three-dimensional work' of the Americans Donald Judd, Robert Morris and Carl Andre. While the Minimal art of the early and mid-1960s was not to be shown in London before 1969, the emergence in New York of a significant kind of modernist apostasy was made clear to British readers of American art magazines and, in particular, of the summer 1967 issue of *Artforum*,

a special number devoted to American Sculpture. This included Fried's impassioned defence of the modernist art of David Smith, Caro, Noland and Jules Olitski against the 'literalism' he attributed to Judd and Morris. It also included Sol LeWitt's 'Paragraphs on Conceptual Art', which offered a name for an emerging movement and proposed, among other things, that 'what the work of art looks like isn't too important'.[44]

At the same time, the exclusiveness of the late-modernist canon of high art was made increasingly evident during the 1960s by the wide-ranging activities of artists, groups and tendencies working outside its terms of reference on both sides of the Atlantic, often with the explicit intention of

undermining its authority. Among relevant artists working in Britain, John Latham (1921–2006) was the major figure. Though he was old enough to have served in the Second World War, he was distinguished from the painters and sculptors of his generation in London by the original techniques he developed for gathering reference and allusion into his work, by the difficulty and idiosyncrasy of his ideas, and by his determined scepticism with regard to precedent and authority (fig.37). In 1966 he was involved with the German-born Gustav Metzger (b.1926) in the Destruction in Art Symposium. This occasion served to engage a constituency of mostly much younger artists in London with an international current of avant-garde activity that embraced the work of Fluxus in Germany and the US, of the Gutai group in Japan, and of the Aktionismus Group in Vienna.

In the spring of 1969 the loose international avant-garde to which these various tendencies had contributed was surveyed in the exhibition *When Attitudes become Form*. Originally installed at the Kunsthalle in Berne, this was restaged in the late summer at the ICA, London, with a partly changed selection of works. The exhibitors on the latter occasion included Victor Burgin (b.1941), Barry Flanagan (b.1941), Richard Long (b.1945), Roelof Louw (b.1936) and Bruce McLean (b.1944). Flanagan, Long, Louw and McLean had all been associated with the sculpture department at St Martin's, where the identification of the medium with a postulation of experiment had served to accommodate such enterprises as Long's lines in the landscape made by walking and Flanagan's hessian containers filled with sand. Burgin had recently returned from the US where he had gained a first-hand acquaintance with the work of the Minimalists that was rare among artists in Britain at the time.

The authority of criticism in the traditional modernist manner had rested on the principle that aesthetic judgement of effects properly followed from the focused analysis of formal properties. The formal properties of most concern were those of painting and sculpture, and these were seen as following from the irreducible technical constraints of the respective media: in the case of painting, the flat surface bounded by its framing edge; and in the case of sculpture, the physical configuration so integrated as to be apprehended synchronically. In each case situational considerations were deemed to be in the last instance irrelevant to the judgement of success or failure. Now that

authority was challenged internationally by a diverse and increasing body of work that was intentionally resistant to the types of analysis on which such judgements had depended, whether by means of its presentation as ephemeral action or performance, by its being located inextricably in relation to some specific context or occasion, by its physical extension over space and time, or by its taking shape not as a painting or sculpture but as a linguistic description or specification.

This last mode of working is associated specifically with the Conceptual art movement, as it emerged in the later 1960s and early 1970s. The work in question marked a new phase in the internationalization of modern art. Eschewing the aura of uniqueness and of medium-specificity that had been a central concern of modernist theory, it tended to present itself in forms that facilitated reproduction and distribution across physical and indeed national boundaries. As both a symptom and a cause of the concurrent crisis of modernism, Conceptual art was initially assimilated into the broad avant-garde tendency represented in the *Attitudes* show, in *Information*, held the following year at the Museum of Modern Art, New York, and in a number of other international survey exhibitions at the time. It became increasingly clear, however, that an 'analytical' tendency within the wider definition of Conceptual Art

39 ART & LANGUAGE
Index: Incident in a Museum XXI 1987
Oil and photo on canvas mounted on
plywood 243 × 379 (95⅝ × 149¼)
Lisson Gallery, London

constituted a distinct movement in itself, one driven as much by the need to address the problematic implications of late, non-literalist modernism as by the counter-attraction of the literalist or Minimalist apostasy. What complicated the issue was that the question of the non-literal or virtual had been largely supervened by a form of Duchampian gesture – a gesture of appropriation taking the textual form 'I nominate X as an artwork'. The danger seen by the analytical Conceptual artists was that this gesture and its minimalist-literalist add-ons were going to limit artists to the repetitive generation of the next most reductive or most exotic object of an informal metaphysics.

Consideration of this issue is particularly associated with the journal *Art-Language,* first published in Coventry in the spring of 1969. In the previous year the first editors of the journal – Terry Atkinson (b.1939), David Bainbridge (b.1941), Michael Baldwin (b.1945) and Harold Hurrell (b.1940) – had adopted the name 'Art & Language' to cover the collaborative activities on which they were variously engaged. At the international exhibition *Documenta 5* in 1972 a large work in the form of an index was shown in the name of an enlarged Art & Language membership that included Ian Burn (1939–93), Mel Ramsden (b.1944) and Joseph Kosuth (b.1945), all then working in New York, as well as the present author.[45] By the mid-1970s Art & Language had expanded further from its base in England and was responsible for publication in New York of three issues of a second journal, *The Fox.* Following the disbanding of the New York contingent in 1976, Ramsden returned to England and joined Baldwin in assuming responsibility for the legacy and continuing artistic work of Art & Language. I remain their collaborator on literary and theoretical projects. Amongst the substantial productions issued in the name of Art & Language over the past thirty years have been numerous series of paintings and painted ensembles (fig.39), recorded songs, a libretto for an opera, and several published volumes of theoretical and critical writings.

Further to my acknowledgment at the outset of this essay that a degree of partisanship is inevitable, it should be clear that my viewpoint on the art of the last third of the twentieth century is largely established by my association with the Conceptual art movement and its legacy, and specifically with the practice of Art & Language. Over the course of that period the epithet 'Conceptual' has been applied in journalism and even in some curatorial writing

to cover an ever-increasing body of artistic work that qualifies neither as painting nor as sculpture but that has otherwise no evident principle in common. Under these circumstances the practical and intellectual legacy of the original Conceptual art movement has become hard to recover. (One might compare the fortunes of the designation 'abstract'. Until supplanted by 'conceptual' as the favoured term of reference for the odd and the avant-garde, it had been applied generically to work without evident representational content, with similar indifference both to the original conditions that had endowed the work of Kandinsky, Malevich, Mondrian and others with a genuinely experimental character, and to the subsequent conditions under which abstract art was gradually exhausted as a modernist possibility.)

Even if those considerations that affect my personal authorship were to be set aside, it should be clear that any single account of recent artistic developments must face strong reservations regarding any pretensions it may have to objectivity and authority. I therefore propose three different exemplary accounts under which the artistic work of the last third of the twentieth century might be considered, each offering a different bearing on the 'modern' and the 'British' conceived as relative values. According to the first of these, the idea of a modernist mainstream has never been better than an anomaly – at best a distraction where the true current of British art is concerned. Perhaps there was indeed a crisis of modernism during the 1960s, but if so it cannot have had any significant bearing upon the work of those artists – Lucien Freud and David Hockney among them – who are most deservedly representative of the national culture. Talk of the exhaustion of painting and sculpture is no more than a product of international fashion. It is symptomatic of a typically avant-garde loss of faith and of the unwillingness of those driven by a desire for short-term success to apply themselves to historically substantial issues and problems. Such an account would be inconsistent with any serious estimation of the Conceptual art movement and its aftermath, but consistent with regard for a wide spectrum of work from late post-painterly abstract painting or third-generation Pop art to the kinds of technically competent but conservative portraits and landscapes that still command high prices in some of the more long-established West End galleries.

According to the second account a productive liberation and expansion in artistic practices and in their audiences

followed from the collapse of the authority of modernist critical protocols, and coincidentally of the standing of painting and sculpture as primary fine art media. It was symptomatic of this expansion that the Arts Council of Great Britain, then the major national grant-giving body for fine artists, was driven during the late 1960s and early 1970s to take account of 'new media' in the constitution of its reviewing panels. Purchases for its own collection were made in 1972 and 1973 under the headings 'Objects and Documents' and 'Beyond Painting and Sculpture'. While it was under the designation 'sculpture' that a distinct group of artists emerged as exhibitors at the Lisson Gallery in the late 1970s and early 1980s, the tendency of those involved was to put a certain strain on the conventional limits of the medium. (The group included Richard Deacon [b.1949], Bill Woodrow [b.1948], Anish Kapoor [b.1954], Shirazeh Houshiary [b.1955] and Tony Cragg [b.1949]. The last, who was responsible for some of the most interesting work of the time [fig.40], moved to Germany in 1977.) During the same period the curriculum of art schools in Britain was liberalized to support work in film and video, in performance and in installations of various kinds. Among the restrictive barriers seen to have collapsed in this account are not only those between specific artistic media, but, more macroscopically, those that have served traditionally to distinguish fine art from popular culture and 'avant-garde' from 'kitsch'.[46] Despite the occasional sally from the professionally scandalized tabloid press, the kinds of enterprise that might previously have been counted as avant-garde art have in recent years been accepted into the public domain to an extent unimaginable in the early twentieth century.

Such an account might help to explain the apparent international success of the generation of artists that emerged in London, and principally from Goldsmiths' College, during the late 1980s and 1990s. Many of these came to public attention through the exhibition *Freeze*, organized in 1988 principally by Damien Hirst (b.1965), who is both the doyen of this generation and, in terms of sheer financial reward, possibly the most successful artist ever to have worked in Britain. With effect from the early 1980s, one significant feature of the 'postmodern' liberation has been the unprecedented presence of women artists at the forefront of avant-garde activity on both sides of the Atlantic. Among notable aspects of the work for which women artists working in Britain have been responsible are a tendency to avoid traditional fine art media, a preference for photography and video (Gillian Wearing [b.1963], Tacita Dean [b.1965]), and the development of a resonant iconography of domestic and autobiographical incident

and memory (Tracey Emin [fig.41], Sarah Lucas, Rachel Whiteread [b.1963], Mona Hatoum [b.1952]). In the culture of post-Second World War Britain Robin Ironside had suggested that modernism was an alien imposition, liable to override the different values of British art. It is an open question how far more recent promotion of British art has been enabled by a tendency to identify 'difference' from some unspecified universal and hegemonic culture as an unquestionable value in the *post*modern.

According to the third account, the Conceptual art movement effected a considerable transformation in the technical possibilities of art and in thought about its functions and audiences – a transformation comparable to that associated with the Cubist movement shortly before the First World War. But Conceptual art no more put an end to painting and sculpture than Cubism put an end to the tradition of figurative likenesses based on stable viewpoints and light sources. And Conceptual art no more licensed an infinite expansion of ready-mades and appropriations and texts-as-artwork than Cubism licensed every subsequent use of collage, montage or assemblage, whether in painting, in film or on advertising hoardings. Rather, what is proposed in this third account is that any works of art that come up for the count as *modern* in the wake of the Conceptual art movement should at least be capable of standing up to its consequences. Notable among these consequences is the realization that it is no longer plausible to conceive of the relationship between art and language – or, to put the

matter in more practical terms, between work of art and essay – as necessarily antinomic. Of course it never has been. But during the long cultural regime that modernism serves to label, the tendency of artists and writers alike was to behave as though the ineffable character of the one was incommensurable with the discursive function of the other. The interesting, if difficult, problem that this third account trails in its wake is just how one might *retain* the critical power of modernist concerns for medium-specificity where the medium at issue is one that admits language into an artistic tradition whose most demanding measures of complexity and depth are necessarily set in part by painting.

Adoption of the first of these accounts might offer a certain reassurance to those concerned with the integrity of a national artistic tradition, albeit at the expense of a certain sentimental indifference or blindness to the relative

critical interest and power of art produced elsewhere. On the other hand, both the second and third accounts keep alive the problems of reconciling a discriminating interest in art produced in Britain with responsiveness to the wider conditions that bear upon judgements of modernity and of aesthetic merit. While these latter accounts are not altogether incommensurable, they suggest different priorities regarding the optimum focus of critical attention: on the one hand an expansive regard over a field extending into areas shared with the media of film, television, popular music and advertising; on the other an intensive inquiry into the possibility of a virtually new and hybrid medium – one in which the virtuality that modernist theory prized in painting and sculpture is secured through the kind of engagement with language that modernist theory tended to anathematize.

Walter Sickert's *La Hollandaise*

DAVID PETERS CORBETT

Walter Sickert's painting, made around 1906, is a complex, layered image. It shows a female nude positioned on the white sheets of a bed, the iron frame of which is set at right angles to the picture plane. Behind the bed we see a dark green wall and, to the spectator's left, part of a large wardrobe with an inset mirror that reflects a jumble of shapes as well as a further mirror across the room. In contrast with the foursquare positioning of the bed, the model's torso is shown swivelled in the opposite direction to her legs. Although the lower half of the body seems in motion, an impression emphasized by the swirl of marks describing the bedclothes around the model's feet, her head, shoulders and arm appear still. To complicate this dialogue between stasis and movement even further, the slurred paint marks within and around the head and upper body impart an extra layer of motion.

This emphatic use of paint is the most striking characteristic of *La Hollandaise*. Sickert applies it thinly, describing the model in expressive but broken touches but also making considerable use of the prepared ground of the canvas, which is allowed to show through in many passages. It does so unashamedly, for instance in the far right-hand strip where the green paint of the wall simply stops in a ragged line. The pigment is made to suggest shape and detail but not to attempt any close description, as can be clearly seen in the summary right-hand curve of the bed head and the detached, free-floating highlight above it. At moments, as in the swelling thigh and buttock that push against the model's right arm, Sickert deploys a heavy black line to define the forms which seems at odds with the broken paint and delicate, shifting highlight and shadow of some of the nearby flesh effects. The most arresting examples of this gestural openness, however, occur in the description of the figure and above all in the model's face. Shockingly, there are no recognizable features, just a conglomeration of painted marks overlaying but not obliterating the wall and the bedstead, elements of which cut through the hair and divide the ear from the head. The result is that the head looks damaged, skull-like (the black opening where the nose should be), an apparent patchwork of flesh without support or human structure. It is a disturbing and haunting image. This self-consciously virtuoso performance is an aspect of Sickert's lifelong fascination with the technical possibilities and difficulties of paint, a 'truculent and hard-mouthed beast' as he described it, that had to be 'bridled' and 'ridden' before it could be bent to the painter's will. We are presented with a masterly demonstration of paint's expressive potential and at the same time reminded that it is not reality we are seeing but pigment on canvas.

But *La Hollandaise* is not just a technical exercise, it is specifically a product of the years from 1905 to 1914 when Sickert was living in the working-class area of Camden Town and drawing inspiration from the life of its streets and interiors. Sickert loved London, as he said, for its shabby, pungent sense of reality – 'the whiff of leather and stout from the swing doors of the pubs' – and he constantly strove to find ways to depict this heady actuality in paint. In this context *La Hollandaise* can seem a brutally explicit image, exploiting the squalor of the model as a sign of the dramatic disorder of the city. Richard Shone has suggested that the title refers to 'la belle hollandaise', a prostitute in one of Honoré de Balzac's novels, and the art historian Anna Gruetzner Robins has discussed the way that Sickert's nudes at this time powerfully reject the conventional artistic idealization of women. Robins puts great emphasis on the fleshiness and signs of aging in the bodies of the models Sickert chose to paint, and we might note the self-conscious, even pitiless, realism such a focus seems to convey as evidence of Sickert's strongly classed and gendered reading of the modern city.

Observing layered and apparently contrasting meanings like these might go some way towards responding to the fascinations and puzzlements *La Hollandaise* seems to hold for us. It is both a refined exercise in painterly technique and a depiction of a louche and squalid London world of prostitution, violence and petty criminality. If these aspects by no means exhaust Sickert's image, they do give some sense of its complexity.

FURTHER READING

W. Baron, *Sickert*, London 1973, revised edition, *Sickert: Paintings and Drawings*, New Haven and London, 2006.

A.G. Robins, *Walter Sickert: Drawings*, Aldershot 1996.

A.G. Robins (ed.), *Walter Sickert: The Complete Writings on Art*, Oxford 2000.

42 WALTER SICKERT
La Hollandaise c.1906
Oil on canvas 51.1 × 40.6 (20 × 16)
Tate. Purchased 1983

The Scottish Colourists

SHEILA MCGREGOR

The Scottish artists Samuel John Peploe (1871–1935), John Duncan Fergusson (1874–1961), George Leslie Hunter (1877–1931) and Francis Campbell Boileau Cadell (1883–1937) were loosely linked by ties of friendship and occasionally exhibited together. But only after Peploe, Hunter and Cadell were already dead was the term 'Colourist' officially used, in the title of an exhibition at T. & R. Annan and Sons in Glasgow in 1948 and again, two years later, by T.J. Honeyman (then Director of Glasgow Art Gallery) in the title of his book about the artists. The designation no doubt endured because it encapsulates the one thing that these painters self-evidently share: a dramatic and sensuous use of colour.

In this the Colourists owed much to the older generation of the 'Glasgow Boys', who had championed the work of Whistler and developed an authentically Scottish brand of naturalism. The Edinburgh-born Fergusson and Peploe, whose early careers were closely intertwined, also drew inspiration from seventeenth-century Dutch and Spanish painting, producing many elegant and free-flowing portraits and still lifes with echoes of Frans Hals and Diego Velázquez.

Fergusson moved to Paris in 1907 at a moment of radical artistic innovation. Peploe followed in 1910, joining what was by then a well-established coterie of English, Scottish and American artists working in a more or less Fauvist idiom and exhibiting at the alternative salons. The streets, cafés and night-spots of Montparnasse proved a source of lively subject matter and both artists quickly abandoned the naturalistic approach of their early work in favour of a more synthetic style. In Fergusson's case this found monumental expression in a series of female nudes, the most famous of which (fig.44) provided the young writer John Middleton Murry with the title of his modernistic arts periodical, *Rhythm*. Fergusson was briefly its art editor in 1911–12.

Though less technically assured than Peploe, Fergusson was more interested in the application of intellectual ideas to painting. His fascination with dance, inspired by the Ballets Russes and the newly fashionable eurhythmics of Jacques Dalcroze, coincided powerfully with his discovery of Henri Bergson. Several commentators before 1914 saw Fergusson as the leader of a vital new 'rhythmist' movement with complex philosophical associations.

The slightly younger Cadell, also from Edinburgh, studied in Paris between 1899 and 1903. After Peploe's return to Edinburgh from Paris in 1912 the two painters became close friends, and the letters they exchanged while Cadell was serving on the Western Front reveal a sense of aesthetic kinship that would be consolidated by joint painting holidays to record the landscape of Iona in the 1920s.

Hunter, like Fergusson, was essentially self-taught. In 1892 his family had emigrated from the west of Scotland to America, where he famously lost all his early paintings in the San Francisco earthquake of 1906. He almost certainly encountered Peploe and Fergusson in pre-1914 Paris and subsequently came to know Fergusson well during a long sojourn in the south of France in the late 1920s. He was, however, a solitary figure, who existed slightly aside from the others.

43 F.C.B. CADELL
Afternoon 1913
Oil on canvas
Private collection

Of all the Colourists Fergusson was the most versatile. He experimented with sculpture, documented the naval dockyards in Portsmouth in 1918 and became an influential contributor to debates about Scottish nationalism. His involvement with the charismatic dancer Margaret Morris helps explain his preoccupation with the female nude in later life. Peploe's pursuit of the 'perfect' still life occupied much of his career, from the vivid Cloisonnism of his Paris pictures to the more subtle and Cézanne-like compositions of the 1920s and 1930s. Cadell found continual inspiration in modish Edinburgh interiors and elaborate still lifes, bringing them to canvas with characteristic accents of black, orange, green, blue, lilac and yellow and a keen eye for abstract pattern (fig.43). Hunter's output – mainly landscape and still life – was less diverse than that of his colleagues, but at the peak of his form he achieved an outstanding fluency and boldness.

The Colourists have suffered from the metropolitanism of English art historians and critics. As Walter Sickert observed in 1925, their omission from Roger Fry's exhibition *Manet and the Post-Impressionists* in 1910 meant, in effect, that they had not been 'licensed'; Herbert Read condemned Scottish painting for its 'slavish' reliance on French Impressionism and Fauvism; and until the 1980s, at least, the Colourists were often left out of surveys of twentieth-century British art. Compared with their Camden Town and Bloomsbury contemporaries, they have received little critical attention. In the last twenty years, however, a series of well-researched exhibitions and monographs, as well as a revival in their commercial fortunes, has brought about a significant rehabilitation.

FURTHER READING

R. Billcliffe, *The Scottish Colourists*, London 1989.

T.J. Honeyman, *Three Scottish Colourists*, London 1950.

P. Long (ed.) with E. Cumming, *The Scottish Colourists 1900–1930*, exh. cat., National Galleries of Scotland, Edinburgh and London 2000.

K. Simister, *Living Paint: J.D. Fergusson 1974–1961*, Edinburgh 2001.

44 JOHN DUNCAN FERGUSSON
Rhythm 1911
Oil on canvas 162.6 × 114.6
(64 × 45⅛)
Courtesy of The Fergusson Gallery,
Perth & Kinross Council

Gwen John's *Nude Girl*

ALICIA FOSTER

Gwen John did not like Fenella Lovell, pictured in *Nude Girl* (fig.46), according to letters sent to her close friend Ursula Tyrwhitt. 'It is a pretty little face,' she wrote, in a cold, objectifying tone, 'but she is dreadful.' And the level *froideur* of the model's reciprocal look, her rigidly held body, might be read simply as reflecting a tense, unhappy relationship between artist and subject. However, the painting has a wider importance – there are layers of resonance beyond the anecdotal and biographical. It is a truly modern nude, which speaks of the circumstance in which it was made – Paris in the 1900s and the great influx of women artists into that city – and also echoes profoundly in the way that some later artists have worked with the body.

At the time of painting Fenella, Gwen John was experimenting with the female nude. She had made a series of drawings of herself naked, unusual works for the period in that the woman artist – standing and drawing in the informal, intimate surroundings of her bedroom – is, at the same time, the naked model. She had also set up her easel in the Académie Colarossi, where she made rapid sketches of a variety of professional models in standard life-room poses. In doing so, she was firmly part of the Parisian art world: the female nude was a significant part of any serious artist's repertoire at the time. But, in common with some of her women contemporaries in the French capital, notably Paula Modersohn-Becker, she was faced with the difficulty of making sense of a body that was both valuable artistic currency and experienced, inhabited. For these women the comfortable distance from the female nude, her 'otherness', was not a given (as it was for Auguste Rodin, Pablo Picasso, Henri Matisse et al.), but instead had to be consciously worked at and assumed, or even (in the case of John's self-portrait drawings and Modersohn-Becker's paintings of herself naked) rejected. For Gwen John, there was the added complication of several years spent as Rodin's life model and lover.

Nude Girl is one of Gwen John's attempts to negotiate this complex relationship. It is crucial to consider it alongside a second painting of Fenella, *Girl with Bare Shoulders* (fig.45), made at the same time and sadly divided from its sister work in the collection of the Museum of Modern

Art, New York. As the title indicates, the latter is not naked, but dressed in an off-the-shoulder white gown, with black sash and bow at her breast. She sits in a similar pose, although there are slight differences: the arrangement of the arms and the size of the canvas vary a little between the two (a matter of a couple of centimetres); the *Nude Girl* has a pendant around her neck on a ribbon, and a lock of hair has fallen onto her forehead.

The game of switching from clothed to naked had a famous art historical precedent in Goya's two *majas*, a reference noted by Wyndham Lewis writing about *Nude Girl* (Lewis 1946, p.484). Also, for English and American audiences in particular, it is likely to have suggested Paris and popular ideas of the women who frequented the city's artistic demi-monde during the belle époque. It is the precise characteristics of the clothing and unclothing of the two figures that suggest these references. The gown worn by *Girl with Bare Shoulders* is daring, distinctly French and modern, recalling both the newest couture – the work of Paul Poiret in particular – and the naughtiness of *déshabillé* (it also bears a striking resemblance to women's chemises of the period). And then in *Nude Girl* she has taken it off. The model's dress has been pulled down to display her body, and she wears only the pendant and ribbon (think of Manet's notorious *Olympia*).

That these two 'looks', dress and undress, were precisely selected by Gwen John, and were not just what Fenella happened to be wearing, has been confirmed by recent conservation work. Infra red examination and X-radiograph photographs have revealed that there were bows painted down the front of the clothed figure (making her gown originally straightforward day wear, rather than suggestive of underwear) and that *Nude Girl* was clothed in an earlier version. The specifics of the dress and its juxtaposition with the naked body were something so deliberated over, so vital to Gwen John, that in both works she was prepared to completely re-conceive and re-paint the torso (see Bustin 1999, pp.102–7).

Nevertheless, although the cues for a game of titillation and seduction might be there – the naked woman with her neck ribbon and dress around her knees, the provocative Parisian frock

45 GWEN JOHN
Girl with Bare Shoulders 1909–10
Oil on canvas 43.4 × 26 (17⅛ × 10¼)
The Museum of Modern Art,
New York

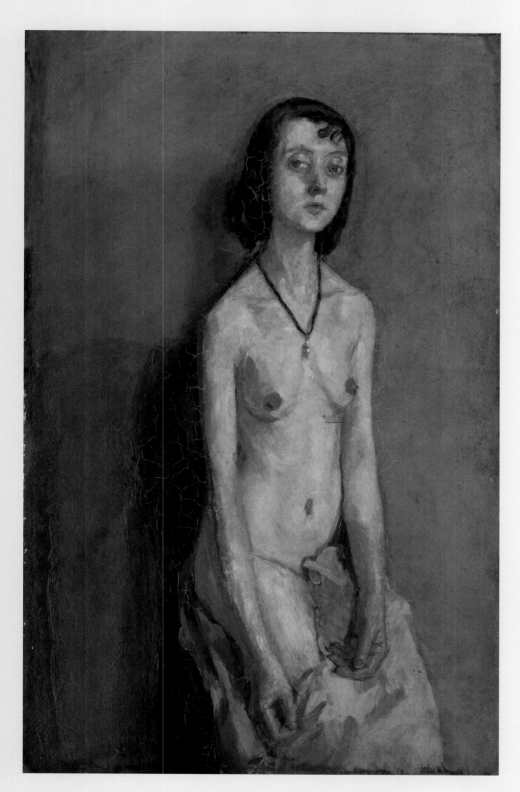

– Gwen John mixes these up with a pose and a look that speak of uneasy scrutiny, of painful hours spent in silence. She does not offer up this body for enjoyment, to be consumed, but as something that has to be confronted (Wyndham Lewis even claimed to identify 'revulsion' for the nakedness of the *Nude Girl* in the painting). There is, at the very least, a strong sense of guarded distance, a distance that was evident in Gwen John's writings about her model both to Ursula Tyrwhitt and to Rodin, to whom she wrote scathingly that Fenella dressed up as a 'bohemienne' and was not, therefore, 'artistique' like herself. *Nude Girl* is then, on one level, a reflection of this woman artist's critical gaze upon another woman. But it is also shaped by the distance of the woman artist from the conventions of representing the female nude – aware of them, but always at one remove. At the same time, perhaps, it depicts John's own knowledge of the awkwardness, the un-naturalness, of being the female model holding the pose.

The legacy of early twentieth-century visions of the nude such as this – which might refer to art history and art world vogues, but also move beyond them, being at the same time passionately objective and painfully existential – can be traced in the work of contemporary artists, from the raking eye of Lucien Freud to the scratchy discomfort of Tracey Emin's autobiographical prints.

FURTHER READING

M. Bustin, 'Gwen John: Nude Girl, 1909–10', in S. Hackney, R. Jones and J. Townsend (eds.), *Paint and Purpose: A Study of Technique in British Art*, London 1999.

A. Foster, *Gwen John*, London and Princeton, New Jersey, 1999.

C. Langdale, *Gwen John*, New Haven 1999.

W. Lewis, 'The Art of Gwen John', in *The Listener*, 10 October 1946.

C. Lloyd-Morgan, *Gwen John: Letters and Notebooks*, London 2004.

46 GWEN JOHN
Nude Girl 1909–10
Oil on canvas 44.5 × 27.9 (17¼ × 11)
Tate. Presented by the Contemporary
Art Society 1917

Direct Carving

PENELOPE CURTIS

Direct carving has been practised for millennia, but for a few decades in the twentieth century it became a by-word for a certain assumed attitude to sculpture. Stone masons have always practised direct carving, as have the stone carvers, or *praticiens*, who carved from artists' models. But for several centuries, from the Renaissance through to the late nineteenth century, few fine art sculptors did their own carving. They generally made their models in clay, may have had these transferred into plaster, and paid others for the task of transferring their concept into stone. In the later nineteenth century this task was made both easier, and more routine, by the improvement in various semi-industrial processes, including the pointing machine, which allowed rather accurate enlargements to be made of a small model in one material on a larger scale in another.

The interest in direct carving (or, in French, *la taille directe*) became stronger as the industrial revolution gathered pace. By the end of the nineteenth century, critics and cultural commentators such as John Ruskin and William Morris were vociferous in their condemnation of the piecemeal labour of the production line. The New Sculptors were examples of artists encouraged by this emerging dissent to return to craft-based principles and to the idea of 'truth to materials' (see Droth, pp.36–7). Taking materials into their own hands limited the edition size and dissemination of their work, but gave back sculptors a sense of the link between their original concept and the finished work. Thus the medium (the material) became a more integral part of the message.

Whereas the New Sculptors were closely linked in their aspirations to the craftsmen and designers of their epoch, in the twentieth century sculptors moved beyond the carefully constructed and homogenous environment of the Aesthetic interior to make unique artworks that, in the very rudeness of their fabrication, broke such established norms. Whereas the carvers who had transferred the models of Francis Legatt Chantrey, John Gibson or Auguste Rodin into marble had great skill and finesse, the new generation who chose to carve their own works – including Eric Gill, Jacob Epstein

(fig.48), Henry Moore and Barbara Hepworth – had little such facility. They learnt on the job, allying that roughness of execution with a vitality in the conception.

The English carvers who followed the new creed of 'direct carving' were, in general, more removed from the mainstream than their counterparts in Continental Europe. In France, *la taille directe* – which had arisen in part from the realization of how few of Rodin's carvings were carved by Rodin – was much more closely allied to the architectural trades, and to regional schools of monumental sculpture. In England it was to become more particularly associated with the avant-garde and with artists who saw themselves as outside the established sculptural and architectural norms.

Nevertheless, there was an early generation of direct carvers, who, coming in the wake of the New Sculptors of the Edwardian period, began to use the technique themselves before it acquired the proselytizing tone of the later 1920s and 1930s. And indeed this generation, which included a large number of women sculptors, used the crafts-based techniques and materials of direct carving to make small-scale works that, like the statuettes of the New Sculptor, were readily collectable and usable within the domestic interior. Their themes were unassuming, their 'symbolism' negligible. They represented animals, insects and other simple forms that lent themselves to the abstraction the hard materials demanded.

John Skeaping (1901–80) was one such artist, whose reputed prowess derived from his mastery of hard and exotic stones and from his earlier experience in working in the field of monumental masonry. The work of his first wife, Barbara Hepworth, reveals a more general shift, in the way in which her earlier abstracted animal and bird stone carvings (akin to many other contemporary works, in Britain and further afield) started in the late 1920s to take on more radically conceived forms. These, largely in wood, push and pull the human (female) form into new and only vestigially familiar shapes. She, and to a greater extent Henry Moore, drew on non-Western carving to suggest ways of rendering the human face and body in expressive directions dictated primarily by the material mass. Moore

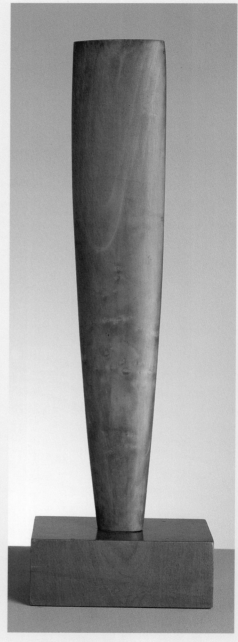

47 BARBARA HEPWORTH
Single Form 1937–8
Wood 78.8 high (31)
Leeds Art Gallery

made uncannily expressive stone carvings of the female torso, while she pushed the more limited monolithic form of the tree trunk towards full abstraction (fig.47).

While for both Moore and Hepworth direct carving was, for a short time before the Second World War, the 'only' way of working, other English sculptors, and notably Epstein, insisted that they be not judged nor confined by one technique. Despite the adoption of direct carving by critics – notably Herbert Read – as the salvation of a moribund school of sculpture, a good many sculptors refused to abandon modelling, even if they also enjoyed the new freedoms that direct carving allowed to figurative representation. Some, such as Moore and Hepworth, enjoyed and benefited from the linguistic sophistication that a critic like Adrian Stokes lent to the carving debate. Eric Gill (1882–1940) allied his interest in a notionally pure and indigenous sculptural technique to his religious position, thus rendering direct carving both more and less than it actually was. For two or three decades, between c.1920 and c.1945, direct carving took on heightened meaning. A mere technique, it came to represent both the sexually liberated mores of non-Christian societies, as well as the evangelical awakening of artists who saw their roots in the supposedly democratic fraternity of the medieval masons. Between the positions represented by Epstein and Gill lay artists such as Moore and Hepworth, as well as hundreds of lesser-known practitioners, who enjoyed the technique if not all its associated interpretations.

FURTHER READING

J. Collins and S. Bowness, *Carving Mountains: Modern Stone Sculpture in England 1907–37*, exh. cat., Kettle's Yard, Cambridge 1998.

P. Curtis, 'Direct Expression through the Material', in *Sculpture 1900–1945*, Oxford 1999.

P. Curtis, 'How Direct Carving Stole the Idea of Modern Sculpture', in D. Getsy (ed.), *Sculpture and the Pursuit of a Modern Ideal*, Ashgate 2004.

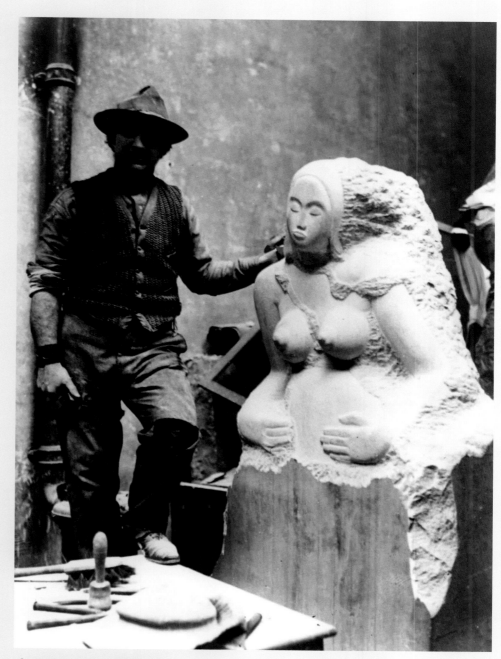

48 JACOB EPSTEIN with his partly finished carving of *Maternity* c.1910
Hopton Wood stone
203 × 91 × 46 (79⅞ × 35⅞ × 18⅛)
Henry Moore Institute Archive

BLAST

RICHARD HUMPHREYS

Blast is the most famous avant-garde arts journal in the history of British art. Conceived in late 1913 and first advertised in *The New Age* in January 1914, two issues, edited by the writer and artist Wyndham Lewis, were published by John Lane's Bodley Head in July 1914 and July 1915. Lewis used a small firm of printers, Leveridge & Co., in Harlesden, north-west London to produce over 3,000 copies, which seem to have been somewhat inefficiently distributed.

Blast's central aim was to promote an aggressive form of modernism and a novel critique of English art, culture and identity that by the summer of 1914 was known as 'Vorticism' and that had its headquarters at the 'Rebel Art Centre' in Great Ormond Street in central London. Much of the impulse to create a movement and to publish *Blast* came from Lewis's reaction to a heated dispute with Roger Fry, the dominant critical and administrative figure among artists associated with the 'Bloomsbury Group' and also the leader of the Omega Workshops.

Blast no.1 was unlike any previous British arts journal in style and content. It had a lurid puce cover with the word 'BLAST' in huge sans-serif typeface running across it from top left to bottom right. Inside, an initial succession of over forty pages of deliberately cryptic, bombastic and humorous manifestos was arranged in large blocks of different-sized sans-serif text on double royal sheets, followed by a more restrained and much smaller serif typeface for the ensuing articles and other prose. Line blocks and half-tone plates provided the illustrations of works by Lewis and his Vorticist colleagues.

As well as the famous opening manifestos, *Blast* no.1 included poems by the American poet Ezra Pound, who contributed significantly to the contents and promotion of the journal, a Vorticist drama called *Enemy of the Stars* by Lewis; stories by Ford Madox Ford (then 'Maddox Hueffer') and Rebecca West; and longer pieces of art theory and criticism by Lewis, the sculptor Henri Gaudier-Brzeska and Pound. The painter Edward Wadsworth contributed a review with translated passages of Wassily Kandinsky's 'Concerning the Spiritual in Art'.

The position adopted by Lewis and his 'little gang', as he called fellow Vorticists, was clear from the cover and open pages. It announced a violently existentialist art of 'individuals', a focus on the 'present' as opposed to the 'sentimental Future' or the 'sacripant Past', and the power of 'vivid and violent ideas', which artists find in 'THE UNCONSCIOUSNESS OF HUMANITY'. It shunned attempts to improve the human condition through modern design or morality and pronounced itself opposed to 'the glorification of "the People"' and 'snobbery'.

What follows this opening onslaught are the famous pages that 'Blast' and 'Bless' various individuals, ideas and national characteristics:

BLAST First (from Politeness) ENGLAND

The English climate, aestheticism, nature cranks and other traits are then attacked, as are French sensationalism, fussiness and parochialism. English humour and sport come in for the same treatment and then a long list of names from Elgar to Beecham Pills, following an almost surrealist method of free association, are arranged across a whole page under the heading 'BLAST'. This is then, as it were dialectically, followed by a 'Blessing' of English maritime power, modern ports and industrial centres, the hairdresser who 'attacks Mother Nature' for a small fee, and English satirical humour from Shakespeare to Swift. France is blessed for its vitality, pornography and 'depths of elegance'. A page of names is then under the title 'BLESS', among them Oliver Cromwell, George Robey and James Joyce.

In effect, and this becomes clearer as the journal moves on to more strictly aesthetic matters, *Blast* sought to embody in its form and typeface an exaggerated and eye-catching expression, a distinctively English modernist vision, opposed in various quite subtle ways to what were seen as the limitations of other types of radical art: Futurism was denounced as too hysterically obsessed with 'automobilism' and too imitative rather than formally creative; Cubism was seen as too domestic and analytical; Bloomsbury Post-Impressionism and even abstraction, were derided for their amateurism and lack of intellectual ambition. The illustrations of works by Lewis, Wadsworth, Frederick Etchells and others were to be seen as representative of a vigorously semi-abstract art, which carried powerful intimations of urban and industrial modernity, while renouncing easy political affiliations and calling for a sceptical but energised embrace of contemporary life (see Harrison, pp.45–7).

Blast of course draws heavily on the polemics and typographical experiments of Futurism (for

49 Front cover and spreads from *Blast* no.1, June 1914, edited by Wyndham Lewis
Tate Gallery Archive

instance Ardengo Soffici's 'I Manifesti del Futurismo' of 1914 and many other texts) and Lewis's aesthetics are indebted to Futurist and Cubist ideas and styles, but the result is entirely distinctive and original. *Blast* no.2 was a smaller 'War Number' with little of the typographical impact of the first issue. It carried poems by T.S. Eliot and Pound, illustrations by most of the Vorticist painters and a great deal of text by Lewis who now dominated the journal. His story 'The Crowd Master' registers both the fatal impact of the war on the London art scene and Lewis's fateful encounter with political reality. An obituary to Gaudier-Brzeska, killed on the Western Front, provided a more immediate symbol of the war's impact. *Blast* proved to be a short-lived but influential and precocious adventure in the story British modernism.

FURTHER READING

R. Cork, *Vorticism and Abstract Art in the First Machine Age*, 2 vols., London 1976.
M.E. Leveridge, 'The Printing of Blast' in *Wyndham Lewis Annual*, VII, Bath 2000, pp.21–31.
W.C. Wees, *Vorticism and the English Avant-garde*, Manchester 1972.

BLAST

THE SPECIALIST
" PROFESSIONAL "
" GOOD WORKMAN "
" GROVE-MAN "
ONE ORGAN MAN

BLAST THE

AMATEUR
SCIOLAST
ART-PIMP
JOURNALIST
SELF MAN
NO-ORGAN MAN

BLAST HUMOUR

Quack ENGLISH drug for stupidity and sleepiness.
Arch enemy of REAL, conventionalizing like
gunshot, freezing supple
REAL in ferocious chemistry
of laughter.

BLAST SPORT

HUMOUR'S FIRST COUSIN AND ACCOMPLICE.

Impossibility for Englishman to be
grave and keep his end up,
psychologically.

Impossible for him to use Humour
as well and be persistently
grave.

Alas ! necessity for big doll's show
in front of mouth.

Visitation of Heaven on
English Miss
gums, canines of **FIXED GRIN**
Death's Head symbol of Anti-Life.

CURSE those who will hang over this
Manifesto with SILLY CANINES exposed.

IF YOU DESTROY A GREAT WORK OF ART you
are destroying a greater soul than if you
annihilated a whole district of London.

LEAVE ART ALONE, BRAVE COMRADES !

Brighton Pier Spencer Gore.

xix.

2 Mapping British Art

CHRIS STEPHENS

THIS CHAPTER LOOKS at the geographies of British art. At its crudest level, this is taken to mean where British art was made during this period and where it was seen and acquired. The intention is not, however, to provide a gazetteer of British art production and consumption. Rather, it is to focus on the ways in which this locational aspect impacted upon the art itself. In what ways – and where – did artists position themselves spatially as part of their practice? And, why? Unsurprisingly, what will emerge is a series of polarities between the centre and the periphery and the metropolis and the country. While London remains resolutely dominant throughout our period, this geographical sweep will reach beyond the shores of the United Kingdom. What we will see are both continuities and changes in the ways in which place related to ideas of modernity and tradition in artistic production.

One must note that the actual scope of Britain changed during our period. At its beginning, the United Kingdom encompassed the whole of Ireland with Dublin an important cultural centre. In 1922 the southern counties seceded from the UK and the Irish Free State was established. Northern Ireland would remain a major political issue for the rest of the century and, especially, from the late 1960s on. Ireland's independence fitted into a wider pattern of imperial disintegration. The first decades of our period saw the British Empire expand, with, for example, Queen Victoria being crowned Empress of India in 1876. Australia and Canada secured Dominion status in 1907 and with the UK, the Irish Free State, South Africa and New Zealand formed a Commonwealth of Nations in 1931. The inter-war period saw growing tensions in the colonized lands and India gained Independence in 1947 with countries of Asia, Africa and the Caribbean following in the 1950s and 1960s.

Geography, however, is more complex than a solely spatial concept. To take it a step further, one might also think in terms of cultural geography in which subjects position themselves imaginatively, socially and politically as much as spatially. It is telling, perhaps, that a particularly resilient form of self-fashioning employed by artists is given the name of a country: Bohemia. In adopting a 'bohemian' persona, artists have repeatedly positioned themselves outside the established social norms of their time.

The bohemian label is a particularly marked form of self-conscious, adopted identity. Others are less deliberate. In addressing cultural geographies of British art, one is, in a sense, drawing near to broader issues of identity and how it was imagined in the art of the period. Such a consideration would be dangerously broad for this essay, encompassing as it might the question of how social position, gender, sexuality and politics have figured in the art of the last 140 years. I will place particular focus, therefore, on the ways in which place and associated cultural identities have impacted upon British art, even when those places are distant from the spaces of production and consumption.

On the one hand, we might consider ways in which distant places – or ideas of them – have figured in artistic practice. The most obvious such places are Paris and New York. The reasons for their prominence – that they were seen successively to be the centres of modernist practice during the period – being equally obvious. During certain periods, to work or exhibit in those cities served as a signifier of an artist's position and ambition. Failing that, they or their cultures could be evoked from afar for the same effect. In addressing this question of how British artists interacted physically or imaginatively with the geographies of modernism, we should also bear in mind that the works of art were as mobile as their producers. The spaces and places of display of the works of British art and their reception constitue a crucial aspect of this process of mapping its geographies. Beyond these more obvious coordinates of modernism, one might also consider ways in which ideas of exoticism and imagined geographies have been generated by artists either from experience of foreign locations or from ideas of them.

On the other hand, we might consider the impact of migration on British art. The movement of peoples is one of the defining characteristics of modernity and, inevitably, it has had an enormous effect on artistic production as artists have brought with them ideas from or of their places of origin. More complex, perhaps, is the way art and artistic production in Britain have been shaped by the legacy of

migrations in subsequent generations from diverse communities, subcultures and traditions.

Inevitably, the question of empire figures prominently in such a discussion, and this aspect becomes more complex with the post-colonial experience, as British art produced by the descendents of immigrants from the Commonwealth came to reflect and address the experiences of dual-heritage communities. In this sense the geography underlying a work of British art might encompass Mumbai in India or Kingston in Jamaica, as much as it does east London or wherever else it might have been produced.

Implicit – or, at times at least, explicit – in all this is the question of shifting ideas of national identity. The period of this volume extends from the height of empire, through the crisis of its loss (not to mention of two world wars), to a post-colonial, multicultural Britain. To paraphrase Stuart Hall, how might a nation of Britain be imagined in this consideration of the geographies of its art?[1] Firstly, one should note the problematic distinction between British and English. This distinction is, it seems, now as acknowledged but avoided as it was once ignored. In their study of Englishness in the early part of our period, Robert Colls and Philip Dodd have asserted that Englishness was generally defined by exclusion, by what it was not. First among those exclusions were the Celts, those occupants of the British Isles who were other than Anglo-Saxon. Certainly, that difference was used by the Irish, Scots and Welsh to assert their own national identities and, at certain times, this could be seen in the art they produced. In terms of visual art, Englishness has most often been seen to reside most quintessentially in landscape painting. This, too, has provided both a refuge and a challenge for those seeking to define or defend a sense of national identity. An English landscape tradition was reasserted whenever a stable English identity was perceived to be under threat: at the turn of the twentieth century from immigration, in the 1940s from invasion and destruction, and in the 1980s from globalization or European integrationism or, perhaps, multiculturalism (or all three). At the same time, those writers who prefer a model of cultural production based on national or ethnic stereotyping have frequently maintained that the English are essentially a literary, or poetic, race rather than a visual one. The climate has frequently been offered as an explanation for national cultural characteristics. This apparent apology for the failings in England's contribution to the modern in art seems to maintain both the idea of a discrete national culture and of a monolithic modernism.

Some would argue that a similar spirit has long dogged histories of British art and excluded those from outside the cultural centre. Rasheed Araeen (b.1935; fig.50), most prominently among others, has demonstrated the important role played in British art by artists from the Commonwealth and other non-Western countries (see Araeen, pp.154–5). The challenge of the present essay is to map the geographies of that art in a manner that is inclusive but that does not eradicate difference or lose historical specificity for the sake of national or cultural homogeneity. Similarly, it is important to find a way of acknowledging

those moments when particular cultural identities have shaped art without descending to essentialist ideas about the relationship between identity and cultural practice. Finally, underlying it all is the question of the validity of writing national histories such as this at a time when globalization makes the drawing of cultural distinctions based on national boundaries seem increasingly problematic.

London and Beyond

In 1870 London was the largest, fastest-modernizing city in the world, and capital of empire. Whatever the historical changes undergone by Britain and its position in the world over the following decades, its capital retained its economic and symbolic dominance over the rest of the country. It was then, and remains, the centre of art production and consumption in the UK. The Royal Academy just about managed to maintain its reputation as the most important exhibiting space in the city until the end of the nineteenth century. Following its decline, the huge presence of other public spaces and commercial galleries ensured London's continued centrality. That is not to say there was not artistic activity in other British cities. During the 1870s to the 1890s cities such as Birmingham, Leeds, Liverpool, Manchester, Newcastle and Nottingham established public art galleries, founded on the belief in art's power for public improvement. At the same time, the spread of art schools encouraged regional activity. It was only at certain moments, however, that a particular city and its artists managed to establish a significant presence on the wider stage of British art.

It is not surprising that Scotland's two great cities, Edinburgh and Glasgow – one a capital, the other Britain's second city in the late nineteenth and early twentieth centuries – feature most frequently. In the late 1800s, while Edinburgh had the Royal Scottish Academy and a tradition of intellectual and cultural activity, Glasgow had the wealth to provide the infrastructure of collectors and dealers to support the Glasgow school, commonly known as 'the Glasgow Boys', which included James Guthrie (1859–1930), George Henry (1836/8–1938), Joseph Crawhall (1861–1913) and John Lavery (1856–1941). An exact parallel to the Newlyn school centred on Stanhope Forbes (1857–1947), many of this group had studied in France and were united

under an adherence to a loosely conceived realism (figs.51 and 52). Their example was evoked in the 1980s when a new school of realist painters emerged from Glasgow. Though their most famous member, Steven Campbell (1953–2007), produced ironic and opaque postmodern narratives (see fig.143, p.224), Socialist Realism was a dominant idiom of that group, most notably represented by depictions of Clydeside dockers studying left-wing texts such as those of Antonio Gramsci by Ken Currie (b.1960). This resurgence of an internationally validated art from Glasgow led to a revival of interest in Scottish art more broadly, with the exhibition *Scottish Art Since 1900* travelling from Edinburgh to London in 1989. This phenomenon is revealing in the way that its promotion and framing drew upon certain preconceptions of Glasgow (as opposed to Edinburgh) and Scotland (as opposed to England). So, Scottish art's internationalism was explained in terms of the 'auld alliance' with France, thus bypassing England and ignoring the fact that English artists had similar links with the Continent at similar times. At the same time, Glasgow was defined in terms of a radical politics summarized by

52 STANHOPE FORBES
A Fish Sale on a Cornish Beach 1885
Oil on canvas 123.5 × 155.6 (47½ × 61¼)
Plymouth City Museum & Art Gallery

the term the 'Red Clyde' with the nascent art magazine, *Variant*, reissuing a 1919 photograph of the red flag being raised in the city's George Square. Ironically, it was, perhaps, a combination of a socialist resistance to the values of the Thatcher period and the investment in the city when it was European Capital of Culture that provided the basis for a later artistic flowering. At the turn of the twenty-first century, it was remarkable (if not unprecedented) that one of the most innovative and successful new commercial galleries, the Modern Institute, was located not in London but in Glasgow, riding largely on a group of graduates from Glasgow School of Art. That the fact of this group's Glaswegian or Scottish identity was not at the forefront of their public image was a reflection, perhaps, of changes in the cultural dynamic of Scotland, which by that time was enjoying devolved government in contrast to the decline and marginalization of the Thatcher years (see Lowndes, pp.232–3).

Frequently, the rise to prominence of a certain city at a particular time was due in large part to the presence of one or two individuals – artists, teachers or collectors. Edward

Burne-Jones and William Morris were the main stimulants behind the development of a Birmingham group at the end of the nineteenth century. Forty years later, painters John Melville (1902–86) and Conroy Maddox (1912–2005) would form the nucleus of a Surrealist group in the same city. University Vice Chancellor, Michael Sadler, was at the centre of a nexus of creative activity in Leeds during the 1910s and 1920s. He had an important collection of work by such key modernists as Paul Gauguin and Wassily Kandinsky, as well as of modern British art. In his orbit was the young critic-to-be Herbert Read, and Henry Moore was among the artists affected by access to Sadler's collection. Between the wars the Edinburgh school was a group of painters producing a conservative modern art of still lifes, landscapes and interiors, centred round the figures of William Gillies (1898–1973) and Ann Redpath (1895–1965). Leeds became an important centre again in the 1950s. The establishment at the university of fellowships in painting, sculpture, music and poetry by the publisher E.C. Gregory led to some of the leading artists of the day spending several years there, including painters Alan Davie (b.1920)

and Terry Frost and sculptors Kenneth Armitage and Hubert Dalwood (1924–76). This, combined with the establishment by Harry Thubron (1915–86) at Leeds College of Art of the Bauhaus-derived Basic Design introductory course, to which the Gregory Fellows contributed, led to Leeds being one of the most innovative places for artistic production of the time. Its position was bolstered by the exchange between the art college and that of Newcastle where Victor Pasmore and Richard Hamilton were developing a comparable course. From the early 1980s Yorkshire became a centre for the display of sculpture, thanks largely to the investment of money bequeathed by Henry Moore to his Foundation.

At moments when a city becomes an important centre for art production, this generally generates an infrastructure of collectors, galleries and critics to support it. London, however, always continued to dominate. At the same time, of course, we must remember that for most if not all of our period the centre for modern art innovation was located outside Britain. Between the mid-nineteenth century and the First World War commerce between London and Paris was relatively easy and commonplace. Both James McNeill Whistler and John Singer Sargent were Americans who came to Britain by way of Paris. Though he settled in London in 1863, Whistler maintained regular contact with the French capital, exhibiting at both the Royal Academy and the Paris Salon. Similarly, having moved to London in 1885, Sargent continued to visit France, signalling his association in his image of Monet painting in the woods near Giverny (fig.53). That such links were seen as central to the making of modern art was reflected in the fact that the New English Art Club, established in 1886 and including Sargent, George Clausen (1852–1944), Philip Wilson Steer (1869–1942), John Lavery and (from 1888) Walter Sickert among its members, was almost called the Society of Anglo-French Painters.

The key here is not so much where British art was made but the constant mobility of art and artists. One might cite two artists by way of illustration. Lavery was born in Belfast, studied in Glasgow, London and Paris and spent parts of his career in France, London, Glasgow, Dublin and Hollywood. William Orpen (1878–1931) was born in Ireland, studied in Dublin and London and made frequent visits to France while managing to be an active member of the artistic scene in London and contributing to the cultural renascence going on in Ireland. French artists, such as

Edgar Degas or James Tissot, travelled to or lived in Britain while British artists did the same in reverse. Sickert lived in France from 1898 to 1905 as well as making frequent visits there. Gwen John settled in Paris in 1904, never to return to her home country to live. Her contemporaries, notably her brother Augustus, were frequent visitors to the city. Travel to and fro was easy, and brief visits were common. Francophilia was synonymous with a modernist approach and in the early twentieth century this was typified by the artists of the Bloomsbury Group, though it was equally true of their rival Wyndham Lewis. Indeed, Lewis's novel *Tarr* draws on personal experience to offer a sardonic view of the life of British artists in Paris in the early 1900s. The key result of this constant commerce was an exchange of technical expertise, as stylistic innovations were passed on, most importantly from Degas to Sickert. It has also been proposed that this dialogue between the two cities ensured the establishment of shared concerns with and approaches to the translation of modern experience into art.[2]

Apart from the brief interlude of the First World War, Paris continued to be the prime destination for British artists, who travelled to be in close proximity to their Continental peers and to study in such informal schools as the ateliers Julien or Colorossi. Roger Hilton was still citing their teaching in the early 1970s. In the 1930s the French capital was unquestionably the leading centre for both Surrealism and the self-consciously internationalist abstract modernism that was represented by the group Abstraction-Création. The British contingent of this tendency was led by Ben Nicholson, and the easy access offered him in frequent visits to his first wife, Winifred, who had settled in the Quai d'Auteuil, was crucial to the authority he could claim. Direct contact with Paris was an essential requirement if an authoritative modernist position was to be maintained. This gave an enhanced status to a refugee artist like Naum Gabo who, having migrated gradually from Russia through Germany and Paris, arrived in Britain in 1936 as one of 'modernism's eye witnesses'.[3]

Paris maintained its allure for some individuals after the Second World War. Young Scots Eduardo Paolozzi and William Turnbull lived there in the 1940s, attracted by the egalitarian nature of the scene where they could meet as equals such figures as Alberto Giacometti, a social fluidity in marked contrast to the resilient conservatism of British art schools. It became clear, however, that Paris's days as

the capital of modernism were over, and for a brief moment some, such as the critic and painter Patrick Heron, hoped to claim that title for London.[4] Ironically, his conception of a 'School of London' was dominated by artists working in St Ives. Heron insisted that the USA was too lacking in culture of any kind to become the centre for modern art. In fact, it had already become so.

Between the wars New York established its reputation as the most modern city in the world and a few British artists, notably C.R.W. Nevinson, visited. The wealth of the United States ensured that international markets were dominated by its collectors and museums, in particular New York's Museum of Modern Art (MoMA). With the migration to America of many European artists at the outbreak of war and the emergence of those painters who, during the early 1950s, would gradually become known to the British as the Abstract Expressionists, it became *the* city of modern art. As with Paris in the first half of the

twentieth century, an involvement with the New York art scene became an important badge of a British artist's own modernity. Recognition by the American art world was sought after and respected. It seems certain that the British Council's advocacy of the group of sculptors that they showcased at the 1952 Venice Biennale, including Reg Butler, Lynn Chadwick and Kenneth Armitage, was greatly encouraged by the reception they received from American collectors and, most especially, from MoMA's Director, Alfred Barr.

As the 1950s progressed American dealers were frequent visitors to Britain and a showing in New York became a key professional marker for such artists as Alan Davie, Peter Lanyon (1918–64) and Patrick Heron. This state of affairs remained in place for the rest of the century with, for example, the first New York show of Damien Hirst attracting great critical attention. During the 1960s the commerce between Britain and the USA, in particular New

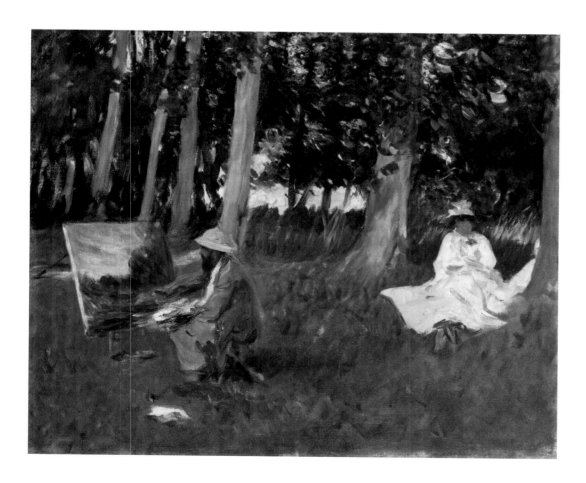

York, took off. For a time British artists were much sought after by American art schools with the levels of remuneration persuading many to take up teaching posts. Others became so well established that they were seen almost as Americans: Richard Smith (b.1931), David Hockney and Malcolm Morley (b.1931), for example. Even at the beginning of the twenty-first century, despite the process of globalization and the ascendancy of other countries and cities, the New York art market (if not the city's art scene itself) retained a particular allure.

London: Microgeographies and Artistic Strategies

London is, famously, a conglomeration of villages with particular areas being associated with artists over certain periods of time. During the nineteenth century London's artists moved westwards from the central areas around Covent Garden. In the mid- to late nineteenth century the intimate streets close to the river at Chelsea were much sought after by artists, and many studios were built during those years. Such was Chelsea's reputation as an artistic zone that the local authority included purpose-built artists' studios in its plans for reconstruction following the Second World War. In the second half of the nineteenth century, however, the most prestigious location for artists' studios was around Holland Park, further north. This was a period when the most fashionable artists – most especially G.F. Watts and Frederic Lord Leighton – earned vast sums of money and spent it, in part, on grand houses and lavish lifestyles in Holland Park Road and Melbury Road. To seek to live in this Kensington/Holland Park area as opposed to Chelsea suggested aspiration to acceptance by the establishment.[5]

Hampstead was another area in which artists congregated from the mid-nineteenth century onwards. Its elevation above the city and its expanse of heath mean that the area hovers somewhere between the urban and the rural. It is indicative of the perception of the place, perhaps, that the asthmatic Ben Nicholson moved there for its clearer air. Through his presence, among others, between the wars the area became synonymous with the avant-garde. During the 1920s and 1930s, Richard Carline (1896–1980) and his family provided a centre for left-leaning

artists and writers. At the same time, Roland Penrose's presence in Hampstead's Downshire Hill ensured its importance to British Surrealism, and a gathering of abstract painters and sculptors, including Nicholson, Hepworth, Moore and, later, refugees such as Gabo and Mondrian made it the centre for British modernism. The significance of a sense of community and the role such proximity played in reinforcing shared artistic and political ideologies was reflected and articulated in Herbert Read's memoir of his time in Hampstead, *A Nest of Gentle Artists* (1962).[6]

A recurring pattern that can be discerned during the twentieth century is the occupation of run-down areas by artists and the resultant gentrification leading to a growth in prices that forces the artists to move on. So, by the post-war period, despite Kensingston and Chelsea Council's building plans, artists were migrating west and north from Chelsea and Holland Park to Fulham, North Kensington and Notting Hill (then becoming a strongly West Indian area). After the 1960s, perhaps following the establishment of SPACE studios at St Katharine Dock (see Malvern, p.216), the predominant direction of migration was eastwards into the increasingly derelict docklands, which were themselves then redeveloped into a financial and business hub under Margaret Thatcher's government. The same process carried on to the end of the century with artists and their associated galleries and suppliers occupying the hitherto run-down and unfashionable Hoxton to the north of the financial district.

A persistent quality of these gatherings of artists was a degree of detachment, of their setting themselves outside of social norms. This desire for separateness and, by implication, authenticity could thus be reinforced spatially by an artist's association with a certain locale or social venues. Though London's bohemians lived mostly in Chelsea and Holland Park, in the late nineteenth and early twentieth centuries the Café Royal in Regents Street provided their main gathering point. In the 1930s London's Bohemia relocated to Soho. This central area had a well-established reputation for cosmopolitanism and sexual licence. Its pubs and private drinking clubs allowed for illicit sexual encounters and provided a relatively safe venue for homosexual behaviour, then illegal. This was especially true during the Second World War when the blackout and the influx of visiting servicemen added to the fun. So prominent did the myth of Soho become that several figures secured

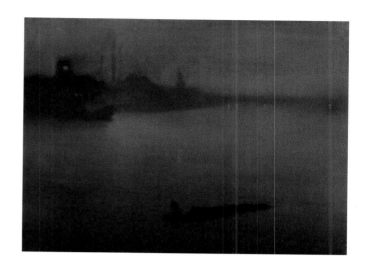

public profiles more through their association with it than through their work. Nevertheless, its cast of characters included some of the most important cultural producers of the time, including the poet Dylan Thomas and the painter Francis Bacon.

So there are areas of London associated with artists – either at certain historical moments or over longer periods of time. There are also certain areas that artists have more consciously elevated in their work or their self-presentation. Our period opens, conveniently, with Whistler's series of Nocturnes, depictions of the river near his home at Chelsea (fig.55). While the titles' allusions to musical form encourage the formalist readings of these works that have tended to predominate, they are also images of place. In the short stretch of the Thames by Chelsea, Whistler highlighted both the sublime beauty of a scene that was not then considered aesthetically pleasing and its modernity. Through the smog that blighted London until the 1950s, we are shown in one painting the river's commerce, as barges pass under Battersea Bridge, and in another, the nocturnal pleasures pursued in Cremorne Gardens, the last remnant of London's eighteenth-century pleasure gardens. The artist claimed: 'I wished to indicate an artistic interest alone, divesting the picture of any outside anecdotal interest which might have been otherwise attached to it. A nocturne is an arrangement of line, form, and colour first.'[7]

Nevertheless, he extracted a formal beauty from what was recognizably the place on many other artists' doorsteps.

An aesthetic engagement with the actual fabric of modern London was further developed by Whistler's pupil, Walter Sickert. Sickert called for an art of the everyday, insisting that 'the more our art is serious, the more it will tend to avoid the drawing-room and stick to the kitchen'.[8] His engagement with working-class life in London was most controversially seen in a series of works showing a nude female figure in a miserable bedroom in the company

56 FRANK AUERBACH
Oxford Street Building Site I 1959–60
Oil on board 198.1 × 153.7 (78 × 60½)
Tate. Purchased 1961

of a clothed male (fig.54). Sickert explicitly related several of these to the recent news story of the murder of prostitute Emily Dimmock in her bedsit, known in the press as the Camden Town Murder, and the works' juxtaposition of the female nude with a fully-dressed man gives them a powerful erotic overtone. The provision of alternative titles for the work such as *What shall we do about the rent?* (or *The Camden Town Murder*) may suggest that ambiguity was part of the artist's intent. Nevertheless, the scenario alone announced the importance to him of working-class existence in London. Sickert located himself in Camden, north of central London, an area of once-grand houses that had by the early twentieth century become rather down-at-heel, not least because of the relatively recent driving through of the railway.

The artists who took up Sickert's challenge, including Spencer Gore, Harold Gilman, Robert Bevan (1865–1925) and Charles Ginner (1878–1952), called themselves the Camden Town Group, perhaps to indicate their allegiance to the working-class periphery of the city's centre. In their search for beauty in the grime of the inner city, they made pictures of working men's eating houses, down-at-heel lodgings and landladies, bland urban squares, the newly arrived motor traffic and, in Bevan's case, the soon-to-be-lost horse markets. Their engagement with the spaces of modernity was most clearly indicated, however, by

Gilman's move to the new suburb of Letchworth and by the works Gore made there in 1912. Such an engagement with suburbia and its bourgeois population would prove rare. While the perceived absurdities of such polite – perhaps pretentious – social fractions later became a staple for documentary photographers like Bill Brandt (1904–83) and Martin Parr (b.1952), few painters engaged with it, preferring the grimy integrity of the city and its poor.

Camden Town and comparable areas on the edges of the ancient centre of London as the locale for a gritty, mobile and transient urbanism would return after the Second World War in the work of Frank Auerbach (b.1931) and Leon Kossoff (b.1926). One-time pupils of David Bomberg, both used the heavy conglomeration of paint to add to the expressive force of their images and to aid in the evocation of urban decay and social degradation. These are, perhaps, most powerfully and pertinently seen in Auerbach's images of building sites near Oxford Street (fig.56). Within these thickly matted fields of oil paint a linear pattern of scaffolding gradually becomes visible in an articulation of the process of reconstruction in the wake of the war. We are reminded that these works were made in a city where large swathes had been eradicated by bombing and were very slowly being rebuilt. Along with the human figure, such tense and melancholy images of the urban fabric and its inhabitants continued in Auerbach's and Kossoff's work

57 GILBERT & GEORGE
Cunt Scum 1977
Mixed media 241.3 × 200.7 (95 × 79)
Tate. Presented anonymously 1998

through the 1980s. While these two artists engaged with specific parts of the capital, the School of London in which they were included did not necessarily take its eponymous home as a subject. In fact, the term was coined by one of its members, R.B. Kitaj, to collect a disparate group of painters working in London during the 1980s into some-thing resembling a movement; exactly who was to be involved became refined subsequently.[9]

Rather unexpectedly, a gritty, bombed-out London would reappear towards the end of the twentieth century. The catalogue of the important international exhibition of young British artists' work, *Brilliant! New Art from London* (1995), had on its cover a photograph of the aftermath of the IRA's bombing of the City of London three years earlier. While the poor taste of such imagery was presumably intended to support the transgressive nature claimed for the art on display, it also set the work within the frame of a particularly tough urban experience. Once again, perhaps, this was an attempt to find some clear distinct ground between London and the established international capitals of art production by claiming a traumatized integrity in defiance of more familiar notions of British reserve and propriety. In this was an echo of the 1970s photo-assemblages of Gilbert & George, which integrated views of the urban populace and graffitied swear words into tough evocations of the modern city (fig.57). In fact, the treatment of the city by these 'Young British Artists' (or YBAs) could be more subtle and sensitive than the *Brilliant* catalogue might suggest (see Gallagher, pp.230–1). Many of Gillian Wearing's works have been concerned with the inversion of roles, and in several she has reversed the gendered assumptions of Charles Baudelaire's writings on the city, the crowd and especially the *flâneur* (the latter being a key modern stereotype: a male observing the life of

58 GILLIAN WEARING
Dancing in Peckham 1994
Colour video 25 minutes
Courtesy Maureen Paley

Cornwall to London's Paddington Station carrying paintings to the Royal Academy from the fishing villages of Newlyn and St Ives. By locating themselves in certain places that became known as artists' colonies, painters set themselves apart from the city and its associations with the modern while maintaining an umbilical link to it. While a key attraction of these locations was a way of life that they were thought not yet to have lost, as Fred Orton and Griselda Pollock have written in relation to colonies in France, it was the extension of the railway line to such places that made them viable for colonization in the first place.[10] While they provided the environment and the inspiration for the making of art, the commerce of that art remained in London. It was not simply that exhibiting societies and buyers resided in the metropolis, but that the eye with which the painters' subjects were recorded was essentially an urban one. The artists remained colonists – in the villages but not of them.

The development of artists' colonies was not unique to Britain, though it was largely a northern European phenomenon. They flourished from 1830 and their heyday was from 1870 to 1910. It has been claimed that 'a substantial proportion of all artists practising in Europe and North America spent at least one or more seasons living and working in one of these colonies'.[11] Of course, British artists did not confine themselves to the British colonies – the most significant of which were at Staithes in North Yorkshire and Cockburnspath in south-east Scotland as well as St Ives and Newlyn in Cornwall – but travelled abroad, most notably to Pont Aven and Concarneau in Brittany. As well as particular forms of social and professional interaction, the primary attraction of such places was nostalgia for an unmodernized way of life, for a picturesque scene of rural community and labour.

At a time of industrialization, urban expansion and consequent social change, artists' colonies and the works that emanated from them offered a reassuring permanence and continuity. In contrast to the constant renewal of the modernizing metropolis, such communities could seem unaltered and timeless. To this end, subjects were frequently posed not only apparently engaged in traditional activity but dressed in traditional clothes, even as such attire was dying out. It is telling that a large part of the art generated focused on human behaviour and, in particular, on rural labour and community activity. Such representa-

the street, consuming specifically female subjects with his gaze), by playing with the dynamics of her urban settings. For example, *Dancing in Peckham* (fig.58) shows the artist dancing self-consciously in a shopping mall in the eponymous run-down district of south London as if seen from a close-circuit security camera. Aspects of life in the city – privacy and public space, performance and anonymity – are thus brought to the surface to be openly considered.

The Persistence of the Pastoral

Nothing better encapsulates the relationship between a certain form of artistic production, the country and the city than the fact that in the 1880s a special train ran from

tions of the rural poor were not confined to artists' colonies, however. There was a trend in the 1880s for depictions of peasants at work in the fields. This trend was dominated by George Clausen, Henry La Thangue (1859–1929) and the artists of the Glasgow School who followed the work of the Frenchman Jules Bastien-Lepage. Though the academic artifice of Bastien-Lepage's work led Degas to describe him as 'the Bouguereau of naturalism', it was the claim of realism that was most important; Clausen insisted that 'a picture should be a record of something seen'.[12] Despite this, one of the key characteristics of Clausen's work from that time is the contrast between a loosely painted background and figure with a more meticulous rendering of the (generally female) sitter's spotless, doll-like face.

Consistent with such a realist agenda, these artists like those of Newlyn employed a plein air approach. Newlyn would become dominated by Stanhope Forbes, a veteran of the colony at Pont Aven where he had studied under Bastien-Lepage. The added value of residing in an artists' colony was the ability to lay claim to an even greater

authenticity. Artists were able to maintain a myth of integration into the picturesque communities that furnished their paintings and so could claim theirs to be a more genuine representation. The artifice is made clear by the fact that, though they are presented as if the view was snatched by the artist, Forbes's subjects were in fact posed and the compositions staged. Such works as his depictions of the people of Newlyn are discourses as much on old-fashioned community as they are on unchanged rural practices. It is striking that women frequently hold a dominant position in this kind of painting, offering perhaps an even greater sense of solid continuity, whilst held securely in a supporting, gender-defined role. The work of these artists was essentially pastoral. Despite the claims for realism, they evoked a lost or passing past and an implied golden age of integrated communality. This pastoralism would recur in British art as a counter to the more brutal aspects of modernity through much of our period.

Of course, artists continued to work in rural locations and to depict rural subjects. At certain times, however, their work and its relationship to its place of origin would

60 PAUL NASH
Landscape at Iden 1929
Oil on canvas 69.8 × 90.8 (27½ × 35¾)
Tate. Purchased 1939

come to greater prominence and relevance. A new pastoral turn asserted itself following the First World War. As in other parts of Europe, the enormous catastrophe of the war undermined the progress of modernist practice and led to a return to a greater degree of representation. There was also, one might discern, a retreat to the country to re-engage with the permanence of nature and of rural life as compensation for the unimagined destruction of modern war. Though the rural landscape and population were themselves undergoing processes of modernization, they continued to offer the perception of such reassurance. A particular English pastoral in the wake of the war is evident in the work of Stanley Spencer. Though his painting of the 1920s returned to themes and modes of expression established before the war, they nonetheless took on a new significance as acts of remembrance and reconciliation.

Spencer had seen war service and made paintings based on his experience. His observation of army life and of war in the Balkans informed the murals he made for the Sandham Memorial Chapel in Burghclere. While the side walls show everyday scenes of army life, behind the altar the fallen troops are shown rising from the ground and piling the white crosses marking their graves at Christ's feet. The Burghclere cycle is a conscious act of remembrance but the same spirit resides in much of Spencer's work, which was driven by a belief that God is in everything. New Testament scenes and spiritual events are shown in the streets, houses and gardens of Cookham, his home village. One painting shows the unveiling of the

war memorial – an act of remembering witnessed by every village in Britain – with young men in cricket whites lounging on the grass representing the ghosts of the dead. The theme of resurrection was made explicit in the monumental canvas Spencer painted between 1924 and 1926 in which the scene of rising souls on the Day of Judgement is relocated to the churchyard in Cookham (fig.59). The scene is populated by the artist's friends and family, including Spencer himself in more than one place and his beloved Hilda as the archetypal mother in the porch of the church. In the background the boat that took visitors on Sunday afternoon jaunts on the River Thames becomes the barque that carries the risen souls to heaven. Thus the quintessential English rural scene of a village churchyard becomes not just the embodiment of the pastoral but the locus for an act of recuperation and renewal.

The First World War figures in British art of the 1920s as an unstated memory indicated by an absence of human life and of incident in empty landscapes and quiet interiors. Post-war melancholy is played out beneath the England's South Downs in Paul Nash's *Landscape at Iden* 1929 (fig.60). As an official war artist, Nash had produced some of the most evocative and memorable images of the conflict. In such works as *We Are Making a New World* (fig.61) he allowed the blasted landscape to speak for the years of destruction and broken trees to serve as signifiers of the fallen men. While some have looked at *Landscape at Iden* in terms of its modernism and its debt to Giorgio de Chirico, others have drawn on the imagery of the war work to

61 PAUL NASH
We are Making a New World 1918
Oil on canvas 71 × 91 (28 × 35⅞)
Imperial War Museum

62 ALFRED WALLIS
*The Hold House Port Mear Square Island
Port Mear Beach* ?c.1932
Oil on board 30.5 × 38.7 (12 × 15¼)
Tate. Presented by Dame Barbara
Hepworth 1968

support a symbolic interpretation.[13] Thus the ordered rows of saplings that recall the ranks of crosses in war cemeteries become symbols of new life when set against the broken trees of *We Are Making a New World,* despite the sadness inherent in the long shadow that they cast in the evening light. The ziggurat-like pile of logs (fallen trees again) becomes a sacrificial altar. A similar air of melancholy emptiness persisted in Nash's work throughout the 1930s, most especially in the Surrealist-looking paintings in which found objects or geometrical forms sit or float on a downland landscape. While these echoed the photographs Nash made of genuinely found objects in landscape, their recollection of or juxtaposition with such ancient formations as Silbury Hill implied parallels between modernity and ancient cultures. Between the wars the downlands of southern England were seen as the site of a lost ancient civilization.

Nash's modern landscapes can be seen in relation to the work of other modernist contemporaries, who in the 1920s turned to landscape and still life. As Charles Harrison points out elsewhere in this volume (see p.48), these were associated with the Seven and Five Society (later 7 & 5) and included David Jones (1895–1974), Ivon Hitchens (1893–1979), Christopher Wood and Ben and Winifred Nicholson. Common in these artists' oeuvre are landscapes viewed through a window so that they become visually part of a still-life arrangement, internalized and privatized. The foregrounds serve to locate the landscape culturally; window furniture – curly handles, for example –

and the objects in front (notably a pair of Staffordshire china dogs in one work by Wood) associate the view with the world of the English country cottage. These artists turned to rural tradition as a means of re-energizing their own modernism. In particular, the Nicholsons and Wood drew inspiration from the paintings of Alfred Wallis.

As Harrison writes, Wallis offered a model for an intuitive alternative approach to the mechanics of painting. He also served a symbolic role as the embodiment of the type of timeless rusticity established in the work of such poets as William Wordsworth, Matthew Arnold or Edward Thomas. The way Wallis was constructed by others is telling. He was generally perceived and described by those artists he influenced and subsequent commentators as a retired fisherman, painting scenes recalled from his past. On his grave – paid for by artists like Nicholson – he is described as 'artist and mariner'. In fact, he spent very little time at sea and his main career had been as a scrap merchant, not to mention another job as an ice cream salesman in St Ives.[14] As a mariner, however, he echoes the figures seen in the paintings of the Newlyn School from fifty years earlier and so offers an image of reassuring permanence and continuity. He was certainly not seen as an equal by his admirers, as one can tell from the way his work was treated. Unlike their own, his paintings were bought in bulk and tended to be given away to friends and colleagues like talismans that somehow stood for a rural authenticity (fig.62).

63 BEN NICHOLSON
1928 (Pill Creek, moonlight)
Oil, pencil and gesso on canvas
49.5 × 61 (19½ × 24)
Private Collection

64 PETER LANYON
St Just 1952–3
Oil on canvas 243.8 × 121.9 (96 × 48)
Private Collection

65 RICHARD LONG
A Line Made by Walking 1967
Photograph and pencil on board
37.5 × 32.4 (14¾ × 12¾)
Tate. Purchased 1976

A LINE MADE BY WALKING

ENGLAND 1967

Wallis was essentially a folk artist akin to a craftsperson. Artists' fascination with him coincided with a new alignment with a craft revival. The 1920s witnessed a resurgence in various areas of craft, with renewed interest in pre-industrial forms and working methods as a means of modernizing them. At the centre of this movement were potters Bernard Leach (1887–1979) and William Staite Murray (1881–1962) – the latter a member of 7 & 5 whose work was shown alongside the paintings of the Nicholsons and Wood – and, in Ditchling in Sussex, the weaver Ethel Mairet (1872–1952) and the sculptor Eric Gill. In a rejection of mass, industrial production this revival was based on the elevation of the hand-made and one can see the same values encoded in the attention to surface paid by, in particular, Ben Nicholson and in the promotion of direct carving in sculpture (see Curtis, pp.72–3). While the latter has come to be seen as a key component of the modern in sculpture, in the context of Gill in the craft community of Ditchling (and later Capel y Ffin) it may be seen as part of this wider revival of traditional craft skills. As Gill's continuation of a medievalist guild tradition suggests, this was a revival that had started, primarily, with William Morris and the Arts and Crafts movement. In the 1870s Morris was advocating the honesty of hand-craftsmanship as opposed to vulgar and inauthentic industrial production within the context of a proposed revival of medieval guilds inspired by radical politics. Morris's insistence that a designer should not commission work in any medium that he could not practice himself had an echo in the concept of direct carving. Implicit in this revival of handmade craft was an idealized concept of rural domesticity. Again, this was actually a way of life that was fast disappearing. The tension between this rural tradition and modernism was encapsulated in the Cumbrian farmhouse lived in by the Nicholsons where, in the 1930s at least, the abstract paintings of Piet Mondrian occupied the same flagstoned space as the work of Wallis, a traditional cooking range, Windsor chairs and oak settles. An echo of this recruitment of traditional rural ways of life was heard at the end of the twentieth century in Jeremy Deller and Alan Kane's *Folk Art Archive*, an artistic project that involved the gathering of material relating to traditional vernacular activities and objects such as rural ceremonies, scarecrows and so on.

Wallis as a symbol of genuine expression and creativity was inherited by a second generation of artists who gathered in St Ives after Ben Nicholson returned there with his second wife Barbara Hepworth in 1939. During the 1950s, some claimed that St Ives was a centre of artistic production as significant as London.[15] It is true to say that this return to the countryside in the years following the Second World War was part of a process of recuperation comparable to that seen following the First. Now, however, the engagement with landscape was conducted in more modernist terms. It is this that distinguished the key St Ives artists from the Neo-Romantic spirit that came to prominence in the late 1930s and during the war. That phenomenon was a response to a sense of threat – from modernization as well as from aggressive ideologies – and was predicated on a revival of earlier British culture. The leading proponents of Neo-Romanticism in painting – John Piper, Graham Sutherland and the latter's followers John Craxton (b.1922) and John Minton (1917–57) – drew upon the English Romantic tradition and, most particularly, on the styles and themes of Samuel Palmer and William Blake. Again, cultural continuity offered stability in the maelstrom of modernity, and an aesthetic of ruination provided a context within which the devastation of the war could be located, visually at least.

An archetypal image of the Neo-Romantics was of a poetic male figure embedded in a landscape. There was some echo of this in the way in which an artist like Bryan Wynter (1915–75) took to living in an abandoned cottage, isolated in the moors near St Ives and devoid of any signs of modernization. His physical and intellectual immersion in the life of a particular landscape represented a drive to get closer to nature and its processes and these informed the abstract painting that he developed later in the 1950s. In common with other such artists, including Peter Lanyon and Terry Frost and their American contemporaries, his project was really a new form of sublime painting, an expression of humankind's vulnerability and transience before nature. While there were powerful echoes here of an earlier landscape tradition, this was now understood through the screen of existentialism.

It was, however, Peter Lanyon's work of the early 1950s that was the most important thing to emanate from post-war St Ives. Between 1952 and 1954 he produced a series of works that tackled the idea of place as opposed to landscape, a conception of a location that encompassed history and culture as well as topography. Specifically, as a native of Cornwall, he sought to express the decline of local industries of farming, fishing and tin mining and the

historic loss of life that resulted from the last. Lanyon's local association was vital to his claims to be able to represent a place with an authentic voice as distinct from those from elsewhere. Through the ambiguities of paint he set out to establish parallels between ancient myth and these more recent histories while also engaging in an act of self-definition. So he saw *St Just* (fig.64) as both an abstracted portrait of that town and a crucifixion, the latter symbolically memorializing and atoning for the many who lost their lives in the local mines. Of course, it is possible to see such works simply in terms of Lanyon's development of a radically new way of arranging forms, using colour and applying paint in an expressive fashion. Each approach confirms his innovation but the tension between the two may be seen as a key weakness in his art.

St Ives was probably the last significant group of British artists who were positioned in a rural location from which they drew the inspiration for their work. Of course, artists have continued to live and work in rural locations. While fitting definitions of Conceptual art, the work of Richard Long and Hamish Fulton (b.1946) can be located in relation to ideas of the sublime. The walks they undertake for their art and the photographic and textual records of them reinforce that notion of human kind as minuscule and fleeting before nature (fig.65). Their engagement with nature must also be seen in relation to the developing ecology movement of the 1970s, an idea that provides a useful frame for an artist like David Nash (b.1945), who makes sculpture not only from green wood but from living trees.

Conversely, some have seen the persistence of an English pastoral relocated to the urban environment. Julian Stallabrass has argued that aspects of British art from the 1990s can be read in pastoral terms, due in part to its fascination with the decay of Britain's largely modernist cities, particularly London. Keith Coventry (b.1958), for example, combined a pastoralist sense of loss with the loss of modernism's idealism by casting in bronze saplings planted by municipal authorities and broken by vandals. In another body of work he produced paintings that appear like the abstract compositions of Kasimir Malevich but are in fact based on the plans of modern housing estates. Rachel Whiteread produced a series of prints from photographs of such post-war housing blocks under demolition, a potent signifier of the failures of modernism, a theme not uncommon in the late 1980s and 1990s. It is, however, Whiteread's *House* 1993 that provides the most powerful,

melancholy image of urban pastoral (see Malvern, p.219). In its evocation not only of a building but also of its generations of past occupants, it served as a reminder of the transience of life as much as of urban fabric.

If the work of artists such as Coventry and Whiteread can be read in his way, then surely (as Stallabrass suggests) a precedent can be found in the work of Gilbert & George from thirty years earlier. Their oeuvre was powerfully nostalgic from the start, epitomized in their 1969 'singing sculpture' rendition of the song 'Underneath the Arches', the most famous number of old music hall stars Flanagan and Allen. This extended into their photographic pieces recording the decayed and defaced surfaces of the city while a gesture towards a recognition of their pastoralism was manifest in their series of large drawings depicting themselves amongst trees and bushes. A strange echo of their photographic pictures can be found, perhaps, in the meticulous reproduction of randomly selected patches of ground that were made by Mark Boyle (1934–2005) and Joan Hills (later Boyle Family; see Wilson, p.192–3).

The Art of Elsewhere

An abiding theme in artistic responses to modernity is that of escape. We have seen that an escape to the countryside and pastoral ideas of a surviving pre-modern past was a recurrent motif in the histories of British art of the modern period. For some the route of escape was away from Britain in pursuit of some kind of otherness or of an alternative set of social rules and values. For others the escape was into an imagined place, into a fantasy world of the past or of the other.

In the late nineteenth century a common destination for such fantasized escapes was the world of ancient Greece and Rome. In reaction against the observations of contemporary life of artists such as William Powell Frith and Ford Madox Brown (1921–93) in the mid-nineteenth century, a number of artists – most notably Lawrence Alma-Tadema (1836–1912) – painted imagined scenes from the classical past. Dutch-born and Belgian-trained, Alma-Tadema settled in London in 1870 following his success at the Royal Academy the previous year. He had visited Italy in 1863 and from that time his work was notable for the apparently archaeological accuracy of his representations of ancient

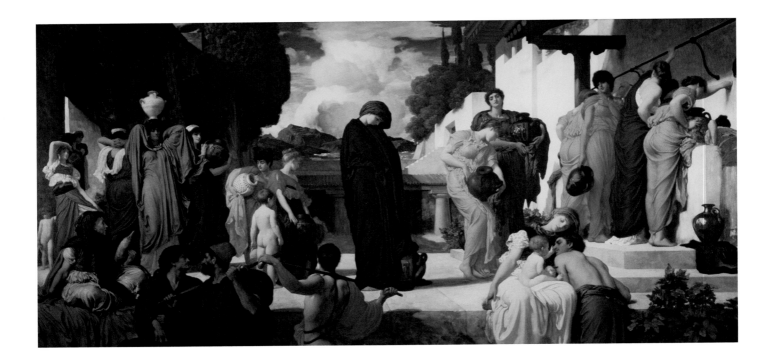

Roman settings. Rather than specific narratives, he tended to present generalized scenes that were seen at the time as realistic in their depictions of credible human behaviour set in a precisely described ancient past. A work such as *A Favourite Custom* 1909 is typical in its virtuoso rendition of marble and drapery and also in its use of the classical setting as a context for lusciously described female nudes.

The greatest of the Neoclassical painters was Leighton, who produced a series of large tableau paintings based on scenes from the ancient world or Renaissance Italy. In their horizontal format and processional figure compositions these drew on classical relief for inspiration. Leighton, however, was less committed to archaeological accuracy than to harmonious pictorial effect. In this he can be considered, along with other Neoclassicists like Albert Moore, to move in an aestheticizing direction (see Prettejohn, pp.34–5). This can be seen in the developments between four large processional works, the earliest of which is Leighton's imagining of the scene as *Cimabue's Celebrated Madonna is Carried in Procession through the Streets of Florence* 1855 (Royal Collection) and the last of which is *Captive Andromache* (fig.66). Leighton's huge commercial success, establishment credentials (he was President of the Royal Academy), apparently unqualified academic style of painting and immersion in an imagined ancient world set him beyond the pale for modernists in the twentieth century. Recently, however, some art historians have sought to recuperate him, arguing that modernizing elements might be found in his treatment of such issues as identity and sexuality and that in his prioritizing of visual

beauty over narrative he anticipated Aestheticism (see Trodd, pp.32–3).

The counterpoint to this late nineteenth-century fascination with classical Greece and Rome and Renaissance Italy was a revival of the medievalism of the Pre-Raphaelites. Burne-Jones was a great admirer of Dante Gabriel Rossetti, with whom he worked on murals of an Arthurian theme at the Oxford Union, and shared with his friend, William Morris, a fascination with Gothic architecture, the writings of Ruskin and the poetry of Malory's *Morte d'Arthur*. Burne-Jones was a founder member of Morris's company, Morris, Marshall, Faulkner & Co., which designed furniture, stained glass, fabric and wallpaper and which formed the basis of the Arts and Crafts movement. Stylistically, Morris sought to dispense with the over-elaborate decoration of Victorian design in favour of an aesthetic that was simple and drew upon natural sources and motifs. As a committed socialist, he sought an art for the people, finding a model in the arts of the Middle Ages. For him, then, the medievalist revival was part of a political as well as an artistic opposition to the forces and structures of modern industry; his campaign for well-designed, handmade products was complemented by a belief in the value of guilds as a mode of artistic organization. The advocacy of the handmade and of traditional craft skills would provide a basis for a key aspect of modern art and craft in the twentieth century, which would include the revival of carving among sculptors and which could be seen in the pottery of Bernard Leach and the weaving of Ethel Mairet.

Burne-Jones's medievalizing paintings sound a more romantic note than those objectives might suggest. His

66 FREDERIC LORD LEIGHTON
Captive Andromache 1888
Oil on canvas 197 × 407 (77½ × 160¼)
Manchester City Art Gallery

67 J.W. WATERHOUSE
The Lady of Shalott 1888
Oil on canvas 153 × 200 (60¼ × 78¾)
Tate. Presented by Sir Henry Tate 1894

King Cophetua and the Beggar Maid 1884 depicts the moment when love transcends reason. Like many paintings of the period it draws on the poetry of Tennyson whose rewriting of Malory's Arthurian narratives provided a lens through which artists frequently approached the Middle Ages. His most famous work provided the subject for *Lady of Shalott* 1888 by J.W. Waterhouse (1849–1917; fig.67). In its style, subject matter and relatively accurate rendering of the landscape, *The Lady of Shalott* can be seen as occupying a space somewhere between the academic classicism of Leighton, the revivalism of the Pre-Raphaelites and Burne-Jones and the early modernists.

In contrast to the late Victorians' fascination with the medieval or classical past was modernism's engagement with the arts of what were termed 'primitive' societies. Artists looked to prehistoric or non-Western forms of expression as sources for their own work. Free from the conventions of the classical or academic tradition, such works were seen to possess a sincerity or integrity of expression. While on an international level Pablo Picasso's *Demoiselles d'Avignon* 1907 (Museum of Modern Art, New York) marked a watershed in this development, in Britain the fascination was seen mainly among sculptors. This 'primitivism' became associated with the ideologies of

68 HENRI GAUDIER-BRZESKA
Red Stone Dancer c.1913
Red Mansfield stone
43.2 × 22.9 × 22.9 (17 × 9 × 9)
Tate. Presented by C. Frank Stoop
through the Contemporary Art
Society 1930

'truth to materials' and 'direct carving' (see Curtis, pp.72–3). Of the last two, the former was based on the belief that the sculptor's material determined the form of the sculpture (a wood carving had, necessarily, to take on a different form to a stone carving), the latter on the importance of an artist executing their own carving as opposed to the established practice of giving a model to a stone carver to translate into stone. Both asserted the importance of the artist's direct relationship with their material, which linked them to these intuitive artists of other cultures.

The first wave of this fascination with other cultures came before the First World War in the work, most notably, of the Jewish-American Jacob Epstein and the Frenchman Henri Gaudier-Brzeszka, both resident in Britain. These artists drew upon the masks and figures of African traditions for such pieces as Gaudier-Brzeszka's *Red Stone Dancer* (fig.68) and Epstein's *Venus* (fig.5, p.23). The key qualities of African sculpture were noted by prominent critic Roger Fry,[16] whose collected essays, *Vision and Design* (1920), prompted the young Henry Moore to visit the British Museum, where he encountered objects

from African and pre-Columbian Mesoamerican cultures that would prove a lasting source of inspiration. Moore's contemporary, Barbara Hepworth, was more strongly effected by the pure and simple forms of Cycladic sculpture, which would continue to exert an influence on artists such as William Turnbull into the 1980s. Frequently, the themes of these primitivizing sculptures would be consistent with their stylistic source as ideas of rhythm, paganism and unfettered sexuality were represented in sculpture. The association with crafted objects from other cultures suggested not just themes and styles but, it would appear, an idea of sculpture's very purpose. The tapping of unconventional sources prompted a tendency to produce sculptures totemic in their nature and addressing the key themes of the natural cycle. Phallic forms were not uncommon and the theme of procreation and maternity became a favourite for many artists.

This engagement with the arts of early and non-Western cultures was part of a larger drive to escape the conventions and processes of modernity in some form of 'otherness'. Some artists found such a thing closer to

69 AUGUSTUS JOHN
Woman Smiling 1908–9
Oil on canvas 196 × 98.2 (77⅛ × 38⅝)
Tate. Presented by the Contemporary
Art Society 1917

home. Augustus John, who became the most famous painter in Britain, was the epitome of the bohemian artist. He set himself outside society's conventions through the then fashionable interest in gypsy culture. While several of his associates studied Romany languages and traditions, John adopted the lifestyle by taking his wife, mistress and children on rambling trips while camping in his traditional gypsy caravan. The family dressed the part of the Romany; in his portrait of his second wife, Dorelia (fig.69), the exotic style of dress combines with the sitter's confident, coquettish smile to present an image of modern sexuality. That John's Romany fantasies were fuelled by a desire to escape is confirmed by his 1910 journey to Italy and southern France in search of peoples untouched by modernity. He recorded his disappointment at the dilution of racial purity by ethnic mixing in much of Provence but found what he believed to be a place and people that retained such purity at Martigues.

The south of France specifically and the Mediterranean in general offered a relatively accessible exoticism to British artists over a prolonged period. The Bloomsbury set frequented the area around St Rémy-en-Provence, where Van Gogh had passed his last years and where, later, Ben Nicholson and Barbara Hepworth would enjoy what was effectively a honeymoon. Italy, as the repository of the Renaissance tradition, continued to hold sway throughout our period. As well as the attractions of the art in cities Florence and Siena, the British School in Rome and its system of scholarships ensured a steady flow of artists from Britain. For some the relative simplicity of rural Italy offered an antidote to the sophistication of Paris and London. Venice, inevitably, persisted to fascinate and probably remained the most painted single city throughout the nineteenth and twentieth centuries. In the 1920s Marseilles in the south of France with its narrow streets, bars and brothels offered rich subject matter for such artists as Nevinson, Edward Wadsworth and Edward Burra. It typified the desire for travel as a means of escaping not only from a place but also from social convention and taboo. Burra's particularly camp take on travel and culture led him to Paris, Marseilles, Spain, New York and Mexico (see Stephenson, pp.114–5). Such places offered him subject matter as diverse as sailors' bars, African-American striptease acts, Catholic statuary and Gothic phantasmagoria. Two generations later, a similar desire to escape local conventions may have driven David Hockney to the Mediterranean and, most importantly for the development of his art, to Los Angeles. The subject matter of his work from the late 1950s and 1960s ranged from graffiti on the walls of London toilets to Californian swimming pools and the poetry of C.P. Cavafy. All were linked by a desire to articulate visually a sense of homosexual desire that was prohibited in Britain. A similar series of impulses led Francis Bacon to make repeated trips to Tangiers in Morocco where he socialized with other gay cultural figures such as William Burroughs and Allen Ginsburg.

Given the increasing ease of travel, the interest among mainstream British artists in places beyond Europe and North America seems relatively slight. The beginning of our period saw the waning of the nineteenth century's Orientalist fascination with the exotic otherness of the Middle East. In the 1920s David Bomberg undertook a series of precise depictions of Jerusalem and the Palestinian landscape. Such excursions remained rare, however, the exception being the two world wars, during which artists were dispatched to record the conflict in places as widely spread as the war's reach itself. So we find Richard Carline flying in Palestine during the First World War, while his brother-in-law, Stanley Spencer, was in the Balkans. In the Second World War, William Coldstream (1908–87) travelled from Egypt to southern Italy, Edward Bawden (1903–89) to Ethiopia and Eric Ravilious (1903–42) to the north Atlantic, where he was killed. Despite its imperial links to Britain, India attracted relatively few artists (although its rich visual traditions offered a source of inspiration for some, most notably Howard Hodgkin [b.1932] who was a regular visitor from the 1960s and built a collection of Indian miniature paintings). Of course, this relative absence of place is a reflection of the fact that such a specificity of subject would be contrary to the accepted criteria of quality in advanced art during most of our period. More recently the Indian miniature has been reinterpreted by several British Asian artists.

Inner Geographies

We have seen how place has figured in British art between 1870 and the present: where art has been made and how artists have drawn on certain locations to position themselves or their work. Places are loaded with ideological

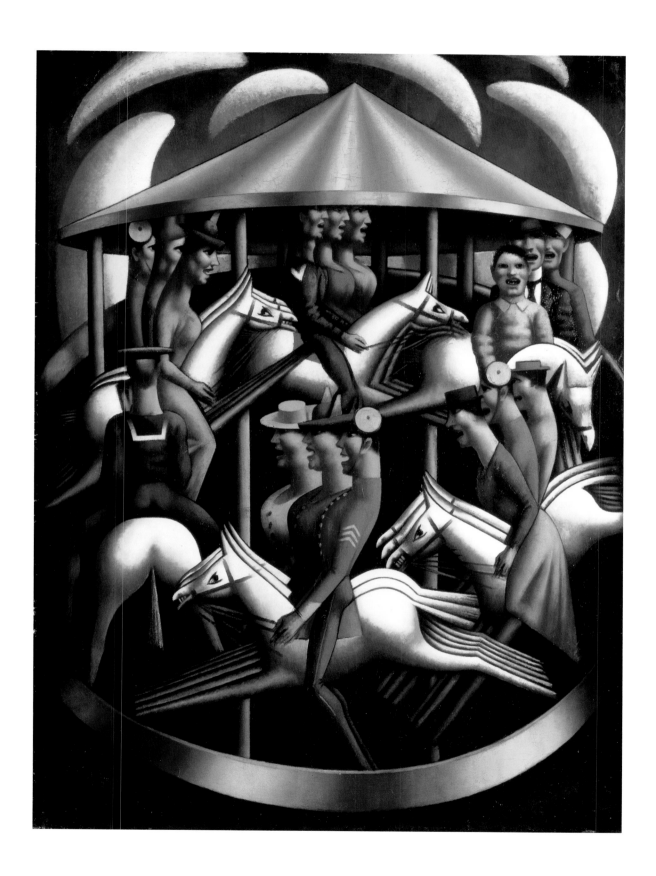

baggage and we have seen how closely linked these ideas of place are to those of modernity and nostalgia and to notions of a national identity. The polarities in ideas of the city – modern, fast-moving, grimy, alienating and anonymous – and of the country – timeless, constant, natural and communal – have persisted as dominant tropes in British art. Both serve in contrasting ways to reinforce national myths. Though apparently 'real', these places are as much products of cultural and individual imaginations. This is true also of those places to which artists have travelled in order to enrich their art. Like the tourists they are, such artists go to a place in order to reaffirm something they already know or expect to find there, to observe and draw upon material evidence of ideas of authenticity.[17] If these relationships between art and place are really about myth as much as anything, it is natural that alongside such actual places has persisted the importance of imagined places and romantic fantasies of ancient civilizations or other peoples.

Vital to a consideration of place and artistic production is the impact of migrations on British art. At the most simple level, we can see the importance of this by considering the fact that many of the leading figures in our period have originated from outside the UK: Whistler, Sargent, Sickert, Epstein, Gaudier, Lewis, Gabo, Freud, Sidney Nolan (1917–92), R.B. Kitaj and so on. In this final section, then, we shall consider the work of certain artists – migrants or the descendants of migrants – in which place is neither necessarily represented nor imagined but is implied or, perhaps, determining. In dealing with issues of ethnic identity and difference one cannot avoid the implication of place even if it is not a single, or even an actual, location.

An important and problematic subject is that of Jewish art in the early twentieth century. Such an art has often been identified – in Britain or internationally – as part of a wider belief in the ethnic determination of cultural expression. Let us not subscribe to the identification of essentially Jewish characteristics in painting or sculpture. It is a fact, however, that during specific periods a number of artists represented specifically Jewish subjects while others were prepared to identify themselves as 'Jewish artists'. While this Jewishness was seen as distinct from Englishness, it is necessarily a part of the cultural geography of British art. In 1914 an exhibition of Twentieth Century Art at the Whitechapel Art Gallery included a Jewish Section selected by avant-garde painter David Bomberg. In a sense this was a response to local priorities as Whitechapel was, by then, an area with a population that was almost 100 percent Jewish.[18] While it was the ethnic origin of the artist that defined this section of the exhibition, several of the artists showed paintings of Jewish subjects. Mark Gertler (1891–1939), like Bomberg a recent graduate of the Slade School, was then making depictions of the traditional Jewish life of his own family. The patron Ottoline Morrell wrote of Gertler's 'Jewish mark' giving his work an 'intense, almost archaic quality', and even when he moved away from Jewish subjects, his racial identity determined the reception of his paintings. D.H. Lawrence considered *Merry Go-Round* the best modern picture he had seen and argued that it could only have been painted by a Jew as it would need a 3000-year 'national history' to depict such destruction and decay (fig.70).[19]

The painting of Jewish subjects had been established a little earlier when William Rothenstein (1872–1945) produced a series of paintings of East End Jews engaged in acts of devotion. He had been encouraged in this endeavour by Sargent, who had himself secured a reputation for the portrayal of a series of prominent Jewish families such as the Wertheims (fig.71). Jacob Kramer (1892–1962), a Ukrainian immigrant, produced a series of paintings around 1919 of Jewish men in traditional religious dress in which simplified and rhythmic forms suggest the process of prayer and ritual while also making the works consistent with contemporary avant-garde painting styles. Though highly stylized, Bomberg's own compositions related to Jewish experience, too; his *The Mud Bath* (see fig.4, p.22) was abstracted from an image of bathers in Schevzik's steam baths in Whitechapel's Brick Lane. The significance of *Mud Bath*'s visual source to its intended meaning is not clear. The fact that it was exhibited outside on railings draped in union flags at the start of the war has also led it to be read in topical terms – its red, white and blue colouring taking on a patriotic significance.

One of the migrations to have most impact on British art was the arrival of refugees from Nazism and Fascism in the 1930s. While immigration remained tightly controlled, existing professional networks and personal connections facilitated the movement of artists and intellectuals who were, for the most part, either Jewish or politically on the left. Certain key individuals would leave a considerable legacy in their influence on art in Britain. Naum Gabo's moderate idea of Constructivism (see Harrison, p.54)

71 JOHN SINGER SARGENT
Ena and Betty, Daughters of
Asher and Mrs Wertheim 1901
Oil on canvas 185.4 × 130.8 (73 × 51½)
Tate. Presented by the widow and
family of Asher Wertheimer in
accordance with his wishes 1922

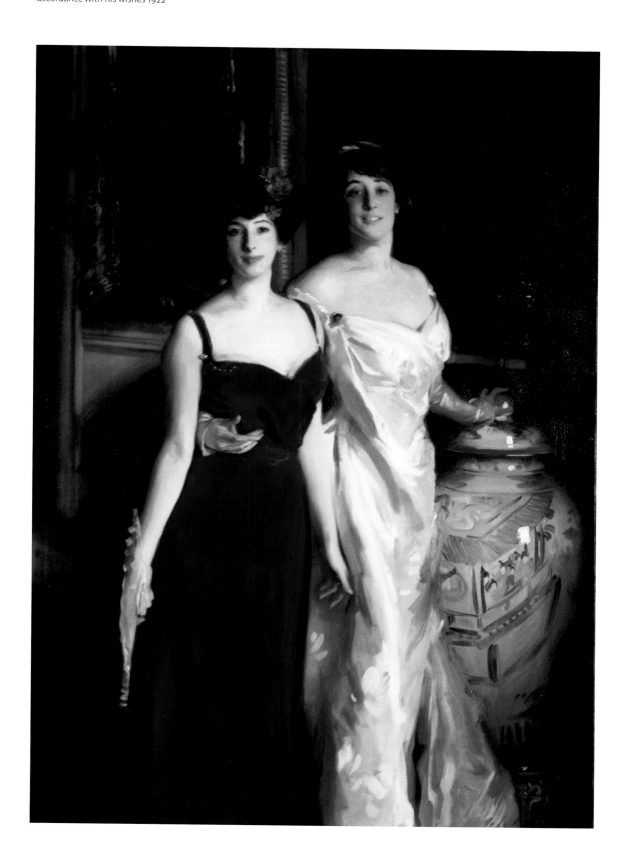

remained a lasting influence on artists in St Ives after the Second World War. This was apparent both in a belief in the ideological potential of art and in certain curving, almost egg-like forms with a transparent quality that recur in the work of artists such as Peter Lanyon and that John Wells termed 'Gaboids'. The Polish painter Jankel Adler (1895–1949) brought a kind of moderate Cubism that continued in the work of artists close to him during the 1940s such as Robert Colquhoun (1914–62) and John Minton (1917–57). He also, probably, contributed to the growing awareness of the importance of Paul Klee who became a figure of great significance in the late 1940s following the appearance of Adler's memoir of the artist in the journal *Horizon*.[20]

While most prominence has been given to the presence in Britain of such abstract artists as Gabo and Piet Mondrian, probably the greatest impact of this mid-century migration was on figurative painting and sculpture. The nature of the refugees meant that a number were realists or social realists and this made them valuable to wartime and post-war projects. The growth in public sculpture following the war was probably the area of activity most affected. The artists Siegfried Charoux (1896–1967) and Peter (Lazlo) Peri (1899–1967) were leading figures in the production of art to furnish the new estates and towns that were replacing the destroyed housing stock. The common subjects such as families at play suited their interest for realist representations of actual people. Painters, too, persisted with realist or expressionist styles, notably Josef Herman (1911–2000), who came from Warsaw as a young man. After the war he established himself in the Welsh mining town of Ystradgynglais whose mining community was presented with pathos and as heroic by the artist.

Of course, the greatest migration of the twentieth century was from the countries of the British Empire and Commonwealth. Elsewhere in this volume, Rasheed Araeen writes of the way that artists from former colonies introduced particular ideas of modernity and modernism affected by their own experiences. One of the first such artists was Ronald Moody (1900–84; fig.138) who came from Jamaica in 1923 to train as a dentist but soon committed himself to sculpture. His insistence that he should be seen simply as a sculptor alongside such contemporaries as Henry Moore and not in terms of his ethnic origin was not an uncommon position to take. Of a younger generation, however, Frank Bowling (b.1936; fig.98) incorporated into his early work references to his origins in British Guiana. In a series of paintings from 1967–9 abstract fields of colour are interrupted by or spread out against stencilled images of the map of South America or of Bowling's

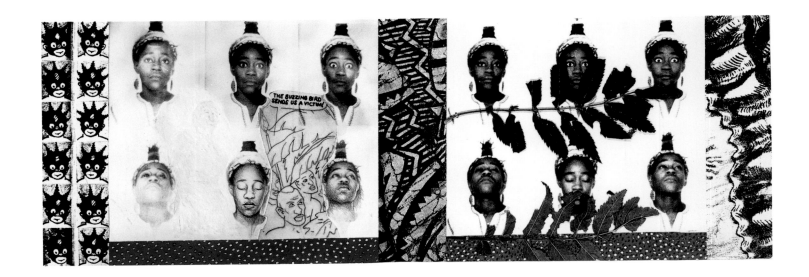

mother's house in British Guiana. The work of Francis Newton Souza (1924–2002; fig.99), who came to Britain from Goa in west India in 1949, is readily accommodated within the aesthetics of expressive European painting in the 1950s. He had, after all, had an education based on Western ideas. However, his particular concern with the conflict and contrast of Roman Catholicism and powerful sexuality was inevitably determined by his upbringing in Catholic Goa.

Artists such as Bowling, Souza and Aubrey Williams (b.1926) prepared the ground for another generation of artists, born in the UK of immigrant parents, who rejected the integrationism of those predecessors and used their art to express the experience of being young and black in Britain. The work of such artists as Sonya Boyce (b.1962), Lubaina Himid (b.1954), Donald Rodney (1961–98), Keith Piper and Eddie Chambers (b.1960) can be set comfortably in relation to other art in Britain and beyond at the end of the 1970s and early 1980s in its use of a range of media and its overt ideological content (see Chambers, pp.226–7). The concern with black experience, however, set it apart. Boyce's *From Tarzan to Rambo* draws together the African diasporic experience with the question of how stereotypes are promulgated by the media and the crisis in white identity that she saw in the two fictional figures of the title

(fig.72). This was a period in which young black and Asian people were rising up against a persistent racism in British society, most obviously manifest in the riots that began in Brixton in 1981 and that spread to similar areas in such cities as Liverpool and Bristol. It is important to note, however, that for many of these artists ethnicity was simply one aspect of more complex identities explored in their art, which dealt also with, for example, female experience in the case of Boyce or sickle cell anaemia in that of Rodney. By the end of the century it could be claimed that black and Asian artists were better represented within the mainstream than in previous decades.

Throughout the period of this volume there were moments when the place in which an artist's work was made or conceived was central to that work. At others, of course, it was largely irrelevant. Even interpreting ideas of place and geography loosely, then, such an approach is strongly skewed. It also risks emphasizing one aspect of a work over other equally significant elements. Nevertheless, one might also feel surprised at how much of British art of this period can be approached in these terms – how tensions between capital and periphery, country and city – as well as the expression of urban experiences and of identities linked to diverse places and cultures – have persistently influenced art production through a period of massive change.

First World War Memorials

After the First World War, artists were called upon to meet the demand for memorials to the many thousands of dead. These losses are represented demographically by the discernable dip in the population statistics of the last century. An equivalent visual impact exists in the vast number of structures built as memorials that occupy both urban and rural space throughout Britain, her dominions and in other combatant nations. From the end of the war in 1918 until the late 1920s, thousands of memorials were constructed. These ranged from simple tablets on the walls of parish churches, carved by local letter-cutters or ordered from ecclesiastical furnishers, to the ambitious government-funded projects of the Imperial War Graves Commission. The latter, designed by the leading architects of the time, remain imposing monuments to the consequences of global conflict.

The drive to memorialize the dead was immense. Nations, regions, communities and families, all sought to create some mark in recognition of both those they had lost – the majority of whom were buried overseas – and the service of those who survived. To this end, architects, sculptors and craftspeople of differing persuasions and abilities were engaged by those charged with commissioning memorials.

The potential scale of the memorial boom had caused alarm. The Royal Academy of Arts,

and other professional organizations such as the Royal Institute of British Architects and the Royal Society of British Sculptors, acted as advisory bodies electing members to assess design competitions and nominating them for particularly prestigious commissions. Matters of taste and policy concerned the cultural elite. The director of the British Museum, Frederick Kenyon, formulated the aesthetic policy of the Imperial War Graves Commission and the Victoria and Albert Museum exhibited exemplars of memorial design from its collection. The Civic Arts Association also held exhibitions and published guidance notes, and various diocesan advisory committees vetted designs and decided what would or would not be permitted on church property.

Opinion varied as to the kind of memorial that should be built. Some argued that a memorial should benefit future generations, and many buildings, scholarships and amenities were created in memory of the dead. Others urged that a monument would be understood more clearly as a gesture of gratitude. The range of monumental forms adopted and adapted was considerable. Celtic crosses, classical cenotaphs, ancient obelisks and bronze figurative statuary, all these were reinterpreted with varying degrees of skill and success. While the restrained classically derived syntax of Imperial War Graves

Commission cemeteries and memorials might be considered one of the most coherent and enduring design solutions to the tragedy of mass death (fig.73), the structures that were built across Britain were contrastingly unpredictable. Whatever the form of memorial a community chose, they tended to place it in a conspicuous location and familiar village and townscapes across the country changed significantly.

Just at the time when artists were attempting to justify a practice independent of the stipulations set down by a client or commissioning committee, and as they were moving away from ideas about the direct social function of art, the demand for memorials was a dramatic and urgent insistence on the application of their skills for the public benefit. Most community war memorials were funded by public subscription. Decisions were then made, determined by the funds available, as to the type of memorial required, the names to be inscribed upon it and its location: competitions were a standard means of selecting a design. The artist or architect selected then created an object that in addition to the associations or symbolism of the work itself would be vested with meaning by its audiences who visited it to remember the dead, either alone or as part of annual remembrance ceremonies that assumed a place in national calendars. Many memorials were hybrid objects

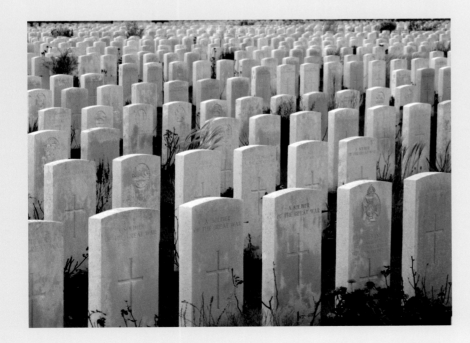

73 Imperial War Graves
Commission cemetery, France

The inscription on the monument reads:

IN PROUD REMEMBRANCE OF THE
FORTY NINE THOUSAND & SEVENTY SIX
OF ALL RANKS OF THE
ROYAL REGIMENT OF ARTILLERY
WHO GAVE THEIR LIVES FOR KING
AND COUNTRY IN THE GREAT WAR
1914–1919

RUSSIA · PALESTINE · CENTRAL ASIA

74 CHARLES SARGEANT JAGGER
*The Driver, Momument of the
Royal Artillery Regiment* 1925
Portland stone and bronze
Hyde Park Corner, London

where form, inscription, materials, and location all functioned in the work of remembrance.

Allied to the variety of memorial types is the variety of makers who were engaged on commemorative projects. Those sculptors typically responsible for statues to royalty and politicians, many of them Royal Academicians, made accomplished figurative representations, most usually in bronze, of 'Peace', 'Victory' and the idealized citizen soldier. The monumental conventions employed in the depiction of great men were reconfigured in the representation of the ordinary soldier, standing in for so many of his dead comrades. A younger generation of talented sculptors who had seen active service themselves, Charles Sargeant Jagger (1885–1934; fig.74) and Gilbert Ledward (1888–1960) among them, interpreted conventional forms with a sharper edge; less well known is the impressive output of the Scot, Alexander Carrick (1882–1966). Eric Gill's memorials carved in local stone, have an understated power as statements of loss and suffering, at one with the environments in which they were placed. Thus memorial making was both centralized in terms of the metropolitan arbiters of taste and their policy and preferences, and diffuse, with towns and villages in the regions opting to engage artists and craftsmen on the professional periphery.

First World War memorials might be viewed as components of a tragic trans-national public art project. The war brought about structures that sought to make present the absent dead and that indicated the depth of mourning experienced by particular communities: it was perhaps the final wide-scale expression of loss in a monumental idiom. Certainly, there was little demand for similar objects after the Second World War, nor in subsequent decades when the parameters, politics and characteristics of conflict changed entirely.

FURTHER READING

A. Compton, *The Sculpture of Charles Sargeant Jagger*, London 2004.

P. Curtis, *Sculpture 1900–1945*, Oxford 1999.

A. King, *Memorials of the Great War in Britain : The Symbolism and Politics of Remembrance*, Oxford 1998.

C. Moriarty, *The Sculpture of Gilbert Ledward*, London 2003.

C. Moriarty, 'The Absent Dead and Figurative First World War Memorials', *Transactions of the Ancient Monuments Society*, vol.39, 1995, pp.8–12.

Frank Brangwyn's *British Empire Panels*

ROBERT UPSTONE

Frank Brangwyn's Empire Panels for the House of Lords are among the most distinctive and ambitious decorative schemes in twentieth-century British art. Intended to celebrate the empire's unity, the commission ended up an heroic failure, mired in economic and political struggles around protectionist imperial trade, colonial disintegration and rivalry in the Conservative Party. Rejected as aesthetically unsuitable, instead of crowning Brangwyn's long career, they left him bruised and bitter.

The commission to decorate the Royal Gallery of the House of Lords originated as an afterthought to the erection of a sculptural monument by John Tweed (1869–1933) to the fallen peers of the First World War. As Lord Great Chamberlain responsible for the fabric of the building, Lord Lincolnshire suggested in 1925 that this 100-foot-long (30 metre), gloomy space be enhanced with mural decorations that marked the sacrifices of war. He approached his friend Lord Iveagh, the wealthy head of the Guinness brewing family and owner of Kenwood House, with its extraordinary collection of art and furniture. Iveagh agreed to fund the project with £20,000 – a vast sum – and quickly chose Brangwyn (1867–1956) as the artist. The scheme was agreed by the Lords Offices Committee, chaired by Lincolnshire, but ominously little was known of it outside this small group.

Brangwyn's initial designs, made in 1925–6, depicted war scenes; one nearly finished panel featured a tank dramatically bursting through the lines, flanked by heroic tommies. But Brangwyn and Iveagh decided that scenes of battle and carnage were inappropriate and, with public sentiment about the war subtly changing, agreed instead to look to the future rather than the past. Brangwyn put together a set of designs that instead of mourning the dead displayed and celebrated the empire they had died for. The result was monumental – a set of sixteen panels, six measuring 20 feet by 13 feet (6.1 × 4 metres), and ten more 12 feet square (3.7 metres square). They were highly unusual; figures, animals and birds peep out from a writhing, thick mass of exotic vegetation, and the result was overpowering and almost psychedelic (fig.75). The sensitive conductor John Barbirolli judged them 'all tits and bananas'. Once apprenticed to William Morris, Brangwyn seemed to have produced a vast, allegorical version of one of Morris's wallpapers. The empire's bounty of food, fruit and raw materials are highly visible

and, while individual countries are recognizable – India and its elephant, Canadian Indians and Cape Town's Tabletop Mountain – Brangwyn deliberately blurred the national boundaries instead of highlighting differences. He sought to stress not the separateness of empire but its human brotherhood and unity. This was ironic, because as Brangwyn worked on his vast scheme through the 1920s the empire was pulling apart. Individual domains pressed Britain for semi-independent dominion status with their own national governments, whilst others openly discussed complete independence. In India in March 1922 Mahatma Gandhi began his sentence for sedition after starting the popular campaign of 'non-cooperation' to boycott British products.

Brangwyn's view of a fecund, fruitful, bountiful empire of brothers was wholly in line with Stanley Baldwin's Conservative government's policies and the image portrayed by the Empire Marketing Board, which existed from 1926 to 1932. The EMB was designed to promote inter-Empire trade and keep out cheap products from America and the Far East. It had what amounted to a propaganda unit producing posters, exhibitions, 'Buy Empire' shopping campaigns, as well as a film unit. Under John Grierson, the film unit made documentaries with titles such as 'Solid Sunshine', advertising New Zealand butter, 'Song of Ceylon' and 'One Family'. Like Brangwyn, these films promoted twin views of the abundance and citizenhood of the empire. Brangwyn's patron Iveagh, as an Irishman with extensive business interests in Dublin, must have held a deeply interested stake in this view of imperial relations, with Ireland pulling from dominion status after its bitter civil war to complete independence. Others, however, rejected the protectionist economic stance of empire trading. In July 1929 Lord Beaverbrook founded the Empire Free Trade Crusade, a political party that sought to topple the Labour minority government elected that year and Conservative leader Baldwin, who both sought to continue imperial protectionism. Briefly Beaverbrook's group allied themselves with Lord Rothermere's United Empire Party, which sought to glue the disintegrating empire together.

Five of Brangwyn's completed Empire Panels were displayed in situ at the Palace of Westminster in spring 1930 but the Fine Arts Commission judged them unsuitable for the Pugin setting and in a room containing Daniel

Maclise's Napoleonic frescoes. In a House of Lords debate the panels were rejected; Lord Iveagh had died in 1927, and with him went the political will to see them installed. But by now the whole view of empire had shifted amid suggestions it was potentially unprofitable to Britain, and an institution that need not necessarily be governed from the centre. Dismayed, and caught up in forces greater than art, Brangwyn nevertheless completed the set of panels, paid for by Lord Iveagh's son. Their cause was taken up by Lord Rothermere, and the work was incongruously displayed at the Daily Mail 1933 Ideal Home Exhibition. Brangwyn's message suited Rothermere's agenda but the panels attracted little comment outside his own newspaper. Despite overtures to the Tate Gallery, they were eventually presented to the City of Swansea, itself an irony in view of Plaid Cymru's foundation in 1925 and its calls for total independence from England.

FURTHER READING

L. Horner and G. Naylor, *Sir Frank Brangwyn 1867–1956*, exh. cat., Leeds City Art Gallery 2006.

F. Rutter, *The British empire panels designed for the House of Lords by Frank Brangwyn R.A.*, London 1933.

75 FRANK BRANGWYN
British Empire Panels c.1930 (detail: centre upper panel, north wall of the Brangwyn Hall, Guildhall, Swansea)
610 × 400 (240 × 156)
City and County of Swansea: Glynn Vivian Art Gallery Collection

The Persistence of Realism in British Painting

TIMOTHY HYMAN

When, in the 1930s, Stanley Spencer declared, 'I am on the side of angels and dirt', he was making a conjunction very characteristic of British Art. A refusal to separate high art from low life is part of the impulse we call 'realism', from Caravaggio to Gustave Courbet, and for Spencer 'dirt' signifies here all those humdrum, lowly, generally unregarded objects he wants to depict even in the most exalted chapel or public space. For several of the most rewarding British painters, a continuing devotion to the matter-of-fact would put them on a collision course with the dominant Anglo-American critical establishment throughout the twentieth century.

John Ruskin famously defined the Pre-Raphaelite project as 'absolute uncompromising truth', but even painters as French-oriented as Sickert and the Camden Town Group also held closely to the specifics of observation, fore-grounding the grimy and banal. Henry Tonks (1862–1937), chief drawing teacher at the Slade when Spencer arrived there, articulated his own commitment to the commonplace: 'Why I hate Post-Impressionism or any form of subjectivity, is because they and its followers, do not see that it is only possible to explain the spirit so long as we are in the world, so that the painting of an old mackintosh ... very carefully and realistically wrought, may be much more spiritual than an abstract landscape.'

But Spencer did learn from Roger Fry's 1909 Slade lectures, and that fusion of French moder-nity with Giotto's blockish forms is evident in all his fellow 'neo-primitives' – William Roberts, Mark Gertler and Christopher Nevinson – as well as in Spencer's own *John Donne Arriving in Heaven* (private collection on loan to The Fitzwilliam Museum, Cambridge), recruited by Fry for his second Post-Impressionist exhibition in 1912.

In the years immediately after the war, from about 1919 to 1923, as many as ten painters would meet each week at the house of the Carline family in Hampstead: Spencer and his brother Gilbert, Paul and John Nash, Henry Lamb, Roberts, Gertler and Nevinson, as well as the Carlines themselves. All would have conceived themselves as 'modernists', yet also (like so many of their European contemporaries) as 'reconstructors'. After the smash-up of war, after the fragmentations of Cubism, the whole-ness of the image must again be retrieved. Their shared idiom was not as verist as that of the Neue Sachlichkeit painters in Germany, nor as idealized as Diego Rivera, Carlo Carrà or Fernand Léger in the same years, but it does convey a similarly renewed belief in the object. For Spencer, especially, completing his anti-heroic war murals at Burghclere chapel, something of a 'Tonks's mackintosh' ethos resurfaced, rather to his dismay. As he wrote in 1926:

I feel, really, that everything in one that is not vision is mainly vulgarity ... I quite agree (damn it) that my John Donne's [sic] are infinitely preferable to my landscapes ... It's awful after four years at the Slade to find oneself not in possession of an imaginative capacity to draw, but to find instead that one has contracted a disease.

In the 1930s Spencer's art would indeed become split, between compositions of 'vision-ary' and often grotesque figures and ever more meticulous and diligently 'realistic' local land-scapes. Not surprisingly, this espousal of what might be described as 'Insignificant Form' seemed intolerable backsliding to Roger Fry, who in 1932 confided to Spencer's future nemesis, Patricia Preece, 'I am sick of his muck'. Yet the naked portraits of Preece painted between 1935 and 1937 would go far to vindicate Spencer's indiscriminate seeing. He likened the slow move-ment of his brush to an ant crawling over every inch of the skin; in the Tate's astonishing *Double Nude Portrait: The Artist and his Second Wife (Leg of Mutton Nude)* 1937, Spencer squats naked before the altar of an uncaring Patricia, and the intensity of detail makes the unidealized flesh shockingly present. In *Hilda, Unity and Dolls* (Leeds Museums and Galleries; fig.76), painted some five months later, an apparently 'straight' and objective depiction again achieves a startling psychological disclosure. Completed over a ten-day visit to Hampstead, it shows his first wife Hilda Carline with his younger daughter. Spencer wanted to recommence the marriage following Preece's return to her lifelong partner Dorothy. We are pushed into close intimacy with the child's intent gaze, while the adult looks wearily away, and the blind-eyed dolls, one of them thrashing terribly about, seem auguries of defeat. As in the Tate *Nude*, the different elements must have been painted in separate sessions, then spliced together.

In the same year the young ex-Slade painter, William Coldstream – who was also a student of Tonk – wrote in *The Listener*: 'The 1930's slump affected us all very considerably ... It seemed to me important that the broken communication between the artist and the public should be built up again, and that this probably implied a move-ment towards realism.' Coldstream's was an empirical truth-to-perception, free of metaphor and metaphysic; what Lawrence Gowing, his most eloquent associate, would term 'Representation-as-such'. (The philosopher A.J. Ayer once declared Coldstream 'the only logical positivist I know'.) The characteristc measuring of the Euston Road painters could become a system of lyrical disillusionment. The pursuit of "objectivity" would inspire painters as various as Victor Pasmore and Euan Uglow (1932–2000), as well as the writing of Adrian Stokes; but by the 1960s the Euston Road persuasion had dwindled to something of an art school sect, to be largely swept away (along with most of the other British 'realisms') by the all-conquering tide of New York Abstraction. In 1954 Clement Greenberg had declared, 'Abstraction is the major mode of expression in our time; any other mode is necessarily minor.' The Tate's acquisi-tion of Spencer's *Double Nude Portrait* in 1974 came at a significant moment: one of several rediscov-eries that signalled to a new generation the possibility of a fresh realist project, a retrieval of the depicted world made not naively, but in full awareness of modernist achievement.

FURTHER READING

J. Clair (ed.), *Les Réalismes 1919–1939*, exh. cat. Centre Pompidou, Paris 1980.
J. Hyman, *The Battle for Realism*, New Haven 2001.
T. Hyman and P. Wright (eds.), *Stanley Spencer*, London 2001.

76 STANLEY SPENCER
Hilda, Unity and Dolls 1937
Oil on canvas 76.2 × 50.8 (30 × 20)
Leeds City Art Galleries

Edward Burra's *Harlem*

ANDREW STEPHENSON

Edward Burra's fascination with the vibrant street life of New York focuses upon the distinctive elevated railways, the rows of brownstone houses and the multicultural communities of the rapidly growing and racially mixed inner-city neighbourhoods of Harlem and Spanish Harlem. Completed in 1934, *Harlem* derives from Burra's journey to the United States from October 1933 until March 1934, when the artist stayed at 1890 7th Avenue in Harlem with the British society photographer Olivia Wyndham and the well-known African-American actress and bisexual celebrity Edna Thomas, then pioneering the revival of Black theatre at the Lafayette Theatre in the neighbourhood. From the end of 1933 Burra's close friend, the ballet dancer and choreographer Freddie Ashton, was also in New York working on Virgil Thompson's all-Black production of Gertrude Stein's opera *Four Saints in Three Acts*. Early in 1934 the artist moved to 125 East 15th Street on the Lower East side and Burra, in his inimitable helter-skelter prose, recorded the excitement of nightlife in Greenwich Village and Harlem:

> We visited a few hot spots one in the village which was camp lovely my dear ... then we went to the Savoy and to Hot Cha ... where a shame making man sat down at the table and burst into La Paloma ... then we went to an underground graveyard called the log cabin my favorite resort.
> (Letter to William Chappell, 3 January 1934, W. Chappell (ed.), *Well Dearie! The Letters of Edward Burra*, London 1985, pp.84–6.)

Such venues attracted a young, socially fluid and racially mixed audience that incorporated cosmopolitan theatrical circles and embraced homosexual sub-cultures. The Savoy Ballroom, situated on Lenox Avenue was famous for its enormous dance floor, big-band jazz and gala drag balls. The piano bar Hot Cha located at 132nd Street and Seventh Avenue drew in a sophisticated crowd of bohemian black gay men. And the Log Cabin Grill at 168 West 133rd Street was celebrated for its blues singers, notably Billie Holiday, and infamous for its smoke-filled atmosphere of marijuana and smell of hog maw.

Nevertheless, *Harlem* offers up a more sophisticated construction of urban culture than might at first be apparent. What is evident is that Burra valorized the pace and distinctive forms of contemporary American street culture and he celebrated its modern boulevardiers. First, *Harlem* accentuates the urbane and sartorial creativity of African-American and Hispanic American style. Trends in fashion such as the polo-neck sweater, the flat cap, the fedora hat, the trench coat and the racoon coat are carefully documented. Details of hairstyles, expressions and gestures are keenly noted as key signifiers of that communal vibrancy enthusiastically promoted by Harlem intellectuals and fostered by its creative institutions. Celebrating such diversity, Burra's approach aligns with the interest in African-American culture signalled in Nancy Cunard's anthology *Negro*, also published in 1934.

Second, *Harlem* testifies to Burra's enduring fascination with interracial sexuality registered by the distinctive erotic appeal of the Afro-American male depicted in the foreground. Characterized as a figure set firmly in opposition to conventional white middle-class English masculinity, he was erotically inscribed by popular associations that positioned the black dude in the context of his hip outsiderness. Some of these understandings were drawn from the novels of Ronald Firbank (*Prancing Nigger* of 1924) and Carl Van Vechten (*Nigger Heaven* of 1926). Other characteristics were derived from contemporary illustration, particularly the 'New Negro types' of Miguel Covarrubias reproduced in popular magazines. Covarrubias also designed the sets for *La Revue Nègre* in which Josephine Baker first performed in Paris in 1925, a role that reinforced European conceptions of the highly sexualized nature of black performance. If this approach corresponded to a trope of negrophilia in currency amongst white American and European intellectuals in the 1920s and 1930s, who mythologized Harlem as a hedonistic, bohemian playground associated with the vogue for the 'New Negro', it was simultaneously marked by an infatuation with black rhythm, spontaneity and sexuality celebrated in dance, jazz and blues music (Burra collected recordings of Bessie Smith, Ethel Waters and Billie Holiday).

Whilst it is important to recall that for many intellectuals in the early 1930s, Harlem held the potent promise of a new black-inspired cosmopolitanism that was socially and sexually fluid, its vitality was also subject to broader socio-economic factors. Highlighting the signs of urban waste and depicting unemployed men congregating on street corners and steps outside tenements, *Harlem* references the devastating impact that the Depression (following the Stock Market Crash in 1929) was having upon such communities. Nevertheless, Burra's art was transformed by his encounter in 1933–4 with this African-American and Hispanic American cultural fluorescence. Accentuating New York's cultural diversity and distinguished by a vital interaction between social life and subculture, *Harlem* celebrates this sophisticated jazz-age culture in which black creativity and sexuality generated compelling music, provocative performance and dance, hip fashion and cool street style.

FURTHER READING

P. Archer-Straw, *Negrophilia: Avant-Garde Paris and Black Culture in the 1920s*, London 2000.

A. Causey, *Edward Burra: Complete Catalogue*, Oxford 1985.

N. Cunard (ed.), *Negro: An Anthology*, New York 1933, reprinted 1970.

J. Skipwith (ed.), *Rhapsodies in Black: Art of the Harlem Renaissance*, exh. cat., Hayward Gallery, London 1997.

J. Stevenson, *Edward Burra: Twentieth-Century Eye*, London 2007.

77 EDWARD BURRA
Harlem 1934
Brush and ink and gouache on paper
79.4 × 57.1 (31¼ × 22½)
Tate. Purchased 1939

The International Exhibition of Surrealism

MATTHEW GALE

The *International Exhibition of Surrealism* that ran at the New Burlington Galleries in London between 11 June and 4 July 1936 was a watershed in the series of exhibitions mounted by the movement. It raised the ambition of their exhibitions to new heights, succeeding in marshalling no less than 360 artworks by fifty-eight contributors from eleven countries. Curiosity about the movement – stimulated by press stories such as Sheila Legge's appearance in Trafalgar Square as a *Surrealist Phantom* with her head entirely covered in roses – attracted 25,000 visitors. Such a level of interest, even if many came to be amused, had been unmatched in the dozen years since André Breton had founded the movement in Paris with the publication of his *Manifesto of Surrealism* in 1924.

One of the most pressing issues within the French group by the early 1930s was the nature of their political commitment to the left: essentially, whether or not they could be reconciled with the restrictions of the Stalinist French Communist Party. In the summer of 1936 the suicide of the Surrealist poet René Crevel, in despair at this disparity, signalled that they

could *not*. This isolation became more acute with the apparent rise in Fascism, seen in the Italian invasion of Ethiopia in June and the outbreak of the Spanish Civil War in July. However, it was not politics or even poetry, but the visual arts that dominated the growing international reach of Surrealism. In his preface to the London exhibition catalogue Breton claimed, in characteristic style: 'The only domain that the artist could exploit became that of purely mental representation, in so far as it extends beyond that of real perception, without therefore becoming one with the domain of hallucination.'

As well as Breton's desire to annex Picasso to the movement, Surrealism had attracted such leading artists as Man Ray, Max Ernst, Joan Miró and René Magritte. However, their mastery of showmanship may be attributed to the arrival of Salvador Dalí in 1929. At a stroke, he and Luis Buñuel transformed cinema through their groundbreaking film *Un Chien andalou*. In Dalí the movement gained its most assiduous, if occasionally hysterical, (self-)promoter, and his genius for attention-grabbing was characterized

by his 1 July lecture at the London exhibition, remembered not for its subject ('Authentic Paranoiac Phantoms') but his appearance in an air-tight diving suit. When he began to gesture that he was suffocating, the audience believed, as he later recalled, 'that all this was part of the show ... extremely amused at the pantomime that we were playing so realistically' (Dalí 1948, p.345). Already the strains between Breton's seriousness and Dalí's tendency towards hallucination were evident and, even though the painter had come to embody Surrealism, he was expelled in 1939.

If a partially asphyxiated painter helped to draw the London show to a close, the appearance of the exhibition itself was innovatory. The selection had been made in Paris by Breton and Paul Eluard, and in London by Roland Penrose and Herbert Read, but the way in which the works were displayed was revised, at the last minute, by Penrose and the Belgian Surrealist E.L.T. Mesens. They based their scheme on disparity: large works were set against small, abstract against illusionistic, with sculptures and African masks interspersed. As well as subverting the incoherent aesthetic of bourgeois interiors, this approach asserted the movement's control over the way in which the art was experienced and undermined the hierarchies of order and rationality that were to be expected in art galleries. By immersion in the experience, the viewer could absorb the Surrealists' interest in dream, the unconscious and the importance of the irrational. This level of control, first tested in the London show, established a pattern for subsequent Surrealist exhibitions.

Up to that point responses to Surrealism in Britain had been rather sporadic. It was seen in Paul Nash's *Unit One* (1934), the Cambridge *Experiment* group and individuals such as the poet David Gascoyne and the artist Julian Trevelyan (1910–88), as well as small exhibitions at the Mayor Gallery and Zwemmer Gallery in London. A number of significant figures, including Nancy Cunard and Roland Penrose, were close to the Parisian group and helped to carry the ideas across the Channel (fig.78). Lacking a British

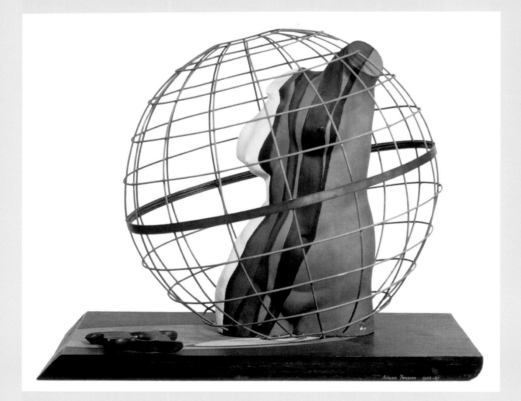

78 ROLAND PENROSE
The Last Voyage of Captain Cook 1936–67
Painted wood, plaster and steel
69.2 × 66 × 82.5 (27¼ × 26 × 32½)
Tate. Presented by Mrs Gabrielle Keiller through the Friends of the Tate Gallery 1982

group, however, the London exhibition was conceived more like an act of colonization for which special attention was needed. It is notable that Breton was simultaneously trying to resist the Museum of Modern Art's *Fantastic Art, Dada and Surrealism* exhibition that would take Surrealism to New York that December, precisely because its organization was outside the control of the movement. As if to emphasize this distinction more acutely, the next *Exposition internationale du surréalisme*, held in Paris in January to February 1938, was an extraordinarily complex installation, involving darkened spaces, recordings of laughter and a disorientation only hinted at in London eighteen months before.

Although Herbert Read was much criticized for tracing antecedents in a British tradition of fantasy – from William Blake through Edward Lear and Lewis Carroll – the *International Exhibition of Surrealism* in London allowed for the rediscovery of strata of suppressed

experience. On visiting to deliver a lecture the poet Paul Eluard sensuously discovered his ideal female type in Edward Burne-Jones's *King Cophetua and the Beggar Maid* in the Tate Gallery, reflecting a Surrealist rediscovery of what they saw as the delirious aspect of Pre-Raphaelitism. The exhibition became a catalyst for such reassessments, as well as for the founding of the Surrealist-orientated London Gallery, the accompanying *London Bulletin* and the (fractious) British Surrealist group, best known for its stand against Fascism and appeasement. It is difficult, now, to grasp the overbearing structures that Surrealism undermined, although in observations like 'when I was a debutante, I often went to the zoo' (Carrington 1989, p.44), the painter Leonora Carrington (b.1917), who was drawn to the movement as a result of the exhibition, captures and subverts them with admirable concision.

79 ANON
View of *International Surrealist Exhibition*
1936
Tate Gallery Archives

FURTHER READING

L. Carrington, 'The Debutante', in *The House of Fear: Notes from Down Below*, London 1989.
S. Dalí, *The Secret Life of Salvador Dalí*, trans. H.M. Chevalier, London 1948.

The Art of the Second World War

VIRGINIA BUTTON

Writing shortly after the Napoleonic Wars, visionary artist and poet William Blake declared: 'Rome and Greece swept Art into their maw and destroy'd it; a Warlike State can never produce Art. It will Rob & Plunder & accumulate into one place, & Translate & Copy & Bury & Sell & Criticise, but not Make' (D. Erdman [ed.], *The Complete Poetry and Prose of William Blake*, New York 1988, p.270). Yet during the Second World War (1939–45) the arts in Britain flourished, playing a crucial role in boosting morale and defining a national cultural identity, which functioned as part of a defence mechanism against external threat.

With the outbreak of hostilities and the rapid subordination of civilian activities to the war effort, pre-war debates about the validity of abstraction versus Surrealism were superseded by the pressing need for cultural unity. In the early months of the war a Mass Observation survey reported that the word 'black-out' had come to symbolize the shut-down of civilization. By early 1942 the infamous Baedeker air raids on Britain's historic cities were a clear indication

that the enemy was intent on the destruction of Britain's culture as well as its docks, factories and homes. Initially dismissed as an elitist luxury, the arts rapidly came to embody what Britain was fighting for.

Standing alone against Fascism, 'island fortress' Britain drew strength from perceptions of national cultural identity that had been developing during the 1930s. By the early 1940s, Neo-Romanticism, based largely on the idea of a heightened emotional response to Britain's land and its history – epitomized by such works as Graham Sutherland's *Black Landscape* 1939–40 [fig.80] and John Piper's *Seaton Delaval* 1941 [Tate, London] – became widely seen as the flowering of a quintessentially British tradition.

Poetic, linear and expressive, Neo-Romanticism provided British artists with a valid alternative to the overbearing influence of Paris, pre-war centre of the avant-garde. Adapting the ideas of art historian Wilhelm Worringer, influential writers such as Herbert Read identified Romanticism as the true expression of the northern temperament. Such thinking both

enabled a revision of British art history and released contemporary artists from the perceived superiority of the French-inspired idea of 'plastic values' that had dominated British art for thirty years, thanks largely to the writings of Clive Bell and Roger Fry. As British troops were liberating Europe, so British art was liberating itself from what were regarded as oppressive foreign influences.

Looking to the Romantic movement of the early nineteenth century for inspiration, Neo-Romanticism indulged fantasies of a lost golden age. But despite its preoccupation with the past, like its nineteenth-century precursor it celebrated the notion of the rebellious, free-spirited individual. As the 'reality principle' took hold, Neo-Romantics gave audiences licence to dream, to value the inner life of the imagination. With its emphasis on the freedom of the individual it came to embody the ideals of British liberal culture, now threatened with extinction by totalitarian forces.

Despite the war, artists continued to pursue a diversity of styles and subjects. However, it was

80 *left* GRAHAM SUTHERLAND
Black Landscape 1939–40
Oil and sand on canvas
81 × 132.1 (31⅞ × 52)
Tate. Purchased 1980

81 *above* GRAHAM SUTHERLAND
Devastation 1941: An East End Street
1941
Crayon, gouache, pen and ink,
pencil and watercolour on paper
64.8 × 110.4 (25½ × 43⅞)
Tate. Presented by the War Artists
Advisory Committee 1946

difficult for any artist to earn a living without the support of the Ministry of Information's War Artists Scheme (WAS), administered by the War Artists Advisory Committee (WAAC). A frequent criticism of official war art was that it conveyed little sense of emotional engagement with the tragic, heroic and dramatic subject of war. For critic Raymond Mortimer, writing in 1941, the entire WAS had been justified by the work of a few artists, particularly Sutherland and Henry Moore, who had responded to the war with an appropriate intensity of feeling. Through their work, he concluded, 'a posterity at peace will be able to learn not what we see but what we dimly yet profoundly feel' (Mortimer, 'The English School', in *New Statesman and Nation*, 16 Aug. 1941, p.158).

The sense of foreboding suggested by Sutherland's pre-war landscapes found full expression in his responses to the effects of bomb damage in London (*Devastation 1941: East End Street* 1941; fig.81). Henry Moore's images of Londoners taking refuge in underground

stations came to symbolize the heroic stoicism of the British people under siege. Yet, far from presenting comforting images of cheerful cockneys making do, they often evoke death and entombment, with bodies swathed in cloth or laid out in tomb-like tunnels (*Tube Shelter Perspective* 1941).

As imaginative and personal responses to momentous events, Neo-Romantic art was singled out as fulfilling the weighty demands made on art at that time: to express individual liberty, pathos and drama, to appeal to and sustain a wide and beleaguered audience, and most of all to define Britain's sense of itself at a time of mortal danger.

FURTHER READING

V. Button, 'The Aesthetic of Decline: English Neo-Romanticism c.1935–56' unpublished PhD thesis, University of London 1991.
D. Mellor (ed.), *A Paradise Lost: The Neo-Romantic Imagination in Britain 1935-55*, exh. cat., Barbican Art Gallery, London 1987.
A. Ross, *Colours of War: War Art 1939–45*, London 1983.

3 Conservatism and Class Difference in Twentieth-Century British Art

JULIAN STALLABRASS

Wyndham Lewis:
'A 1000 mile long, 2 kilometer deep body of water even, is pushed against us from the Floridas, to make us mild.'[1]

François Jonquet to Gilbert & George:
'I can't understand how you can be conservative and at the same time avant-garde.'[2]

IT IS A COMMONPLACE that twentieth-century British politics were mild and compromising, untroubled by the extremes that wracked the other major European powers. Alone amongst them, Britain suffered no abrupt transformation of its politics by revolution, coup or invasion. While the components of its political compromise certainly changed, no major challenges from Right or Left found success, and for most of the period lacked any prospect of success. Another piece of received wisdom is that (variously) avant-garde and modernist art were regularly associated with radical, and indeed revolutionary, politics. Here, Britain again seems to be an exception: its vanguards and modern movements were generally politically muted affairs, and those that took up radical political positions in art often did so against modernism and avant-gardism. There was no British equivalent of French Surrealism, with its attempts to engage with the Communist Party, for example, or of the entire model of avant-garde activity emulating the political vanguard (and Breton's attempt to push the British Surrealists into an alliance with Trotskyism was met with pragmatic silence [see Gale, pp.116–17]).[3] Nor was there an equivalent of Hannes Meyer's Bauhaus programme, let alone of anti-aesthetic Soviet Constructivism (it was rather the prettified, liberal version of that movement, stemming from Naum Gabo and Antoine Pevsner [1884–1962], that was embraced in Britain). Equally, it is difficult to find Continental figures in the visual arts who resisted modernism with as much prominence and popular success as Stanley Spencer, David Hockney or Gilbert & George (see Stephens, pp.24–6).

My subject here will be the middle class in British art, its depictions of itself and others in class terms, and how those factors changed as the fortunes and composition of the classes changed. The focus on class difference provides a particular perspective on British art but necessarily means playing down work that had definite political orientation although it did not directly represent class – including various forms of abstraction and conceptualism. It also provides a particular focus on class politics that tends to underplay the rapidly changing factors of race, gender and sexual preference. I can only say that readers should bear

these deficiencies in mind, and I hope that the benefits of this particular focus warrant them: after all, following a great deal of salutary restorative work since the postmodern turn, class is once more (as it was before the development of Marxism) the most neglected of these elements. Following the logic of its subject matter, this piece is not a survey; there will be an uneven attention, too, on those periods where class conflict, political dissent and controversy was most in evidence – particularly the period prior to 1914, the 1930s and the 1970s onwards.

The essay's scope is set by two moments, both political and artistic, that coincide. Politically, it ranges between the 'strange death of liberal England' just before the First World War, which produced long periods of Conservative dominance in the inter-war and post-war periods, and the 'strange death of Tory England' in the 1990s precipitated under the Major regime.[4] Artistically, these moments correspond to the rise of the first radical and self-conscious avant-gardes in British art, of contrasting political inflections – Bloomsbury and Vorticism; and the apparently definitive surrender of avant-garde functions (if not the ghost of its form) in the conservative populism of 'young British art'.

Between these two moments class as expressed in British art has been governed by the various cycles that affected social life as a whole – economic, political and technological. The regular pattern of boom and bust that characterized much of this period produced in art many similar, repeated characteristics of reaction that echoed across the decades. Recessions, including those in the 1930s and 1990s, focused art-world attention on British matters, and both were accompanied by widespread complaints about the indignities undergone by artists in adapting to their straightened circumstances. In the 1930s slump many railed against the overt commercialization of art, deteriorating standards, and about artists who were more concerned with marketing than the inherent qualities of their art.[5] These writings resonate with judgements made about 'young British art' in the 1990s (see Gallagher, pp.230–1). The prolonged periods of Tory rule, punctuated by Labour administrations that regularly disappointed their

radical supporters, gave rise to similar patterns. The rise and assimilation of various technologies of visual cultural production and reproduction, notably photography, cinema, television, video and the Internet, brought about reactions of embrace and resistance, connected with the economic and political cycles. The slow adoption of new technologies in the British art world, particularly when compared to Germany and the US – photography being a notorious case – was linked to a widespread middle-class suspicion of industry and its products.[6]

Another way to characterize this period is to say that it was a time of middle-class dominance of politics, marked by the reduction of the Lords' powers in 1910 and expressed in the long periods of Tory government. The middle class steadily increased in numbers throughout the period, especially between 1920 and 1950, and in the process became increasingly technical and scientific in character.[7] More specifically, this renewed Toryism was founded on the growth of a salaried professional class, a class that had risen from insignificance in the middle of the nineteenth century to dominate the middle class by 1914. For Harold Perkin that rise was based on 'human capital' created by state-supported school and university education, and it was fuelled by the needs of the expanding state and empire, by the need to administer large cities and cater to the intellectual needs of a national population increasingly aware of itself as a politically constituted body.[8] The period also saw the steady decline of organized religion, and with it the removal of one of the great divides in the middle class as the importance of the gulf between the Church of England and Nonconformists fell away.[9] Near the beginning of our period – in 1918 – Britain became what we would now recognize as a functioning democracy, as the franchise was extended from male house-holders to all males over twenty-one and all women over thirty (women were to gain equality in this ten years later). The electorate was tripled in size, and working-class power first found full parliamentary expression So this is also the period of variable pressure from the organized working class over middle-class hegemony. That pressure and the resulting effects on the depiction of class difference will be examined here. Again, Britain is exceptional within Europe: while in the inter-war period working-class power was successfully shut out of mainstream politics by diverse methods in France, Germany and Italy, in Britain it achieved a degree of integration.

Another important feature in Britain's stability was that between the wars the working class remained split in political allegiance, a large section of it voting Tory (again, a factor unique in Europe).[10] Until the late 1970s its elites of all political persuasions settled on favouring social calm over headlong modernization and growth. This policy was deeply reflected in the middle-class culture of much of this period (so compellingly described by Ross McKibbin); given the social stresses engendered by increasing mobility, the response was the development of a conversational culture that valued humour and politeness, and abjured divisive talk about religion and politics (and with it large tracts of intellectual debate *tout court*).[11] Walter Sickert, writing of his time in France where fellow painters had discussed with as much clarity as they could muster the defects of his painting, noted with exasperation the contrast with London where friends were judged according to whether they were 'nice about' one's work.[12]

There were artists who reacted violently against the culture of conciliation and its mores, but they were exceptions; and, while many artists lived bohemian existences of which the middle class hardly approved, they internalized many of its values. This essay will attempt to lay out the middle ground of political, social and artistic conservatism, and will juxtapose it with a few of the exceptions, from Right and Left, usually isolated figures, who attempted to oppose it. Much of the radical opposition was oriented romantically to the past rather than the future, to various forms of prelapsarian and often rural community. For Peter Fuller (whose moralistic writing had a sway in the 1980s, which from this historical distance is difficult to imagine) such conservatism was the strength and very identity of British culture: 'real achievement in British art has, again and again, been bound up with a certain fidelity to a prior, conservative tradition and with informed refusals, reticences, and reluctances in the face of the modern world.'[13]

Perry Anderson and Tom Nairn's historical and theoretical accounts have been among the most influential attempts to explain British mildness in politics, and lack-lustre economic performance following the middle of the nineteenth century. They point to the incomplete character of the bourgeois revolution in Britain, which left royalty and aristocracy in place.[14] Britain developed a capitalist class but it was less than fully bourgeois, with its large admixture of aristocracy and gentry. Moreover, successful bourgeois entrepreneurs absorbed aristocratic ideals and

vigorously pursued ennoblement. Another way of putting this is to say that only in Britain was industrialization an indigenous process (rather than imported in an already developed form), and as such it was necessarily more closely tailored to existing social structures.[15] The ideals of the ruling elite remained rooted in aristocratic culture and the rural idyll. Martin Wiener in his analysis of English resistance to industry and commerce, founded on the work of Anderson and Nairn, points to (among many symptoms) the rural location of the most prestigious public schools, the long-held-to freedom of their curricula from any taint of science or practical utility, and their aspiration to prepare for the world not industrialists but soldiers, politicians and civil servants – the people needed to run the empire.[16]

Recent accounts of British modernism have tended to claim either that it was not as timid as the standard histories (particularly that of Charles Harrison, see, for example, pp.38–64) suggested, or that to reduce the history of British art to modernism is to lose sight of its varied riches and particular character.[17] Both positions, while valuable in themselves, lose sight of the signal fact that British modernism was far less radical than that of France, Germany or Russia – a matter that is inextricably connected to politics and demands explanation. Perry Anderson describes the parameters that sustained modernism in terms of the following tensions, within which it operated: semi-aristocratic ruling orders, and with them a still current classical tradition to be rebelled against; semi-industrialized economies, against which new technologies stood out as genuinely novel, offering unexpected and unknown opportunities; and semi-emergent and insurgent labour movements, which could similarly be the repository of ideal political visions.[18]

If we take the classic case of France, it is apparent that all were powerfully in place – as Anderson points out, the modernism of Proust took its stand against a still poignantly felt classical culture; France's industry was highly concentrated in small points against an ancient agrarian backdrop; labour was unpredictably rebellious and from the 1920s sustained a large Communist Party. Using these parameters to think about the relative weakness of British modernism produces a strikingly different picture. While the semi-aristocratic ruling orders were still strong (and their culture nurtures the classically informed modernism of Eliot and Pound), the other factors were weaker. As the oldest industrial nation, Britain was highly familiar with

the benefits and costs of industrialization, and many of its politicians sought to rein them in. This was the basis on which Wyndham Lewis mocked the Italian Futurists, open-mouthed at their newly mechanical world ('Elephants are VERY BIG. Motor cars go quickly').[19] The British labour movement following the First World War was highly unionized, and was (generally) pragmatic and materialist in its aims. Naturally, then, the romance of the machine was less strongly felt than in Germany, France or Italy, as was the plausibility of looking to the working class to lead a fundamental revolt against capitalist society and culture.

More than that, the old order persisted and modernized itself. As McKibbin puts it, the monarchy more than survived: borne by radio and television, it strengthened its hold on the public imagination, becoming more ceremonial, glamorous and at the same time domestic.[20] In the public mind, the monarchy's role in both world wars sealed it to the fate of the nation as a whole. Monarchs shared the aims of moderate conservatism, doing nothing in word or deed to alienate the Labour movement.[21] Up until 1939 an aristocratic world of 'Society' brought together the worlds of fashion, learning, politics, sport and the arts in a mix that was not found in Continental Europe.[22] That world legitimated itself in the public eye, through the constant attention of the mass media, by its glamour, veneer of modernity and Americanization, though it remained deeply conservative in outlook.[23] After the Second World War much of that public role devolved upon the royal family alone.[24] Aristocratic culture, then, survived at the price of steeping its traditions in the media world, where they were radically transformed.

Anti-industrial and anti-entrepreneurial attitudes stimulated by the industrialization of the country increased in strength during the relative downturn in Britain's economic fortunes in the latter half of the nineteenth century.[25] Stanley Baldwin's claim in 1926, of one of the world's most urbanized nations, that 'England is the country and the country is England' was, says Wiener, already a cliché, and the general view of the English character was that its innate conservatism had tamed 'the dangerous engines of progress' unleashed by industrialization.[26] Indeed, Baldwin saw his priority not as wealth creation or reducing unemployment but as the protection of British institutions from extremism.[27] In this aim he was successful – the Labour Party was absorbed into mainstream politics and class war was averted.[28] His regime also saw the beginning of peacetime

state management of the economy, in which unrestrained competition was opposed by the encouragement of cartels and price-fixing, to the same ends of social pacification.[29]

Wiener argues that the increasing professionalization of the middle class, relying on their regular salaries and predominantly providing services, distanced them from the mindset of the industrial capitalist.[30] It was not that all or even many artists, and certainly not those of the avant-garde, were straightforwardly middle class in these respects – indeed, with few exceptions, their life experiences were quite different. Far from being salaried and expecting slow and predictable advancement, their income was irregular and precarious. Far from conforming to middle-class moral expectations, many led a bohemian existence garnished with casual sexual encounters – and this often got them into trouble at just the points where their lives intersected middle-class convention. John Skeaping in his charming if typical memoirs, recounts being ostracized by his parents following the break-up of his marriage to Barbara Hepworth.[31] Nevertheless, artists' origins and upbringing were generally middle class through most of this period (and could hardly be otherwise, given the systematically poor economic prospects of artists), and they generally served the middle class.[32] In that sense there is a variable relation across the period between artists and that class, which can be tracked in part through an analysis of class difference in their work.

As Barnaby Wright has argued, there was an unstable aspect to artists' attitudes to middle-class professionalism. Insofar as they wished to portray their activities as transcendent or redemptive, the idea that they constituted a profession was harmful. Yet, they also yearned for some protection from full exposure to market forces, and for that the exclusive status of the profession was useful.[33] It was pursued first of all through specific curricula in art training (initially at the Slade) and in the publication of art criticism in dedicated art journals.[34] In these terms even Bloomsbury's horror of the professional – and praise of the amateur, above all of Paul Cézanne – was ambivalent, founded on the offer to the public of an exclusive, quasi-professional service: the provision of unalloyed aesthetic feeling.[35]

Raymond Williams's analysis of the Bloomsbury Group as a progressive 'fraction' of the professional middle class does much to explain its prominent place in the British art world in the early twentieth century. Its composition, mostly Cambridge-educated, was that of the rising profes-

sional class, and many of the group had family links with colonial administrators.[36] Its members' stress on personal clarity and candour, and on rational self-realization, was directed against the starchier manners and vulgar instrumental concerns of their elders.[37] Its relation to the working class was one of clear separation, along with concerted charitable efforts to improve their lot.[38] Roger Fry believed that class difference brought about a good deal of snobbish pretence in art appreciation, and that a classless society might encourage a more rational approach to art.[39] But that was far in the future; those courting Bloomsbury's approval could be denied full entry on grounds of class: Janet Woolf, for example, has tracked Mark Gertler's social discomfort in Bloomsbury circles, and equally their distaste for him as the son of Jewish Polish immigrants.[40]

If there was no unified Bloomsbury outlook that cut across its various activities, this was because it was against such unifying schemes in principle, for they interfered with the sovereign development of the individual.[41] Of their extensive charitable and activist efforts, and of John Maynard Keynes's theories of state economic management, Williams comments: 'The governing object of all the public interventions is to secure this kind of autonomy, by finding ways of diminishing pressures and conflicts, and of avoiding disasters. The social conscience is, in the end, to protect the private consciousness.'[42] In this their aim was at one with Baldwin's, and it helped ensure Bloomsbury's long dominance of British art. Furthermore, part of what artists sold (increasingly to the professional middle class) was the very image of subjective autonomy, and of spiritual transcendence – the utopian image of anti-professionalism.

Yet economic circumstances could force a more overt professionalization on artists, as the slump did, taking them into commercial propaganda for companies such as Cadbury and Shell, and into interior design.[43] It led artists such as Paul Nash to rethink artistic competence in such a way as to encourage both state and business patronage.[44] Later it would move them to demand from the state various assurances for their support, through teaching, grants and other measures.

The immediate pre-war period has a number of features that mark it out from the long period of conservative pacification that followed: as George Dangerfield famously argued (from the standpoint of the 1930s, as another war loomed), there had emerged a number of serious perceived threats to democracy: a Tory army rebellion plotted over

the imposition of Irish home rule; the protests of the suffragettes, who took to widespread arson as well as their better-known window-breaking and hunger-strikes; and above all a unionized working class becoming aware of their power and, at least in some aspects, influenced by syndicalism, which saw ever-growing strike action as a means to effect a revolutionary transformation of society.[45] The 'Triple Alliance' of railway workers, miners and transport workers threatened severe disruption, and in the summer of 1914 delivered it. The general opinion in Europe was that Britain was in swift decline.[46] Furthermore, while the upper- and middle-class memories of that period are gilded, and that fondness reflects their genuine prosperity at that time, their increasing wealth was built on the declining income of the working class and fuelled the prospect of serious strife.

Further, since the last quarter of the nineteenth century, the nation had undergone a rapid and intense modernization, which (as Lisa Tickner notes) involved much technological change, increasing rationalization, secularization and fast imperial expansion. Typewriters, telephones, gramophones, electric lighting, motor vehicles, tube trains, the telegraph and even aeroplanes and airships were transforming everyday life.[47] Also slowly emerging at this time was a national awareness of the social state of the nation that went beyond statistics, and was expressed first in books with popular accounts of, say, slum life (read by slum dwellers themselves) and also in cheap newspapers, and then through the illustrated magazines in photographs.[48]

In reaction to such disorienting changes and social threats, many looked back longingly to a pre-industrial era. Among them were, of course, two of the most influential commentators on art: John Ruskin and William Morris. Ruskin, in recommending Britain's imperial leadership, was struck by the contrast between the grandeur of that role and the environment of the homeland itself: 'The England who is to be mistress of half the earth, cannot remain herself a heap of cinders, trampled by contending and miserable crowds' but must become happy, secluded and pure.[49] (In this passage Ruskin remained wholly innocent of the notion that the profits of empire helped fund the very domestic industrial development that he deplored, as well as manufacturing the necessary instruments of subjection to be used against populations near and far.) He explicitly recommended that industry be civilized by the ideals of the professions, using the clergy as his example.[50]

Ruskin was convinced that every failure in art was an ethical one, whether of an individual or a nation, and his characterization of the British was of a people governed by a senseless, dissolute and merciless quest for diversion: 'How literally that word Dis-Ease, the Negation and impossibility of Ease, expresses the entire moral state of our English industry and its Amusements.'[51] And indeed it was Ease that remained the personal ideal of the English gentleman, and the provision of something like it but on a larger scale, the preoccupation of governments.

Morris looked back to a faux-medieval craft ideal, and with similar intent. As Wiener points out in his analysis of the appeal and success of such positions, the subtitle to his utopian book *News from Nowhere* was *An Epoch of Rest*.[52] There are good Marxist reasons for Romanticism, since looking back to an era when the division of labour was less sharply enforced may also be a way of looking forward to a time beyond capitalism. In Walter Benjamin's *Arcades Project* just such a model is found, with a rehabilitation of ideal features of the past in the light of an imminent modernist future.[53] In Morris the ideal is of an autonomous creative labour in which all workers (and all will be workers) enjoy good living conditions, education and leisure time: 'what these three claims really mean is refinement of life for all; what is called the life of a gentleman for all.'[54] While Morris speculated in detail about the causes that would lead to capitalism's destruction, and foresaw a bloody reckoning between the classes, it was less clear how his particular vision of utopia would emerge from those struggles.[55] That deficiency, and the extreme character of Morris's vision, which sanctioned the extinction of every trace of modernity, allowed one sympathetic reviewer of *News from Nowhere* to state: 'we are not bound to consider *News from Nowhere* as a socialist guide book: let us consider it as a vision of the Promised Land.'[56] As Anderson argues, it was socialism's lack of political power in Britain at this time that encouraged radicals to speculate on improbable futures.[57]

Both Ruskin and Morris were of course complex and voluminous writers, whose views changed over their long careers; but what was most regularly taken from both was their ideal visions of quiet rural ease, and a matching aestheticism, which played to the establishment of deep English myths. That baleful influence was durable over Right and Left. When Peter Fuller and Toni del Renzio traded blows in an unintentionally risible battle over the

82 WALTER SICKERT
Off to the Pub c.1912
Oil on canvas 50.8 × 40.6 (20 × 16)
Tate. Presented by Howard Bliss 1943

true character of English art following the Hayward Annual in 1988, among the central bones of contention was the legacy of Ruskin – who for Fuller was the greatest exponent of the English Romantic aesthetic, and the cosh with which to put paid to weak and rootless English modernism.[58] In the mid-1980s, faced with the catastrophic effects of Thatcher's monetarist policies in deepening the recession, the Islington Communist Party distributed flyers with the remarkable slogan: 'William Morris was a Communist. Why not you?' – an appeal unlikely to play persuasively in the borough's fetid and desperate council estates.

In various forms this Romantic, anti-modernist attitude was prevalent through much of the period. Dangerfield expressed his amazement at the archaic character of the commercially successful 'Georgian Poetry' of the pre-war period: that these modern, young poets, among them Rupert Brooke, took refuge from the threatening twentieth century in the eternal English countryside,[59] and attached themselves to a socialism of 'a William Morris sort'.[60] There were painterly equivalents, particularly Augustus John, avant-garde in expressive style but conventionally transferring his bohemianism to the pastures, as he played at being a gypsy, travelling in a horse-drawn caravan (see

Stephens, p.100). The timing of these recreational com pensations was no accident: as Lisa Tickner points out, caravanning became popular just as transport was becoming motorized.[61] A connected point is made by Raymond Williams in his acute remark that there was an inverse proportion between the importance of the rural economy and the cultural importance of rural ideas.[62] In contrast to the US and Continental Europe, the English rural economy was inessential to the needs of the elite and had been allowed to wane. Depopulated, relatively free of threatening class antagonisms, the countryside was a blank canvas on which the fantasies of urbanites could be projected.[63] This fascination with an imagined ancient country life spread through the middle class after 1914. As Wiener puts it: 'Rarely had a triumphant class come into its own inheritance with more diffidence, more readiness to adopt as its own the values of the class it replaced.'[64] In these circumstances of a dominant rural ideal, artists' portrayals of the urban working class tended to views of their exotic and modern entertainments, accompanied by more intimate domestic scenes that played up the major and minor evils of impoverished city life.

Sickert, to take one example, was more interested in the atmosphere, light and patina of working-class or petit-bourgeois existence than in individuation; his is a psychology of pose not facial expression, of quiet boredom and implied anguish, or the aftermath of violence. The rationale for dealing with working-class subject matter was the impulse to realist story-telling, from which no subject should be ruled out, and it is true that Sickert's handling of paint and subject is similar when he depicts other social classes. In trying to describe the ideal practice of painting, Sickert writes of a fictional subject, a man of 'good breeding', standing and chatting in an English front room at tea time, from which he aspires to find not an individual subject but a combination of mood, pose and lighting that produce 'the quintessential embodiment of life', an 'Everyman'. He describes these elements as 'things of the spirit, phantom sensations built of dust and sunbeams, of personal sympathy and a light play of mood'.[65]

Yet, in works such at *Off to the Pub* class is central (fig.82). The male model for the painting was a petty criminal called Hubby who worked for a time as Sickert's model and dogsbody.[66] The interest here is in bringing an alien world of squalor, tedium and tension before a middle-class audience for painting. Artists waste their time dressing up

83 WYNDHAM LEWIS
The Crowd ?exhibited 1915
Oil and pencil on canvas
200.7 × 153.7 (79 × 60½)
Tate. Presented by the Friends of
the Tate Gallery 1964

working-class models as ladies and posing them in the studio, wrote Sickert; rather, let them 'climb the first dirty little staircase in the first shabby little house' and find the model's true significance in her kitchen or, better, her bedroom (see Corbett, pp.66–7).[67] As Richard Shone points out, Sickert's subjects are the melodramas of the music hall.[68] Only naively can they be seen as depictions of real life; rather they are pre-consumed fictionalized scenes transposed into paint for the delectation of a middle-class public (just as the demotic subjects of the young British artists, of whom Shone has written sympathetically, were drawn from television, movies and pop music).[69] Shone adds: 'Nothing we know of Sickert's character and views could lead us to suppose that he was motivated by a tender social conscience.'[70]

In the fervid, conflictual atmosphere of spring 1914 Sickert wrote: 'The artist can be no Liberal, no Socialist. He knows with Santayama [sic] that the Liberal ideal, "The greatest happiness of the greatest number" means "the greatest laziness of the lowest possible population".' Art's moral justification is to be found in setting an example of 'contented industry'. Such sentiments of indifference to social hierarchy were and are found regularly among artists and in the art world, and would be relayed decades later, by Francis Bacon, for example.[72]

At this point, in the period just before the outbreak of war, Wyndham Lewis found his brief success, as avant-garde art became momentarily fashionable, and he was courted by aristocratic society. As Tickner remarks, Futurism and its English variant brokered relations between avant-garde art and the aristocracy by transforming the artist into 'a sportsman-adventurer in the grip of technophiliac lust'.[73] Also (as Tickner further notes) this consumerism was fed by mingling the vulgar with the elite, mixing, as Lewis put it, gold with flint or glass, by loading the motifs of working-class entertainment into the vehicles of fine art.[74] Both Lewis's painting and his manifesto statements in *Blast* foster contradiction and play with the rhetoric of avant-garde excess, in a parody of Filippo Tommaso Marinetti: 'Curse abysmal, inexcusable middle-class (also Aristocracy and Proletariat).'[75] So Vorticism promised to fight on both sides at once.

It was at this point, too, that Lewis painted *The Crowd* (fig.83), the only large-scale Vorticist painting by him to survive and one plainly meant as a manifesto piece. Lewis's view of the working class (and of 'primitives' generally) was

deeply and self-consciously ambivalent. They were the prey of mechanical instincts, and their apparently free lives were spectacles 'as complete as a problem of Euclid'.[76] Lewis criticized the Futurist romanticization of the rioting crowd, and was always concerned with the danger of dehumanization, domination by mechanical instinct, the loss of individuality and with it creativity, on both a personal and a collective level. Paul Edwards points out that *The Crowd* is a riposte to Luigi Russolo's *The Revolt* 1911, in which red masses borne along by fiery diagonals break into the modern city.[77] In *The Crowd* the tiny dynamic elements are constrained by the severe city grid, and the flag-bearing revolutionaries, components of the grid and in places indistinguishable from it, are merely products of the system that they aspire to oppose.[78] Mass politics, with its vulgar, material ends will destroy the conditions under which creativity flourishes; in this (though the mode of expression could not be more different) Lewis approaches Sickert's blithe repudiation of liberalism and socialism.

At the same time, for Lewis the middle class was corrupted by excessive softness, romanticism, femininity, homosexuality and subjectivity, and primitive mechanical culture may be part of the antidote: 'WE NEED THE UNCONSCIOUSNESS OF HUMANITY – their stupidity, animalism and dreams. We believe in no perfectibility except our own.'[79] 'Our own' here is the cultural elite, threatened by Communism or even excessive democratic reform. Yet there is a dialectical relationship between the artist and the mass or the crowd: 'The only possibility of renewal for the individual is into this temporary Death and Resurrection of the Crowd.'[80]

The point of *The Crowd*, then, a perverse piece of pastoralism, is to bring to the corrupted middle class a vision of its own immersion in the mass, from which some redemptive quality (of modernist form perhaps, of willing adherence to the grid) may be snatched. Yet, despite the sophistication of Lewis's dialectical thinking, given the circumstances in which it was painted (of dangerously militant action by the unions, of suffragette flouting of the law, let alone army revolt), there is a simpler reading: *The Crowd* is a pessimistic and conservative piece of political painting, in which Lewis gives his patrons a sublime vision of working-class revolt, while assuring them of their utter distinction from the insect masses.

If Lewis successfully appealed to his elite audience of aristocratic patrons and other wealthy figures, that is no

mystery. For his was an entertaining, irreverent, scandalous movement that fed off the very energies that it despised – and finally offered a comforting vision to the elites who supported it: that through opposing the mass, the elite may find in that struggle a renewal.

The period immediately before the war was Lewis's, and it was not to be repeated. His attempts to restart avant-garde activity in Britain after 1918 met with no success, and his literary battles with Bloomsbury led him into severe material difficulties. That failure is a register of the anti-intellectual conservatism of middle-class life in the 1920s, and indeed of much of the inter-war period. Lewis's contradictory embrace of the machine environment, and his insistence in describing in painting and in writing its effects on human beings, was particularly uncomfortable in the post-war period, which for many was a time of mourning and recoil from industrialized slaughter.

An indication of Lewis's oppositional principles can be found in his prose, which, unlike that of most critics (and indeed artist-critics) of the period is dense, provocative, spiky and even rebarbative. It is the antithesis of the eminently reasonable, patiently educative tone that prevails particularly in British writing about contemporary art, which can read as if some genteel and reassuringly normal chap at the club is guiding you through befuddling displays of the modern, without too much troubling of the mind with arcane notions. We may sample some of this writing to get the general tone:

> Some of his [Sickert's] Camden Town interiors have been called morbid, but the artist was only aiming at the truth, and the truth always contains beauty ... The truth should never offend us, and if Sickert has been talked about largely because of his paintings of 'low life' in low tones, it must also be acknowledged that he can transform even a sordid theme by the glittering magic of his style.[81]

> A few modern artists may be Communists, and some undoubtedly are Jews ... But the majority of modern artists are neither Jews nor Communists, nor racialists nor politicians of any kind. They are just artists, and, if anything, the more 'modern' they are in spirit as artists, the more disinterested and detached they become. In short, the good artist is very rarely interested in anything but his art.[82]

> I am not at all certain that the historian of that distant time who looks back with justified condescension upon ours may not perhaps envy a little the historian, however ludicrous his errors, to whom the artists who are the common objects of their study were familiar figures, known either directly or through friends. Therefore it seems to me that there is an obligation upon those to whom has fallen the privilege of knowing artists, to place on record something about their personalities and their opinions.[83]

> I have given as sincere an appreciation of Picasso as my inveterate habits of valuing work will permit. I cannot touch here on what may be designated his psychology nor on the psychology of the worshippers and theologians of his paintings with their metaphysical Gnostic or Freudian interpretation turn him into a cult hero of a new mysticism.[84]

> In the arts it is sometimes necessary but always dangerous to theorize. Theorists tend to produce art that may be serious but can hardly be sensuous or human.[85]

And the critics were predominantly chaps. McKibbin has written eloquently about the great and persistent sexual segregation at all levels of English society into the 1950s, despite women's growing numbers in the workplace, and that division was held to faithfully in mainstream art discourse.[86] The harder, class-conscious claims of Marxist criticism, established in Britain in the 1930s by Francis Klingender, Anthony Blunt and others, did not of course offer such comforts. Indeed, a strong feature of leftist writing in Britain is that it allied complex analysis and a clear but elevated literary style – seen, for example, in the work of John Berger, E.P. Thompson and T.J. Clark. As we shall see, when a large leftist front in British art was mobilized in the 1970s, it included women, and its writing, produced generally from within the universities was technical, complex and unyielding in its intellectualism – in overt reaction to the clubbable criticism that preceded it.

During the First World War state-sponsored scenes of class harmony at home and on the front, some even provided by Lewis, prevailed. The national government (apart from bringing much of the economy under its direct control) favoured union labour, in part because it was less liable to strike.[87] In the post-war settlement the main gain of the working classes was a reduction in working hours

from an average of 54 to 48 hours a week. For the first time weekday diversions, particularly the cinema, were open to working-class people.[88] Another powerful social factor, novel in Britain, was the unprecedented militarization of the nation, which had previously only maintained a small, professional army, in contrast to the standing armies of millions of conscripts found in Continental Europe. The newly enlarged armed forces, with the prestige of their victories in the war (repeated, of course, in 1945), became bastions of Toryism.[89] The overall effect of the post-war settlement by the mid-1920s was, as McKibbin puts it, to enthrone the middle class as the dominant force in national life, while not unseating the upper class and subordinating the lower class.[90]

Yet this was not the way the middle class saw matters. There was another durable aspect of its identity that McKibbin stresses: while many features of the middle class changed in the period he examines from 1918 to 1951, it remained (with some variations in intensity) anti-working class and defined its own identity through that hostility.[91] Such hostility had structural sources but was heightened by the genuine, though short-lived, post-1918 change in the respective fortunes of the middle class, which for a few years lost ground to labourers, and the association of that time with the despised figure of the profligate, showy nouveau-riche war profiteer.[92] In part, the divide was based on the great disparity of life experiences: the middle-class were predominantly salary- rather than wage-earners, recipients of a predictable income that allowed for planning, saving and insurance that the vagaries of lay-offs and overtime did not.[93] Enmity towards the newly powerful unions was sustained, as they increased membership, promulgated strikes and made governments pliant.[95] That solid hostility contributed much to the defeat of the General Strike, as middle-class people stepped in to drive trams and trains, and shift coal. It was also seen in the opposition to the idea of widening education in the inter-war period, defended with the reflex notions that it would make people less willing to do manual work and would exacerbate the 'servant problem'.[96]

The main political task of the inter-war period, as seen by both major parties, was to foster tranquillity and stability, softening class conflict. It was exemplified by Baldwin (and similarly Ramsay McDonald) in an 'emollient, patriotic ruralism'.[97] Rigid economic stability was maintained at the price of growth, and there was no taste for imperial

'adventures'.[98] Such a vision and policy appealed to a middle class that, as we have seen, drowned its religious variegation, along with the division in any region between natives and the many incomers, with its polite, anti-intellectual conversational culture.[99]

Something of the middle-class ideals of the period can be grasped through Meredith Frampton's extraordinarily controlled and labour-intensive paintings of the interwar years, pursued methodically in a style that changed little from the mid-1920s up to the Second World War. While there was a good deal of polite painting of calm interior scenes and gentle landscapes, in Frampton (1894–1984) that ideal reaches a peculiar intensity. His style was eloquently pinned down by Richard Morphet, who wrote that Frampton aspired to model three-dimensional objects in paint, did so with extreme lucidity and achieved in his work 'a quite exceptional sense of permanence and stasis'.[100] The sitters for his portraits were middle-class achievers – public servants, scientists and cultural figures. As Morphet notes, the totality of control in these pictures encompassed not just their calmness of scene, lack of ambiguity in description and perfection of technique but extended to their frequent reference to planning, architecture, diagrams and maps: 'Orderliness is at the heart of his view of the world.'[101] These pictures also reflected changes in the composition of the middle class, which were taking place rapidly in the 1920s and 1930s, as the number of clerks fell and the numbers of technical and scientific workers, along with business people, rose.[102]

The domestic and rural calm of many British paintings following the First World War has been seen as a deliberate compensation for its violent chaos.[103] This was part of a general trend to Neoclassical order following the war across Europe (and particularly in France and Italy), though none was as concerted or as unopposed as in Britain where avant-garde activity virtually disappeared for more than a decade.[104] Frampton had served in the war as a map-maker, plotting from aerial photographs the continually shifting features of front-line landscapes under barrage.[105] Frampton's total commitment to order and stasis reflected the political effort to instil social calm in the nation following the war, alongside the longer-term middle-class aspiration for ease. It is evident in *A Game of Patience* (fig.84), where the model is an idealized middle-class woman, contemplative but at leisure in her Neoclassical surroundings that open onto a quiet and ordered rural landscape. The discipline of

her clothing, hair, pose and gestures is as ordered as anything in interwar Léger, and while the fruit and corn on the table gesture to fertility, the clerical collar hints at strict morality.

This middle trend in British painting was merely a more extreme version of a rentier ideal that obtained generally across modern art, and was brilliantly characterized by Meyer Schapiro, who dwelt on its characteristic subject matter: natural spectacles seen from the viewpoint of the relaxed spectator, artificial spectacles and entertainments seen similarly, the artist's studio and its accoutrements, and 'isolated intimate fields, like a table covered with the private instruments of idle sensation', in all of which the viewer is constructed as a passive consumer and the world of action is eliminated.[106]

In many parts of the world any prospects for the calm enjoyment of wealth were shattered by the Wall Street Crash of 1929 and its long-drawn-out economic and political consequences. Yet Britain's experience of the Great Depression, known here as 'the slump', was in sharp contrast to that in Europe and the US. Due to the slow growth rates and relatively high unemployment of the 1920s (again, in contrast to France and especially the US), when the slump occurred, it was slower to make an impact and did so with less disastrous effects. Although growth rates were low even in the 1920s, from the middle of that decade the middle class had greatly improved their economic position. The 1920s had seen a boom in the buying of British art, and the buyers were middle class, often buying for speculative purposes.[107] Their tastes tended to be more conservative than those of richer patrons, and they particularly bought landscapes in oils and watercolour, as well as prints.[108]

As it developed, the slump was geographically very uneven in its effects (as Margaret Thatcher's first recession was to be nearly fifty years later), with the result that the government was able to rely on its support in the prosperous south, while northern industrial towns, particularly mining and shipbuilding areas were hurt most. Since the areas that suffered most from the Depression were solidly Labour even at the best of times, it made little difference to the government's electoral prospects. Rather than try to reduce unemployment, it was government policy to improve the benefit system through centralization.[109] The Jarrow marches, and other such manifestations, were meant to bring to southern attention the extent of suffering in the north.

Again, the experience of the middle class was very unlike that of the working class, and it widened the gulf between their political outlooks. Most working-class people in the 1930s experienced periods of unemployment, while most middle-class people did not; furthermore, the middle class benefited from falling prices and were able to increase their consumer spending.[110] One of the things they bought, given that other investments seemed unattractive, were houses, and new suburban ribbon developments spread across the country. In the late 1930s 300,000 houses a year were built and in the inter-war years the British housing stock was increased by a half; they were occupied overwhelmingly by white-collar professionals.[111] Indeed, the slump helped this development by keeping interest rates low. The rise in home ownership, almost exclusively a middle-class affair, was fostered by Conservative governments that saw it as a bulwark against socialism, allowing building to take place without planning, and subsidizing much of the construction.[112]

The ideal of suburban living was founded on middle-class attachments to rustic imagery and, with it, hostility to, and the ideal of separation from, industry and from the people that its factories created. It also, of course, did much to cause the destruction of the very environment it purported to value, particularly in the south of England.

The spread of suburbia and the rise of commuting had profound effects on middle-class social life. As McKibbin puts it, 'The social separation of men from work and the physical separation of men and women from collective life or informal sociability became . . . a fact of middle-class life – as it was later to become a fact of working-class life.'[113] Middle-class sociability was of necessity organized, generally in clubs and associations, and was sexually segregated, in a manner that was in tension with the ideal of companionate marriage centred on the home.[114] Something of that worry – of women's isolation in the suburban home – is evident in the Frampton painting; his model, after all, is mustering her discipline to play patience.

Much middle-class consumer spending in the 1930s was done for the home, and avant-garde artists responded to this new environment, in which their conventional means of living had been removed, in an entirely rational manner, moving to make small items for the large number of new modern homes. Much of the mildly modern, small-scale work produced in the 1930s was meant to inhabit these mutedly modern and eclectic suburban villas (as well as

urban flats). Here even abstraction lost the radical connotations it may have once had, and became simply decorative and unthreateningly modern. Some of it was sold through shops such as Harrods and Selfridges.[115] The names of some 1930s shows spelt the matter out: the Zwemmer Gallery's *Room and Book* (1932) or Duncan Miller Gallery's *Modern Pictures for Modern Rooms: An Exhibition of Abstract Art in Contemporary Settings* (1936). As Andrew Stephenson has noted, Bloomsbury, and Roger Fry in particular, condemned this development as fostering poor-quality art, which was purchased by (in his Arnoldian terminology) complacent, hypocritical, materialist middle-class philistines.[116]

Artists' responses to the slump have been analysed by Stephenson, who sees in them more than a pragmatic series of measures to make money out of art criticism, interior design or the painting of comfortably British landscape works. Rather, it was a move from the upper-middle-class world of Bloomsbury, who (at least in their statements) despised in art the merest taint of commerce and for whom the word 'professional' was an insult, towards a career-oriented status, meant to capture the patronage of business and the state, and towards cultivating new middle-class buyers who were as interested in investment as in aesthetic quality.[117] He argues that Unit One, formed in 1934 as a collective to raise the profile of modern art in Britain, directed its efforts at the growing middle-class market for art, assuring their buyers of their professionalism, touring the regions, stirring up press controversy, tailoring avant-garde layout and rhetoric to corporate advertising ends, and finally branding themselves with their collective identity.[118] This was no once-and-for-all development but rather one of series of ebbs and flows of the professional ideal in art, tied to the economic cycle. For John Berger, for example, modelling the protagonist of his novel, *A Painter of Our Time* (1958) on the émigré sculptor Peter Peri (1899–1967), avant-garde separation from market demands and an utter devotion to the expression of oppositional politics through the medium of paint had become the ideal.[119]

The slump polarized political opinion, as did the dramatic events in Europe, from the comparative success of the dictatorships of Left and Right in dealing with the recession to the Spanish Civil War. Even so, Britain did not develop a mass Communist Party of the type that formed in France, Germany or Spain. At its pre-war height, it had only 16,000 members (by contrast the French Communist Party

[PCF] had 328,000 members in 1937, and the German Communist Party [KPD], before its banning by the Nazis, around 350,000).[120]

That comparative weakness may be registered through the diverse activities and modest success of the Artists' International Association (AIA). Its publication *5 on Revolutionary Art* (1935) was highly eclectic and demonstrated little in the way of systematic Marxist thinking about contemporary art. Its diverse range of writers included Herbert Read, who argued that high modernist art was to be recommended for keeping art inviolate from social contamination until such time as society will be able to appreciate art's universal qualities.[121] Indeed, Read's essay, the first in the book, glibly associated 'revolutionary art' with revolutionary politics, making dangerous radicals of Barbara Hepworth and Ben Nicholson, and the entire abstract wing of modernism who, as Read put it in a tellingly spun manner, 'are more or less openly in sympathy with the Communist movement'.[122] In any case, he continued, the essential components of art are archetypal, the product of the unchanging character of human nature and the physical world, and for this reason the artist may justifiably 'take up an attitude of detachment'.[123] It hardly needs saying that this position was entirely unmarked by dialectics or materialism. The only contribution with a firm basis in Marxist thinking was that of the émigré Francis Klingender. He attempted to place the character of modern art in a broad art-historical sweep tied to the rise and fall of the bourgeoisie as a force for radical change; in this schema the 'technological revolution' of modern art, fettered to the escape from content, a flight from the world of a decaying class, had no more meaning than a kaleidoscope.[124] The eccentricity of the contributions provided little basis for the development of a sustained materialist discourse on art and culture. Indeed, there was little in British Marxist thinking that could match the sophistication found in Europe, nor would there be until the end of the 1950s.[125]

If there was an exception, it was the isolated figure of Christopher Caudwell, the most brilliant Marxist cultural critic of the 1930s, who struggled against elements of the British resistance to modernity, notably the divide between art and science, which he saw as a prime symptom of the crisis of bourgeois culture.[126] His work also fixed on the contradictions that the artist threatened to expose, in particular the compulsive character of market relations as

85 JAMES BOSWELL
The Means Test 1934
Lithograph on paper
17.1 × 13.3 (6¾ × 5¼)
Tate. Presented by Ruth Boswell,
the artist's widow 1977

against the illusion of individual freedom.[127] At a time when there were widespread worries about the social isolation that the retreat to the suburbs created, Cauldwell wrote: 'The deepest and most ineradicable bourgeois illusion ... is that man is free not through but in spite of social relations.'[128] In the face of countervailing evidence, the growing complexity of economic organization and the rise of the state, the bourgeois illusion of social liberty reproduces itself, he claimed, in psychoanalysis and the arts. It can never be admitted that the elements of individual subjectivity are determined (and indeed this remains a central feature of contemporary art).[129] He further argued that art could alter people's emotions and outlooks in an adaptive way, in response to rapidly changing social relations.[130] Yet his work was widely misunderstood, even within Marxist circles, and his legacy is even now far more uncertain, and his work less read and written about than that of the adherents of the backward-looking idylls.[131]

The core artists of the AIA, including James Boswell (1906–71), leant heavily on German models, particularly the work of George Grosz. Boswell gave up fine art during the 1930s, not only of necessity to do advertising work for Shell but also to make lithographs for leftist newspapers and magazines, including the *Daily Worker* and *Left Review*. Class warfare of an overt kind is waged here, with strong satires of bourgeois behaviour, alongside fond and tragic scenes of working-class life. In *The Means Test* he fixes effectively on the consequences of the state's administration of welfare for the long-term unemployed (fig.85). When AIA work was shown in Moscow in 1937, one critic wrote that while the exhibitors successfully revealed the bourgeoisie for what they are, their depictions of the heroism of the class struggle left much to be desired.[132] While this was a predictable critique, it had some point to it, either because heroism was in short supply, or because what there was remained small-scale and isolated, or because

artistic models for depicting it lacked any plausible use in Britain. There has been relatively little art-historical literature about this socialist tendency in British art in the 1930s, and very little about Boswell, whose attentions were also turned on the snobbier pretensions of the art world, for instance in an angry though amusing depiction of the International Surrealist exhibition in 1936 (see Gale, pp.116–17), contrasting the manners of the self-regarding elite who frequented the show with a quote from Herbert Read about the desperately disrespectful character of the work displayed there.[133]

Against the standard views of calm retreat and contemplation, and indeed against their complement in depictions of entertainingly raucous working-class entertainment, were works that attempted to track social difference within a single frame, and in doing so produce a pictorial rendition of the social state of the nation. Through the mass media the nation's inhabitants were emerging into consciousness of themselves as a social entity. It became widely known during the slump that half the population was ill fed and that the poorest 30 per cent could not afford the means of subsistence.[134]

One such view, which has since become very well known though it was a commercial failure at the time of its publication, is the book, *The English at Home* (1936; fig.86) by Bill Brandt. It was new not only in presenting an overall view of the English nation but, as its title suggests, in the technical novelty of showing them in dark interiors, with the use of the flash-bulbs.[135] The book was not intended by publisher or author to carry a radical political message – and indeed much is done to defuse it, not least with the last page showing doffed top hats with the legend 'God Save the King'. Yet in the polarized social conditions of the 1930s it could certainly be read politically. Many of Brandt's juxtapositions across the page (and indeed on the front and back covers), while certainly full of social colour, point to an inequality that went beyond mere English social habits: the drawn and weary face of the man in the centre of 'Workmen's Restaurant' is contrasted with the relaxed main figure of 'Clubmen's Sanctuary' and the lowered head of the serving-man who waits on its members. Even when the juxtapositions are not made directly across the page, even a casual viewer will compare the faces of the children in 'Their Only Window' to the pictures of middle-class recreation in expansive, sunlit gardens and golf courses, and to richly laid Mayfair dinner tables.

The middle class, the implied readership of the book, are not exactly excluded from its pages, though they are certainly squeezed between the exoticisms of flat cap and top hat. They appear in sporting guises, or wearing costumes or fulfilling highly identifiable roles (golfer, horse-racing fan, army officer, professor), and occasionally as commuters crossing bridges or streets. Of their professional life we see nothing, for both Brandt the émigré and his publisher were more interested in playing to costumed cliché, in part because the book with its bilingual captions was directed at a European audience (where there was a larger market for photography).[136] In one picture a middle-class woman at home does appear, nearly as disciplined in clothing, coiffure and pose as Frampton's, though she is engaged in another solidly identifiable English ritual – 'Afternoon Tea'.

This vision of a differentiated national unity had its comforts. Raymond Mortimer in his skilful introduction that navigates between the dangers of Bolshevism and conservative nationalism, wrote of returning to England after a time abroad and being struck by all that would normally be unseen, 'the hedges and steeples and bungalows', English tea and 'bobbies' and *Punch*.[137] Mortimer also focuses on the agreeable quaintness and strangeness of the rigidity of English habits of dress but beyond this, in writing of slum children, a miner's family and men at a hostel, asks: 'Is there any English man or woman who can look at these without a profound feeling of shame?'[138] Mortimer writes: 'One's pleasure in being English is somewhat modified by knowledge of this unnecessary, this humiliating squalor.' But he also believes that such squalor can be ameliorated without destroying England's 'pleasant traditions and individual liberties', though those will be imperilled if it is not.[139]

While the book had an ethnographic aspect, related to Brandt's German upbringing and its courting of foreign markets, it had nothing of the rigour and systematic character of August Sander's examination of his nation.[140] While Sander attempted to fix the identities of individuals, to place them in strata at a time of bewildering social change, Brandt's dwelt on conventional and (it seemed) unchangeable certainties in a society institutionally protected from the gales of modernity.

In the same period another photographic model for the depiction of class difference was found in the activities of Mass Observation, an organization dedicated to making an anthropological study of the British working class. It was

86 BILL BRANDT
Front and back cover of *The English
at Home* B. T. Batsford, London
1936
Bill Brandt Archive Ltd

initially funded by wealthy patrons, including industrialists, and while the intellectual interests of its members spanned science and surrealism, its aim was to illumine that class who were seen by those not born into it 'as almost a race apart'.[141] Tom Harrison, one of the founders, had been engaged in anthropological fieldwork in Malekula, Vanuatu, and had published a popular account of that work, influenced by Bronislaw Malinowski.[142] While the mass of diarists who contributed to Mass Observation's archive were mainly lower-middle-class urban types with an interest in leftist politics, those employed directly by the organization were Oxbridge graduates of independent means.[143] In addition to its call for and collection of social diaries from the general public, Mass Observation under-took a large-scale examination of Bolton that employed a wide variety of techniques to wrest facts from their working-class subjects, including initiating conversations with them, sometimes incognito, eavesdropping on them and following

them.[144] It also used photography, and in 1937–8 Humphrey Spender (1910–2005), who worked as a photojournalist for the *Daily Mirror*, took a number of short trips to Bolton to photograph its inhabitants.[145]

While Brandt often elicited the cooperation of his subjects, Mass Observation preferred methods of depiction that left subjects unawares. Spender, with varying degrees of success, spied on his subjects in streets, markets and pubs (though not, because of the need to remain invisible, in homes or factories). He would hide his Leica camera under his jacket.

In *Dominoes in the Pub, Bolton* (fig.87), the image is determined by these means, and is far less accomplished than Brandt's set-up photograph of a domestic interior that appeared on the back cover of *The English at Home* (fig.86). The viewpoint is low, since Spender could not risk raising the camera to his eye, and the narrow band of focus is on the hands and beer mugs of the far players – no flash

87 HUMPHREY SPENDER
Dominoes in the Pub 1937
Black and white photograph
Humphrey Spender Archive,
Bolton Museums

could be used to supplement the available light and allow greater depth of field. There is also a little blur caused by the movement of the figures. In these ways the recording power of photography is compromised by the techniques used to remain unobserved.

The results are neither an ethnographic measuring of the subject common in imperialist photography, nor the participant-observer model (of the kind that Malinowski had undertaken in the 1920s and illustrated with his own photographs), but rather photographs of working-class people caught unawares by an outsider.[146] Spender's pictures were not used by Mass Observation in its publications, in part because of the expense of photographic reproduction, and in part because Harrison had little idea of how to use them alongside the great volume of textual facts that had been gathered.[147]

An aim of Mass Observation had been to bring facts about the social character of the nation to its inhabitants, and some of its publications, which were critical about the lack of information imparted by the government and the deference of the press hit a popular nerve. Its analysis of the Munich Crisis, *Britain by Mass Observation*, sold 100,000 copies in ten days.[148] Even before the war its skills were turned to electioneering, and it was credited with winning a by-election in Fulham for Labour by informing the candidate about the constituents' most urgent concerns. It was also involved in sending out false Conservative campaign literature to confuse their supporters.[149] Yet its role changed rapidly when war was declared, and it became an organ of government, its skills in social data-gathering being in advance of the newly founded polling organizations Gallup and MORI.[150] It was used by the Ministry of

Information to assess the attitudes of the population to war and the Blitz.

As is well known, the Second World War altered the balance of power between the classes, and enabled Clement Attlee's government to set in place the elements of a Welfare State, including unemployment benefit that was no longer means tested, the National Health Service and an expanded secondary education system. Once again, a considerable state propaganda effort produced much art that showed the classes striving together in unison against the Nazi threat, and these works were shown to wide audiences not only in galleries but also in pubs, social clubs and schools. War propaganda tended to dwell less on the iniquity of the Nazis (the true extent of which was not known to the British public until the end of the war) and more on the promised reformation of the country when the conflict ended.

Yet, in some ways the war (while it lessened class antagonisms, at least for its duration) reinforced the image of England as a fundamentally rural nation, set against industrial and inhuman German might.[151] Workers were the basis of the war effort but the imagined nation that they were defending was not one founded on working-class culture. In fine art the isolation of Britain from European influences produced a surge of rustic Neo-Romanticism, which included ruins and idyllic rural scenes by John Piper (see Button, pp.118–19). In Alberto Cavalcanti's famous propaganda film, *Went the Day Well?* (1943), imagining the consequences of a Nazi incursion, an archetypal English village inhabited by quirky loveable folk comes under threat – and heroically resists. In the years that followed, St Ives once again became an important locus for British art, as pastoral versions of US abstraction were produced by Patrick Heron and others, in a compact that was undoubtedly self-consciously modernist, but also retained an engagement with a particular landscape, light, and the apparently eternal rhythms of waves, tides and the flight of gulls (see Stephens, p.54).

One large switch in policy, and one of the major gains for the working class, was that the state became committed to the reduction of unemployment (following Keynes's theories) by running a budget deficit during economic downturns.[152] Though the means had changed, social calm was still the aim: the unions were pacified by sympathetic government policy and genuine forms of consultation and power sharing. Stability of prices was valued above economic growth.[153] While the hated means test was

ended, state benefits were not targeted at the poorest, and indeed the middle class benefited from the creation of the Health Service and particularly the expansion of secondary education more than any other sector.[154] The ideal of equal treatment could not survive the extent to which British class and social structures were left untouched, particularly in education, where, overwhelmingly, working-class children went to secondary modern schools and middle-class ones went to grammars. Those state and civil institutions that were strongly defended by vested interests (such as the fee-paying schools) were left alone.[155]

Nevertheless, post-war reforms, particularly in education, led to much optimism about the new society that would be engendered. In a book about children's art R.R. Tomlinson (an inspector of art for the London County Council) believed that the reform of art education to encourage creativity would stimulate the full maturity of people's imaginative power, and cited Matthew Arnold's hope that culture would do away with class and let 'all men live in an atmosphere of sweetness and light'.[156] Even the suburbs (much despised by the architectural profession which had no hand in their design) received sympathetic and indeed affectionate attention in a book by J.M. Richards and John Piper. Richards argued that the suburban ideal was reformable, and that the suburban world should be approached with 'respect and decorum'. Piper's illustrations showed houses cosseted by mature trees and shrubs, and garlanded with touching fragments of diverse architectural fantasy.[157]

A fundamental change for the art world was that state subsidy continued after the war, though, following Keynes's prescriptions, the model was transformed from one that favoured wide public participation to the defence of an elite view of quality against encroaching mass culture.[158] State funding was evident in the placing of public sculpture in the new towns, council estates and schools that were a large part of post-war reconstruction. These tended to reinforce traditional family values and gender roles that had been fractured by the war. The remarkably differentiated and stable world of gender relations in the middle class has been thoroughly analysed by McKibbin. It was of course put under pressure by events, and women did move into new professions – notably clerking – up to the 1950s, but where they did so the status and wages in those professions fell.[159] Much quasi-official art played a role in restoring the old familial order. For example, one

88 RICHARD HAMILTON
$he 1958–61
Oil, cellulose paint and collage on wood
121.9 × 81.3 (48 × 32)
Tate. Purchased 1970

cast of *Family Group* 1949 by Henry Moore was placed outside Peter and Alison Smithson's Hunstanton School (fig.89); it trod a finely judged line between the advanced guard of US modernism and the dangers of Socialist Realism, in producing a modern, humanist ideal of the nuclear family. It is a vision of universal human values in which class difference is erased by smooth, generalized surfaces. When another Moore *Family Group* was unveiled in Harlow New Town in 1956, Kenneth Clark was reported as saying that it 'was a symbol of a new humanitarian civilization of which this town itself was the complete expression'.[160] Moore became in this way one prominent official face of British art, his public sculpture widely commissioned at home, and his work constantly promoted abroad by the British Council.

The vision foundered, unsurprisingly, on economic grounds. From the early 1950s the economy was put under considerable strain by continuing imperial military actions, which the British state took more frequently than any other nation, as it attempted to suppress anti-colonial revolt in Malaya, Kenya, Cyprus and elsewhere.[161] Labour and material shortages were exacerbated by large increases in military spending and by continuing conscription.[162]

Through the later 1950s and into the 1960s British people became much wealthier, though the comparative gains were uneven, with the middle third of the earning population enjoying an income that rose faster than the rest.[163] Working-class consumerism became a concern on the left, and in influential books both Richard Hoggart in *The Uses of Literacy* (1957) and Raymond Williams in *Culture and Society* (1958) mourned the loss of solidarity and community that this new affluence had produced.[164] After all, many consumer goods – televisions, washing machines and above all the car – tended to shut people off from communal spaces, while the car actively destroyed them. In many respects, the limited leverage that the working class obtained over the state furthered the elements of professionalization: of higher living standards for all but the lumpenproletariat, meritocracy and increased access to higher education, (slowly) increasing equality for women, and the growth of government services, of the Welfare State and also of the global corporation.[165]

These effects were registered in the work of Richard Hamilton and in parts of British Pop art generally, in which concern about the social effects of consumerism was combined with a relish for advertising kitsch and a close backwards look at Dada, which was new at least to Britain (see Stephens, pp.188–9). Art reacted slowly to technological change, noted Hamilton, asking how many cars and vacuum cleaners had appeared in twentieth-century art.[166] *She*, a skilfully montaged amalgam of advertising images, including a winking eye and a toaster-vacuum cleaner hybrid, produces a perverse commercial utopia (fig.88). Hamilton commented:

> The worst thing that can happen to a girl, according to the ads, is that she should fail to be exquisitely at ease in her appliance setting – the setting that now does much to establish our attitude to women in the way that her clothes alone used to. Sex is everywhere, symbolized in the glamour of mass-produced luxury – the interplay of fleshy plastic and smooth, fleshier metal.[167]

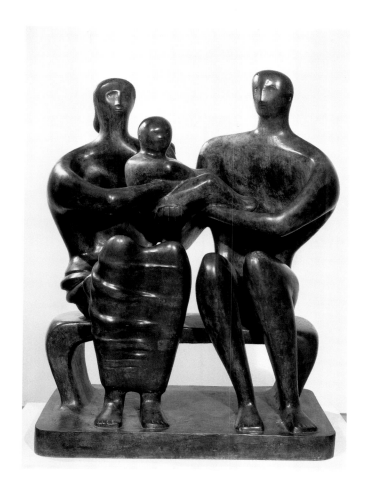

Hamilton's female is as bound to and defined by the home as Frampton's, but the middle-class solidity of the earlier model has thinned and fragmented into a spectral emanation, governed and sexualized by consumption. The combination of female body and consumer item is the same as that found in Marcel Duchamp and Francis Picabia, and works to the same fetishistic purpose: that the body is taken as consumer object (assembled from discrete parts) and the commodity takes on the allure of flesh.[168]

In this change attitudes to the wealth and world power of the US were central. There were many reasons for ambivalence: Britain's siding with the US in the Cold War threatened its nuclear destruction; middle-class discomfort at the wealth and ostentation of US troops in Britain during the straightened circumstances of the war continued to rankle;[169] and that feeling was exacerbated by the decline of empire and the rise of this brash, uncultivated and overtly racist power. Among the working class, admiration of the Soviet Union, founded on acute awareness of the unequal share it had taken in the defeat of Nazism with its many millions dead, continued to be a widely held view at least up until 1956. In the new climate of consumer glut Hamilton and others produced a declassed vision of the effects of US consumer culture that skirted both celebration and critique but certainly welcomed the apparent flattening of cultural distinction brought about by consumerism, not least because it caused a relaxation of middle-class moral deportment. At this time the scene of rentier art that Schapiro had described was broken, not in favour of social action, but in a new vision of uniform passivity based not on the ideal of idle contemplation and spectatorship but on that of shopping.

From the mid-1970s this idyllic scene of conspicuous consumption for all foundered on the oil crisis, and the persistence of an economic condition that Keynes's theories had not anticipated – 'stagflation', the combination of low growth and high inflation. The increasing synchronization of economic cycles across the globe meant that all nations entered recession at the same time, and stagflation naturally fed union demands for catch-up wages, which further fuelled inflation.[170] Edward Heath's modernizing experiments with free market ideals and increasing competition in British commerce failed, in part because they were opposed by the unions. The dominant right wing of the Labour Party offered calming consolation: as Wiener put it,

the modernizing rhetoric of the 1960s was set to rest, and both Harold Wilson and James Callaghan acquired farms and were often photographed there, presenting themselves (as Baldwin had done) as reassuringly rural men.[171]

To return briefly to Anderson's parameters for sustained modernism, which, it will be remembered, were the survival of a semi-aristocratic ruling order and culture, an indeterminate technological impetus and a semi-emergent labour movement: in the late 1970s, while Britain maintained its royal and aristocratic frameworks, there was no longer an identifiable classical culture that was supported by them. Even less did the other features apply; Britain's industrial economy was vast but lacklustre, run down by under-investment, particularly in the public sector, and any attempt to invest it with modernist romance would have seemed absurd. The labour movement's aims were thoroughly well known and, among most of the middle class and even much of the working class, mocked and despised. By this point the in-any-case weak impetus of British modernism was dead.

What had been created, however, in the expansion of the universities and of state funding for the arts was a strand of contemporary art that could stand relatively free of the market. The ambit of this art was academic, and it was a product of the height of state command of the economy, in that it relied for its creation and consumption on a segment of middle-class state employees – lecturers, teachers, social workers, probation officers and so on, who had regular contact with working-class people. The artists of this strand were undoubtedly members of the professional class who looked to the state (often through the medium of the university) for the ultimate ratification of their status and credentials.[172] We have seen that a range of art criticism in Britain had remained gentlemanly in tone but this new strand was anything but: it was determinedly radical, properly informed by Marxist social and cultural theory (being made newly available in translation), and sternly technical.[173] The products of Art & Language, in both their writings and art works, may stand as an indicative measure of the change (see Harrison, p.62). Both are aimed firmly at the university-educated (indeed most likely postgraduate) audience.

To take a single example from Art & Language: in 1975 they made a piece called *Dialectical Materialism (Dark Green)*, which resembled one of their map works, and proposed puzzling relations between its various elements:

90 ART & LANGUAGE
Dialectical Materialism (Dark Green)
1975
Photostat, dimensions variable
Collection Charles Harrison, England.
Courtesy Art & Language and
Lisson Gallery

THERE IS NO EASY WAY OF AVOIDING THE DANGERS OF PRACTICAL
ANACHRONISM. THEY ARISE BECAUSE THE WORKING-CLASS MOVEMENT
REMAINS FRAGMENTED IN ORGANIZATION AND CONSCIOUSNESS AS A
RESULT OF 30 YEARS OF CAPITALIST EXPANSION.

dark green

the described colour, an ellipsis in quotation marks and a political slogan (fig.90); they later explained: 'What would you insert (write) in the black space of the ellipsis-in-the-box-in-quotes (the most prominent place in the work) given that what might appear there would be indexed by both the political slogan and the name of a colour?'[174] This, then, is a pedagogical work, an exercise made, as if for students, in the arbitrariness of classifications and power relations. It is critically self-reflexive, for a jibe about 'practical anachronism' is also directed at Art & Language themselves. The result is a reduced, playful but mordant take on the expression of class difference, in which political idealism becomes subject to 'the rigorous and relentless order of the vernacular of administration', the order of a new professional class, which harbours no illusions.[175]

Engaged in further education, and in workshops in working-class communities, Jo Spence (1934–92) and Terry Dennett (b.1938) used the traditional means of photography to highlight its uses, ideology and institutions in what were intended to be 'lessons'. *The History Lesson*, for example, was university-initiated, the result of a commission from MIT in 1982; logically, Spence and Dennett, far from producing fine art editions, made laminated prints for circulation in educational settings, and their work was intended to provoke discussion.[176] This was an attempt to make photographic theory more accessible, and to sidestep the marginalization of such work in professional art or political magazines.[177] The aim was to uncover through psychoanalysis and historical materialism what had been hidden or made invisible.[178] While the results were a good deal easier to understand than the works of

91 JO SPENCE and TERRY DENNETT
'Colonisation' from
The History Lesson 1982
Black and white photograph
Collection of the artists

92 GILBERT & GEORGE
Class War, Militant, Gateway 1986
Mixed media
Left to right 363 × 758, 363 × 1010,
363 × 758 (143 × 298½, 143 × 397½,
143 × 298½)
Collection of the artists

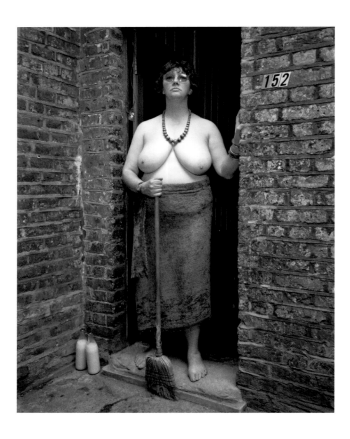

Art & Language, this work was equally unembarrassed by serious intellectual engagement and exploration. Its products were often funny as well as informative: in 'Colonisation' (one part of *The History Lesson*; fig.91), Spence and Dennett stage a telling condensation of class, gender and imperial themes in their mock recreation of a truly overt and exploitative ethnography of the working-class woman, and of

> her right to exhibit herself as a 47-year-old social actor, in daring to offer some very different renderings of the female body from those, say, in women's magazines. In that particular homogenized and declassed world, where everything is idealized ... women are enjoined to identify with the universalizing effects of photographic styles in fashion and advertising which minimize skin texture and colour, disguise sagging flesh and flabby, tired or diseased bodies, and efface the ageing process.[179]

It was, for its time, a startling Brechtian form of consciousness raising, which relied on a number of fragile factors: Spence's own personal bravery in displaying her body, particularly during her treatment for cancer; the

rising wealth and social mobility of the working class; and the formation of an environment of sustained leftist thinking, unattached to the existing Communist states.

Labour administrations had, since the reforms of the immediate post-war period, been content to rely on rising living standards to pacify its supporters and had attempted no deeper transformation of what remained a deeply divided society. McKibbin puts the matter plainly: because the social-democratic definition of democracy had not entrenched itself in civil society, the political settlement of 1945 depended on the survival of the industrial working class.[180] A party with the will to face the social effects of demolishing that class as an organized force could dismantle it. In 1976 James Callaghan led the switch to a tight money policy that anticipated the position of the later Tory regime. It could not save his government, and Margaret Thatcher was elected in 1979, committed to driving down state spending and basing her political support on an appeal to sectors of the working class, particularly the self-employed and those who aspired to home ownership.[181]

The shift was a profound one. Maurice Cowling wrote of Baldwin and his Conservative Party in the 1930s that they shared many fundamental values with their Labour opponents: 'There was the same affectation of dislike for the millionaire press. There was the same distaste for the ostentation of wealth. There was the same concern with decency and virtue and a belief . . . that the rich had a duty to be kind to the poor.'[182] It is evident how far Thatcherism departed from those attitudes, in the courting of Rupert Murdoch's media empire, the crowing about the mid-1980s 'economic miracle' that benefited the wealthiest, and the infamous statements by Norman Tebbit and others about the unemployed (Tebbit's advice was that they, like his father in the 1930s slump, should get on their bikes and look for work). Stuart Hall, in writing of the 'regressive modernisation' of the Thatcherite project argued that it was based on the unfinished character of British bourgeois transformation, and thus remained bound to the tradition.[183] It forged from contradictory elements of apparent cultural conservatism (the return to 'Victorian values') a powerful new hegemony.[184]

Geoffrey Wheatcroft, in his book *The Strange Death of Tory England*, shows that there was a significant shift in the class leadership of the Conservative Party from (put crudely) aristocratic and gentlemanly to petit-bourgeois.

93 MICHAEL LANDY
Scrapheap Services 1995
Video and mixed media duration:
11 min., 20 sec.
Tate. Presented by the Patrons of
New Art through the Tate Gallery
Foundation 1997

From the traditional Tory point of view, Thatcher and her ilk were not Tories. He examines the previous leftist credentials of some of her key supporters – of Hugh Thomas who had written a history of the Spanish Civil War, of Alfred Sherman who had served in the International Brigade, of Paul Johnson who had edited the *New Statesman* – commenting that, in this shift from the Left, 'they became right-wingers but not Tories'.[185] In other words, they were not attached to the old ideals of stability, managed change and attachment to tradition.

Thatcher did have a few cultural admirers, though for her petit-bourgeois philistinism she gained the undying hatred of the cultural elite. Those admirers were of a predictable class outlook: Philip Larkin, it emerged after his death in the publication of letters and diaries, had been an adoring fan.[186] Gilbert & George have been public supporters, with George stating that Thatcher made a 'revolution in England' in getting people not to rely on the state; indeed, he recommended a wholesale privatization of the state.[187]

Thatcher's vision was a natural fit with Gilbert & George's in many ways. They complained about the obscurity of much contemporary art and the 'nationalisation' of artists. She grasped the appeal of ignoring intellectual opinion to speak to 'common sense', attacking art subsidy on the grounds that it was a net payment made from the poor to the rich.[188] That common-sense ground was the place where skilled working-class and petit-bourgeois attitudes overlapped. Her own lack of interest in the arts was true to her lower-middle-class origins (and to those she most needed to appeal to).[189] For Gilbert, 'Socialism wants everybody to be equal. We want to be different',[190] and this was a familiar return to the principled individuality of the autonomous artist.

Gilbert & George's conservatism is in provocative juxtaposition with their flaunting of gay sexuality and their oft-repeated obscenities. They gesture towards issues of race, class, sexuality and empire but only to harness these hot cultural issues to their evolved and readily recognizable brand: 'Our art is as English as England is anyway global. If you want to live in the world this is the place. It's the only place where you have a total grasp of the whole world. Whatever is happening in every country you can feel it in London.'[191]

Their massive triptych, *Class War, Militant, Gateway* (fig.92), each section of which is over 3 metres high and

10 metres long, was made in the immediate wake of the Miners' Strike, in which the power of the British union movement was broken. The works include red flowers, fey half-naked workers brandishing red poles, the artists themselves, views of London and ill-defined work-places. They march, says Gilbert, to take over the city; George adds: 'The city as a direct extension, like the individual'. Further, George says of the stooped figures crouching behind the flowers in *Gateway*: 'People weighed down by their burden, not walking straight. We like that contrast.'[192] Read in order, the workers march, stop still, then stoop before the towering figures of the artists. While Lewis admired and feared the muscular, mechanical strength of the masses, here it is their feminized weakness and pliability that is found attractive, though the end result of submission to the authority of the elite is the same.

Thatcher laid waste British heavy industry, and with it the basis of unionized power. Direct comments on this historical development in the art world were, it should be no surprise, rare, although Michael Landy (b.1963) made a large installation, *Scrapheap Services*, that put the matter plainly: mannequins are posed as if in the process of sweeping up thousands of laboriously made tin figures, cut from drink cans and bearing their brands (fig.93). The figures were defined by their consumption but, as wages ceased, they were refigured as trash – disposable packaging. The mannequins act as agents of a mock corporation that cleanses the human detritus of deindustrialization to create a sanitized rural environment.

Thatcher did much to dispose of the anti-entrepreneurial spirit of the middle class, and the fundamentals of her vision (particularly the attachment to privatization and the unquestioning support of US imperialism) were confirmed in the regime of her admirer, Tony Blair. While under Thatcher these developments were masked with conservative cultural talk, under Blair they are out in the open: no tradition should stand in the way of global competitiveness, of the free play of the market.

It was not only working-class cultures that were destroyed. The abandonment of the old Conservative values did much to further a decline in bourgeois mores. For Wheatcroft, the bases of Tory power – hunting, the Church of England and the armed forces – were all launched into decline. By the end of the 1980s, claims Wheatcroft all these features of English life were not merely declining but were in many circles despised.[193]

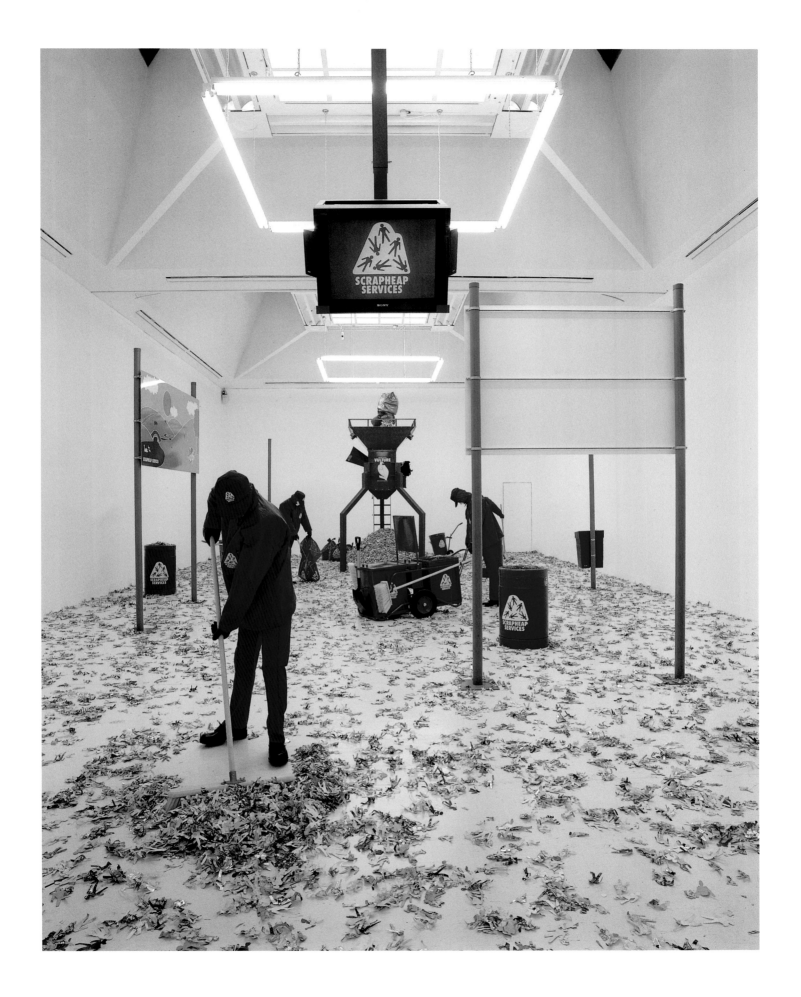

To this undermining of the basis of Conservatism, we may add the loss of empire, and the noxious question of the extent of integration with Europe.[194]

Some indication of the change may be registered in the work of Sarah Lucas. She poses repeatedly as a proletarian character: tough, masculine, overtly sexual and confrontational. In *Self Portrait with Mug of Tea* the fag gives the viewer the finger, while the picture is centred on Lucas's crotch (fig.94). That she does this in the period shortly after the working class as a serious political force had been defeated gives the image a conservatively elegiac air. Its most identifiable characteristics of clothing, pose and behaviour are transposed into art work for the faint nostalgic and provocative spark that they still retain. While this practice of role-playing owes something to Spence, it is the opposite of Brechtian. Here ready-made identities are played out in pantomime transposition, and the old middle-class hostility to workers (now displaced onto the inconvenient detritus, 'chavs' and such like) is replayed as retro entertainment. Furthermore, Lucas does not only appear as a working-class type but as a celebrity artist whose work may be seen as a concerted, large-scale branding and publicity exercise for 'Sarah Lucas'. In this, of course, she is far from alone (we may compare, with their differing class affiliations, the brands Emin, Hirst and Turk who play in the fields of celebrity, along with the Windsors).

Yet there is a more serious point here. Professionalization, in Perkin's sense, came under threat, as the insecurity that has long been a feature of working-class life crept higher up the social hierarchy. Public-sector professionals are increasingly governed with managerial tools that ensure that market models are adhered to.[195] Short-term contracts and wages with large performance components undermine the salary culture. This condition is compounded by the severe democratic deficit with greater centralization of power, a more presidential form of government, and the decreasing distance between the main parties. If at the beginning of this period Britain first attained its full status as a democracy, at its end that status is open to doubt.[196]

As the political establishment decided that it would be a good idea to forget about social stratification, Martin Parr produced a book, *Think of England*, in which the classes merge in displays of colourful vulgarity and social stereotyping (fig.95). Parr's book may be seen as a reply to Brandt's. Again, this work is governed by a fascination with prejudicial cliché: it imparts a vision of a mostly white (or, on the beach, pink) middle England in which objects and people conspire to confirm received ideas – where breakfasts are always greasy, the upper class (or those who dress as such) haughtily quaff champagne and chase foxes, while the lower orders flaunt their invariably broiled and hairy backs, heavy gold jewellery and cemented make-up. Parr describes himself as having 'a perfect middle-class pedigree', and this shows in the book's relative downplaying of the middle class (just as in Brandt) in favour of the entertaining extremes of the class spectrum.[197]

The cover of *Think of England* is a riposte to Robert Frank's famous photograph *Parade, Hoboken* 1955, in which social alienation is strongly represented by the separation of the figures and the masking of one by the US flag. Parr swapped the traditional black and white of documentary for garish colour in the 1980s, and while the narrow band of focus blurs all but the hanging flags, there is a suggestion here that there is nothing to hide, and no suppression of subjectivity by dumb patriotism, but rather the contented, colourful flaunting of settled class identities beneath the Union Jack.

Class in Britain has certainly not disappeared, and part of the utility of Parr's work is to remind viewers of its continuing theatrical visibility. Rather, polarization has increased, as much of the working class has been reduced to precarious insecurity, and a layer of the population remains out of official work and unassimilated into the civil realm. As insecurity grows adn widens, the basis on which art rested throughout the twentieth century – of professionalization and transcendent autonomy – erodes.

That the vision of a classless society remains an illusion is proved by the thoroughly unassimilable character of class-conscious art, especially that which expresses class antagonism. The performance artist Ian Hinchliffe (b.1942), a veteran of the scene for over thirty years, continues to hold forth from a peculiar niche: he is manifestly working-class, a learned, articulate but foul-mouthed drunkard. This combination breaks with the usual class clichés, and thus puts middle-class viewers in an unaccustomed place – the same place that Antonio Gramsci willingly put himself in times of fuller possibility: as a pupil of the workers.[198] Hinchliffe's bad behaviour is accompanied by a great range of historical and cultural references (unlike the successfully entertaining and thoroughly conventional model of Tracey Emin, the class primitive, an Alfred Wallis for the 1990s).

At *Woodwork*, an art event held in Vauxhall Spring Gardens, he resurrected the eighteenth-century compère of the pleasure gardens, Mr Simpson, to orate among plaster torsos memorializing the history of the rise of middle-class culture and the governance of art by the state (fig.96).[199] His class rancour is unconcealed (no one present at the launch of a book in which he was involved will forget his clattering up the stairs of the ICA on crutches – he had been recently mugged – railing in full throat against the 'Hampstead cunts' that run the place), and the art world deals with him (in the ICA incident, at least) by calling the police. What Hinchliffe's long career, unblemished by honours or commercial success, points to is the unutterable in the

nexus of class and contemporary art.[200] This area of deep obscurity is built into the very structure of art. As Caudwell understood, the main role of art is to assure the middle-class professional of his or her own autonomy, freedom and lack of determination by social and economic forces. For as long as that basic structure holds, the pressure from below of the undifferentiated and collective mass must be inimical to it. Yet the forces set in train in the destruction of working-class power and much middle-class professional privilege will bear with them long and deep consequences. As even the Gulf Stream that Lewis railed against falters as the sea grows less salty, British class relations, and the art that they have fostered, may further lose their mildness.

Francis Bacon's *Three Studies for Figures at the Base of a Crucifixion*

MARTIN HAMMER

97 FRANCIS BACON
Three Studies for Figures at the Base of a Crucifixion c.1944
Oil on board
each 94 × 73.7 (37 × 29)
Tate. Presented by Eric Hall 1953

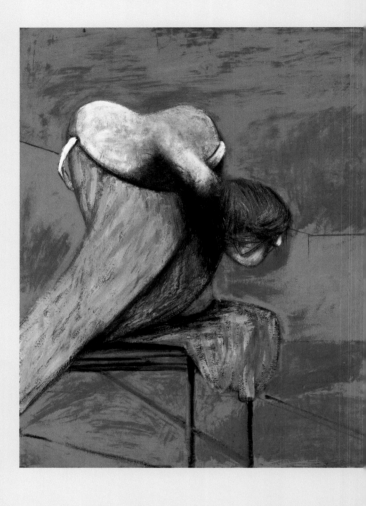

Francis Bacon's *Three Studies for Figures at the Base of a Crucifixion* (fig.97) was first exhibited in April 1945, just as a protracted, horrifying World War was ending, and news was filtering through about the Nazi death camps. While some elements were rooted in his mid-1930s pictures, Bacon surely conceived the triptych as a distillation of the current wartime atmosphere. This was certainly how it struck one appalled critic: 'These pictures expressing his sense of the atrocious world into which we have survived seem to me symbols of outrage rather than works of art.' A more sympathetic viewer also recalled the resonance, in violent times, of Bacon's 'unrelievedly awful' images: 'Their anatomy was half-human, half-animal, and they were confined in a low-ceilinged, windowless and oddly proportioned space ... Each was as if cornered, and only waiting for the chance to drag the observer down to its own level.' That combining of attributes is exemplified by the right-hand panel, at once a howling, yawning or roaring beast, and a human presence pouring out hysterical rhetoric or emitting a primordial scream of pain and anguish. The figure also demonstrates that Bacon was already transforming photographic imagery to his own expressive purposes. Paintings from the early 1940s reveal more explicitly that he was steeped in press imagery of Nazi orators such as Hitler and Goebbels, and John Russell reported that 'much in the *Three Studies* now seems to him to be a relatively direct and primitive adaptation of strange forms that he had memorised while poring over books of animals.' Moreover, the figure's head in the left panel was adapted from a favourite illustrated book about ectoplasms.

Beyond its immediate visceral impact *Three Studies* is a highly ordered work, the central bird-like creature flanked symmetrically by balancing wings. The religious connotations of the triptych are reinforced by the title, which seemingly equates Bacon's debased creatures with the traditional witnesses to Christ's agony. Yet Bacon subsequently explained that he had intended to position a big Crucifixion image above the triptych. The three 'figures' had other connotations: 'I thought of them as the Eumenides, and at the time I saw the whole Crucifixion in which these would be there instead of the usual figures at the base of the cross. And I was going to put these on an armature around the cross ... But I never did that.' The monstrous Eumenides, or Furies, were protagonists in Aeschylus's great Oresteia dramas, favourite reading matter for Bacon, and they had featured in T.S. Eliot's *The Family Reunion* (1939). For Bacon, the Crucifixion encapsulated the fundamental tragic reality of human existence, and the classical allusion reinforced such dark overtones.

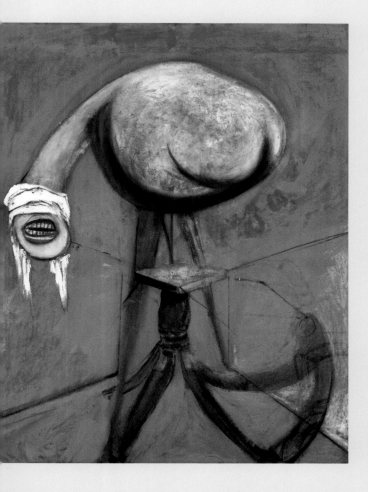

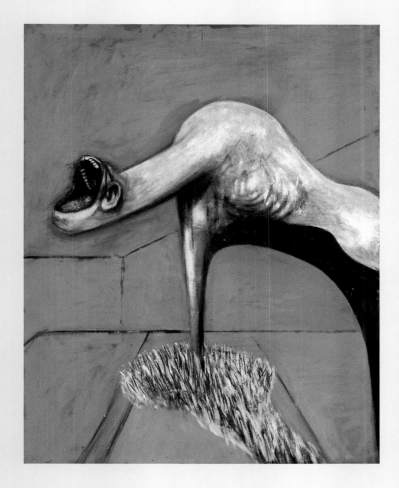

Three Studies can also usefully be viewed in the context of British art. We might note Bacon's friendship with Graham Sutherland, a slightly older painter celebrated for his writhing landscapes and his contributions to the War Artists Scheme (WAS; see Button, pp.118–19), portraying bomb-shattered buildings and apocalyptic steel foundry interiors. The triptych was first exhibited alongside paintings by Sutherland. Stylistically, Bacon's use of black lines to define rudimentary spaces recalls Sutherland's *Horned Forms* 1944 (Tate), where the principal forms are likewise sculpturally modelled in grisaille and played off against flat orange backgrounds. Both artists worked on hardboard supports, combining oil paint with pastel. The ambiguous imagery of Bacon's right-hand panel is foreshadowed in Sutherland's *Green Tree Form: Interior of Woods* 1940 (Tate), where an uprooted tree evokes some monstrous creature lumbering through

the darkness. Both artists adored Picasso, whose work could still be contemplated in wartime via recent issues of the magazine *Cahiers d'Art*. Reproductions of *Guernica* and its studies demonstrated how modernism could be adapted to commenting upon the dire circumstances of modern life, and Picasso's 1927 sketchbook drawings prompted Bacon to extend an idea 'of organic forms that relate to the human image; but is a complete distortion of it'. Bacon's longstanding fascination with Crucifixion imagery was shared by Sutherland, who had chosen the subject when commissioned in 1944 to create a large picture for St Matthew's Church, Northampton. Indeed, the theme was widely employed by artists and poets during the war as a symbol of man's capacity for barbarism. Sutherland's admiration for Matthias Grünewald was matched by Bacon's quotation from the German Renaissance painter's *Mocking*

of Christ 1503 (Alte Pinakothek, Munich) in the bandaged head in *Three Studies*. Finally, Sutherland and Bacon were fascinated by W.B. Stanford's literary study *Aeschylus in his Style* (1942) and were especially taken by the startling metaphor: 'The reek of human blood smiles out at me.' In the *Three Studies*, similarly, distortion and anguish coexist with suggestions of compassion and tenderness, and with the decorative orange, Bacon's 'favourite colour'.

FURTHER READING

M. Hammer, *Bacon and Sutherland*, New Haven and London 2005.

M. Harrison, *In Camera: Francis Bacon, Photography, Film and the Practice of Painting*, London 2005.

M. Peppiatt, *Francis Bacon: Anatomy of an Enigma*, London 1996.

J. Russell, *Francis Bacon*, London, 1979.

D. Sylvester, *Interviews with Francis Bacon*, London 1980.

Art in Post-War Britain: a Multiracial View

RASHEED ARAEEN

Art must reflect the society in which it is produced, its specific culture and ideology. But, at the same time, art must also question and challenge what may be an obstacle to development as a more humane and enlightened society. Britain is now a multiracial society as a result of post-war immigration from Asia, Africa and the Caribbean, and among the arrivals were visual artists who by the end of 1950s had turned the mainstream into a multiracial art scene. Their encounter and experience of modernism in Britain produced in them a creative response that not only enriched its visual art production, but also redefined the whole context by which modern art has been perceived and understood (see also Stephens, pp.106–7).

The achievement of Afro-Asian artists in Britain is an important contribution to this society's struggle to come to terms with its past as well those continuing legacies which may be obstructing its march forward. Without now redefining itself it cannot fulfil its aspirations for a multiracial, postcolonial society. But all this depends on the way Britain continues perceiving itself: whether it comprises separate and exclusive cultural communities or an integrated whole in which all its citizens are equal without being categorized separately on the basis of racial or cultural differences. Even when it must adopt or recognize its cultural diversity, this should not become a substitute for the equal rights of all its citizens who must be free to think and act according to their own aspirations and imagination.

Although the discrepancy between these artists' own perceptions of themselves as free citizens and British society's expectation of them to be culturally specific has hindered their integration and acceptance within a common British history, this has not prevented them from entering the mainstream and confronting it. In fact, when we look at the work of Afro-Asian artists in the same way we look at the work of artists of European origins, using common criteria – both aesthetic and historical – what we see is not an exotic addition to post-war British art, as is generally perceived, but instead a contribution that occupies a central position within historical developments of modernism.

When the first generation of Afro-Asian artists arrived in Britain in the 1940s and 1950s – with the exception of Ronald Moody who came

98 FRANK BOWLING
Who's Afraid of Barney Newman 1968
Oil on canvas 234 × 122 (92⅛ × 48⅛)
Tate. Presented by Rachel Scott 2006

here from Jamaica in 1923 – what they encountered was a continuity of figuration within Western modernism. The response of artists like Ronald Moody, Francis Newton Souza (fig.99), Avinash Chandra (1931–91), Ivan Peries (1921–88), Uzo Egonu (1931–96) and Frank Bowling was not to follow in this vein but instead to innovate a form of figuration that reflected the complexity of enhanced experiences of modernity in a Western metropolis by those whose previous experiences were limited by the modernity of the colonized world (fig.98). However, this gap between the 'centre' and the 'periphery' began to collapse when other artists like Aubrey Williams (1926–90), A.J. Shemza (1928–85), Ahmad Pervez (1926–?79), Iqbal Geoffrey (b.1939) and Balraj Khanna (b.1940) put themselves in the forefront of the emergence of new abstraction in Britain after the arrival of Abstract Expressionism from the US in 1956. By the mid-1960s the situation changed so radically that we find Kim Lim (1936–97), David Medalla (b.1942), Li Yuan-Chia (1929–94), as well as the current author (fig.50, p.79), challenging the very boundaries of modernist art practice, and in so doing creating pioneering works of Kineticism, Minimalism and Conceptual art.

The 1970s was a period of new social consciousness, resulting particularly from the women's movement and black struggle, out of which emerged new methods of artistic practice. Again, we see Medalla and Araeen involved in the forefront of developing a new approach to the political avant-garde. However, after a brief emergence of what is known as the 'black art movement' in the early eighties, the whole thing was reversed with the arrival of postmodernism and postcolonial cultural discourse that legitimized culturally specific works, allowing artists like Anish Kapoor and Shirazeh Houshiary to establish themselves as the successful role models for young Afro-Asian artists in the 1990s, who were concerned with their identities.

It is therefore important that the work of Afro-Asian artists is not put into a specific cultural category or seen as peripheral to mainstream art history, particularly when they have pushed the boundary of modernism beyond its Eurocentric limits and fulfilled its historical mission to allow within it a place of all people and all cultures. However, the history of modern art is still perceived to be the exclusive domain of white European/North American achievements, a myth that denies the reality of the

whole modern world and what it has produced as art. The aim of the revised history of art in post-war Britain is to debunk this myth and establish a new framework for the re-writing of the history of modernism not only in the West but the whole world.

99 F.N. SOUZA
Crucifixion 1959
Oil on board 183.1 × 122.0
(72⅛ × 48⅛)
Tate. Purchased 1993

FURTHER READING

R. Araeen, *The Other Story*, exh. cat., Hayward Gallery, London 1988.
Third Text: A Very Special British Issue, vol.22, no.2, March 2008.

Festival of Britain

BARRY CURTIS

The Festival of Britain was conceived in wartime Britain as a celebration of 'recovery'. Eight years of discussion and planning generated an ambitious brief with a priority for the imaginative role of the arts. The opening ceremony in London took place in May 1951. The Festival was intended to memorialize the centenary of the Great Exhibition, to define the British character, to sketch out the possible roles for a post-imperial nation, to prepare the public for new technologies and their impact, and to introduce the citizens of a new Welfare State to the cultural options that a more democratic and participative society offered. Post-war Britain was known for its New Town initiatives and innovative Hertfordshire schools, but London was a damaged and bleak city with few signs of abundance or modernity.

The nineteen pavilions (fig.100), thirteen cafés, cinema and concert hall were co-ordinated by Hugh Casson and allocated to young architects and designers who would play significant roles in the reconstruction of the nation. The brief was to provide modern structures on the 4½ acre site between Hungerford and Waterloo Bridges on the bomb-damaged South Bank of the Thames, arranged according to picturesque compositional principles and telling an uplifting story about Britain and its people. For the critics of the Festival this was seen as compromised flimsy modernism presented in the patronizing tones of wartime public information. However, the Festival was popular with visitors who seemed appreciative of its narratives and its glimpses into a better future. The Royal Festival Hall, recently restored to its original condition was a complex triumph of innovative technique and sociable planning.

The 265-foot-(81-metre)-diameter Dome of Discovery by Ralph Tubbs and the 250-foot-(76-metre)-high Skylon by William Powell and Hidalgo Moya were two memorable landmarks, both deploying the visual language of science fiction and emblematically memorialized by the London Eye, which now occupies the site. 'The Lion and Unicorn' pavilion, designed by R.D. Russell and Robert Goodden provided an anthropological display of characteristic British objects. Architects used prefabricated technologies, developed in wartime, but the spirit of the place was colourful, festive and, like the décor of Battersea Gardens, indebted to historical styles associated with popular pleasure.

The ironies involved in reconciling tradition and innovation, and the compromised nature of Festival modernity led to a great deal of negative response; the style was seen by some as 'whimsical' and 'effeminate'. Richard Hamilton, an established artist of the next generation, writing on the Festival in 1961, recalled it as superficial and overly concerned with pageantry. The event was also considered unnecessarily insular, with no interest in the influential artistic cultures of Europe or America. However, in time it became possible to appreciate the 'post modern' aspects of the Festival's project (Banham and Hillier 1976), and more recently to appreciate how it functioned as a nationwide consciousness-raising phenomenon, involving regional exhibitions and events and widespread cultural participation (Connekin 2003).

The Festival coincided with the emergence of a new impetus in British art – a re-evaluation of realism (Hyman 2001), and the founding of the Independent Group at the Institute of Contemporary Art, which had opened in the previous year. Hamilton's *Growth and Form*

100 View of the buildings for the Festival of Britain, opened 4 May 1951
Private Collection

101 GRAHAM SUTHERLAND
Origins of the Land 1951
Oil on canvas 425.5 × 327.7
(167½ × 129)
Tate. Presented by the Arts Council
of Great Britain 1952

exhibit was indicative of a new interest in scientific and technological themes. On the South Bank site art was used in decorative and illustrative ways with large murals by John Minton, Keith Vaughan (1912–77), Victor Pasmore, Josef Herman and John Piper and there were freestanding sculptures by Henry Moore, Barbara Hepworth, Jacob Epstein and Frank Dobson (1888–1963), which were less integrated thematically but prominently sited. Graham Sutherland's mural *Origins of the Land* was closely related to the central symbolic project of establishing continuities between the land and the people on a vast historical scale, fusing geology and organic forms (fig.101). As well as official Festival commissions some artists were commissioned by the individual architects of different sections of the site. These included young sculptors like Lynn Chadwick and Reg Butler who went on to make an impact at the Venice Biennale of 1952. Eduardo Paolozzi collaborated with Jane Drew and Maxwell Fry to contribute a fountain in steel and concrete that is indebted to his involvement in the Parisian avant-garde milieu, but also characteristic of a new integrative impetus, bringing art and environmental design together in a way that was characteristic of the Festival's intentions.

There is abundant testimony on the Internet, notably on the Museum of London website, to the contemporary and continuing popularity of the event. The Festival provided a brief glimpse of how a war-torn Britain could be regenerated through a form of pleasurable social democratic modernism. The Labour government, which was closely associated with what was seen as a wasteful (million-pound) venture, was replaced by the Conservative Party shortly after the Festival closed in September 1951; they quickly cleared the site, leaving only the Royal Festival Hall and an area of wasteland that has only recently been reclaimed.

FURTHER READING

B. Appleyard, *The Pleasures of Peace*, London 1989.

M. Banham and B. Hillier (eds.), *A Tonic to the Nation*, London 1976.

B. Connekin, *The Autobiography of a Nation*, Manchester 2003.

M. Garlake, *New Art, New World*, New Haven and London 1998.

The Competition for a Monument to 'The Unknown Political Prisoner'

ROBERT BURSTOW

The international competition for a monument to 'The Unknown Political Prisoner' of 1951–3 was organized in London by the Institute of Contemporary Arts and culminated in an exhibition of 146 finalists at the Tate Gallery. It attracted more entries from Britain than any other of the fifty-seven participating nations and awarded three major prizes, including the Grand Prize of £4,500, to British entrants. Although no monument was ever built, the competition reveals how British art and art institutions were implicated in the ideological and propaganda struggles of the Cold War.

Despite the ICA's association with left-wing politics, and the competition's universalizing theme, it was widely assumed that the monument was targeted at political oppression and internment in the Eastern bloc. Communist nations and sculptors eschewed the competition, though other oppressive one-party states participated. In welcoming 'symbolic or non-representational' treatments of the theme, and appointing jurors sympathetic to modernism, the competition favoured Western modernists as finalists and prize-winners. Among British entrants, F.E. McWilliam (1909–92), Eduardo Paolozzi and Elisabeth Frink (1930–93) won 'runner-up' prizes for maquettes representing, respectively, the Prisoner subjugated by a gaoler, dwarfed by prison blocks, and holding a bird of freedom; Barbara Hepworth won joint Second Prize (alongside Naum Gabo for the USA, Antoine Pevsner for France, and Mirko Basaldella for Italy) and Lynn Chadwick won an Honourable Mention for abstract conceptions symbolizing the Prisoner's intellectual integrity and his triumph over oppression; and Reg Butler won the Grand Prize for a skeletal tower that metamorphosed imagery of imprisonment, surveillance, torture and execution with that of escape, absence, transcendence and 'apotheosis', while allusions to the Cross, an empty tomb and grieving Marys invoked the symbolism of Resurrection. The success of surrealist, constructivist and expressionist maquettes proved highly controversial, provoking tabloid outrage, parliamentary debate, adverse Prime Ministerial comment, and an attack on Butler's maquette in the Tate (fig.103). Moreover, the competition's political tendentiousness became more apparent when the organizers, having previously only indicated that the monument would be erected in Western Europe or the US, announced a site behind the Iron Curtain, in West Berlin, where it would form a dramatic riposte to the recently erected Socialist Realist, Soviet Victory memorial at Treptow. On a hilltop site, later offered by the Berlin Senate, Butler's monument was to tower over the Russian sector and reportedly be visible from 100 miles inside East Germany (fig.102).

The ICA was persuaded to sponsor the competition by its recently appointed Director of Public Relations, Anthony Kloman, who was trying to soften the Institute's radical image in order to raise funds from American 'big businessmen'. Senior ICA managers, including Herbert Read and Roland Penrose, were led to believe that the anonymous patron was the American oil-millionaire, 'Jock' Whitney. But it is now known that Kloman was working for 'old friends' on behalf of the US government and that Whitney was a 'front'. The exact source of the funding remains uncertain but documentary and circumstantial evidence suggests that it originated from an office of the CIA specializing in 'psychological warfare' and led by former colleagues of Kloman's in the agency's wartime forerunner, the Office of Strategic Services.

Senior CIA officers and their wealthy political friends, like Whitney (another wartime OSS officer), shared in the political outlook of the fiercely anti-Communist and internationalist 'New Liberalism'. For an ideology that broadly embraced avant-garde culture as a symbol of Western individualism and free expression, a modernist monument commemorating the victims of Stalinism promised a doubly apt symbol of anti-Communism. However, in the wake of the public, press and political furore that greeted Butler's victory, the backers unexpectedly withdrew their commitment to build the winning design, privately admitting that it was 'too ultra-modern'.

The competition's aborted outcome demonstrates not only that the backers failed to anticipate the inherent difficulty of conceiving a modernist, public monument but also that their commitment to modernism was expedient and pragmatic. Rather than helping to identify Liberalism with cultural freedom, the competition demonstrates that the backers, like their Cold War adversary, sought to exploit the

traditional propaganda weapon of the public monument and manipulate aesthetic and institutional practices for their own ends: modernist sculpture was promoted at the expense of social realism or traditionalist forms; British sculptors were acclaimed to the detriment of their main rivals, the politically less dependable Italians (as Kloman expressly hoped); and the ICA became the 'gateway to Europe' for American high culture, supplanting its former association with more critical, Marxist-Surrealist European culture. If in the short term the competition failed to woo Eastern bloc communists to capitalism, then it succeeded indirectly in the longer term by contributing to the modernization and Americanization of British and the wider global culture.

FURTHER READING

R. Burstow, 'Butler's Competition Project for a Monument to "The Unknown Political Prisoner": Abstraction and Cold War Politics', in *Art History*, vol.12, no.4, Dec. 1989, pp.472–96.

R. Burstow, 'The Limits of Modernist Art as a "Weapon of the Cold War": Reassessing the Unknown Patron of the Monument to the Unknown Political Prisoner', in *Oxford Art Journal*, vol.20, no.1, 1997, pp.68–80.

A. Lapp, 'The Freedom of Sculpture – The Sculpture of Freedom: The International Sculpture Competition for a Monument to the Unknown Political Prisoner, London, 1951–3', in *Sculpture Journal*, no.2, 1998, pp.113–22.

A. Massey, *The Independent Group: Modernism and Mass Culture in Britain, 1945–59*, Manchester and New York 1995.

102 *left* REG BUTLER
Photomontage showing the proposal for a Monument to 'The Unknown Political Prisoner' on its proposed site in West Berlin 1957
Collection of the artist's estate

103 *right* REG BUTLER
Working model for a monument to 'The Unknown Political Prisoner' 1955–6
Forged and painted steel, bronze and plaster 223.8 × 87.9 × 85.4 (88¹⁄₈ × 34¹⁄₂ × 33⁵⁄₈)
Tate. Presented by Cortina and Creon Butler 1979

The Independent Group

DAVID ALAN MELLOR

In 1952, only two years after the new Institute of Contemporary Arts (ICA) had opened in Dover Street in London's West End, the Independent Group (IG) was embedded within it as a kind of cultural pressure group. It was made up of dissenters from the recently established consensus for a Parisian-based Surrealist-modernist agenda favoured by that older generation who had founded the ICA – Sir Roland Penrose in particular. The IG's initial movers included the Courtauld Institute art history student Reyner Banham and his wife Mary, the critic Lawrence Alloway, the innovative young architects Peter and Alison Smithson and James Stirling, as well as the painters, sculptors and collagists Richard Hamilton, William Turnbull, John McHale (1922–78), Magda Cordell (b.1921), Nigel Henderson (1917–85) and Eduardo Paolozzi.

In the IG's expansive period – from 1952 to 1955 – lectures and informal discussions in pubs, participants homes and, more formally, in the ICA, together with experimental environmental exhibition formats, were the vehicles for evolving a vision of social modernization stemming from industrial technologies. The IG can be taken to represent a third wave of twentieth-century British *avant-garde* art – after the Vorticist moment of 1914 and Unit One in 1934. It shared similar interdisciplinary bases and strong links to technological imperatives with those earlier visual culture insurgencies. Collage methods and an abiding interest in architectural design encountered each other through optics and mentalities well accustomed to the practices of pre-fabrication that had so characterized the military technologies that dominated British industrial practices in the 1940s and 1950s. This assemblage technique marked out the practitioners and critics within the IG circle.

Very early in its existence, the IG acknowledged André Malraux's vision of a world of photographic multiplicities and virtuality in his *Museum without Walls*. This concentrated on the spectacle of photo-mechanical reproducibility – as with Paolozzi's seminal April 1952 epidiascope lecture of (mostly American) torn-out magazine advertisements and photo-features, which revelled in a low, vulgar modernism, an aesthetic wholly at odds with the high moral seriousness of the humanist and welfareist universe of such ICA affiliates as Henry Moore. This lecture had been a form of collage-as-performance, with Paolozzi acting as a kind of provocative and improvisatory image-jockey. In the following year, together with Nigel Henderson, Paolozzi designed the ICA exhibition *Parallel of Life and Art*, which drew together scientific, medical, anthropological and art-historical photographs in an enveloping environmental form.

A correspondence was made between these scavenged images and the contemporary pictorial lingua franca of organic abstraction, a stylistic possibility extended by Nigel Henderson in his *Head of a Man* (fig.104), fabricated for Group 6's

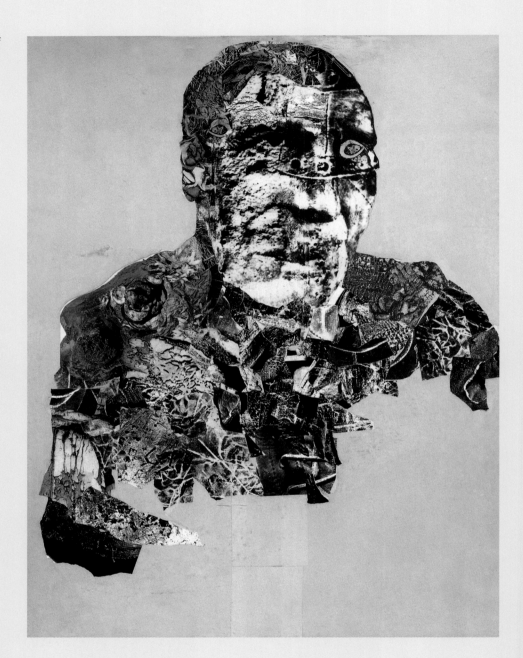

104 NIGEL HENDERSON
Head of a Man 1956
Photograph on board
159.7 × 121.6 (62⅞ × 47⅞)
Tate. Presented by
Colin St John Wilson 1975

105 RICHARD HAMILTON
Trainsition IIII 1954
Oil on wood 91.4 × 121.9 (36 × 48)
Tate. Purchased 1970

installation for the ambitious multi-part and multi-curated exhibition, *This is Tomorrow*, held at the Whitechapel Gallery in the summer and autumn of 1956. Henderson's *Head of a Man* sat in a stylized Bethnal Green garden shed, but such a domestic context belied its disjunctive significance, since it invoked another area within IG's preferred iconography of the vulgar – science fiction and the horror film. Infinitely aged, alien and an abraded and blasted palimpsest of photo-mechanical traces, *Head of a Man* was adjacent to Paolozzi's impacted flat assemblages of motor-car technologies, which composed portraits, in his *Automobile Head* screenprints of 1954.

In that same year Paolozzi's delirious engagement with consumer technologies was rivalled by Richard Hamilton with his *Trainsition* series of paintings. While the painterly style and technique was somewhere between Cézanne's watercolours, Divisionism and early Duchamp, Hamilton centred himself upon the imaginary narratives of Hollywood entertainment. *Trainsition IIII* draws on the recurrent thriller film device of a speeding automobile viewed from an equally speeding train; like the contents of Reyner Banham's retrieval of Futurist theory, Hamilton dissected a mobile, speeding optic (fig.105).

The manifold pleasures and terrors offered to the contemporary consumer that provided the armature for Hamilton's poster design for his Group 2 installation – a fairground 'crazy house' for *This is Tomorrow*: '*Just what is it that makes today's homes so different, so appealing*'.

The ambience of American carnival spills over into this display of consumer abundance: a domestic space crammed with a cornucopia of contemporary goods, emblems and furniture. The formative years of the IG took place within a unique moment: this was the social decompression at the end of food and material goods rationing in Britain. It could be said that the IG was calibrated to the advent of the unleashed market economy after the dismantling of the siege economy that had reigned from 1941. This historical moment saw the augmentation of this return to a market economy by the proliferation of promotion and advertising industries in Britain. Yet in their collages and cut-ups Paolozzi, Hamilton and McHale had recourse to advertising and promotional sources which were predominantly American (fig.106), just as the Smithsons decked out their architectural drawings of their 1952–3 East End Golden Lane housing project with photograph cut-outs of Marilyn Monroe and Joe DiMaggio, testaments to an imaginary USA grafted onto a projected British culture.

FURTHER READING

R. Hamilton, *Collected Words 1853–1982*, London 1982.
D. Robbins, *The Independent Group : postwar Britain and the aesthetics of plenty*, exh. cat., Institute of Contemporary Arts, London and Cambridge 1990.
E. Paolozzi, *Eduardo Paolozzi: writings and interviews*, Oxford 2000.

106 EDUARDO PAOLOZZI
*I was a Rich Man's Plaything
from Ten Collages from BUNK* 1947
Collage mounted on card
35.9 × 23.8 (14⅛ × 9⅜)
Tate. Presented by the artist 1971

4 Between God and the Saucepan: Some Aspects of Art Education in England from the Mid-Nineteenth Century until Today

PAUL WOOD

Introduction

The question of education has been a matter of significant dispute in the world of British art since the eighteenth century; that is, since 'British art' and indeed 'Britain' as such began to take on their modern form. For all that, however, art education is something of a Cinderella subject. Art itself, even in Britain where it has never been as central to a sense of national identity as in certain other European countries, has nonetheless excited passions beyond its own borders. In the past, public debate has sometimes been intense, scandal has occasionally flared, while at the beginning of the twenty-first century British art occupies a vivid, albeit unstable, position in the spectacle of media and celebrity that defines contemporary culture. Not so art education: its literature and its debates are overwhelmingly the property of those with a professional stake in it. This has both positive and negative consequences. On the one hand, considerable moral and practical commitments are involved; on the other, a stultifying mix of territorialism and myopia can shroud the field. If the public at large does have an image of art schools, it lies somewhere between envious fantasies of student promiscuity and fear of having the wool pulled over its eyes by privileged narcissists escaping from the real world. It is hard to know what to do with all of this. Does one plunge into debate about assessment, quality control and benchmarking, thereby alienating all but the most ardent educationalists? Or does one skim over the day-to-day hard work and the conceptual difficulty to focus on a confection of egos and advertising, of dedicated pedagogues, bright young things and the vitality of the fashion industry, thereby becoming complicit in the myth itself?

I do not know the answer to these questions. What I do know is that for good or ill I am a product of that very system and must perforce weave the truth – and the biases – of that experience into my account of art education. What I also know is that how a system reproduces its relations of production is both crucial to its continuation and central to its identity. More than twenty-five years ago, I wrote a long pamphlet titled *Politics of Art Education* with a

colleague, Dave Rushton (fig.107).[1] Both of us had been art students in the 1960s and 1970s, both of us involved initially with Conceptual art and later active in its political/cultural diaspora. The point of mentioning this is that, when I now look back on that text, two things strike me. One is that its rhetorical voice comes from a different world. Both post-war social democracy and the Reagan/Thatcher/Brezhnev Cold War, as well as their would-be revolutionary critics (of whom we were two), are separated from the present by a gulf as deep as that which separated those times from the 1930s. Yet the second thing, strange to say, is how little has changed. The voice of management, and the equal and opposite choruses of the rational planners and the creative free spirits, drone on undiminished. They say you should be wary of desire lest you are granted that

which you wish for. The elevation of modular over linear teaching programmes, the educational incorporation of theory, the breakdown of modernist medium-specificity, the critique of the (mostly male) expressive author, perhaps even a questioning of the authority of the Western canon were all songs in our radical repertoire. Yet the fact that these have come to pass, and now count, if not as the norm, then as significant components of a contemporary education in art and design, has been in the end less significant than the fact that the underlying structure (and of course the wider structure-beyond-the-structure) has remained intact.

The last third of the twentieth century witnessed the development, even the normalization, of an 'expanded field' of art activities that first emerged between the late 1960s and the mid-1970s. Art education reflected this, administratively in the so-called 'Coldstream revolution' initiating 'degree-equivalence', and content-wise in its long aftermath.[2] In the extended period covered by the present essay, there have been three broad paradigms of art at work, three distinct senses of the identity of the artist towards which the idea of an education has been dedicated. These are, in chronological order, classicism, modernism (which actually has two phases) and finally the pluralistic state just referred to that we have, inadequately, come to call postmodernist. An inexact equivalence holds for the design aspect of the education in the transition from artisanal craft skills to the inculcation of more overtly managerial competencies, the latter recently much influenced by the advent of the computer. These 'long waves' represent a framing backdrop to the more detailed performances chronicled below. Within this historical framework there are two coordinates between which I shift the focus of my attention, not systematically but as best seems to help the story. These two, it goes almost without saying, are 'art', on the one hand, with its baggage of the ideal, the self, the spirit and value, and on the other, commerce, trade, improving manufactures, i.e. design, with the market inscribed on its heart. To some extent, this is just the way of the world – *our* world, at any rate. When Britain was engaged in winning the real 'first world war', vying with France for global domination in the eighteenth century when France was, in Angus Calder's phrase, a 'revolutionary empire', that empire needed both these cultural forms. It is no cause for surprise that the Royal Academy, with its attendant Academy Schools, was virtually co-emergent in the middle of the eighteenth century with the Society for the Encouragement of Arts, Manufactures and Commerce. No surprise either that the pecking order was established early, too. At the very beginning of his first Discourse, delivered on 2 January 1769, Sir Joshua Reynolds observed that 'an institution like this has often been recommended upon considerations merely mercantile', before going on to condemn such restricted ambition and assert the true order of things between the fine and applied arts: 'If it has an origin no higher, no taste can ever be formed in manufactures; but if the higher Arts of Design [that is, painting and sculpture] flourish, these inferior ends will be answered of course.'[3]

Academic and Classical

Despite those confident-sounding beginnings, however, the century that elapsed between them and the start of the period covered by the present book cannot be regarded as one of cumulative achievement. In the fine arts the Academy stabilized and prospered, but by the middle of the nineteenth century had become synonymous with artistic conservatism, even in artistically conservative England. And the Academy did nothing in the sphere of the practical arts. Various private schools had also opened, but they functioned basically as diversions for the offspring of the well-to-do and as feeders for the Academy. In the field of design the situation was worse, despite the opening of Mechanics Institutes in major cities including Birmingham, Manchester, Glasgow and Liverpool. By the 1830s things had got so bad that the government set up a Select Committee to look into the question of the arts and their connection with manufactures, resulting in a recommendation to establish a Normal School of Design in London (fig.108), along with support for similar schools in major cities, with the aim of improving quality in the spheres both of production and consumption. The linked goals were higher standards of goods (which would notionally help British designs in the face of French and German competition) and the ever-elusive 'improvement of public taste'. However, the flaw in the scheme introduced by the Board of Trade was that the Council of the School of Design, the body it set up to administer the funds provided by government, was largely made up of Royal Academicians. And these individuals were both opposed to industry and

SCHOOL OF DESIGN.

jealous of the Academy's pre-eminence as the training
ground for real artists. There thus began a wrangle that
persisted right through the Victorian period, namely
whether those studying the various branches of design
should or should not be permitted to draw the human
figure.

Benjamin Robert Haydon (1786–1846), chief lobbyist for
an overhaul of design education and critic of the Academy's
hierarchy, who had been the driving force behind the
establishment of the Select Committee in the first place,
favoured an art education that looked for its example to
France: a grounding in figure drawing that could then be
developed in the directions required by various specialized
types of design. The British Schools of Design, however,
turned out to be very different. The Scottish painter
William Dyce (1806–64), appointed to compile a report
on European models of art education, came out strongly
against the French system for what he regarded as its
blurring of the line between fine and applied art. Earlier,
Dyce had been in Rome where he had come under the
influence of the strongly Protestant Nazarene group. This
coloured his view of art as an austere craft practice and
disposed him, rather, to the German model. The German
trade schools, or *Gewerbeschulen*, were part of an integrated
system of technical education involving non-art subjects,

as well as museum study in the pioneering contemporary
German collections, and they were rooted in geometrical
drawing and perspective. It was this model, opposed not
merely in practice but in principle to the inclusion of any
fine art elements in 'practical art' instruction, that became
the cornerstone of the British public art education system.
The 'norm', as it was instituted in the Normal School of
Design, was a tightly circumscribed training in drawing and
modelling based on copying patterns derived from classical
example. Haydon noted in his diary, with some exaspera-
tion: 'The Council has resolved that the *Figure* should
not be the basis of education; 2nd that every Student who
entered the school of design should be obliged to *sign a
declaration* not to practice either as Historical! – Portrait
Painter! – or Landscape Painter!'[4]

Thus originated one of the defining characteristics of
art education in this country for much of the next hundred
years, especially as regards its inclination towards the practi-
cal arts: namely its sheer tedium and the utter restriction
of any intellectual horizon, at least for those outside the
circles of the Academy and without access to Continental
ateliers. These gentlemen learned to reproduce French
academic practice tailored to the distinctive English
climate. The identity of the artist involved here is an
elevated figure, a man of taste, in whose judgement is

109 ANON.
*The Antique School of the Royal Academy
at New Somerset House* c.1780–1783
Oil on canvas 110.4 × 164 (43½ × 64⅝)
Royal Academy of Arts, London

entrusted the central values of the culture as a whole – in theory at least. The practice was often more a matter of 'face painting' and minding one's p's and q's with the powerful, whether of the landed aristocracy or more unusually the emerging industrial manufacturers. But either way, the education of such an artist of the Academy was quite distinct in its aims from the education meted out in the Schools of Design. There were seven stages in the latter course of study, beginning with learning to draw straight lines, before progressing to curves. The next stage involved further 'progress' to shading, albeit the copying of already shaded figures of cylinders, spheres, etc. The next stage involved three-dimensional modelling from casts, though not casts of figures but casts of classical ornamentation or of natural things such as fruit and shells. The level after that consisted of being allowed to draw these casts. After that, the dizzy height of colour was achieved, though only the copying of coloured drawings of, again, fruit and flowers. It was only in the penultimate stage, if anyone ever got that far, that the student was allowed to study the figure, though once again only copying outlines of already

drawn figures, before at last progressing to draw from the figure in the round – though, sadly, only casts of it. Even the final stage, which was supposed to impart instruction in history and principles, essentially involved yet more copying. Actual life drawing was not part of the general course, being restricted to those following specific crafts that required it; and those granted this privilege had, as Haydon noted, to sign an undertaking that they would not take advantage of the experience by trying to become real artists. Student numbers remained pathetically small, and by the late 1840s only fourteen provincial schools of design were in operation. There were conflicts between the national system and more progressive colleges such as Manchester (set up on Haydon's initiative and including life drawing), and the whole saga came to a head when in April 1848 the Board of Trade dissolved the Council of the School of Design.

The failure of the relatively short-lived Schools of Design opened the door for another bureaucratically over-determined system, which this time, however, proved to be of extraordinary longevity. The framework for art education

introduced by the Victorian civil servant Henry Cole (1808–32; fig.110) in the aftermath of the Great Exhibition of 1851 persisted in its core features until the First World War. Indeed, in some of its other aspects such as the way drawing was taught, and its centralized administration, the shadow of Cole's system continued to fall across British art education up until the Second World War. Henry Cole was a career civil servant whose watchword was efficiency: the very thing the Schools of Design had not achieved. The art education system over which he presided was the result of another parliamentary Select Committee, and Cole himself would settle for nothing less than being made 'General Superintendent' of a full-blown Department of the Board of Trade, as he himself put it, 'analogous to the Naval and Railway Departments'.[5] Cole's principal ally was the Academician and friend of Dyce, Richard Redgrave (1804–88), who, as well as being appointed the Art Superintendent of the National Course of Instruction, became the system's leading theoretician. Numerous pamphlets appeared throughout the 1850s and 1860s, as well as the actual designs that were circulated for copying in the schools, culminating in his collected writings, published in 1876 under the title *Manual of Design*.

By the time Cole retired in 1873, there were 120 schools of art, compared to about 20 when he took over. All adhered to the same nationally organized curriculum, which persisted long after Cole himself had stepped down. But it was an incredibly rigid system, involving laborious progression through a series of stages – no less than twenty-three in total – each of which had to be successfully completed and the appropriate certificate obtained before moving on to the next level. Somewhat surprisingly, another thing that Cole's system shared with its predecessor was a neglect of the very thing it was set up to achieve: namely an education in design for use in industry. Perhaps this becomes less surprising when one acknowledges the persistence, well into the Victorian era, of Reynolds's appraisal of the relative priority of art and design. Though no ally of Cole, John Ruskin (1819–1900) was reflecting a wider prejudice when he famously wrote in the Preface to his own course of art instruction, *The Elements of Drawing*: 'Try first to manufacture a Raphael; then let Raphael direct your manufacture.'[6] Be that as it may, the fact is that Cole's 'national course of instruction' rapidly became a system for the production of art teachers, whose competence would be limited to the elementary drawing they themselves had mastered. Once the centre of gravity shifted from the provision of a vocational training in design for artisans to the provision of an instruction in elementary drawing as part of a developing system of general elementary education, the entire apparatus was moved in 1856 from the Board of Trade to the jurisdiction of the Council of Education. At the same time, Cole's department moved from central London to South Kensington, a location that soon became synonymous with the system itself. In due course the National Art Training Schools and the related collection of artefacts that Cole had, in effect, salvaged from the Great Exhibition mutated into the Victoria and Albert Museum and the Royal College of Art.

Once again, as with the Schools of Design, the twenty-three stages of the Cole system – which hardly anybody ever got through – revolved around copying. Even in a relatively vigorous school such as Manchester around half the students were operating at Stage Two, namely, 'Freehand outline of rigid forms from the flat copy' (fig.111).[7] It is telling that one of the recurring motifs in contemporary debate was that of 'drill', referring not only to the repetitive mode of instruction inflicted on the students but equally to the figure of the 'well-drilled South Kensington teacher'.[8]

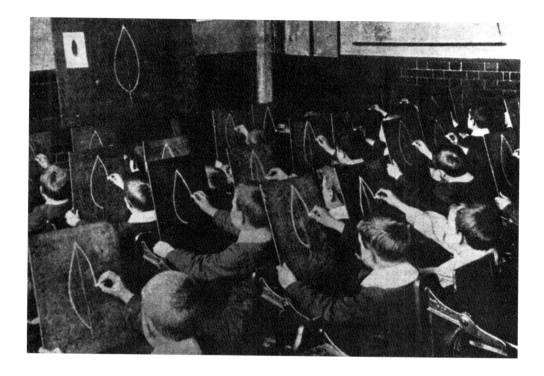

No less a figure than Sir Charles Eastlake (1793–1865), President of the Royal Academy, argued in 1864, before yet another parliamentary Select Committee, that 'it is the very fact of the system of instruction being so stereotyped that makes it safe'.[9] The key word here is 'safe'. In the South Kensington system the teaching of drawing had the same social function as the teaching of basic literacy in the rest of the emerging programme of public education: conferring enough competence to keep the workshop of the world moving, while ensuring people knew their place. It says something about cultural identity that the military metaphor for art education that took hold in Victorian England was square-bashing, a form of training dedicated to knocking all vestiges of individuality out of the recruit. A circular, sent out to government inspectors in 1868, stated unequivocally: 'You should endeavour to disabuse persons of the notion that the kind of drawing which has hitherto been known as an accomplishment in schools for the rich, is that which would be taught under the present Minutes in schools for the poor.'[10]

The paradigm of art in play here, obviously, is classicism, albeit an etiolated classicism that had dried out into a husk and was increasingly incapable of addressing the effects of modernity. Nonetheless, a belief in the change-

less objectivity of underlying values continued to stand behind an education in art. For Redgrave both the unmediated study of nature and reliance on contemporary design practice were 'capricious', out of place in a system of education. Objects of study should solely be 'derived from the antique or from the best periods of the Renaissance'.[11] But however high-flown the ideals, the practice that resulted was desperately barren. Having observed that 'the schools as I remember them were faultless in everything except the instruction dispensed there', George Moore subsequently left this description of a South Kensington art education:

Having made choice of a cast, the student proceeded to measure the number of heads; he then measured the cast in every direction, and ascertained by means of a plumb-line exactly where the lines fell. It was more like land-surveying than drawing, and to accomplish this portion of his task took generally a fortnight, working six hours a week. He then placed a sheet of tissue paper upon his drawing, leaving only one small part uncovered, and having reduced his chalk pencil to the finest possible point he proceeded to lay in a set of extremely fine lines. These were crossed by a second set of lines, and the two

sets of lines were elaborately stippled, every black spot being carefully picked out with bread. With a patience truly sublime in its folly, he continued the process all the way down the figure, accomplishing, if he were truly industrious, about an inch square in the course of an evening.

This could go on for as much as six months, and as Moore concluded, the resulting effort 'had neither character nor consistency; it looked like nothing under the sun, except a drawing done at Kensington'.[12]

For all the power of the classical ideal, however, nineteenth-century art education was also shaped by other more modern ideas. Henry Cole was a personal acquaintance of John Stuart Mill and a confidant of Prince Albert during work on the Great Exhibition of 1851. Cole's educational model of painstaking progression from the simple to the complex was a fairly straightforward application of the utilitarianism he derived from Mill and Jeremy Bentham, who also, it is worth noting, regarded geometry as providing the basis for drawing. Another element of the thinking behind the National Course of Instruction was the social extrapolation from Charles Darwin's theory of natural selection. Cole subscribed to an evolutionism that forbade any system of government grants or compensation, on the grounds that any such 'interference' would violate the natural order. Unlike France and Germany, which both had systems of government support, in England, artisans who wanted an education in art had to do it in their spare time after work. On the other side, there were no funds for employers to send workers for extra training during the working day. Cole was a Fellow of the Anthropological Society, along with Darwin himself and the soldier-anthropologist Augustus Pitt-Rivers, who was in the process of formulating his ideas about the evolution of the design of utensils, weapons and musical instruments and working towards his own evolutionist museum. Philip Steadman writes that there is 'evidence of close contact' between Cole and Pitt-Rivers, 'working in the same intellectual milieu' as the German Gottfried Semper on 'theoretical schemes for the biological study of handicrafts', as well as architecture, and 'drawing much of their raw data from those same collections of early artefacts which were available for study in London in the 1850s' in the wake of the Great Exhibition.[13] In short Cole's educational practice can be related to an influential set of ideas held by Victorian

intellectuals interested in 'the construction of large-scale philosophical theories of the development of human culture according to explicit evolutionary schemes'.[14] Taken together with the debate about the nude, the result, far from reflecting a timeless classical ideal of art, represents a highly condensed and particular set of assumptions about race, class and gender, and their negotiation in terms of an educational system – this latter itself locked into maintaining a wider social, not to say imperial, order.

Early Modernism, and Arts and Crafts

The wider ideals and beliefs behind the national system were widespread among the Victorian intelligentsia, but in terms of practice, as a way of teaching art, the Cole system by no means went uncontested. Ruskin, who had himself initially practised a form of instruction scarcely less laborious than that described, came after 1870 to the belief that: 'The professorship of Sir Henry Cole at South Kensington has corrupted the system of art teaching all over England into a state of abortion and falsehood from which it will take twenty years to recover.'[15] One of the factors behind Ruskin's changed position was the bequest of a wealthy lawyer and collector, Felix Slade, according to which Professorships in Fine Art were established at the universities of Oxford, Cambridge and London. Ruskin took the chair at Oxford, and it was his encounter with the Cole system in operation that gave rise to his criticism. But arguably more important was the fact that University College London added to the bequest and set up a new school of fine art, opening in 1871 and named after its benefactor as the Slade School. Its first head was the Academician Edward Poynter (1836–1919). The school immediately had several advantages. Being part of a university it was more secure than private art schools, with an Academician in charge it had a social cachet and so attracted the sons and daughters of a wealthy social milieu, and last but by no means least, it was independent of the national course of instruction.

In one of his lectures, titled 'Systems of Art Education', Poynter was explicit in stating his aims for the Slade. He began by observing that 'Except at the Royal Academy there is no school of any importance in London for the study of high art'.[16] As for the national organization headed

by Cole, 'in the various branches of the Government Schools, the primary object is confessedly the study of ornamental design, as applied to the industrial arts', and 'attention is only paid to high art in so far as the study of the figure is necessary for some particular branch of ornamental manufacture'. As for the private art schools, while they did at least study the figure, their principal function was to establish levels of proficiency sufficient for students to enter the Academy. Indeed, Poynter comments that in English schools of art 'every kind of difficulty would seem to be put in the way of study from life', such that 'it would appear to be considered a dangerous practice'.

Poynter notes, by contrast, that 'in France a very different order of things prevails to that which is to be found in England'. This difference centred on life drawing. He describes in some detail how in the atelier system French students encountered the model from the outset, before being 'placed before the antique'. His object is to emphasize the 'grounding in the knowledge of form' that life study provides, in contrast to the 'trivial minuteness of execution' encountered in the English system. Poynter committed himself to something quite different for the Slade: 'a course which will be modelled chiefly on the system of the French ateliers'. The Slade subsequently became the main conduit for French theory and practice into the English art world, initially through Alphonse Legros, who had been in the realist circle around Courbet and became Professor at the Slade in 1876, and through Lecoq de Boisbaudrin's institution of a practice of rapid drawing from observation. The formation of the New English Art Club in Chelsea in 1886 reinforced the connection with more forward-looking French ideas (see Harrison, p.42), and the drawing practice followed by Frederick Brown (1851–1941) and Henry Tonks (1862–1937) among others underwrote an emphasis on form that lay at the heart of the burgeoning modern movement. It was influential in English fine art teaching into the middle years of the twentieth century.

The impact of these methods is conveyed in the somewhat romanticized fictional biography of a young English artist, published as *The Education of an Artist* in 1906 (fig.112). The protagonist, Claude Williamson Shaw, who works for a firm of printers, comes late to art after perceiving, as he puts it, 'that Life is a larger tapestry than the pattern woven by the author of Self-Help', the Victorian manual of thrifty self-improvement published by Samuel Smiles. He

encounters an artist, Patrick Lund, who begins to reveal to him the values of genuine art ranging from Rembrandt to Monet, at the expense of Victorian favourites such as William Powell Frith. 'Outspread before them on the table were proofs of *The Fifty Best Modern Pictures*. Lund had turned them over rapidly, frowning, without a word of comment until he came to Frith's *Railway Station*. Then he exclaimed 'Lord !' walked to the window, and stared out over the chimney pots.'[17] Soon, at Lund's behest Shaw goes to Paris to study. The description of his first encounter is worth contrasting with the prevailing system of art education in contemporary England:

Apprehensive, slightly trembling, Shaw knocked at the professor's door. He explained his business: that he wished to join the morning course for six months; that he was absolutely ignorant of drawing but that he had painted a little … 'You are quite ignorant of drawing? Yes? That is no matter. It is better so. You have no bad faults to correct. You come here every morning from eight till twelve. Good. You want anything? I am here. I paint here. Two, three times a week I criticise your work' … They crossed the courtyard, descended a few steps, and entered the large studio. A score of men were at work, some painting, some drawing the model in char-

coal, who was standing upon a throne in what seemed to Shaw rather a complicated attitude . . . A few of the students looked up when the professor and Shaw entered. Shaw was relieved to find that their absorption was so intense that they gave only a momentary glance to the newcomer. 'Where will you have your easel' M. Dinet whispered. 'Look at the model. Then choose your view' . . . The professor gave him a piece of chalk. 'Draw a little line from one leg of the easel to the other, and write your name across the line. See? That is your position for the week . . . Now you begin.'[18]

The subsequent teaching is no less interesting when set against English practice. Shaw is less than competent. The professor sits down and works on his drawing of the life model, showing by example how it should be done. Then 'the professor rose and returned the charcoal to Shaw. "Neglect the details", he said. "Construct the form of the face and hands, not the features and the fingers. Seek the masses. Get the indication line right. Au revoir".'[19] This is the practice invoked by Poynter, looking as it does towards emergent modernism. It is a world away from South Kensington. And it was this world, not the cramped evolutionism or the dessicated classicism of Cole and Redgrave, that informed the education of the most adventurous (and economically advantaged) English artists of the next generation.

A sea-change was under way in the conception of what an artist was, and these relatively technical debates about life study and appropriate styles of drawing were its harbinger. The academic ideal of the artist as the purveyor of unchanging values, essentially that amalgam of biblical and classical narratives lying at the centre of European civilization, and using the laboriously acquired competences of the 'grand style' to achieve this, had been eroded by modernity. Eventually, a new form of art had emerged in France, dedicated to the expression of that modernity. By the final decades of the nineteenth century it was becoming a force even in the relatively constrained practice of English art – with considerable repercussions for what might constitute an education into such a view of art. An exploration of the conditions of the emergence of modernism, and its subsequent translation into an international phenomenon, in effect a new academy, is beyond the scope of the present essay. Suffice to note that by the early twentieth century Roger Fry (1866–1934) was able to write

of 'a reconsideration of the very purpose and aim as well as the methods of pictorial and plastic art'. From the point of view of education, the key shift concerns the acquisition of skills. As Fry points out, the public had come to value skill in the production of an illusion 'above everything'. Yet now, 'skill was completely subordinated to the direct expression of feeling', and the production of illusions had been eclipsed by the striving for a self-sufficient aesthetic reality.[20]

The appearance of the Slade, and the openness that it marked to French example, particularly to the new wave of the Impressionists and their successors, meant that younger English artists who wanted – and had the wherewithal – to align themselves with the emerging modern movement, could do so. But coupled with the failure, or perhaps better, the systemic irrelevance of the South Kensington system, this did nothing to solve the problems of an education in the practical arts. The Royal Commission on Technical Instruction of 1882 remarked in its subsequent Report that 'There has been a great departure . . . from the intention with which the Schools of Design were originally founded viz. the practical application of a knowledge of ornamental art to the improvement of manufactures.'[21] Salvation of a kind, though, was at hand in the emergence of the Arts and Crafts movement. William Morris (1834–96) himself was not directly involved in education, though he did give evidence to the Royal Commission on both the requirement for a universal teaching of drawing and the need to connect it with instruction in craft techniques. For Morris 'everybody ought to be taught to draw just as much as everybody ought to be taught to read and write' and especially 'a man who is going to be a designer wants to be taught to draw thoroughly'.[22] By the time Morris gave his evidence, the national South Kensington system had been ameliorated by Poynter's influence. To Morris Poynter had 'tried to correct the evil' of 'elaborate cross hatching' and 'mere mechanical finish' by shifting the emphasis 'to teach form by drawing'.[23] It is worth underlining however that though, for Morris, Poynter's emphasis on form was a step in the right direction, his own position was distinct from both the attenuated classicism of the South Kensington system and from the emergent *art pour l'art* modernism of the Slade. It derived from late-Romantic, utopian socialist ideals that came down through Saint-Simon and others to Thomas Carlyle and Ruskin, and were given their most forceful expression by Morris himself. All these figures were alarmed by the dehumanizing effects of nineteenth-

113 ANON.
Silversmiths' workshop at London
Central School of Arts and Crafts c.1907

century capitalism and industrialization (see Stallabrass, p.126). Morris, in particular, developed a socialist perspective in which an artistic or technical education would be part of the production of a whole human being: 'What I want to see really is, and that is the bottom of the whole thing, an education all round of the workmen, from the lowest to the highest, in technical matters as in others.'[24] Deeply opposed to the alienating effects of market-induced specialization, Morris rejected capitalism as holding out any hope of fulfilment either for the intellectual or the decorative arts; instead, he discerned the lineaments of the future socialist commonwealth in the Middle Ages when, in Morris's words, 'there was an intimate connection between the two kinds of art' and 'the best artist was a workman still, and the humblest workman was an artist'.[25]

Underwritten by these aims, the Art Workers Guild was founded in March 1884.

Morris's workshop ideal was not, initially, taken up at South Kensington. But his colleague Walter Crane (1845–1915), who had lectured there without much impact, became the first President of the Arts and Crafts Exhibiting Society in 1888, and other colleges took up the challenge. Birmingham embraced Morrisonian ideals and began to teach jewellery and silversmithing from 1890, Crane became Director at Manchester in 1893. Glasgow became renowned for its Art Nouveau-influenced design. In London, several schools of art were set up with a crafts syllabus, including Camberwell amongst others. But the most important was the Central School of Arts and Crafts, established in 1896 with William Richard Lethaby, another

of the founder members of the Art Workers Guild, as its Head. The Central was the biggest and best-equipped college in the country, described in 1901 by the German architect and design educationalist Hermann Muthesius as 'probably the best organized contemporary art school' (fig.113).[26] The old National Art Workshops at South Kensington had been reconstituted as the Royal College of Art in 1896, and Walter Crane became the principal in 1898. Crane introduced some design and crafts into the teaching, and despite his resignation the following year due to the continuing intractability of the Cole system, he acceded to a powerful position on a newly constituted panel of the Board of Education, advising, once again, on the reorganization of art education. The Royal College was transformed in 1901 with the institution of four schools: Painting, Sculpture, Architecture and Design. All were run by erstwhile members of the Art Workers Guild, with Lethaby as the head of the School of Design, organizing a wide portfolio of craft classes, from wood-carving, pottery, printing and metalwork to tapestry, stained glass and book illumination.

The problem for subsequent art and design education in Britain was that this was as far as it went. As Nikolaus Pevsner (1902–83) put it, 'once this stage was reached, once a certain amount of craft instruction had penetrated into some art schools', the movement 'hesitated, halted and broke down'.[27] The snag was that the very attraction of the crafts, under the sign of a more organic, less alienated kind of production, carried with it an antipathy to industry, the machine and mass production. The focus on the small-scale, the artisanal, the hand-worked, and the consequent orientation towards a relatively small sector of middle-class taste that was disposed to such products, insulated developments in education from the real cutting edge of twentieth-century production. It was elsewhere, in the German-speaking countries, that the revolutionary change in twentieth-century art and design education was to be initiated.

The Education Act of 1902 had led to local authorities taking over educational provision in their areas. This had the important consequence that they were able to raise money on the rates to support local art schools. According to Stuart Macdonald, this set the tone for what followed, right up until the revolution in art education after the Second World War: local authority-run institutions, combining art and craft or small-scale design teaching,

and orientated towards local industries. A centrally examined national qualification was instituted, the Intermediate Examination in Art and Crafts, for which students had to submit a range of tightly circumscribed work: drawings of both the clothed and nude figure, anatomical studies, a three-dimensional model of a human figure, some craft work and a short written piece. Yet once again, as in the late nineteenth century, longevity was not necessarily a sign of health, and the system limped along. Fine art teaching continued to consist of an increasingly wooden academicism on the one hand and a rather watered-down modernism on the other, the latter always at least one (and usually a lot more than one) step behind European developments. In the field of the practical arts, as the Gorrell Report of 1932 noted, 'it is common knowledge ... that co-operation between Industry and Art Schools is not always as close as it should be'.[28] Some of the malaise leaks through the words of the Council of Art and Industry report of 1934: it was the job of the art school 'to impart improved taste and a wider understanding of art'. By contrast, 'it is for the factory and not for the art school' to furnish students – that is, those part-time students on release from their places of work – with 'the necessary experience of the methods and processes of manufacture'.[29] It was this kind of snobbish conservatism, always looking down its nose at industry and industrial workers, yet clinging to an outmoded and equally complacent sense of the values of high art (according to which the contemporary modern movement represented something like a disease imported from 'abroad'), that so angered Pevsner when he came to this country from Germany at the beginning of the 1930s.

Pevsner was acquainted with the latest developments of the European avant-garde, notably the ideas of Walter Gropius and the Bauhaus, predicated on a rejection of the subjectivism and aestheticism of the pre-war modern movement, which most of those involved in art in Britain had not yet even caught up with. As far as Pevsner was concerned, the increasing divorce of art from a civic, public role during the nineteenth century and the influence on the modern movement of what he called 'that criminal doctrine of art for art's sake', had rendered a government-sponsored system of art education deeply problematic. What interest could there be for 'a liberal state in spending money on an art understandable only to a small set of connoisseurs'.[30] There is some significance to this. Subsequently, when the Bauhaus became canonized in the 1960s, its teaching was

widely seen as a way of 'freeing' fine art education from the constraints of the incumbent national system, a propadeutic to a fully modernist art practice freed from the 'literary' and the 'academic'. In the 1930s, from a position close to the epicentre of the Bauhaus revolution, Pevsner saw it as substantially remaindering fine art in its Frenchified, aestheticist incarnation. In the report on art and design education that he published in 1937, he wrote: 'It is wrong, sociologically and morally wrong, to base the organisation of art schools on provision for future painters and sculptors.'[31] He did not want to abolish fine art entirely, but he did want to change the balance through a form of instruction that would redirect aspirations, 'to let every future artist pass through a complete craft or trade training in the school. If that deters superficial talents from continuing, all the better. And all the better also if it induces as many students as possible who entered the school with the idea of becoming painters, to change their minds and devote their gifts to design'.[32]

One of the few in England to embrace a similar position was Herbert Read (1893–1968), who explicitly located himself in the tradition of Ruskin and Morris, while distancing himself from the limitations of handicraft. As Read saw, the 'real problem' was 'to think out new aesthetic standards for new methods of production'. Like Pevsner, Read considered that a new approach to design had to build on the structuralist, formalist lexicon developed at the Bauhaus, noting with a certain relish that 'on the whole we should benefit from the total abolition of all academic instruction in art'.[33] Yet the reality of art and design education was 'a system that has grown up in a haphazard way', leading to a crippling 'confusion of values'. The result was a paradoxical situation wherein existing art and design education, tainted by adherence to outmoded notions of 'fine art' and 'taste', was effectively useless, and 'the best formal designs' were being produced in those industries – Read cites the electrical industries – 'where the artist as such never enters'. As Read saw it, 'the only alternative is to convert the schools into factories – which is exactly what the Bauhaus was in Germany'.[34] Likewise sustained by Gropius's conception of the Bauhaus as representing a restructuring of the social role of art, Pevsner was critical in equal measure of unreconstructed fine art thinking *and* the pettifogging shortsightedness of many of the British businessmen with whom he came into contact: 'the narrow-minded, badly dressed provincial

bourgeois whom one meets in so many . . . industries'.[35] Looking back from our own market-obsessed culture, wherein, as Fredric Jameson wrote, it is easier to imagine the end of the world than the end of capitalism, it is unusual to find the modern movement unhesitatingly identified with a radical social agenda. Pevsner even wondered if the Gorrell Committee report of 1932 might herald nothing less than the 'beginning of a "New Deal" in art education'.[36] It was not to be, of course; the 'new beginning' came later and in markedly different circumstances. But Pevsner's integrated vision of the social role of an art and design education remains a benchmark:

occasional improvements of design cannot be of more than ephemeral value so long as conditions of life remain as they are. But it would be a grave error to leave industrial art alone for the time being in order to devote all available energies to other fields. The battle has to be fought on all fronts. Not one of the subjects is less essential, not one can be neglected, neither slum clearance nor the renovation of school buildings, neither the levelling-up of class contrasts nor the raising of standards of design.[37]

Modernism and Degree Equivalence

Pevsner was writing in this vein on the eve of the Second World War. By the time it was over, the world was a different place, and it is important to realize that it was different not just from the 1930s but also from the world of globalized capitalism that we inhabit today. The war had not yet been completely recast as the triumph of democracy over totalitarianism, with this latter term effectively conflating the Soviet Union with Nazi Germany. For many the war had been the result of capitalism's failure: its economic failure in the Depression of the 1930s and its political failure to confront Fascism in Germany and Spain. With all its faults, it was the Soviet Union that had done most to defeat Fascism, and at the highest cost (see Stallabrass, p.142). Few in Europe wanted Soviet-style Communism, but very many indeed sought a way between Russian state socialism and American consumer capitalism. European social democracy held out some hope of a third way. Basic industries and services, from coal and the railways to electricity and gas supplies, were taken out of private hands. Although social democracy was weak in Britain compared to some European nations, the Welfare State represented an enormous change from the pre-war conditions that lay behind Pevsner's admonishments. The Education Act of 1944 set new terms for secondary education for all, and in the field of art education the Ministry of Education *Pamphlet No.6* of 1946 set out to re-examine 'the whole field of education within the national system'.[38] The Bray report of 1948 recommended a new national structure, and the National Advisory Committee on Art Examinations was convened in September 1949 to administer the National Diploma in Design (NDD).

The NDD, however, fell far short of what was needed, in retrospect sharing more with the inter-war situation than with what was to come. Some of the tone can be gleaned from the 1946 *Art Education* pamphlet: 'The stimulus that might be given to students by such undertakings as the making of costumes and settings for a pageant, or painting decorations in a local school or hospital, is bound to be of real value.' Practical instruction still had a traditional craft and trade bias: the 1946 text listed 'painting and decorating, cabinet making, printing, dress or millinery'.[39] Many of the skills that were taught were soon at their last gasp as the consumer society began to gather pace, and mass production in new materials replaced a wide range of artisanal skills. One survivor retrospectively characterized NDD art teaching as 'conservative and unadventurous', going on:

> Though creative activity and experimentation went on under the system, they were seen as extras rather than the main concern of the study programmes, which primarily prepared students for an examination which tested competence in specific arts and craft skills . . . In painting, the skills required were figurative and representational. The work to be assessed, for example, had to be a modest easel picture which included a minimum of three figures, at least one with hands clearly visible.[40]

The painting style that was encouraged 'leant towards English Post-Impressionism, with colour intensities reduced to tonal values and an emphasis on anecdote and narrative subject-matter, as exemplified by Sickert and his followers.' The whole affair was 'mildly authoritarian and highly prescriptive'.

Outside this backwater, however, the current was moving quicker. By the mid-1950s the Cold War was in full swing, and the government was much exercised about Technical Education and the need for new, more managerial, competences, extending far beyond traditional trade skills. The 1956 White Paper ushered in a high level system of Colleges of Advanced Technology, as it sought to restructure Further education for the new era. In art and design, already in 1950, the journal *Art and Industry* had argued that 'training of industrial designers must rest on a broader basis' and that 'a system of higher education designed to produce the new and highly-skilled co-ordinator' should be developed without delay.[41] This new order of perception about the requirements of the technologically

115 ANON.
'The old standing uneasily beside
the new', late 1950s

sophisticated and consumer-oriented society that was coming into being was matched by developments happening in art and design education itself not as a result of government planning but as a result of initiatives taken by practitioners with a more up-to-date sense of the situation than was vouchsafed to the patrician old guard of English fine art. The connection is important. It is all too easy to regard the eventual implementation of the degree-equivalent Diploma in Art and Design as a heroic struggle to formulate a modernist programme and to free art education from the shackles of the academic past, symbolized by the NDD. It may well have been that, but it was also part of a much wider-ranging strategy of modernization that was changing Higher education across the board and was doing so in the name of the managerial competences required by a new phase of capital growth. Not for the last time, the submerged relationship of modernism to modernization counted for as much if not more than the highly visible appearance of the new artworks, the new clothes and the new consumer durables.

By 1958 administrative moves were being made, leading to the publication of the first 'Coldstream' report of the National Advisory Council on Art Education in 1960. Chaired by the erstwhile Euston Road school painter Sir William Coldstream, the Council set out to create the framework for a new qualification, the Diploma in Art and Design (DipAD), intended to match university-level academic and technical education. As to the content that was to fill that framework, from the mid-1950s a small number of artist-teachers, working for the most part outside London in places such as Leicester, Leeds and Newcastle, brought about innovations that laid the basis for the new system of art education. Among the most prominent were Tom Hudson (1922–97), Harry Thubron (1915–85) and Richard Hamilton (b.1922). The principal London-based exponent of this new wave was William Johnstone (1897–1981) at the Central school, who gave teaching positions to Hamilton, Victor Pasmore (1908–98) and others. In all cases the legacy of the Bauhaus loomed large.

Remote from the mandarin smooth-talking of the official documents, Hamilton's account has the ring of truth about the gulf that had opened up between the consumer society and its emergent varieties of modernism on the one hand, and the status quo in art education on the other. As he saw it, 'design education has changed with a changing world ... but fine art education has stuck in a deeply worn groove'.

Just how deep can be seen from his thumbnail sketch of the prevailing situation, the husk of 'Beaux Arts' pedagogy (fig.115): 'study of the antique, in which the student cowers beneath the theatrical gestures of an over life-size plaster cast; still-life, requiring the manipulation, and subsequent rendering in paint, of a collection of junk no self-respecting second-hand dealer would bother to bid for; finally, and above all, the nude, a suburban housewife with a yen for romance comes into the life class to earn herself a new dress – posing for art students whose main ambition is to dribble paint like Jackson Pollock or to cut holes in building board as neatly as Ben Nicholson'.[42] Hamilton and like-minded colleagues inhabited an intellectual universe framed by European Constructivism and American modernism, as well as by an openness to the newly

emergent popular culture that was beginning to be
addressed by members of the Independent Group. By
the beginning of the 1960s, for such figures art education
was in crisis. In Hamilton's view, 'with the relaxation of
traditional disciplines, which has been forced upon the
academies by the changed structure of art in the twentieth
century, we have been left with a void'.[43] It was this void
that Hamilton, Hudson, Thubron and others set out to fill
with Basic Design.

The models were provided by the pre-war Bauhaus
of Walter Gropius and László Moholy-Nagy, and the
contemporary Hochschule für Gestaltung at Ulm headed by
Max Bill and the Argentine Tomás Maldonado. Hamilton
particularly took on board the extent to which the teaching
at Ulm had excised the residual individualist/expressionist
elements of the Bauhaus curriculum. Hudson, having
conducted research into child art in the early 1950s,
seems to have retained more of the subjective ethos.[44] He
thus regarded his teaching at Leicester, and subsequently
at Cardiff, as balancing intuition with more objective-
constructive factors: 'We aspire towards a true psycho-
logical orientation of the individual. We must therefore
concern ourselves with the world of "internal" necessity
and the world of "external" reality'.[45] Similarly, Thubron
said of the teaching at Leeds that 'explorations are of a
scientific and analytical nature', yet also seek to address
'freedoms directly relating to the individual's spirit and
imagination'.[46] All of the programmes, however, began
with the investigation of a kind of visual grammar rooted
in the Bauhaus Vorkurs. The degree course at Newcastle,
which lasted for four years, began in the first year with
what Hamilton himself called a 'rigidly defined programme
of work'.[47] This involved the 'systematic study of funda-
mental elements' such as 'point, line, plane, perspective,
proportion, mechanical articulation, kinetic effects, colour
and so on',[48] a procedure of investigation that Hamilton
likened to the mastery of an alphabet. The other key
element was the equally systematic programme of fort-
nightly reviews in which the students' work was publicly
discussed and analysed by Hamilton, Victor Pasmore and
other tutors. Interestingly, given subsequent problems that
surfaced in the DipAD and indeed continue to stalk its
BA successor up to the present day, the Newcastle course
also involved written work in art history 'so that written
language becomes a natural tool of expression'.[49] This
highly directed course of study in the foundation year was

then 'gradually relinquished' in later years, leading to
what Hamilton described as 'a great variety of styles and
attitudes'.

Among these attitudes, it has to be said, ran a faultline
of endemic sexism that has become a staple of subsequent
feminist critiques of modernism's own myths of liberation.
Most of this has focused on transatlantic masculinism and
the cowboy image attached to Abstract Expressionism and
its derivatives. But English modernism was not lacking in its
gender stereotypes. Care has to be taken with anachronism
here: what appears in period photographs of art college
studios to be a mildly risible preponderance of he-men, all
beards and cable-knit sweaters pointing out the mysteries
of form to elfin teenagers, was sartorial resistance to a
strait-laced culture still wedded to the suit and the rolled-
up umbrella. Many of the jokes in a film like *Hard Day's
Night* (1964) play on that kind of generational gulf. But
there is no gainsaying the underlying attitude to creativity
evident in the lectures given by the modernist sculptor
Reg Butler (1913–81) at the Slade in 1961 (fig.116). Observing
that 'there are biological differences between men and
women which it has become fashionable to ignore; the high
proportion of female art students is a consequence of this',
the author of the formally progressive *Monument to the
Unknown Political Prisoner* went for the sexist bullseye with
his assertion: 'I am quite sure the vitality of a great many

female students derives from frustrated maternity, and most of these, on finding the opportunity to settle down and produce children, will no longer experience a degree of passionate discontent sufficient to drive them constantly towards the labours of creation in other ways.'[50] What is so jaw-dropping about this in retrospect is less its content as such (which, after all, is a staple of the culture), than the ease of its pronouncement: part of a chummy introduction casting a mildly caustic eye over the you've-never-had-it-so-good landscape of modernizing Britain – all student grants and E-Type Jaguars – before scaling the heights required of the serious art student, who has 'to face the full and quite horrible responsibility of working with no other purpose than to express themselves creatively'.[51] These submerged parts of the iceberg of modernism – the philosophical psychology, the politics, the anti-intellectualism – that underlay the anti-academic rhetoric of autonomy were to prove its undoing in the critical climate that emerged in the later 1960s and 1970s. But a decade before that, in an English artistic culture that was only just beginning to free itself from an earlier, more literary, more patrician stage of modernism, they were to all intents and purposes invisible.

Eventually set up in 1964 following the Coldstream recommendations, the degree-equivalent courses spanned three years. They were, however, preceded by a one-year Foundation Course, which could be undertaken at a local college. They also had as a precondition a minimum academic requirement of five passes at the General Certificate of Education (GCE) 'Ordinary' level standard. School students who went on to do art at 'Advanced' level could omit the Foundation year and gain entry straight to the Diploma Courses. But the normal progression was from 'O-level' study at school to the Foundation Course and thence to one of the relatively few nationally recognized colleges awarding a Diploma validated by the National Council for Diplomas in Art and Design. This whole system, which it is now so easy to describe and which in the early 1970s mutated into the award of an actual BA degree – the system that continues fundamentally unchanged to the present day – was the cause of colossal aggravation when it was summoned into being in the early 1960s. It certainly represented the biggest upheaval in art education since its distant origins in the nineteenth century.

There were many areas of dispute. One that was significant at the time tends now to be overlooked because the matrix of tertiary provision has altered. This was the separating out of the elite degree-equivalent courses from a numerically larger vocational sector. (The vocational 'designer/craftsman or technician' was fastidiously damned in Coldstream as 'one who, though capable of appreciating creative work, is not normally called upon to initiate such work' – clearly not officer material.) Vocational students, and the colleges that taught them, remained very much the poor relations in the rush to establish the blue-riband sector. Indeed, the cull of colleges that applied to offer the new Diploma courses was the second main cause of distress. Out of eighty-seven colleges that applied, only twenty-nine were approved in the spring of 1964.[52] A combination of factors, including the sheer inadequacy of places available, as well as massive regional imbalances in provision, led to feverish upgrading and a second round of submissions. As a result, a further eleven colleges were admitted into the elite in 1966. That was it, however, which meant a lot of disgruntled tutors and colleges relegated to the second division of vocational provision.[53]

A third and related area of conflict reprised the century-long tension between art and design. The lingering patrician bias of the Coldstream reformers comes out in an exchange on 'The Future of Art Colleges' from 1957. Julian Trevelyan, of the Chelsea and Royal colleges, averred that 'painting is the basis of all art training', since it confers 'some sort of control . . . of the elements of colour, balance, form, all these things, and once you've mastered them, you can move on'. Others saw things differently, believing that 'art schools are inferior technical institutions'. However, Robin Darwin, a senior figure on the Council and Rector of the Royal College, clinched the argument for a special role for the fine arts with his assertion that painting 'has an infinite about it' and that, 'particularly with the young, it can allow them some sort of touch with God . . . which a saucepan can't'.[54] The ghosts of Reynolds and Ruskin would have nodded appreciatively. Despite the influence of the Bauhaus and other modernist ideas within the DipAD, a deeply traditional sense of fine art as the receptacle of civilizing values continued to have the upper hand.

The other great area of conflict lay in the academic requirements that were laid down for the new qualification. These concerned both the O-level entry requirement, and the stipulation that within the degree-level courses, 15 per cent of time be devoted to 'Art History and Complementary

117 ANON.
Freedom to Create 1968
Handbill produced during
Hornsey occupation

later something was going to blow up. The occupation of Hornsey Art College in north London by its own students in the summer of 1968 has achieved mythical status (fig.117). The Hornsey occupation is not only compared with the politically more self-conscious activities at the London School of Economics, and with contemporary student militancy throughout Europe and the United States, it is sometimes privileged over them. The argument goes that whereas the latter were mired in leftist politics, the former was free of dogmatism, openly challenging orthodoxies of all stripes, Left no less than Right – an English manifestation of Situationist critique. It is the belief of the present writer that this is a weight Hornsey can scarcely bear. But that is part of the nature of myths: it is the symbolic status that matters, not the calculable achievement. In the early to mid-1960s, Hornsey, under its Principal Harold Shelton, was regarded as perhaps *the* most dynamic art college in the country, a sort of flagship of the new art education, making a splash in the media and attracting various hot properties from the burgeoning worlds of design and fashion. In Lisa Tickner's description, Hornsey was on the way to becoming 'a specialist design research institute somewhere between the Bauhaus and the Royal College of Art'.[55] Historically, the crisis was precipitated when the ambitious college management ran into the consequences of short-sighted local government reorganization. Although the college had achieved a high profile, facilities were not good and improvements were needed. Instead, cutbacks occurred, including a freeze on Student Union funds. In the enervated conditions of the time a protest meeting rapidly turned into the full-scale occupation of the college. A partition separating staff and student eating areas was removed – in itself a symbolic gesture – and in adjacent rooms there began a series of intensive plenary discussions involving Hornsey students, students from other colleges, staff and many visiting speakers that lasted through the six weeks of the occupation. When it finally collapsed, the college was closed and did not re-open until November, well after the normal beginning of the academic year. Not unusually in such situations, there were reprisals: those students perceived as 'ringleaders' were expelled, and staff who had supported the occupation were dismissed.

Those are the bare bones over which the cloak of counter-cultural myth has descended. The most famous text to emerge, among the many that were produced, has been *Document 11*, bearing the title 'The Structure and

Studies', leading to an examinable component alongside the student's practical work in either art or design. It is difficult now to appreciate the furore that this caused, seeming as it does to be no more than a requirement for basic literacy coupled with at least some knowledge of the field in which one aspires to practice. But at the time it functioned as a sort of lightning conductor for a constellation of concerns embracing everything from resistance to patrician definitions of the national culture to a modernist philosophical psychology that drove a wedge between the visual and the verbal. When I first went to Barnsley School of Art in 1967 to study the Foundation Course – in complete ignorance, it should be said, of 'modernism' – I quickly imbibed the lesson that the two qualities in art we were supposed to disparage were the 'academic' and the 'literary'. At a stroke, both theoretical reflection (except for the homage to a Bauhaus grammar of 'point, line and plane') and any conventionally representational art were set beyond the pale. A deep-seated suspicion of the old was widespread, and little seemed older and more discredited than the academic proprieties it was felt were being used to shackle the new art education.

In the increasingly volatile cultural climate of the 1960s, with students at the epicentre of the conflicts, sooner or

Content of Art Education'.[56] Its main focus is on the disputed 'academic' status of the DipAD, in particular the O-level entry qualification and the art history/complementary studies component of the courses, as well as the related division of courses within the overall national system into degree-equivalent and vocational. Its real force however lies not in the delineation of concrete alternatives to the existing structure so much as in a dissenting view of what an art and design education should be. The main claim concerns the shortcomings of 'the linear structure' of existing education, compared to 'a network system' that will generate flexibility, leading to the emergence of what is called a 'bridge personality', able to 'make vital connections between apparently different disciplines'. This is coupled with a claim for the virtually complete disjunction between verbal and written language, implicitly identified with the 'linear', and 'ability in art', which is, of course, aligned with creative 'network thinking'. There is no question that left-wing politics, those of both the traditional Communist Left and the emergent New Left, were seriously deficient when it came to understanding the consumer society and the world of the new mass communications media – the very sea in which art students were swimming. But the opposition of 'network' and 'linear' thinking remains largely rhetorical. The most robust of the claims is that art history should 'inform and permeate studies in art and design' – quite so, but any genuine integration of theory and practice would have demolished the modernist premises of the word/image disjunction itself. The potential for a critique of modernist assumptions about artistic creativity remained undeveloped in the Hornsey debates.

More to the point, worse problems arise out of the single concrete example with which *Document 11* fleshed out its argument for flexibility. A lengthy description is offered of a computer typesetting machine supposedly lying idle in a Fleet Street newspaper building, capable of operating 'at high speed and low cost' but prevented from being used by the rigid attitudes of the human typesetters who regard it as 'a threat to their means of livelihood'. New technology was a serious issue, then as now. But all *Document 11* has to say is 'if their education had been different, they would respond differently'. Indeed, the designer who is 'adaptable' will 'survive', while the one who is not 'will be eliminated'. The alarmingly Darwinian rhetoric does indeed let the managerial cat out of the bag. Luddism is not an option, but a failure to relate the human

costs of technical innovation to the profitability it promises remains a failure. Resistance to technology and resistance to the untrammelled sway of market forces are categorically distinct strategies, though seldom represented as such within the prevailing ideology. As it happens, history provided the test. Forced introduction of new technology in the print industry was a key part of the Thatcher government's industrial relations policy of the 1980s, aimed at destroying trade unionism and transforming British capitalism into a kind of safe haven for the multinationals (not least the media empire of Rupert Murdoch). The defeat of the print unions was as significant as the related defeats of the steel workers and the miners in opening the way for an almost complete domination of economy, society and the media by the values of big business, to which new technology – and design – have largely been annexed. Of course, many struggle to promulgate intermediate technology and dedicate their design practices to resisting rather than promoting capitalism, but it is a struggle against the grain of the system. Naivety about the socio-economic totality that an education system serves is little recommendation for being taken seriously in the long run. The Hornsey students can be forgiven their utopic moment in the carnival of 1968. But they are ill-served by successors who celebrate their enthusiasms at the expense of recognizing their limitations.

Politics and Polytechnics

Things were moving fast in art in the late 1960s, and with benefit of hindsight one of the things that quickly becomes evident about the Hornsey occupation is that in certain key respects its targets were already becoming out of date. Two factors merit attention: the administrative structure of the colleges of art and design, and the conceptual structure that was being challenged.

The context for the Coldstream reforms was a wider consideration of higher education provision.[57] The Colleges of Advanced Technology were granted university status, but of greater consequence for the art sector was the inception of the Council for National Academic Awards (CNAA) in 1964, and the adoption of the so-called Binary System in higher education. The result of this was that by the end of the decade, the vast majority of the twenty-nine, and

subsequently forty, independent colleges awarding the degree-equivalent Diploma in Art and Design were in the process of being incorporated as mere 'Faculties' into much larger 'polytechnic' institutions. Henceforth, the art qualification was a simple BA, like everything else, and the Arts Faculties became subject to the entire administrative superstructure of the polytechnic, in terms of staffing, accountability, staff/student ratios, status on committees *and* academic entry requirements (which rather than being relaxed were increased to A-level status). This had the effect of further entrenching both the erstwhile diploma/ vocational level distinction and the academic component of art history and complementary studies. The potential bureaucratic opposition to utopianism became much bigger, much stronger and by no means necessarily sympathetic to the special – and potentially expensive – claims of the arts as such. Polytechnic administrations were notoriously hard-headed, and the 'softer', cultural subjects were not the forte of the engineers and accountants who ran them.[58]

Intellectually speaking too, the targets of the sixties, student radicals were in flux. Opposition was aimed at the patrician, old-university aspect of Coldstream's academic component. But Coldstream's modernism, rooted in the 1930s Euston Road school's admixture of social realism and French painting practice had already been eclipsed by transatlantic modernism. The compound of Abstract Expressionist practice and Greenbergian formalist theory had already proved compelling to the most forward looking of British artist-teachers. The 'Advanced Sculpture Course' at St Martin's School of Art had begun in the 1950s and became the base for most of those identified with the 'New Generation' of British sculpture, which came to prominence in the mid-1960s (see Harrison, p.36 and Westley, pp.190–1). Under the practical leadership of Anthony Caro (b.1924), and with a couple of visiting seminars conducted by Greenberg himself, St Martin's became the bridgehead for the dissemination of American modernist ideas into the hitherto insular world of British art. However, American modernism was even less disposed to the incursions of theory into practice than had been its French-influenced predecessor. It was axiomatic to the disposition against the academic and the literary that reflection damaged creativity. According to Greenberg, self-criticism was 'altogether a question of practice . . . never a topic of theory'.[59] The institutionally framed

demand for originality *could not* entertain reflection upon the conditions of practice as a possible constituent of an art practice.

It was precisely this contradiction that led to the confusing situation whereby in British art, and particularly in British art education, high modernism was subject to challenge almost as soon as it rose to prominence. The new 'A' course at St Martin's, involving Peter Kardia, Garth Evans and Gareth Jones among others, saw questions being raised early on about the premises underlying Caro's formalist practice and the attendant system of 'crits' employed in teaching it. In the retrospect of Nick de Ville, 'the course sought to widen the prevailing discourse of sculpture by opening up the debate about the nature of contemporary art to influences as diverse as linguistics, phenomenology, cybernetics, psychology and cultural theory. Although its approach to these fields was less than systematic, engagement with them expanded the horizons of art's possible subject matter'.[60] In 1967 Richard Long (b.1945), while still a student at St Martin's, was beginning to produce works in which elements were placed in different locations, such that a spectator could only ever see one part, and thus have a solely 'mental realisation' of the whole. In Charles Harrison's account such work effectively positioned itself as 'strategically out of reach' of modernist critical protocols.[61]

St Martin's also witnessed the most spectacular collision of modernism and its critics in the shape of the notorious 'purification' by John Latham (1921–2006) of Clement Greenberg's summa of modernist art theory, *Art and Culture*. Latham borrowed the book from the college library and made it the subject of a kind of performance artwork: inviting students to a 'chew-in', after which the resulting pulp was rendered down into liquid form and returned to the library in a test tube. The college authorities failed to appreciate this ironic 'distillation' of modernist principle and created a martyr by terminating Latham's contract. However, the symptoms of paradigm shift evident in developments at St Martin's were not restricted to London. It was the same conflict between theory and practice or, rather, the systematic marginalization of theory *from* practice that drove the 'Art Theory' course implemented at Coventry College of Art by members of the Art & Language group in 1969 (see Harrison, p.62 and Stallabrass, p.142). The prime movers in the design of the course were Terry Atkinson (b.1939), Michael Baldwin (b.1945) and David

Bainbridge (b.1941). Among its key components were 'Techne' and 'Romanticism'. The former was not about technology as such, just as the latter was not an art-historical study of the Romantic movement. In their different ways both held up to scrutiny conventionally modernist assumptions about the nature of the art object and the conditions of art practice – both drawing heavily on the contemporary critique of institutionalized modernism by Conceptual artists working on both sides of the Atlantic. Subsequently, Atkinson and Baldwin published a long essay, titled 'Art Teaching', derived from the experience of the Art Theory course.[62] Two of its principal critical targets were the entrenched 'material-character, physical-object' paradigm of art-making, and the possessive individualism that was cultivated by its modernist authors, whether practising artists, teachers or students.

Conceptual art proved a step too far for the liberalism of the Coldstream system. The Art Theory course at Coventry lasted formally for barely two years. In Charles Harrison's account, 'it was opposed by several of the staff and regarded with deep suspicion by the administration. It was dismantled by the arbitrary exercise of power from above'.[63] In a letter from the Chief Officer of the NCDAD to the director of the polytechnic into which the art college had by then been absorbed, the Art Theory course was deemed to display 'lack of balance'.[64] Students at Coventry who were my exact contemporaries, including Philip Pilkington and Dave Rushton were prevented from following their preferred course of study, under the influence of the NCDAD officer's assertion that 'tangible, visual art objects' had to be submitted for the final assessment. At Newport College of Art, Peter Berry, Kevin Wright and I had been following a comparable, albeit less highly organized, route with Keith Arnatt (b.1930), and we underwent the same institutional strictures.[65] All of this now seems like a storm in a teacup, but the significant point is that the avowedly liberal art education of the DipAD carried embedded within it unexamined assumptions about the nature of art practice, and that these could not accommodate actual changes in art practice that were happening in the contemporary art world outside the colleges.

Text-based Conceptual art might have provided a limit case for the administrators, but it was only part of a more widespread challenge to the centrality of traditional art practices. In the late 1960s and early 1970s photography and film, as well as environments or installations, and soon video, all served to de-centre that production of objects for aesthetic contemplation on which the very idea of a 'fine art' education – however liberally conceived – was premised. The emergence of what subsequently came to be ratified as *post*modernist art was indigestible to a system covertly premised on modernism itself. The value of the collisions provoked at Coventry, Newport and elsewhere was that the contradictions were brought out into the open. They also paved the way for more militant student activity later in the decade, as the boundaries between art practice as such and other disparate forms of cultural radicalism, became definitively blurred.

That second wave of student radicalism brings into focus a further condition characterizing art education in the period. The DipAD had been predicated above all else on expansion. The driving force behind Hornsey, underlying the hopes for 'network thinkers' and interdisciplinarity, was the clamour for more resources: more staff, more modern equipment and buildings. Yet in May 1967 the government announced a moratorium on further expansion in art education. There were various false dawns after that, notably the optimism of the Coldstream-Summerson Joint Report published in 1970 in belated response to the student activism of 1968. But in 1970 a Conservative government was elected, with Margaret Thatcher as Secretary of State for Education; and by 1972, with the economy beginning to run into rough waters, the state was ruling that 'it is doubtful whether the interests of economy and rational distribution of provision will justify the approval of more than a few courses' at new centres.[66] This retrenchment formed the backdrop for later radical activities in the art colleges. As well as more conventional militant activities in which students mobilized against cuts in educational provision and rising tuition fees, as well as rising unemployment and racism in the culture at large, the Art & Language/ Conceptual art diaspora became more politicized, extending through several student generations and various colleges.[67] An Art & Language-inspired project under the rubric of 'School', aimed at uniting these different voices and gave rise to several combative, self-published journals: *Issue* at Trent Polytechnic in Nottingham, *Ratcatcher* at Hull and *Ostrich* at the Royal College of Art.

In 1976 as part of growing opposition to cuts in education, and the closure of teacher training colleges, 130 colleges, polytechnics and universities, including several colleges of art, experienced student occupations of varying lengths and

intensities. The response to this wave of militancy was of a very different order from that which greeted the utopianism at Hornsey. In an attempt to develop the politicized Conceptual art student network, Rushton investigated the possibility of using then new technology to maintain a flexible information service between radicals in the colleges – the stillborn Art Microform Journal (a sort of premature anticipation of the various 'intranets' now routinely used by college administrations). And, more conventionally, two publications appeared, both edited by Rushton and myself. *Politics of Art Education* offered a detailed critical survey of art education between 1945 and 1977, as well as including more conjunctural essays by students from the Royal College and Leeds. *The Noises Within . . .* represented an anthology of the most vivid contributions from the critical local journals of the mid-1970s.[68] This was intended as a contribution from the art sector to a much wider debate on the prospect of 'counter-courses' running across the range of the humanities and the social sciences.[69] In common with much else of a similarly radical temper, these guerrilla initiatives rapidly foundered on the reefs of the 1980s.

Postmodern and University

Ironically, it was the very depth of the recession of the 1980s, coupled with the abrasively reactionary politics of the Thatcher government, that finally gave rise to change. The generation of so-called 'Young British Artists' of the 1990s became part of the most publicly fêted upsurge in British culture since the 1960s; indeed, in the field of the erstwhile 'fine arts', for better or worse they collectively achieved one of the highest profiles ever (see Gallagher, pp.230–1). This success was inseparable from developments that had been taking place in art education. By then the bureaucracy of the polytechnics was being replaced by the even more pervasive administrative protocols of the new universities, into which the polytechnics were transformed by Conservative education policy. Far from withering, 'Complementary Studies' expanded into fully institutionalized Cultural Studies departments. The long-running tension between studio practice and critical thinking continued, but more insidiously a new element had appeared. This was schooling in 'Business Studies', as part of an exponential growth of the market ethos and

the transformation of art students into potential small businessmen and women.

In cities like Manchester and London, goaded by the apparently complete absence of career prospects, and the generally hostile environment of Thatcherite Britain, art students took things into their own hands and, playing capitalism at its own game, began to take over empty properties to mount exhibitions and related activities. *Freeze,* put on in 1988 by students from Goldsmiths College in London, was only the best known. During the 1980s and 1990s Goldsmiths established a reputation as *the* art college of the moment, much as St Martins had been in the 1960s. Indeed, it was Goldsmiths that, arguably, finally put an end to modernism as a living force in art education, long after it had ceased to be so in the art world at large. Efforts like the Art Theory course at Coventry and the 'A' course at St Martins had signalled the new avant-garde's challenge to institutionalized modernism, but the system with all its inertia and vested interests had continued. However, change across a broad front did gradually happen within the evolved system of the university-embedded BA. The impact of feminism and the sea-change from traditional leftism to identity politics permeated educational practice – as did the challenges to medium-specificity, to expression theory and to orthodox conceptions of authorial identity that had become commonplaces in the wider culture of art. It could be said that Goldsmiths was both symptom and cause; either way, the college institutionalized these changes, not before time, and very successfully.

According to Gill Perry Goldsmiths' teaching involved 'an open-studio system in which traditional divisions between departments of painting, sculpture, photography etc were abolished, enabling students to move and work between – or combining – different media and genres' (fig.118).[70] For Perry this more open structure liberated a generation of artists, not least women artists, and led directly to a hitherto unknown diversity in British art. Although Jon Thomson (b.1936) had begun to develop new approaches at Goldsmiths in the 1970s, it took time for the changes to bear fruit. Thomson himself acknowledged that the course represented a kind of synthesis of the twin legacies of the Duchampian tradition of the ready-made and the phenomenological consequences of Minimalist installation. By the account of Nick de Ville, who himself worked at Goldsmiths, there were four key features to the new approach. The first was a basis in a social rather than

exclusively individual form: 'students were organised in open group structures, seminars became the principal fori [*sic*]' of the teaching. This 'encouraged media to be reconsidered within the broadest frames of reference'; that is to say, the focus was shifted away from a modernist emphasis on the exclusivity of different media, and a synthetic approach was cultivated. No less important was the fact that the art-history component was systematically enriched with 'additional forms of intellectual enquiry'. The wave of new theory that had increasingly displaced exclusive histories of art, as well as relatively traditional approaches to practice, albeit in an 'expanded field' of new media, was incorporated into the teaching rather than being a post hoc add-on. The result was an emphasis on 'the cultural situatedness of the individual practitioner' at the expense of a modernist 'valorisation of the autonomous and self-willed artist'.[71] In the 1980s Victor Burgin (b.1941), who was subsequently to become Professor of Fine Art at Goldsmiths in 2002, had remarked of modernism's increasingly sclerotic exclusivity that 'the consequence of modern art's disavowal of modern history remains its almost total failure to be about anything of consequence'. To this barrenness he contrasted the possibility of an art that was 'no longer to be defined as an artisanal activity, a process of crafting fine objects in a given medium, it was rather to be seen as a set of operations performed in a field of signifying practices, perhaps centred on a medium but certainly not bounded by it'.[72] With benefit of hindsight, this reads as a virtual manifesto for the type of art education developed at Goldsmiths. Thompson himself defined 'two of the main concerns' of the Goldsmiths attitude as 'the desire to be formally lucid and materially direct' set against an 'intention to deal with the emerging complexities of contemporary life in an open-handed way'.[73]

Despite the success of the 1990s generation, however, and despite the diversity fostered by Goldsmiths and other colleges that have adopted less exclusive approaches to art teaching, not everything in the garden is rosy. De Ville ended his account of British art education, culminating in the open and highly successful Goldsmiths model, on a surprisingly hesitant note. Recognizing the need to qualify the incipient rationalism of the Bauhaus tradition imported into British art education by Hamilton and others with the disturbance and unruliness of other aspects of the modern tradition, he remarks that Hamilton himself achieved just this through a parallel interest in figures such as Kurt Schwitters. In this he exemplified 'the best ambitions of British art education over the last several decades'. But de Ville goes on to reflect that in the institutional art education that developed, such a 'balance has proved elusive' and that 'its value for the future is even more uncertain'.[74] He is far from alone in registering misgivings.

Writing for the now defunct CNAA in 1992, David Sweet, then a Principal Lecturer and subsequently Head of Department at Manchester, observed that 'Right at the centre of fine art education is something nobody really wants to talk about . . . The neglected topic is nothing less than the definition of the subject itself.'[75] Sweet was writing from a position fundamentally at odds with the Goldsmiths model, indeed advocating a late form of modernist medium-specificity. But for all the anachronism of his proposed solution, his statement of the problem stands. As many others have observed, there *is* a problem over the definition, purpose and certainly the teaching of 'fine art'. British art and design education is Janus-faced. The design component today is more articulated to serving the market economy than ever before, while the sole raison d'être for any kind of art practice is the inculcation of forms of self-consciousness which – however political or unpolitical they may be – cannot do other than question the premises of the status quo and its 'official' culture.

In art education that culture takes the form of what Victor Burgin has referred to as 'a Tsunami of management control', with its models of quality control imported from industry.[76] This is now so pervasive, so invasive even, that it begins to influence the very substance of what can be taught. Andrew Stonyer, an art teacher of many decades, experience, traces a key shift to the late 1980s when 'the balance sheet had replaced the book of the month as the topic of conversation' in college staff rooms.[77] He notes the growing concern with 'economics' and 'efficiency', with the senior management of institutions increasing their influence over the decision-making process. The increasing sway of the balance sheet, indeed the introduction of 'internal market' systems in some institutions, is matched by a vocabulary of 'benchmarking', 'learning outcomes' and so on, which use the ostensible values of openness and realism to insinuate a layer of constraints on what can and cannot be essayed. For Stonyer this is bound up with what he regards as the single most serious problem, namely the 'modularization' of courses and an increasing preoccupation with assessment: 'the means by

which value for money could be ensured'. Moreover, his is not a lone voice. In a talk given on the occasion of an exhibition devoted to the work of Black Mountain College in the United States, David Ryan, an art teacher with considerable experience of the current system, contrasted the openness of the situation at Black Mountain with the 'current situation of fine art education: bordering on crisis'.[78] For Ryan, too, the crisis is rooted in a collision between the open-endedness of the subject being taught and the increasing pressure for 'instrumentality' that prevails in the institutionalized education system. Ryan isolates several factors including 'the restructuring of (open) curricula'; 'the projection of university-wide academic structures onto the discipline'; and 'financial and economic restructuring'. Broadly speaking, this is the same range of factors noted by Stonyer, though Ryan also goes on to indicate a further concern. This is the infiltration of values in the wider culture by the values of the market, such that students are increasingly perceived, both by management and to an extent by themselves, as 'consumers'. In such a world the possibility of open-ended work is overtaken by a culture of 'the commodity and the checklist'.

In my experience of art education and indeed of art-history provision in the contemporary university, I cannot think of a single teacher who would demur from this analysis – at least, none whose judgement I would trust. Comparable misgivings appear to be felt at the heart of the system. The London-based journal of contemporary art *Frieze* devoted most of its summer 2006 issue to a review of 'art schools then and now'. In the part devoted to art education today, Irit Rogoff, Professor of Visual Cultures at Goldsmiths, wrote of 'the extreme bureaucratization and result-oriented culture overtaking British higher education', noting that this template of being required to specify in advance the expected outcome of a process is 'completely alien' to the idea of an art education. In effect, the open-endedness on which such an education is premised, with its requirement for a kind of structural instability, has been 'captured and held hostage' by 'overwhelming bureaucracy'.[79]

This whole range of questions becomes increasingly volatile when even the practitioners themselves are not sure what an art education is, or might be. With the diversification of what constitutes art in the period after the exhaustion of the modernist paradigm, the one certainty seems to be that it is badly served by increasingly invasive administrative protocols. When even research becomes conscripted to the monies educational institutions can claim from government funding bodies the better to secure their own continued existence, then the situation seems, paradoxically, to carry more echoes of the Academy in the *ancien régime* than it does of the open-ended critical enquiry and dissent from the spectacle that we associate with the legacy of the avant-garde. It may seem no less paradoxical to be writing of a kind of crisis in a situation where art and its attendant institutions play more prominent roles in the cultural life of this country than they ever have. Yet, even to pose the issue in relatively conservative terms – that is assuming there *is* some kind of relatively stable, assessable, teachable core to the constellation of activities involved – art education in this country remains perennially challenged: the same long-running doubts about the compatibility of art and design, the same ambivalence about commerce on the one side and ivory towers on the other, the recurrent sense of a void at the conceptual heart of the enterprise, and the now redoubled sense of a rearguard action against a pervasive, almost totalitarian, culture of management values. When I wrote *Politics of Art Education* in the late 1970s, I conjured up an image of art and design education as a figure 'with one foot in the Atlantic, one in a country estate, its head in the boardroom and its heart in an attic' whose contradictions and tensions traced the wider forces at work on British capitalism.[80] Odd that I should have missed out the hands. But now I can see what they are doing: one continues to clutch a paintbrush, the other is tapping on a computer keyboard. Despite Goldsmiths, despite the Young British Artists, despite Tate Modern, the structural weaknesses in the edifice are still there, and outside, in the deserts of global management, the storm is blowing harder. There are always good students, and there are always dedicated teachers, but increasingly these people succeed despite, rather than because of the institutions in which they work. Higher education, art education included, is relentlessly transmogrifying itself into the education industry, and taking its place in the wider consciousness industry. It remains to be seen whether an experimental or critical art practice, let alone an education devoted to encouraging such a thing, can survive in these conditions.

The Art of Swinging London

CHRIS STEPHENS

The term 'swinging London' was coined in April 1966 by an American journalist reporting for *Time* magazine on a cultural revolution in Britain. In fact, the phenomenon the term sought to describe was already in decline. The article incorporated a map of 'The Scene' that included art galleries among its hip boutiques, nightclubs and restaurants. In the 1960s, in an unprecedented manner, fine art occupied common space with more popular cultural forms. London then was seen as the most vibrant city in the world, a centre for fashion, music and design. There was an air of confidence and iconoclasm fuelled by the increasing economic power of the working classes and the young. A long period of rationing and of Conservative government had been succeeded by a boom in consumer goods, apparent prosperity and a generational shift symbolized by a Labour administration.

The roots of art's penetration into a broader, more popular cultural realm lay in the activities of the Independent Group and the Pop artists that followed. Their belief in the importance of popular culture equal to that of high art led to a crossing of boundaries between the two realms (see Harrison, p.55). Crucially, many of these artists were fascinated not simply with certain objects or products but with their means of mediation. Just as the city and motorized transport had fascinated the modernists of the early twentieth century, so artists like Richard Hamilton, Richard Smith and Derek Boshier studied the ways in which photography, mass media, packaging and advertising framed certain products and values. Hamilton's *$he* examines the relationships between sexuality, gender, domestic products and their design and marketing (fig.89, p.140; see also Stallabrass, p.141–2). Smith made abstract paintings based on the forms and colours of cigarette packaging and advertising. Boshier's series of paintings referring to toothpaste were influenced by his reading of Vance Packard's critique of the American advertising techniques that were rapidly being adopted in Britain.

Artists' engagement with expanding media and the resultant panoply of imagery extended to a fascination with the notion of the 'pin-up'. Peter Blake (b.1932) adopted the persona of a fan in much of his work while other artists, such as Gerald Laing (b.1936) and Antony Donaldson (b.1939), based their work on their personal enthusiasms and so signalled not only their

119 DAVID HOCKNEY
We Two Boys Together Clinging 1960
Oil on board 121.9 × 152.4 (48 × 60)
Arts Council Collection

engagement with contemporary popular culture but also their belief that such things were worthy subjects for high art. These included dragster racing cars, Art Deco cinema facades, topical themes and individuals like the space race and Che Guevara and, most especially, erotically charged images of women. Two iconic women – Marilyn Monroe and Brigitte Bardot – were especially common subjects. This was an age of celebrity cults, and for a while the art world and the realms of fashion and celebrity came together.

David Hockney became the 1960s manifestation of the celebrity artist, his homosexually driven dandyish behaviour playing to the popular press and chiming with what was seen as the spirit of the age. At times the prominence of his persona conspired with the apparent banality of his art to threaten the seriousness with which it was received. Coolly abstracted Californian swimming pools overshadowed earlier overtly homoerotic works whose celebration of desires still illegal in Britain showed courage and com-

mitment (fig.119). A similar fate was suffered by Bridget Riley (b.1931), who had developed a form of abstract painting in which black and white patterns created illusions of movement and stimulated sensations of imbalance and disorientation in the viewer (fig.120). These were based on theories of phenomenology and perception and fitted into a wider redefinition of the relationship between the art object and the viewer and of ideas of stasis and kinetics in art. However, they were rapidly appropriated by the design and fashion industries and by association reduced to little more than decoration.

As for many artists, the USA provided Hockney with a rich source of images of an exotic and opulent consumer culture of comfort and convenience. He, Riley and many who followed enjoyed success in the United States and, reciprocally, new American art was increasingly available to be seen in London. The Kasmin Gallery opened in 1963 with a Kenneth Noland exhibition and went on to introduce others of the post-painterly abstract artists promoted

120 BRIDGET RILEY
Fall 1963
Emulsion on hardboard
141 × 140.3 (55½ × 55¼)
Tate. Purchased 1963

by Clement Greenberg. The same year Robert Fraser opened his gallery and showed most of the leading British Pop artists and Americans such as Claes Oldenburg, Jim Dine and Ed Ruscha. Fraser's gallery and the nearby Indica Gallery epitomized the unprecedented inter-action of the worlds of art and popular culture. Indica's director, John Dunbar, was married to Marianne Faithful and backed by Beatle Paul McCartney. It was at Indica that Fluxus artist Yoko Ono met McCartney's colleague, John Lennon, though it was Fraser who held an exhibition of Lennon's own art. Such exchanges reflected not only that art had become associ-ated with popular youth cultures but also the growing relationship between art schools and pop music. It was Fraser who brought together

the Beatles, artists Peter Blake and Jann Haworth (b.1942) and photographer Michael Cooper (1941–73) to produce one of the iconic images of the 1960s, the cover for the Beatles 'Sgt Pepper' album. Ironically, it was from this meeting of high art and pop celebrity that the most potent symbol of the demise of 1960s optimism and liberalization appeared. In February 1967 Fraser was arrested for possession of heroin and convicted along with Rolling Stones Mick Jagger and Keith Richards. Immortalized in a series of works by Richard Hamilton (including *Swingeing London* 1967; Tate, London), the event appeared to be a reassertion by the establishment of more constrained modes of behaviour.

FURTHER READING

D.E. Brauer, C. Finch, N. Rifkin, W. Hopps, *Pop Art: US/UK Connections 1956–66*, Houston 2001.
T. Crow, *The Rise of the Sixties: American and European Art in the Era of Dissent 1956-69*, London 1996.
D. Mellor, *The Sixties Art Scene in London*, London 1993.
C. Stephens & K. Stout (eds.), *Art & the 60s: This was Tomorrow*, London 2004.

Constructed or Constructive? The Teaching Methods of St Martin's Sculpture Department

HESTER R. WESTLEY

St Martin's Sculpture Department in the 1960s was not only the epicentre of sculptural innovation but a school in which pedagogy itself was an important and occasionally volatile innovation. Through the decade the department boasted an unprecedented cohabitation of two approaches to the making, means and goals of sculpture. These polarized approaches to art instruction emphasize what critical history conventionally regards as the divisive debates between those of a 'formalist' tendency and those we might term 'anti-formalists'.

The Sculpture Department's modest beginnings belie its swift acclaim and reveal its energizing ambitions. On Frank Martin's arrival in 1952, the modelling section was a subordinate service unit for the Painting Department. Martin's missionary zeal to establish an autonomous Sculpture Department fuelled his ambition to establish sculpture as the defining visual art form. Martin (1914–2004) recruited progressive sculptors impatient with centuries-old academic assumptions perpetuated in the classroom by the 'Academy' model of teaching by technical instruction (see Wood, p.194).

Martin created a space for sculptors to bypass such constraints. This period in the early 1960s shaped the form of new sculpture and its attendant pedagogy. For instance, Anthony Caro's 'experimental evening classes', pioneering fresh approaches to medium and form, attracted a loosely affiliated group of students eager to balance their academic training with experimentation (fig.121). Students and faculty alike resisted the current pedagogy's assumption that sculpture was synonymous with 'craft' but still believed that a rudimentary grounding in traditional skills was an essential rite of passage. Once the student satisfied these requirements, he/she could join the unaccredited Vocational Course, later formalized as the Advanced Course (known as the 'A' course), which offered training in the alternative formal vocabulary appropriate to modern sculpture.

Informing the Vocational Course was the modernist conception of sculpture as an autonomous entity: work created intuitively by a solitary artist, which found its rightful place in the art gallery. Championed by modernist critic Clement Greenberg, this teaching exemplified his no-nonsense approach to aesthetic rigour. As he explains in a letter to Frank Martin: 'No other art school manifests a spirit nearly so invigorating and at the same time mature; no other art school demands as much of its students.' (3 Feb. 1964; letter in Tate Archive, London.)

Caro's former students (collectively termed the New Generation) David Annesley (b.1936), Michael Bolus (b.1934), Phillip King (b.1934), Tim Scott (b.1937), William Tucker (b.1935) and Isaac Witkin (1936–2006) rapidly rose to the rank of tutor. They replaced notions of sculpture as figurative, pastoral and organic with urban,

121 ANTHONY CARO
Early One Morning 1962
Painted steel and aluminium
289.6 × 619.8 × 335.3
(114 × 244 × 132)
Tate. Presented by the
Contemporary Art Society 1965

122 BARRY FLANAGAN
Four Casb 2 '67 1967
Canvas and sand
182.9 × 38.1 × 38.1 (72 × 15 × 15)
Tate. Purchased 1976

formal abstraction fashioned in colourful new materials. These tutors also sought new modes of pedagogy to complement their sculpture's formal departures.

Their students formed a coterie that comprised Barry Flanagan (b.1941) and Bruce McLean (b.1944) among others. They were encouraged to regard the classroom as a professional studio and formed reciprocal relationships with their tutors, while studio activity centred around the 'crit'. These students re-conceived their tutors' lessons in a style characterized by ironic subversion; they challenged the materials as well as the assumptions of the sculptural object (fig.122).

Untouched by the dictates of national curricula, the Vocational Course found its counterbalance in the undergraduate syllabus conceived by tutor Peter Kardia (born Atkins) in 1964. Kardia's Diploma in Art and Design offered an imaginative response to the prescriptions of the 1960 Coldstream Report, requiring as it did a national overhaul of art school pedagogy by redefining fine art as distinct from any given medium (see Wood, p.182).

Kardia's syllabi responded to institutional anxieties about the dictates of this report, as well as the emergent generation's larger questions about the goals of sculpture. No longer viewing the sculptural object as a *fait accompli*, Kardia's programme examined the definition of both the art object and the creative process itself. Shifting the locus of sculptural action from the welding shop to the seminar room, Kardia sought to dispel the twin modernist myths of the artist as a uniquely gifted individual and the art teacher as what Herbert Read has called a 'psychic midwife'. Denying the centrality of individual 'skills' and privileging 'process', Kardia broadened their very sense of identity: the artist was no longer an isolated individual but a relational and provisional series of perspectives informed and shaped by politics and culture. Former students who benefited from Kardia's contribution are artists Gilbert & George (b.1923 and 1933), Richard Long, Hamish Fulton (b.1946) and John Hilliard (b.1945) among others.

Reflecting on his time in the Sculpture Department, sculptor Richard Deacon (b.1949) explains that St Martin's 'was one of the very few places where conceptualists and object makers actually had a dialogue and a respect for each other's practices' (conversation with the author 13 Feb. 2004). Such a mutual respect between 'the makers' and 'the thinkers' enriched beyond measure the Sculpture Department of the 1960s. By the early 1970s, these conversations among conceptualists and object makers became institutionalized distinctions: the 'A' course was devised for those students conceptually inclined, the 'B' course for those intent on the importance of 'object' sculpture. What was once a mutually informing exchange became a competition of opposing views of sculpture.

FURTHER READING

T.A. Neff (ed.), *A Quiet Revolution: British Sculpture Since 1965.* London 1987.
H.R. Westley, 'Traditions and Transitions: St Martin's Sculpture Department 1960–79', unpublished PhD thesis, Courtauld Institute of Art 2007.

Art and Counterculture in the 1960s

ANDREW WILSON

The *International Poetry Incarnation* staged at the Royal Albert Hall on 11 June 1965 marked the emergence of a publicly identifiable counter-culture – encompassing predominantly the visual arts, theatre and performance, music, film and literature, alongside a dissenting political radical-ism that embraced various forms of personal and social liberation from the use of drugs to the enactment of anti-psychiatry, from black power to sexual liberation. An audience of approxi-mately 7,000 people came together to listen to an international group of Beat poets and writers; robots by multimedia artist Bruce Lacey (b.1927) were in attendance, and a happening by artists Jeff Nuttall (1933–2004) and John Latham was planned. The Albert Hall event dismissed poetry that had become locked into the printed page in favour of a carnivalesque poetry of event that in its assault on dominant culture was also ready to break down barriers between different disciplines.

The title of Jeff Nuttall's account of this period – *Bomb Culture* – emphasizes the extent to which the beginnings of such an identifiable counterculture was formed in the shadow of the very real possibility of nuclear annihilation and had its beginnings in the founding of the CND protest movement in 1958. Chief among artists in this milieu was Gustav Metzger (b.1926). A child refugee from Nazi Germany where most of his family perished in the Holocaust, in the 1950s he sought a fusion of his artistic practice with a committed political position that saw him take part in the activities of the Direct Action Committee against Nuclear War and its actions against rocket bases in East Anglia before moving to London in 1959, where he was later a founding member of the anti-nuclear Committee of 100. His subsequent evolution of theories of Auto-Destructive Art and the realiza-tion of an 'aesthetics of revulsion' were also an embodiment of his political activism – not as an illustration of ruins or a metaphor for social sickness, but as the presentation of a clear, unfettered and progressively destructive force. That destructive force was itself a part of that which it was commenting on and, in the process, the ego of the artist was effectively eliminated (fig.123).

Metzger's ideal of a socially engaged public art was examined and codified through the 1966 Destruction In Art Symposium (DIAS), which he initiated and which brought together fifty artists from ten countries, among whom were the Viennese Actionists, performing outside Austria

for the first time. DIAS was only partially concerned with art; subjects it addressed included 'atmospheric pollution, creative vandalism, destruction in protest, planned obsolescence, popular media, urban sprawl/ overcrowding, war … biology, economics, medicine, physics, psychology, sociology, space'. One basis for such a wide-ranging approach, typical of 1960s counterculture, can be located in Lawrence Alloway's 1959 identification of a 'Long Front of Culture' informed by earlier investigations by the Independent Group. Just as hierarchies between high and low art had been dispensed with, those categories that delineated and divided different kinds of practice, and the boundaries between them, had been ignored by the Independent Group. Through the 1960s such attitudes came to underpin the far-reaching attempt to search for and evolve new languages of expression and action – languages that were expressly formed by social and political identifi-cations of engagement, and that made clear the necessity for changing social contexts within which the work of art might be situated. For many artists like Metzger, a new language of engagement entailed the absolute negation of any artistic or other type of categorization. Just as the written word was being questioned and destroyed by writers, so artists moved away from the object to create a new space for their evolving language, which asserted the urgent need for social, political and aesthetic change at the level of life.

123 GUSTAV METZGER
Acid action painting
South Bank Demonstration 3 July 1961
Nylon, hydrochloric acid, metal
Three nylon canvases are arranged behind one another. Acid is painted, flung and sprayed on to the nylon which corrodes at point of contact within 15 seconds

124 MARK BOYLE
Holland Park Avenue Study
1967
Plastic 238.8 × 238.8 × 11.4
(94 × 94 × 4½)
Tate. Purchased 1969

Avant-garde theatre was investigating an experiential language in which representation was dismissed in favour of the unpredictabilities of life itself and conformed to the defining identification of a cultural revolution in which there were only participants and no spectators. Mark Boyle, collaborating with his wife Joan Hills, not only questioned this relationship between performer and audience in a series of events in the early 1960s, they also made the decision to take the world in its totality as their material, a commitment realized in the commencement of their 'Earthprobe' project in 1968 (and still ongoing). One thousand sites in the world were randomly selected, the intention being that a square surface area would be re-presented as a relief and the biological and chemical make-up of that area recorded, along with photographs and sound recordings of the site (fig.124). One

earlier example of Boyle and Hills's characteristic immersion in a wider frame of activity was their founding of Sensual Laboratory in 1966 following their participation in DIAS. This was an umbrella company for their event-based activities and within a matter of months they also fell under the same management as the band Soft Machine, for whom they produced light shows, most notably during a residency at UFO club in 1967. Boyle and Hills also carried out a number of events at the London Arts Lab at this time – a place that exemplified a countercultural blurring of distinctions between different forms of artistic expression.

John Latham, another participant in DIAS, was less preoccupied with the notion of destruction than with the invalidation or dematerialization of objects in favour of a process of cognition carried out in time rather than locked in space. This

approach, examined through a personally articulated scientific philosophy, in addition to his presentation of an event structure as the basis of his work, planted the seeds for the emergence in the late 1960s at St Martin's College of Art (where Latham had taught) of a form of Conceptual art. This exchanged the sculptural object for sets of different critical strategies that included the event and in part pursued an engagement with life beyond the studio (see Westley, pp.190–1).

FURTHER READING

J. Green, *Days in the Life: Voices from the English Underground 1961–1971*, London 1988.
J. Nuttall, *Bomb Culture*, London 1968.

Conceptual Art

WILLIAM WOOD

The term Conceptual art is first credited to the American Sol LeWitt in 1967. Its adoption in Britain can be dated to 1969 when Barry Flanagan printed a portfolio entitled *Documentation of Primary Conceptual Art by British Artists 1966–68* and Art & Language published the first issue of their journal, *Art-Language,* with the sub-title 'The Journal of Conceptual Art'. Where the artists in Flanagan's portfolio were all associated with St Martin's School of Art in London, the *Art-Language* editors were connected with the Coventry College of Art in the Midlands (see Harrison, p.62 and Wood, p.183). These two groups represent the two major tendencies in Conceptual art in Britain. For graduates of St Martin's such as Flanagan, Richard Long and Gilbert & George, Conceptual art was a slightly subversive and ironic actualization of the more radical tenets of the Advanced Sculpture course at the School. By naming as 'sculpture' things such as piled fabrics or music hall-style performances, photographs documenting walks in the wilderness or sticks and stones in a gallery, they acted out the limits of Anthony Caro's intentional framework. Because such activities required forethought and had little in common with conventional forms and materials, it was deemed to be conceptual, blending at this point with manifestations of performance and Earth art in the United States and *arte povera* in Europe.

At Coventry the focus was on determining what kind of a concept art can be said to be. This predominantly involved textual explications of an analytic philosophical bent devoted to examining the normative standards of art's production and exhibition. The writings of the group, which came to include students on the Art Theory course at Coventry, were reproduced as prints, booklets and in *Art-Language*, and later in catalogues and in London's leading art journal, *Studio International*. Though often difficult and opaque, their writings were in direct dialogue with artistic currents in New York where the main Art & Language figures, Terry Atkinson and Michael Baldwin, had been exhibiting since 1968. There, the group had close contact with dealer Seth Siegelaub, critic Lucy Lippard, as well as artists such as LeWitt and Mel Ramsden (who later joined the group) and Joseph Kosuth, the 'American Editor' of *Art-Language*.

Art & Language's New York connections were matched by the St Martin's group's links to Europe through artist Jan Dibbets, dealer Konrad Fischer and curators Germano Celant and Harald Szeemann. Szeemann's exhibition, *When Attitudes Become Form*, staged in Bern in 1969, included Long and Flanagan, and when the exhibition toured to the ICA in London, critic Charles Harrison added other British artists, notably Keith Arnatt (b.1930) and Victor Burgin. The Yale-educated Burgin was well-versed in

contemporary American art and philosophy, advocating what he called 'Situational Esthetics' in *Studio International* in 1969. He described his works as temporary interventions intended to change viewers' perceptions of their surroundings. Within a year he was developing texts, such as *All Criteria* (1970), which consisted of typewritten instructions requiring the reader to perform complex mental gymnastics when faced with the sheet on the gallery wall or on a magazine page (fig.125). In a lighter, related vein, Arnatt played with the artist as a figure of fabrication, as a person sanctioned to provide plausible lies. Texts such as *Is it Possible for Me to Do Nothing as My Contribution to this Exhibition?* (1971) were replete with logic and citation but, as the title suggests, ended up as knowlingly fruitless attempts to display thought as art.

Arguably, such an attempt may have proved the limits of Conceptual art. As a trend, English Conceptual art peaked in 1972, when most of its recognized practitioners were included in Documenta V, in Kassel, West Germany, and in *The New Art*, a survey of such work at London's Hayward Gallery. In both exhibitions artists demonstrated the problems associated with claiming to examine or to present concepts as art. Because Long had cultivated the persona of a nomadic walker, his display of sizeable stone circles hinted at Neolithic rather than contemporary practices. Gilbert & George showed

125 VICTOR BURGIN
Performative/Narrative 1971
Photograph and texts
16 elements at 34 × 67
(13³⁄₈ × 26³⁄₈) and one element at
34 × 24 (13³⁄₈ × 9¹⁄₂)
Collection Ghislain Mollet-Viéville,
Musée d'art Moderne et
Contemporain de Genève

126 ART & LANGUAGE
Index 01 1972
Eight filing cabinets, texts and photostats,
dimensions variable
Installation at Musée d'art moderne
Lille Métropole, France
Collection Daros, Zurich

photographs and a large drawing-installation exploring bar culture, a move away from their previous performances and publicity stunts. Burgin and Art & Language presented forms of reading rooms containing collected texts, but, where Burgin argued in the catalogue for art to question its social role, Art & Language had determined that it represented a society of language users itself and staged their collective 'conversation' in two convoluted 'Indexes' to their writings (fig.126). Critics dismissed the St Martin's work as overly conventional and the reading rooms as intellectually sterile – English Conceptual art foundered, it would seem, at the very point that it became a manageable fixture of the national art world.

Indeed, the next years saw Arts Council and Tate purchases of Conceptual art while the St Martin's artists moved on to blue-chip status and Burgin and Art & Language came to have a major impact upon various forms of art and cultural theory and education. By turning to psychoanalysis and cultural studies in his study of 'the politics of representation', Burgin has remained concerned with art's social condition, while Art & Language's conversation has metamorphosed into paintings and extensive art-historical writing that is still concerned with the way art is produced and exhibited. Although it is often claimed that today's artists practise Conceptual art, it rarely has the questioning character of its predecessor, although one

might single out Jeremy Deller (b.1966), Ceal Floyer (b.1968) and Simon Starling (b.1967) as conscious inheritors of Conceptual art problems.

FURTHER READING

Art & Language, exh. cat., Van Abbemuseum, Eindhoven 1980.
C. Harrison, *The British Avant-Garde*, London 1971.
C. Phillpot and A. Tarsia, *Live In Your Head: Concept and Experiment in Britain, 1965–1975*, London 2000.
A. Seymour, *The New Art*, London 1972.

Object and Sculpture

CLARRIE WALLIS

In 1981 a number of young British sculptors participated for the first time in major exhibitions to considerable acclaim. They included Tony Cragg, Richard Deacon, Antony Gormley (b.1950), Shirazeh Houshiary, Anish Kapoor, Alison Wilding (b.1948) and Bill Woodrow. The cumulative effect of these shows was to introduce the 'New British Sculpture of the 1980s'. The Whitechapel Gallery hosted solo exhibitions by Cragg and Gormley and the two part *Object and Sculpture* exhibition, held jointly at the ICA, London and the Arnolfini, Bristol, brought together work by eight sculptors: Edward Allington (b.1951), Deacon, Gormley, Kapoor, Margaret Organ (b.1946), Peter Randall-Page (b.1954), Jean-Luc Vilmouth (b.1952) and Woodrow. (Cragg had had a solo show at the Arnolfini in 1980 and therefore was not included.) The following spring Houshiary and Wilding exhibited together at Kettle's Yard, Cambridge.

Object and Sculpture is widely considered to be the first large exhibition of a new sculptural aesthetic. The introduction to the catalogue explained that the exhibition did not intend to define a new group or movement but aimed to 'raise certain issues about sculpture today'. Reflecting on the fact that twelve years had passed since the seminal exhibition *When Attitudes Become Form*, which brought together a broad range of conceptual-based practice (see W. Wood, p.194), the authors acknowledged that 'the work in this exhibition has much that distinguished it from work made at that time'. While all the artists were trained to have a strong concern with material and with processes as factors central to the making of art, *Object and Sculpture* brought to the fore a new way of object making. This reclaimed procedures and areas of enquiry that would have been regarded as alien by their immediate predecessors: for example, an engagement with the object *per se*, an exploration of the role of the image, and the relationship between the literal and the metaphoric.

While those artists associated with 'New British Sculpture' constituted neither a group nor precisely a generation, most were born in the late 1940s, only a few years after Hamish Fulton, Gilbert & George, Richard Long and Bruce McLean. However, their work emerged on to an international stage some ten years later than that of those older contemporaries. Deacon and Woodrow studied at St Martin's School of Art; Cragg, Deacon and Wilding were all at the Royal College of Art; Woodrow, Kapoor and Houshiary attended Chelsea School of Art, while Gormley went to the Slade after studying Anthropology at Cambridge University.

Sculpture in Britain during the 1970s roughly divided into two tendencies: an interest in formal concerns as exemplified by the abstract constructed sculpture developed in the wake of Anthony Caro, or a conceptual approach, as in the case of Richard Long. Both approaches, albeit in different ways, sought to question the nature of sculpture. However, this younger generation of artists' work can be understood as a synthesis of the dialectic between formal and conceptual. As the catalogue to *Object and Sculpture* explained:

> The work is neither figurative nor abstract, nor could it simply be termed as abstracted. It is associative, and in some cases is also symbolic or metaphorical ... [And it] seems to refer both to objects in the world, and to sculpture given some status as a category of special objects separated from the world.

Deacon, who had initially employed strategies derived from Conceptual and Performance art, became increasingly interested in new approaches to the object through his reading of William Tucker and Donald Judd. Tucker developed the modernist conception of sculpture as an autonomous object with a poetic dimension 'subject to gravity and revealed by light'. By contrast, Judd had broken with the traditional notion of sculpture, instead proposing a new category, the 'specific object', grounded in reality, to define the new 'literal' three-dimensional work being produced. The objects Deacon began to make can be understood as an attempt to reconcile these different notions of the sculptural object. Works such as *If the Shoe Fits* 1984 (Tate) bring to mind the material world of everyday objects while their titles encourage a more metaphorical reading.

Moreover works by Cragg, Woodrow and Richard Wentworth (b.1947) extended subject matter into new cultural territory, re-positioning the debate in terms of 1980s urban culture in a

127 BILL WOODROW
Twin-Tub with Guitar
1981
Washing machine
88.9 × 76.2 × 66
(35 × 29⅞ × 26)
Tate. Purchased 1982

128 Installation view of *Object and Sculpture*, Tate Gallery 1981
Tate Gallery Archive

post-industrial age. *New Stones – Newton's Tones* 1979 (Arts Council Collection, South Bank Centre, London), exhibited at Cragg's first solo show at the Lisson Gallery in 1982, is reminiscent of Long's practice (fig.40, p.64). However, instead of using natural materials, Cragg collected plastic fragments, which he ordered by the colours of the spectrum to create a large rectangle on the floor. For Cragg, discarded materials and fragments from our manufacturing society are found in various states of 'returning to nature'. Used and abandoned, they can once more be regarded as a new raw material. Woodrow's sculptures of this period were made from discarded objects and materials, such as obsolete electrical equipment and domestic appliances found on the streets of South London. With *Twin-Tub with Guitar* 1981 (fig.127), exhibited in *Object and Sculpture*, he reassembled

the partially dismantled elements of a washing machine to create a new form that at the same time retained evidence of the object's original identity and function.

The particular sculptural concerns of Gormley, Kapoor, Wilding and Houshiary often seem very different to those mentioned above. Since the early 1980s Gormley has used his body to make sculpture that explores the experience of being in the world. His work addresses the relationship between our physical and spiritual selves. Kapoor's enigmatic forms covered in pure pigments engage with metaphysical polarities, while Houshiary's sculptures, paintings and drawings are largely inspired by the poetry of Rumi, the thirteenth-century mystic, and the quest for self-knowledge. Wilding's Constructivist approach to making sculpture in a variety of materials seems to offer a direct link

to, for example, Deacon's practice. Nevertheless, all the works operate through visual as much as verbal conjunctions. It is perhaps a desire to construct meaning through process, materials, forms and image, to relate sculpture back to the world of object, experiences and states of mind that defines this cohort of British sculptors.

FURTHER READING

Objects and Sculpture, exh. cat., Institute of Contemporary Arts, London/Arnolfini, Bristol 1981.
Transformations: New Sculpture from Britain, British Council for XVII Bienal de Sao Paulo 1983.
T.A. Neff (ed.), *A Quiet Revolution, British Sculpture since 1965*, exh. cat., Museum of Contemporary Art, Chicago 1987.

5 The Spaces of British Art: Patronage, Institutions, Audiences

SUE MALVERN

TO TALK ABOUT PATRONAGE, institutions and audiences, the infrastructures of twentieth-century British art, is to discuss both how art gets mediated to its publics and where art is seen, in what context and for what possible uses and meanings. Analysing the organizations and forums for art puts the focus on how art is received, but institutions not only shape the consumption of art, they also influence its production. Modern art, as it came into formation in the late nineteenth century, differentiated itself from academic traditions both in its forms of organization and by where it was seen. It was not separable from the rise of the art market, with its network of individual dealers and art critics promoting art. To advance their work and control its reception artists formed independent associations, which often worked in alliance with dealers hosting their exhibitions and in partnership with sympathetic critics publishing in newspapers and journals aimed at an educated middle class. Alongside the growth of the market and usually as a supplement to national galleries established earlier in the nineteenth century, modern European nations set up new national galleries of modern art that in turn helped to foster audiences for contemporary art. These national galleries of modern art were one of the sites for making visible national cultural identities, promoting art to audiences imagined as citizen-members of a unified and enlightened national state. Struggle between older traditions and modern art, which contested the control over modes of representation that previously existed, was a feature of the period at least until the Second World War. Acquisitions policies and the shaping of displays at modern art galleries were in turn closely intertwined with the networks of dealers and critics. Although in the modern period the art market transformed the relationship of art to its audiences, older forms of patronage where work was commissioned directly from artists sometimes persisted. However, it is an indicator of modernity that the patron was almost always the state.

Modern art was formed on the basis of international exchange and travel amongst artists. A case in point would be the New English Art Club (NEAC), founded in 1886. Although its members by and large trained in Paris,

it is often identified as the first modern artist-led organization in Britain to secede from the Royal Academy, the national institution for the regulation of art. Its title is significant, however. The structures through which art is mediated to its publics, including how international projects are funded and organized, are almost invariably based on national identities and are the primary mechanism by which the state acts as patron in the promotion and production of modern art.[1] A prominent and influential example of this is the Venice Biennale, established in 1895 but a significant event since the end of the Second World War, which has given rise to numerous alternative biennials. The Venice Biennale organized as it is in a series of national pavilions, has been analysed as a location for the reassertion of European identity and the representation to the rest of the world of the political power of France, Germany, Britain and Italy.[2] The sites for the display of art, whether in Britain or abroad, remain important for the representation of a distinctive national identity to be seen and judged in a comparative perspective.

Weaving through this essay is a case study of the Tate Gallery and the way its promotion of British modern art was played out against, and sometimes superseded by, 'foreign' modern art as its collections were reorganized at critical points of the twentieth and twenty-first centuries. The cultural economy of Britain is highly concentrated in the metropolis, and the vicissitudes of the Tate exemplify how the nation advertises its investments in contemporary art to itself and to those it imagines as its 'others'. Although regional centres have sometimes been crucial to the development of modern art, for example Leeds before 1914 or Glasgow in the 1980s (see Stephens, p.81, and Lowndes, pp.232–3), artists and critics nearly always migrated to London. An official policy of fostering the arts in the regions that developed in the 1980s was short-lived as the acceleration of global capitalism from the 1990s once again re-emphasized London and its international financial markets; this time within the context of a radically altered understanding of national boundaries.

In 1897 the Tate Gallery was established at Millbank as a branch of the National Gallery, Trafalgar Square. In its

early years there were lengthy and unresolved struggles over control of the Chantrey Bequest, virtually the only fund for making acquisitions and managed by the Royal Academy. Because there was almost no funding from the government, the Tate was dependent on private benevolence and voluntary initiatives, such as the Contemporary Art Society set up in 1910 by a circle of critics, collectors and museum curators to make purchases of modern art for national and regional collections. From the end of the nineteenth century until the outbreak of the Second World War, it tended to be the case that private initiatives stepped in to supplement inadequate state support for sustaining the culture of contemporary British art, a situation that was by no means unique to Britain. By contrast, the Second World War and its aftermath saw extensive state intervention in the arts, paralleling the formation of the Welfare State: the Arts Council was established in 1946, and the Tate gained its independence from the National Gallery as well as its first grant-in-aid in 1955. It is said this is the point when the British government saw culture as an instrument of policy, it being the business of the state to promote it. Again comparable developments took place in government support for the visual arts, and culture in general, in other European countries.

The 1970s began with economic recession and an oil crisis, and, after the election of the Conservative Margaret Thatcher in 1979, increasing failures of state funding for national cultural institutions led to the growth of private sponsorship and the emergence of the corporate patron. Two publications neatly circumscribe this shift from state-sponsored culture to the privatization of the public sphere. Janet Minihan's *The Nationalization of Culture: The Development of State Subsidies to the Arts in Great Britain* traces its story from the late eighteenth century and, appearing in 1977, was something of a memorial to the evolution of a system of support that was shortly to be dismantled. Chin-Tao Wu begins her *Privatising Culture: Corporate Art Intervention since the 1980s* (2002) with a comparative examination of the state of public subsidies for art in Britain and America, and then traces corporate involvement in public museums as an instance of a new form of patronage. To these two accounts should be added Brandon Taylor's outstanding *Art for the Nation* (1999), which is concerned as much with the discourses that surrounded initiatives as with the mechanics of institution building, and also examines the role of art galleries in

London in encouraging audiences to perform what he terms 'the privileges and duties of the citizen'.[3] The text traces the emergence of national galleries and institutions, from the Royal Academy in 1768 to the inauguration of Tate Bankside in 2000, as a discontinuous, often contested narrative of a sometimes fragmented national identity in which the imagined audiences for art were repeatedly remade. Nicholas Pearson has also published a cogent and powerful analysis of the political implications of state patronage, *The State and the Visual Arts: A Discussion of State Intervention in the Visual Arts in Britain, 1760–1981* (1982).[4] What is intriguing about Minihan's and Taylor's accounts of state patronage in twentieth-century Britain is the omission of the war artists schemes in both world wars. For example, about 250 artists were employed by the state in various ways in the First Word War, including virtually all the artists who would count as significant when in the same period the Tate started assembling lists of desired acquisitions to constitute a national canon. One task of this essay is to reinstate these schemes and examine their implications for formations of support systems for modern artists, and their role in the incorporation of and resistance to modern and avant-garde art.

This essay will focus on the three periods, outlined above, which might be termed the age of public/private initiative, the era of the state as patron and the period of global capitalism. These could be mapped over three phases of British state formation, against which what counts as 'British art' might be seen. The first, that of public/private initiative, would coincide with the high point of British imperialism, leading to the First World War. For example, both Hugh Lane – an important dealer and collector of French modern paintings to be discussed below – and Robbert Ross – art critic, owner of the Carfax Gallery and a Tate Trustee and adviser instrumental in the formation of its collections – advised on the development of the Johannesburg Art Gallery, established in 1910 and designed by leading British architect Edwin Lutyens. The second era, that of national patronage, would correspond with the dispersion of the British Empire and the formation of the Commonwealth. One indicator might be the high visibility in London of artists from former colonies such as Francis Newton Souza (1924–2002), Frank Bowling (b.1936) and Aubrey Williams (b.1926) – see Stephens, p.107 and Araeen, pp.154–5). The reorganization of London's major national art galleries and the independence of the Tate in

1955 were the outcome of an enquiry headed by a Canadian, Vincent Massey, and the Tate hosted two significant surveys of Canadian art in 1938 and 1964. The third period of privatization might parallel the emergence of the European Union as a major point of reference for national imaginings, at least in the cultural sphere, and of globalization. Brandon Taylor describes how in the 1980s and 1990s boundaries become fluid: 'Certain kinds of contemporary art, like the public to whom it was addressed, would be perceived as being *in* Britain but not necessarily *of* Britain; *in* London but not *of* it.'[5] London became less a national capital and more one site in a network of international exchanges.

Although the three periods I have outlined appear to map neatly onto private, public and multinational, throughout the twentieth century the distinctions between public and private, individual collector and public patron, independent organizations and state institutions were never so clear cut. Roger Fry (1866-1934, art critic, writer, museum advisor, curator and artist), D.S. MacColl (art critic and Keeper of the Tate from 1906), Charles Aitken (Director of the Whitechapel Art Gallery and later Keeper of the Tate from 1911), and C.J. Holmes (1868-1936, painter, Director of the National Portrait Gallery and then of the National Gallery), were key players in the Contemporary Art Society. In the 1990s, John Walker and Rita Hatton wrote an extended critique of Charles Saatchi (b.1943) for acting as a dealer and speculator in the contemporary art market rather than simply as a collector.[6] But Hugh Lane earlier in the twentieth century assembled a significant collection of modern art through accumulating capital by dealing in art, and was sometimes criticized for this. This account of patrons, markets and institutions will argue that infrastructures are far from seamless and the audiences for art rarely homogenous.

Private Initiative, Public Institutions

In 1911 Robert Witt produced a short book titled *The Nation and its Art Treasures* aimed at prompting the government to take action to prevent the sale of masterpieces from British private country houses to foreign collectors.[7] What was new about Witt's argument was the notion that the state had an obligation to protect and preserve culture for future generations, an idea of a national heritage that also had implications for the professional management of national museums and their need to modernize Boards of Trustees, with peers of the realm or 'highly cultivated amateurs' being replaced with experts in the art market.[8] Together with the art critic Claude Philips, D.S. MacColl and Roger Fry, Witt had founded the National Art Collections Fund (NACF) in 1905 to intervene through fund-raising and save works of art for the nation. (An early and spectacular success was Velázquez's *Rokeby Venus* acquired for the National Gallery in 1906.) His primary concern was with the canon of Renaissance art sometimes termed 'Old Masters', but Witt also devoted a chapter to the Tate as the national collection of modern art, pointing out that in fourteen years of existence public funds had only added nine works of art, and arguing that it needed its own trustees with expertise in buying modern art. The NACF was an obvious precedent and there was an overlap of personnel when the Contemporary Art Society (CAS) was formed four years later. Its founders included Otteline Morrell, a significant patron of modern art, and her husband Philip, a Liberal MP, as well as Roger Fry. Its membership was representative of the interdependence of a network of museum professionals, art writers, collectors and art dealers in the formation of modern British art, and the running of an organized crusade to shape the Tate's collections. MacColl, for example, had led a campaign in 1904 to discredit the Royal Academy's control of the Chantrey Bequest and its influence on what counted as significant contemporary art at the Tate. The bequest, which became available in 1875, was an important source of patronage for contemporary artists, and when the Tate first opened, the Academy's acquisitions hung in the the Tate's own galleries on Millbank. Indicative of the extent to which the Academy was an outmoded institution no longer capable of representing the interests of British art can been seen in the opposition to the Academy's preference for purchases from its own members, which was orchestrated in such highly placed circles that it resulted in a House of Lords Select Committee enquiry in 1904-5 and the Chantrey Bequest being termed an 'incubus' by the 1915 Curzon Enquiry into the function of the nation's art collections. When the Tate got its own Board of Trustees, an outcome of the 1915 Enquiry, Aitken wrote to the National Gallery Trustees with recommendations for appointments including two artists'

representatives: one for the 'Official Art' of the Royal Academy and one for 'Unofficial Art', drawn from artists' organizations such as the New English Art Club and the International Society.[9] The Academy sent a delegation to the Treasury, ultimately responsible for nominations, complaining about lack of consultation and articulating what was at stake: 'a matter which involves the whole field and future of British Painting and Sculpture and touches artists in their most vital interests'.[10]

The Curzon Enquiry, a committee of the Trustees of the National Gallery, was established to investigate the retention of works of art in Britain as part of the national collections, and Witt's book was designed to influence and anticipate its conclusions. The Tate had come into existence when the sugar magnate Henry Tate donated his personal collection to the nation and a lengthy discussion with the National Gallery about housing the bequest was resolved by Tate offering to pay for the building if the government would offer a site. As a consequence there had never been any thorough consideration of its function and collecting policy. By 1914 Tate's original gift of sixty-eight works, mostly naturalistic narrative paintings by late Victorian academic artists that chimed with the collector's own penchant for social improvement, had been extended through various gifts and bequests to include works by G.F. Watts and Alfred Stevens, some transfers from the National Gallery, the Chantrey purchases and the bulk of the Turner collection, housed in an extension funded by the art dealer Joseph Joel Duveen. The Inquiry recommended that the gallery become the national historic collection of British art, extending its coverage in order to tell a coherent narrative of the evolution of British art, of particular importance for attracting foreign visitors. But the most urgent mission was to establish a collection of modern art by artists born abroad as 'essential for the artistic development of the nation'.[11] On the one hand, the audiences imagined for a national history of art were foreign; on the other hand, having foreign works of art in the national collections was vital to indigenous culture.

Right from its origins the Tate had been known as the 'British Luxembourg'.[12] Created in Paris in 1818 as a national gallery for living French artists, the Luxembourg Gallery was expanded in 1864 to include modern foreign art, and in 1912 Edmund Davis, a wealthy and prominent art collector based in London, who made his fortune from mining interests in South Africa, offered forty works by

British artists including those from the circle of Charles Ricketts (1866–1931) and Charles Shannon (1865–1937), and painters such as William Orpen (1878–1931), Augustus John (1878–1961) and Henry Tonks (1862–1937), doubling the collections of British works and making it the largest national foreign school represented in Paris museums.[13] Davis's gift to Paris, and the international comparison implied, was one factor in the desire to create a British collection of modern foreign art, but a major impetus was the loan of thirty-nine modern paintings mainly by French nineteenth-century artists to the National Gallery from the collection of Hugh Lane in 1914. Lane was born in Ireland to an Anglo-Irish Ascendancy family and as an art dealer in London made the wealth that funded his personal collection of French early modernist art. His relationship to British artists was celebrated in William Orpen's *Homage to Manet* 1909 (fig.129), where he sits on the right with D.S. MacColl behind the Slade teacher Henry Tonks, being addressed by the writer George Moore and watched by the artists Philip Wilson Steer (1869–1942) and Walter Sickert (1860–1942), beneath Edouard Manet's portrait of his student Eva Gonzales at her easel, a painting Lane bought in 1906. Lane combined dealing with cultural philanthropy, setting up a Municipal Gallery of Modern Art in Dublin to foster Irish identity, advising on acquisitions and installing works of art for the new Johannesburg Gallery in South Africa in 1910 (Edmund Davis was also a benefactor in 1933–6). He eventually became Director of the National Gallery of Ireland in 1914 where he declined to accept a salary.[14] The same year, because Dublin had failed to commit itself to building a new modern art gallery, he offered to lend his collection of modern Continental art to the National Gallery in London. The Trustees required a legal bequest before they would exhibit his paintings, and there was resistance, with, for example, one Trustee, Lord Redesdale, objecting to space in the nation's art galleries 'being assigned to . . . a picture dealer, for the purpose of holding an exhibition of his wares'.[15] Lane did not in fact deal in modern art. The standing of his proposal and the status of his loan changed very dramatically when Lane perished with the sinking of the Lusitania in May 1915.[16]

Because of the significance of the Lane Bequest, Joseph Joel Duveen's son Joseph Duveen, an art dealer mainly to Americans and a collector in his own right, offered to fund an extension to the Tate for the Modern Foreign Art Galleries, which opened in 1926. These developments in

turn influenced the textile manufacturer Samuel Courtauld who offered £50,000 to the Tate in 1923 to buy modern French paintings from a stipulated list of names. What was sanctioned as the significant modern movement for the purposes of enlightening British audiences was art produced in Paris in the late nineteenth century, from Manet to the Impressionists and Post-Impressionists – Paul Cézanne, Vincent Van Gogh and Georges Seurat – but stopping short of early-twentieth-century artists such as Henri Matisse and Pablo Picasso. As Brandon Taylor has carefully demonstrated, the Modern Foreign collection was installed in the Tate as a supplement, behind the galleries narrating the legitimate historical evolution of British art and beyond the Turner Rooms (fig.130). 'Foreign' art was carefully maintained in its difference and its out-of-place-ness, while British art was nonetheless shown to be demonstrably cosmopolitan.[17] Identifying 'modern foreign' with French late-nineteenth-century painting paralleled diplomatic ties that were cemented by the First World War. That French visual art was the natural counterpart to British was made explicit in Duveen's donation of the Modern Foreign Galleries: 'Mr Duveen's gift at the present moment is particularly well-timed as it marks the increasing unity of the Allied Nations, for ... when we speak of modern foreign art, it is predominantly of the painting and sculpture of our allies and above all of the French artists that we are thinking.'[18]

Because the Tate was located by the Thames on Millbank it was at some distance from the major commercial art galleries that from the 1860s onwards had clustered around Bond Street. Described as a transitional space between upper-class Mayfair and bohemian Soho, Bond Street was close to London's new shopping district on Oxford Street with its modern department stores, such as John Lewis's, which opened in 1864, and Liberty's, which followed in 1875.[19] Commercial galleries were orientated to an exclusive luxury market and, by being small scale and specialized, distinguished themselves from the mass spectacle of the Royal Academy summer shows. The Grosvenor Gallery, for example, fashionable from when it opened in 1877 until its closure in 1890, showed British modern artists, together with work from abroad, mainly France and America. Its architecture and decorations were sumptuous and intimate, emphasizing the cultivation of taste and masking its commercial purposes. Like the Tate later on, it was an appropriate space for middle-class women to visit, newly

visible in the metropolis.[20] As galleries became increasingly professionalized and interiors simpler and plainer, they also became more socially exclusive and more masculine.[21]

Private commercial galleries provided venues for exhibitions by artists hoping to seek new audiences, and the relationship among dealers, their patrons and artists in the formation of modern art was intimate. The New English Art Club held its first exhibition in 1886 at Martin Colnaghi's Marlborough Gallery; in 1910 and 1912–13 Roger Fry's highly influential exhibitions of French late-nineteenth-century art, together with contributions by British and other European artists (which led to the invention of the term 'Post-Impressionism'), were held at the Grafton Galleries; the Vorticists, dominated by Wyndham Lewis (1882–1957), held their first group exhibition at the Doré Gallery in 1915. Exhibitions generated reviews in the 'quality' press, such as *The Times*, *Sunday Times*, *Manchester Guardian*, *Daily Telegraph* and *Observer*. Critical acclaim influenced commercial success and developed audiences for new art, while having a work enter the

PLAN

MODERN FOREIGN, SARGENT AND
TURNER GALLERIES

TURNER GALLERIES, VI—X
MODERN FOREIGN GALLERIES, XI—XIII
SARGENT GALLERY, XIV
GROUND FLOOR GALLERIES, XXVII—XXXV

collections of the Tate was the ultimate endorsement of an artist's standing, and hence the importance of organized campaigns such as CAS to reshape its acquisitions. By the early twentieth century the nexus of dealers, critics and modern artists had usurped the Academy as the authority on British visual art.

The outbreak of the First World War caused a marked contraction in the art market. Upper-middle-class patrons signified their commitment to patriotic needs by avoiding conspicuous consumption and art was seen as inessential to the war effort. Large numbers of artists volunteered for military service in 1914–15 before the introduction of conscription. From 1916 the art market revived but the demand was for witnessed war paintings in a modernized style appropriate for the representation of modern war. Christopher Nevinson, who saw brief service at the Front as a voluntary ambulance driver, capitalized on the developing market for such works. *La Mitrailleuse* (fig.131) was exhibited at the London Group in 1915, and purchased by the Contemporary Art Society who presented it to the Tate in 1917. The war also became the occasion for extensive state patronage for art, the scope of which was

unique in Europe. Various war artists schemes emerged, beginning in 1916, and younger artists associated with the avant-garde, such as Nevinson and Paul Nash began working for a government propaganda agency, Wellington House. That British art had been recruited to the war effort was signalled in the title of the monographs – *British Artists at the Front* – that Wellington House produced for its artists, timed to coincide with exhibitions at the galleries of leading London dealers. When Lord Beaverbrook became Minister of Information early in 1918, he set up a scheme for the commissioning of a wide spectrum of artists to paint major history paintings to commemorate the war, selected to represent a collection designed to satisfy expert audiences. Known as the British War Memorials Committee, its advisors included Robert Ross, who as a Trustee of the Tate was also involved in drawing up lists of contemporary British artists who ought to be represented in its collections. In accordance with its aspirations, and contrary to the assumptions of much literature on the subject,[22] the scheme did not dictate styles to artists nor did it allocate subject matters.[23] Seventeen canvases, mostly 10 × 6 feet (3 × 1.8 metres), the size of Paolo Uccello's *Battle of San Romano* in the National Gallery, were produced including large canvases by artists such as Lewis, William Roberts (1895–1980), Nevinson, Nash and a reduced 'Uccello'-sized canvas, 6 × 7 feet (2.1 metres), by Stanley Spencer. When the paintings were shown at the Royal Academy in winter 1919–20 as *The Nation's War Paintings*, critics remarked on the anomaly of the pre-war avant-garde exhibiting at the Academy but concluded that, in a contest of the ancients and moderns, the moderns had triumphed. Ross proposed that the set of big paintings might be hung in a special extension to the Tate, but the politics of the period, and Ross's untimely death in 1918, resulted in all the work going to the Imperial War Museum, newly established in 1917, which neglected to show most of the canvases. The Tate closed during the First World War, and when it finally reopened fully in 1922, thirty-nine works on loan from the Imperial War Museum were hung. They included smaller drawings and paintings by Lewis, Roberts and Nash, and Spencer's *Travoys Arriving with Wounded at a Dressing Station at Smol, Macedonia, September 1916* of 1919 (fig.132).[24] When Frank Rutter reviewed the new Tate, he described it as a gallery that finally could be confidently recommended to visitors from abroad as 'one of the most interesting and certainly the most up-to-date art gallery in London'.[25]

Taylor writes that the nineteenth-century conviction that the public could be improved, even morally redeemed, through exposure to art began to decay in the period 1890–1918.[26] By the 1920s and 1930s, the spaces for exhibiting art to the wider public no longer encompassed the interests of the urban poor and were increasingly addressed to a cosmopolitan and specialized audience for modern art, a change he attributes to alterations in Britain's social composition. One consequence of the war was a general levelling and simplification of English class structures, including an expanded, more dominant but also more homogeneous, middle class. Artists began to emerge from a wider range of social backgrounds than hitherto and to enter the profession through accreditation by art school training increasingly supported by bursaries and prizes.[27] The British War Memorials Committee wanted to produce major history paintings that would first of all satisfy experts or, more precisely, that would impress the audience expected for a modernized Tate and planned for by a close coterie of professional curators and critics. But it also conceived itself as a modern Renaissance patron, as the selection of the Uccello as an emblematic precedent could

signify, exercising the authority formerly vested in the monarch and aristocracy. Beaverbrook was also a press baron, involved in developing mass media including cinema, whose audiences differed from the more select publics for art.

In the period before the First World War artists had organized to bypass both the Academy and the dealer system. The most radical group was the Allied Artists' Association set up in 1908 as an international co-operative. Modelled on the Salon des Indépendants in Paris, it held large, eclectic exhibitions, at first by hiring the Albert Hall.[28] It attracted European artists including Wassily Kandinsky whose works were then bought by Michael Sadler, shortly to become Vice Chancellor of Leeds University. Sadler, who built up a major collection of modern art, mainly by British artists, is an example of a modern patron for whom buying art was an extension of commitment to public service and also ensured membership of a modern intelligentsia. Collecting art from artists contesting paradigms was adventurous; buying directly from artists enhanced a collector's self-perception as a progressive patron and made it possible on a limited budget.

Although the art market recovered slowly in the 1920s, it contracted markedly in the Depression of the 1930s. When artists regrouped to promote modern art in associations such as Unit One (1933) and Circle (1937), it was often in an alliance with architects and designers, pitched at a market for small-scale works and organized in new London art galleries such as the Mayor Gallery and the Zwemmer Gallery.[29] The rise of Fascism and anxieties about the threat of another war made sustaining an international community for modern art imperative. Émigré artists and architects such as Naum Gabo and Walter Gropius fleeing Fascism began to arrive in England in the late 1930s. When Paris fell in 1940 Britain was the only European nation that was not occupied by Hitler with the infrastructure of institutions, galleries, dealers and critics capable of sustaining an avant-garde.

The State as Patron

A comprehensive review of German modernism, *Twentieth Century German Art,* was held at the New Burlington Galleries in 1938, as a rebuttal to the exhibition, *Entartete Kunst* held in Munich in 1937 that condemned modern art as racially degenerate. It opened the day before the annual *Große Deutsche Kunstausstellung* in the Haus der Deutschen Kunst, Munich, and Hitler denounced the London show in his opening speech. The New Burlington exhibition included works by Max Beckmann and Oscar Kokoschka (1886–1980), such as the latter's *Self-Portrait as a Degenerate Artist* 1937 (fig.133). Kokoshka, then in exile in Prague, fled to London in 1938 and became a British citizen in 1946.[30] The rise of Fascism with its persecution of modernist art in Germany was a determining factor in the reorientation of the collecting policies at institutions such as the Tate and the expansion of audiences for modernism.[31] The Museum of Modern Art (MoMA), New York, which opened in 1929 with Alfred Barr as its director was usually cited as the exemplary precedent for the renewal of the Tate, achieved under the directorship of John Rothenstein, appointed in 1938. *The Visual Arts* – a Political and Economic Planning pamphlet produced in 1946 by the Arts Inquiry, an independent organization set up in 1941 at Dartington Hall to argue for an expansion of state support – urged the establishment of a new national Museum of Modern Art and mentioned New York as the obvious example.[32] The Massey Enquiry, a government investigation into the function of the Tate and the National Gallery published in the same year, also recommended a new National Gallery for Modern Art by splitting the Tate into two, one part for the national collection of British art, the other for international modern art.[33]

In 1943 Barr, who once wrote that he hoped New York would one day have a museum like the Tate,[34] produced a pamphlet entitled *What Is Modern Painting?* for new audiences confused and bewildered about the correct position to take on abstract art. His answer was that 'the work of art is a symbol, a visible symbol of the human spirit in its search for truth, for freedom and perfection'. In Barr's account modern painting was described as evolving organically from Impressionism, to Post-Impressionism, Cubism and abstraction, and its progress was a metaphor for emancipation; modern works of art were 'victories in a long war of independence' of service to history and politics. Through his exhibitions, acquisitions and installations at the Museum of Modern Art, Barr expounded an exemplary history of modernism as a linear narrative of continuous renewal directed towards art's deliverance into the universal, the transcendent and the unpolitical. In *What Is Modern Painting?* Barr argued that, unlike speech, painting had no

133 OSCAR KOKOSCHKA
Self-Portrait as a Degenerate Artist 1937
Oil on canvas 110 × 85 (43⅜ × 33½)
Private Collection on loan to the
Scottish National Gallery of Modern
Art, Edinburgh

foreign languages, just local dialects or 'a kind of visual Esperanto'.[35] Because they were topical, Barr reproduced two paintings – Richard Eurich's *The Withdrawal from Dunkirk* 1940 (National Maritime Museum, London), an official war painting commissioned by the War Artists Advisory Committee in London and shown in New York in 1941, and José Clemente Orozco's *Dive Bomber and Tank* 1940, commissioned for the MoMA's *Twenty Centuries of Mexican Art* and painted on site – to argue that Orozco's was modern, Eurich's was not. This comparison, in which a British artist specializing in realist images of war reportage and described as painting 'with characteristic British reticence' comes out unfavourably, reinforces the notion that America, as the most intact economy to emerge from the war, dominated modern art, just as France had led in the first half of the twentieth century.[36] American contemporary art was extensively promoted in Britain and Europe after 1945. The art writings of Clement Greenberg, who championed American Abstract Expressionism, |exempli- fied a version of modernism that by the 1960s had become a critical orthodoxy. In 1968 Patrick Heron (1920–99) labelled the dominance of American art, symbolizing the values of free enterprise, 'a kind of cultural imperialism'.[37]

The relationship of British modern art to American initiatives is more than a simple one-way process of influence, however. During the war, when the *Studio*, which emerged as an important forum for promoting modern art in the 1930s, canvassed opinions about whether Britain should have a Ministry of Fine Arts, respondents were opposed to the idea but pressed for state funding citing their admiration of the Works Progress Administration (WPA) in the United States.[38] The WPA employed artists during the Depression, and one consequence was the sustainment of a visual culture that flourished as Abstract Expressionism in 1940s. It was an exceptional instance of American state support, but a useful model for a distinc- tively British commitment to Romantic socialism. More interestingly, works by artists who would subsequently become the most conspicuous ambassadors for a British modernism of international standing such as Henry Moore (1898–1986) and Barbara Hepworth (1903–75), were acquired by Barr's MoMA before they were represented in the Tate. Both artists showed in Barr's pathfinding *Cubism and Abstract Art*, 1936, and both had works purchased; Moore's *Two Forms* 1934 was funded by a donation made

by Michael Sadler.[39] The first Henry Moore to be acquired by the Tate was *Recumbent Figure* 1938, presented by the Contemporary Art Society in 1939 and originally commissioned by the architect Serge Chermayeff for the garden terrace of his home in the Sussex Downs (fig.134). Moore became a Tate trustee in 1941. The Tate did not acquire a Hepworth until 1950.

The War Artists Advisory Committee (WAAC) was established at the start of the war by Kenneth Clark (1903–83) then director of the National Gallery (see Button, p.118–19). Eventually employing over 500 artists, including many who had been official artists in the First World War such as Nash, Nevinson and Spencer, the scheme was meant to create a legacy in the form of a visual record but it was also a response to the assumption that conscription would be introduced from the outset of war, putting workforce planning on the national agenda. It was possible to argue for deploying artists as part of the national effort in a way that was impossible in the earlier war. Although the WAAC did not regulate how or in what way an artist should work, its purposes meant that figurative images were produced in a consensual modernized style, and the scheme, while it played a role in popularizing modern art, did not make the reputation of artists in a way that could be said for Paul Nash in the First World War. Exhibitions of WAAC artists that toured Britain and abroad, including *Britain at War* held at the New York MoMA as well as other American and Canadian cities in 1941, were part of a wide wartime culture of arts events that developed new audiences for art. From 1941 highly popular exhibitions of war artists' works were

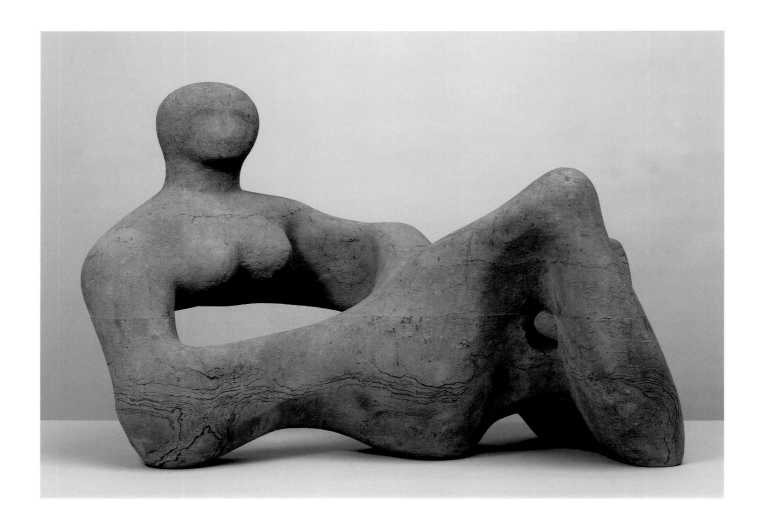

held at the National Gallery, whose permanent collection was in store for safety. The most important organization was the Council for the Encouragement of Music and the Arts (CEMA), an initiative of the philanthropic Pilgrims' Trust, which sent musicians and theatre companies on regional tours to sustain national morale. The Arts Council of Great Britain, established in 1946, was its direct successor.

The war demonstrated that there was a broad audience for art and culture in general. The development of popular audiences was also a feature of organizations involved in left-leaning politics in the 1930s such as the Artists International Association (AIA) exhibition *Unity of Artists for Peace, Democracy and Cultural Development*, known as *Art for the People,* held at the Whitechapel Art Gallery in 1939 and their travelling exhibitions for factory canteens co-organized with CEMA. The AIA also negotiated the payment of a royalty to artists of £5 per picture per year for exhibitions, a form of state patronage.[40] When the Labour Government was elected in 1945, it seemed to presage a new nationalization of art as part of the establishment of the Welfare State. In effect, however, although the Arts Council's founding charter referred to its mission to promote access to the arts, which implied broad audiences, the reference to 'the fine arts exclusively' meant that it was addressed to elite metropolitan audiences, what Raymond Williams later called 'the always confident executors of a pillared and patented Art' (see Stallabrass, p.127).[41] John Maynard Keynes, architect of the economy of the Welfare State and a long term patron of British modern art in its Francophile variant promoted by Roger Fry and the Bloomsbury Group, described the Arts Council as a 'very English' form of state patronage, 'informal, unostentatious … half-baked if you like'.[42] As a quango (quasi-autonomous non-governmental organization), the Arts Council was established simultaneously as a public body invested with the authority of the state and as independent of political control by its incorporation of a meritocracy drawn from the educated intelligentsia as voluntary advisers and administrators. Pearson points out that the quango resolves an issue about state power in Britain. Influential groups are incorporated, neutralizing dissidence and opposition, while areas of public policy are effectively privatized by being delegated to organizations 'not part of the public machinery of political decision' such as an elected parliament.[43] The Arts Council was an answer to the *Studio*'s question about whether Britain should have a Ministry of Fine Arts by providing a form of state patronage that preserved a semblance of liberal freedom for art. Its existence was also a tacit acknowledgement that a vibrant culture of modern art, essential for projecting the values of a post-war alliance of the Western powers as free of official ideology and opposed to the Eastern bloc, was dependent on public subsidy. As a recent study of government grants to the arts in Western Europe and the United States puts it, state patronage is justified as essential for the public good and as fostering merits which the consumer has as yet failed to recognize and will under-provide.[44] In Europe a strong historic aristocratic legacy was absorbed into new state institutions for art patronage, usually based on patterns established in the eighteenth century.[45]

During the war the Tate Gallery collected extensively in modern British art because, it was said, 'British painters have become the chief custodians of the great artistic traditions of free Europe'.[46] Almost no works by foreign artists were purchased, and the inaccessibility of European dealers' galleries is only a partial explanation.[47] For example, when Matisse's *Red Studio* 1911 came onto the London market in 1944, it went to MoMA, not the Tate. There were some bequests and gifts, including Edvard Munch's *Sick Child* 1907, declared degenerate and sold by the National Socialists from the Dresden Gallery in 1938, acquired and given to the Tate by a Norwegian collector in 1939 shortly before Oslo was occupied by Germany. In a similar vein J.B. Manson, Rothenstein's predecessor usually excoriated for his conservatism, arranged for Max Liebermann's last *Self-Portrait*, painted in 1934, to be donated as a gesture of solidarity with the German Jewish artist forced to relinquish all his honours when the National Socialists came to power.[48] However, works by the numerous European émigré artists present in London in the 1940s were not on the whole collected by the Tate.

The outcome of the Massey Report was the independence of the Tate from the National Gallery and the allocation of its first grant-in-aid in 1955. In 1951 the galleries were re-hung and 'modern foreign art' was made the key element in the gallery's image by being moved to the main galleries at the front, alongside galleries with British art hung chronologically and ending with British modern art in rooms adjacent to foreign art (fig.135). Nonetheless, the Tate continued to be installed as three collections: historical British, modern British and modern foreign. A symptom

FIRST FLOOR PLAN.

PRINCIPAL FLOOR PLAN.

REVISED JAN. 1953 R.H.

REVISED NOV. 1949 C.E.C.

TATE GALLERY SCALE 32 FEET TO 1 INCH FEET H. M. OFFICE OF WORKS
JAN. 1938.

of the reversal in the standing of modern foreign art in relationship to national culture was the conviction, manifested as late as 1962 by the Tate's director, then Norman Reid, that 'British painters have so far played only a minor role in this visual revolution of the twentieth century'.[49] In 1965 the collections were reorganized into two parts. British art up to 1900 was hung separately but national modern and foreign modern art were reintegrated on the grounds that 'the art of the present is indivisible and it is no service to British artists to consider them in isolation', as if British modern art had finally come of age. This was some twenty years after the French had integrated their modern and national art in the Musée national d'art moderne.[50]

Separating the Tate from the National Gallery also formally signalled a reorientation of the standards to which British art aspired to be judged in the national imagination.

Rather than taking part in a continuous tradition of European Renaissance art, it was to compete for a place in the story of international modernism. In this narrative, art was increasingly divorced from social context. The unadorned gallery, devoid of architectural detail and painted white came to represent the ideal viewing space for modernist art.[51] The Tate in the 1950s and 1960s had inherited an elaborate Edwardian Baroque building designed by Sidney Smith and extended by Duveen's lavish additions, including a monumental Sculpture Hall added in 1937 and designed by the American architect John Russell Pope in a severe modernized Neoclassical style. In the 1960s, when the Tate installed its expanding collection of both British and foreign modernist art, panelling obscured the architecture, including boxing-in architraves, dados and cornices. In 1964, a year before the major re-hang of modern art, it hosted the exhibition *Painting and Sculpture of a Decade*,

'54–'64, organized and funded by the Calouste Gulbenkian Foundation, an independent charity. Showing over 350 international paintings and sculptures by more than 160 artists surveying the decade, the catalogue celebrated the show as the 'institution of an avant-garde as the indispensable official art of the day'.[52] It was installed on freestanding panels attached to walls, designed by the architectural partnership Alison and Peter Smithson, 'annihilating the existing architecture' (fig.136).[53]

Critical for projecting the international reputation of British art was an artist capable of bearing the double burden of representing both national values and modernist status. Henry Moore, already collected by MoMA, became that figure when in 1948 he won the International Prize for Sculpture at the first Venice Biennale held after the war.

Moore's drawings of London people sheltering in the Tube during the Blitz have been described as galvanizing popular interest in modern art because they seemed to speak for the ordeal and endurance of a nation (fig.137).[54] Promoted extensively by the British Council and highly visible internationally especially in Germany and America, Moore represented 'the preeminent artist of western democracy'.[55] The British Council was established in 1934 to promote British culture abroad aligned with British commercial interests, partly in response to German fascist propaganda and at first as an annex to the Foreign Office. It took over responsibility for the British pavilion at the Venice Biennale in 1948.[56] The British Council also sponsored the British contribution to the São Paolo Biennial, founded in 1951 and modelled on the Venice prototype. Barbara Hepworth

carried off the grand prize there in 1959.[57] The art committees of both the Arts Council and the British Council were run by overlapping circles of influential curators, critics and professional arts administrators. John Rothenstein, Kenneth Clark and Herbert Read all served on the British Council's Advisory Committee for Fine Art, for example, and John Rothenstein was the commissioner for the British Pavilion at Venice in 1948. A crucial figure in the role of the British Council in fostering the international reputation of British art was Lilian Somerville, director of the Fine Arts Department for over twenty years from 1948 to 1970. It was Somerville who engineered the showing of works by J.M.W. Turner from the Tate's collections alongside those of Moore in the first post-war Biennale and who devised the exhibition *New Aspects of British Sculpture* with Kenneth Armitage (1916–2002), Reg Butler (1913–81) and Lynn Chadwick (1914–2003) among others, for the 1952 Biennale, a show that was termed 'a geometry of fear' by Herbert Read in his catalogue essay, and endorsed by Alfred Barr as displaying the most interesting works in the whole event. Somerville was also an adviser to major corporate collectors such as Stuyvesant and the Gulbenkian Foundation.

Some measure of the increased confidence in British art after the war, also a consequence of the increasing availability of subsidies, is the emergence of organizations and venues to counterbalance official institutions such as the Tate and the Arts Council. In 1947 Herbert Read, along with Roland Penrose and E.L.T. Mesens, echoing demands made elsewhere, called for the foundation of a Museum of Modern Art in London. What eventually emerged in 1948 was the Institute of Contemporary Art (ICA), intended as a meeting place for artists rather than audiences and to foster an experimental and creative avant-garde.[58] Very early on the ICA was the recipient of Arts Council funding, which, while it allowed the Council to sponsor what might be controversial without appearing to do so, also reaffirmed the institutionalization of the avant-garde celebrated in *Painting and Sculpture of a Decade, '54–'64*.[59] When Bryan Robertson, who trained at the Sorbonne and had run a small innovative gallery in Cambridge, was appointed to the Whitechapel Art Gallery in 1952 it became an alternative venue for major exhibitions of contemporary artists that was neither part of official establishment nor the private dealers network. The Whitechapel had been founded in 1901 in London's East End by Canon and Henrietta Barnett as part of their philanthropic projects of social reform, which aimed to bring culture to the working-classes. Its situation, away from the West End and the art market, meant that its audience was more heterogenous. Under Robertson's directorship, it became the New York MoMA's preferred London location for its international exchange programme, including the 1958 Jackson Pollock exhibition. Robertson's 1954 exhibition for Barbara Hepworth set a precedent for showing a living artist's work in a non-commercial space. On the scale of a museum show, a retrospective surveying the artist's *oeuvre* at mid-career and accompanied by a scholarly catalogue and press releases was a means to shape an artist's reputation.[60] In the 1960s Robertson established the New Generation series, showing emerging contemporary artists, most famously a group of graduates from the Royal College of Art who would become identified with Pop art, such as David Hockney. The shows were sponsored by the Peter Stuyvesant Foundation, who were seeking venues to promote public relations.[61] When Robertson, with John Russell and Anthony Armstrong Jones, published *Private View* (1965), his book about the London art scene, he celebrated the independence of the Whitechapel against the conservatism of the Arts Council.[62]

London from the 1950s onwards was increasingly cosmopolitan. Artists began to arrive from the colonies, for example Aubrey Williams from Guyana, who switched from agricultural engineering to study at St Martin's School of Art in 1952–3, winning the Commonwealth Prize for painting in 1965, and Francis Newton Souza, from Goa in India who arrived in 1949 and rapidly established a high profile (see Araeen, pp.154–5). In part this was attributable to large-scale post-war migrations, epitomized by the arrival in 1948 of the *Empire Windrush* at Tilbury with 492 Jamaicans recruited to the British labour market. But the emergence of a generation of Afro-Asian artists was also an outcome of imperial policy in the 1920s and 1930s, which established schools to train a local cadre of administrators who formed an intelligentsia often active in anti-colonial struggles. An example of such a policy is *The Arts of West Africa*, edited in 1935 by Michael Sadler at the behest of the Colonial Office, which promoted an art education in the Africa colonies that was sensitive to local culture including acknowledging the impact of colonization.[63] After the independence of India in 1947 Britain dismantled its empire, shedding its colonies, and a series of nationality acts redefined British citizenship increasingly narrowly.

The Imperial Institute, for example, was renamed the Commonwealth Institute in 1957. Two Commonwealth Biennials of Abstract Art were held there in 1963 and 1965. Nonetheless, African and Afro-Caribbean artists had been present in London from the 1920s and 1930s.The Nigerian artist Aina Onabolu (1882–1963) studied in St John's Wood and Paris in 1920–2, and was responsible for recruiting Kenneth Murray as Nigeria's first art education officer in 1927. Murray arranged an exhibition of Nigerian modern art at the Zwemmer Gallery in 1937 including Ben Enwonwu (1921–94), later a leading promoter of modernism after Nigerian independence. Jamaican artist Ronald Moody (1900–84) came to London in 1923 to study dentistry, switched to sculpture and worked in Paris, returning to London in 1941 (fig.138). None of these artists' works was collected by the Tate in the period, and the 1986 Royal Academy exhibition *British Art in the Twentieth Century* included no works by Afro-Asian artists, either born in Britain or abroad. A landmark publication, registering the exclusion of these artists, was Naseem Khan's report, *The Arts Britain Ignores* (1976), part funded by the Arts Council, which led to the setting up of the Minority Arts Advisory Service (MAAS), named consciously to echo the Caribbean *mas* or carnival and the Spanish word *más* or greater.[64] Rasheed Araeen's exhibition, *The Other Story: Afro-Asian artists in Post-War Britain*, 1989, made these artists visible at the same time as it sharpened debates about tokenism and ghettoization. In the 1980s Afro-Asian artists, both those born in Britain and elsewhere, established an infrastructure of galleries, journals and support networks in what Stuart Hall has termed 'a struggle to resist exclusion, reverse the historical gaze, come into visibility, and open up a "third space" (between the weight of an unreconstructed tradition and the impetus of mindless modernism) in cultural representation'.[65] In the 1980s, the 'four-percent rule' established, controversially and problematically, that arts organizations should allocate that proportion of their budgets to black arts, which because of a lack of long term monitoring and analysis generated tokenism and stigmatization.[66]

Public funding bodies, including the Greater London Arts Council and regional arts associations, provided support for extending networks especially through artists' initiatives. From the 1960s onwards artists seeking cheap and easily adaptable accommodation for studios moved to the East End of London, then an area of economic

decline.[67] In 1968 Peter Sedgley and Bridget Riley, with the support of the Greater London Council (GLC), the Arts Council and the Gulbenkian Foundation, began SPACE, an initiative to convert derelict industrial buildings into studios, opening St Katharine Dock for ninety artists. In the early 1970s fine art graduates from the University of Reading approached the GLC with a proposal to occupy housing scheduled for demolition, setting up ACME.[68] It became the largest housing association managing short-life housing in London, providing space for more than 350 artists in 204 properties by 1978. Artists' initiatives produced artist-run galleries, such as Robin Klassnik's Matt's Gallery, which started when Klassnik invited other artists to show in his studio, and Maureen Paley's

Interim Art, which she set up in her ACME house.[69] The Whitechapel Art Gallery already had a long-standing tradition for showing East End artists. In 1977 its new director Nicholas Serota and the gallery's newly created Education and Community Officer Martin Pewcastle widened the scope of the Whitechapel Open, run annually since 1971, to include artists with studios north and south of the river, and in an acknowledgement of the diversity of the local population, printed the poster in Bengali and English. The gallery hosted *The Arts of Bengal* and a show of contemporary artists from Bangladesh in 1979, just as in 1906 it had shown exhibitions of Jewish art and culture and in 1914 had included a Jewish section in its show *Twentieth Century Art*, curated by the artist David Bomberg, son of a Polish Jewish immigrant (see Stephens, p.104).[70]

Multinational Capitalism: The Privatization of Public Art

In a series of articles that appeared in *Art Monthly* in the late 1990s analysing the phenomenon of the YBAs (Young British Artists), Simon Ford referred to the 'surge to merge culture with the economy'.[71] He was quoting the Director General of the Association for Business Sponsorship of the Arts (ABSA), an organization – Chin-Tao Wu calls it a trade association for corporate patrons – set up in 1976 with a grant from the then Labour government and led by the chairman of Imperial Tobacco.[72] What had taken place in the 1990s in Ford's account was a rebranding of British art as a form of lifestyle marketing in order to sell London as the major European financial centre and a premier tourist destination. Such developments were rooted in a wider transformation, beginning in the 1970s, which in art was marked by a collapse of confidence in the narratives of institutionalized modernism and the contestation of its paradigms specifically its claims for universality (see Harrison, p.63, Stephens, p.106 and Wood, p.182). The title of Rasheed Araeen's *The Other Story* had a double meaning: both the history of Britain's 'others', its colonized peoples, against whom Britishness defined itself by its difference, and an 'other' story of the modern that refused to repress politics and resisted exclusionary narratives. The election of Margaret Thatcher in 1979, after an economic recession and the 1973 oil crisis, accelerated an agenda of privatiza-

tion and the dismantling of the Welfare State that inevitably encompassed retrenchment in state subsidies for the arts.

While the marked contraction in public expenditure on the arts in the last thirty years has not been matched by any curtailment in the visual arts, the nature of contemporary art and its contexts has changed profoundly. Rather than retrenchment, the period has produced a booming art market and an enormous expansion in the audiences for modern and contemporary art, signified by the opening of Tate Modern at Bankside in 2000. How publics for art are addressed and the ways in which art is marketed, however, have altered in ways unimaginable in the earlier twentieth century. If modern art's public was once an elite and specialized one, then from the 1940s a process of democratization, including the expansion of education, enlarged and enfranchised an audience to participate in viewing modern art as part of a national entitlement. The gradual replacement of state subsidies with private and commercial sponsorship has changed the viewer from a citizen into a consumer. The Tate website, for instance, invites potential sponsors to 'align with the innovative, market-leading Tate art brand' and 'leverage marketing, promotion and PR campaigns'.[73] When plans to split the Tate collections and develop a museum of modern art were under discussion in 1992, one consultant put it: 'the visitor … becomes the customer to whom we are offering the product of a museum visit.'[74]

Tate Modern was established in G.G. Scott's Bankside power station, built between 1947 and 1963 and decommissioned in 1981, enhanced by an extensive renewal and rebuilding by the architectural partnership Herzog and de Meuron. The initiative dates back to around 1991–2 and began with ideas about a temporary museum of modern art to unpack the over-stretched site at Millbank. Billingsgate was considered as a possible venue. Tate Liverpool had already opened in 1988 as part of a drive to regenerate the depressed economy of a region that had seen riots in 1981. This paralleled plans to decentralize arts provision signalled by the Arts Council policy document *The Glory of the Garden* (1984), which proposed to devolve various responsibilities to Regional Arts Associations and to develop business sponsorship of the arts.[75] When Bankside was announced in 1994, it terminated the development of regional Tates. The last initiative was a Tate St Ives that opened in 1993 in partnership with Cornwall County

Council. The decision was to develop a MoMA for London, 'a project which has the scale and ambition for a great metropolitan city'; it was imagined as a rival to New York and Paris. The primary aim for Tate Modern from the very earliest days of discussion was to place the emphasis on a visitor experience that had to be innovative.[76]

When Nicholas Serota was appointed Director of the Tate in 1988 he announced a new policy for hanging the collection. Both British art before 1900 and modern art were to be reintegrated into one chronological sequence, which would be interrupted with thematic displays and unexpected juxtapositions. At the same time panelling and screens were stripped out revealing the original architecture at Millbank. Bankside, which is a very large building, was to be organized as a set of suites, each one a self-contained display that audiences would make more than one visit to view. Moreover, whereas in the Tate's collection the balance of loans to owned works was 1:20, in the new Tate this was to rise to 1:5. The Tate's purchasing grant had been frozen to its 1979 level, and the Patrons of New Art was established as an organization at the gallery in 1982 to raise revenue from private sources for acquisitions of contemporary art. Setting up an ambitious project on an international scale was also a mechanism for fostering the expansion of the collection through donations. At the same time as Tate Modern opened, coinciding with and capitalizing on millennium celebrations, the whole organization was also given a new corporate identity, designed by Wolff Olins, which aimed to unify its four sites, identifying itself as a brand rather than a set of institutions.[77] Millbank became Tate Britain. Visitor numbers rose from 4 million in 1991–2000 to 7.5 million in 2000–1. In 2005, 50 per cent of visitors to Tate Modern came from abroad and 57 per cent were under thirty-five.[78]

The corporate patron, both as sponsor and collector, was already present in the 1960s. Peter Stuyvesant sponsored shows at the Whitechapel when Bryan Robertson offered 'all the ingredients: art, youth (but not too young) and internationalism'.[79] Philip Morris Tobacco sponsored *When Attitudes Become Form*, organized by Harald Szeemann in 1969 and shown at the ICA (see Wood, pp.194–5 and Wallis, pp.196–7). In 1983, Raymond Williams, speaking about the Arts Council, argued against corporate sponsorship that was a matter of commercial calculation and public relations: 'we shall have lost a half-century of effort, of achievement and of dignity.'[80] Artists'

initiatives were as significant in the 1990s as they had been in the 1960s but were increasingly sponsored by businesses. Damien Hirst's now canonical exhibition *Freeze*, which is taken as the origins of the 1990s phenomenon 'Young British Artists', or 'YBAs', was sponsored by the London Docklands Corporation, while Olympia and York, the developers of Canary Wharf, funded the catalogue. *House* 1993–4, by Rachel Whiteread (b.1963), a public commission by the independent organization Artangel, involved casting the interior of a Victorian terrace scheduled for demolition as a sort of temporary monument to lost communities; it was sponsored by Beck's beers for whom the artist also designed a limited edition beer bottle label (fig.139). Corporate sponsorship is a new form of patronage and has replaced an earlier generation of patrician art patrons deriving individual wealth from family fortunes made in industry such as Henry Tate or Samuel Courtauld. Nonetheless, an interest in sponsoring the arts tends to come from elites within a corporation such as the managing directors, who, like traditional patrons, use art for its associations with power and prestige. Chin-Tao Wu refers to the corporate patron as a 'modern-day Medici'.[81]

Artists' projects such as Hirst's *Freeze* show benefited from short-term lets made available by property speculators, whereas an earlier generation of artists tended to be supported by local authorities such as the GLC. Arguably, accommodating artists pursuing innovative projects assisted in the gentrification of run-down areas or their redevelopment for more affluent occupiers.[82] Artists in *Freeze* were also quickly signed up by commercial galleries. The figure usually credited with the YBA phenomenon is Charles Saatchi, advertising executive and art collector who, beginning in 1992, hosted a series of exhibitions entitled *Young British Artists* at his private gallery. Saatchi made his fortune through founding an advertising agency, Saatchi and Saatchi, with his brother Maurice. By the 1980s the firm, which ran Thatcher's election campaign in 1979, had established itself as the largest advertising conglomerate in the world. It capitalized on the growth in the information and service industries due to increasing globalization and benefited from shifts in capitalism that increasingly emphasized consumerism and the marketing of products and services.[83] It has been said that advertising in the 1980s became politicized, commercial and assumed the status of art, 'in other words it became more controversial, more

140 CHRIS OFILI
The Holy Virgin Mary 1996
Acrylic, oil, resin, paper collage, glitter,
map pins and elephant dung on canvas
243.8 × 182.8 (96 × 72)
Courtesy Chris Ofili – Afroco
and Victoria Miro Gallery

lucrative and more pretentious'.[84] Saatchi and Saatchi were known for their creative approach to advertising and their innovations, and for their early development as an international corporation.

Charles Saatchi began collecting in the late 1960s and by the 1980s was acquiring works of art on a lavish scale. He tended to buy extensive examples of works by artists who interested him. He was one of the Patrons of New Art, but after controversy about an exhibition by the American artist Julian Schnabel at the Tate in 1982, he resigned.[85] The following year he bought a disused warehouse in Boundary Road, St John's Wood, north London, which was refurbished by the architect Max Gordon. With a succession of temporary exhibitions on the scale of museum collections and often stunningly installed, the Saatchi Gallery was for a time the most impressive exhibition space in London.

Sometimes described as a 'super collector', Saatchi is a controversial figure because he has breached assumptions about how private collectors are supposed to behave and has caused questions to be made about his motivations. To date, Saatchi has made only limited donations to public collections; works were donated to the Tate in 1992 and to the Arts Council Collection in 1999. Early on Saatchi assembled his collection through the advice of dealers, principally Larry Gagosian in New York, but subsequently he has bought directly from artists, often on visits to studios. He has also sponsored artists, for example providing the painter Jenny Saville (b.1970) with an income soon after she left art college so that she could paint full-time. The most controversial aspect of his activities is the sale of works of art from his collection, often for a profit, effectively making him a speculative dealer rather than a collector. In the 1990s Saatchi's influence on the art market was enormous; his tendency to buy directly from artists, together with the profile of a gallery space that was gradually opened to the public, meant that he had such a substantial hold over both production and distribution of contemporary British art that he was termed 'the Rupert Murdoch of the art world'.[86] In a move that seemed obviously intended to mimic and rival Tate Modern, he reopened his gallery in 2003 on South Bank as part of a refurbished and privatized County Hall, once the home of the Greater London Council (controversially abolished in 1986 under Thatcher).[87]

The Turner Prize was also the initiative of the Patrons of New Art, and specifically the idea of Max Gordon. An annual competition for contemporary British art, it was intended to be the equivalent of the Booker Prize for literature and to make itself just as well known. Set up in 1984, it was reformed in 1991 with Channel 4 as its new sponsors and is now limited to British artists under fifty who have had a significant exhibition or works in the public domain in the previous twelve months. The Turner Prize functions as a forum for discussing contemporary art and is intended to attract a young audience: a sector that is also a key consumer market.

Contemporary art – which now emphasizes mobility, diversity and difference – is increasingly used to boost economies. Tate Modern, the Turner Prize and the Saatchi Gallery were crucial components at the turn of the millennium in promoting London as Europe's premier financial market and business centre. The YBAs were an appropriate phenomenon for remarketing a post-imperial Britain as 'cool Britannia': young, entrepreneurial and 'with attitude'.[88] Biennials are now an expanding feature of an international art circuit. Liverpool Biennial, for example, was set up in 1998 to promote and develop an infrastructure for the arts in the region as a means to build confidence, generate tourism and promote a positive image of the city.[89] Difference and diversity is increasingly marketable so that the problem for Afro-Asian artists is not so much making themselves visible as the kind of visibility the work is now subject to and in whose interests.

In 1999 an exhibition of the YBAs' work, *Sensation*, opened at the Brooklyn Museum, New York, to widespread controversy. New York's mayor, Rudy Giuliani, wanted the show closed because he argued that the painting *The Holy Virgin Mary* by Chris Ofili (b.1968), complete with the artist's trademark elephant dung, was offensive to Catholics (fig.140). The exhibition consisted entirely of works from Charles Saatchi's collection. Its showing in Brooklyn was the third venue on a tour that had originated in 1997 at the Royal Academy. The London art scene is obviously transformed from its position at the start of the twentieth century; the irony of a controversial showing of purportedly avant-garde British art being held at the Royal Academy at the end of the century is inescapable.

Bringing to Light:
Photography in the UK, 1980–2007

EMMA DEXTER

Despite the extraordinary achievements of nineteenth-century British photographers, which had established Britain as a world leader in the new art form, there is a painful truth in John Szarkowski's now famous observations that 'the photographic tradition died in England sometime around 1905' and that 'in the thirties, England had forgotten its rich photographic past, and showed no sign of seeking a photographic present'. Despite this gloomy prognosis, however, there was a present and future for British photography in the twentieth century, though it remains a confused and still insufficiently understood story – in which mavericks, refugees, passionate amateurs and tireless magazine editors all played a part in keeping the photographic flame alive. Unfortunately twentieth-century Britain lacked the institutional framework to promote and celebrate its photographers on a national and international level, leaving the reputations of practitioners as diverse as Cecil Beaton (1904–80), Bill Brandt (1904–83), Angus McBean (1904–90), Grace Robertson (b.1930) or Tony Ray Jones (1941–72) to languish in a way that would have been unthinkable in the United States, where the Museum of Modern Art's Photography Department had, since the 1930s, been instrumental in collecting and promoting photographic culture, and crucially establishing its links with modernism. It was as late as 1976 when the Victoria and Albert Museum – a museum dedicated to decorative and applied arts – appointed its first photography curator and, in tandem with the Science Museum, started collecting photography for the nation. As a result, the medium's fine art credentials were overlooked, as neither the National Gallery nor Tate took responsibility for collecting. Much changed in the 1970s, when artists started to use photography either as part of Conceptual art practice or in order to document performances. For this reason Tate started to collect photography, but it was not until the 1990s that a substantial photographic collection was started.

This tardy interest in photography amongst major British galleries left the field open for the establishment in the 1970s of a network of small-scale independent exhibition spaces, projects and magazines, all dedicated to the medium. Venues such as the Photographers' Gallery, London (founded 1971); Impressions, York (1972); Stills, Edinburgh (1977); Side Gallery, Newcastle (1977); Open Eye, Liverpool (1977), and Camerawork, east London, were essential to the development of British photography during the 1980s. Other independent but public spaces such as the ICA, Serpentine, Hayward, Arnolfini and Ikon held important photographic exhibitions, launching figures such as Martin Parr. The journal *Creative Camera* continued to be an important crucible for debate, while in Birmingham's Handworth area, the Ten.8 Collective was a community-based photographic project and magazine, founded by Derek Bishton, John Reardon and Brian Homer in 1979, which brought discussion of race, representation, social justice and community to debates around photography. Established in the late 1980s, Autograph, the Association of Black Photographers, started organizing regular touring exhibitions, events and publications, providing a much needed counterbalance to the predominantly white, male-dominated field of what was perceived as the photographic establishment of the 1980s.

In terms of practice, British photography from 1980 to the present day can be characterized by the dominance of two key strands. The first was heavily indebted to conceptualism, and was a form of deconstructive photography which interrogated the very nature of the medium itself, sometimes including text or consisting of artificial tableaux. The other was the older tradition of socially engaged straight photography, heavily influenced by the European and US traditions of humanist reportage practised by, amongst many others, Henri Cartier-Bresson or William Klein. Both of these strands of photography became key reflectors of the changes wrought in British society after the election of Margaret Thatcher in 1979. These changes included a massive rise in unemployment, the closure of much traditional heavy industry such as coal and steel production, increased social unrest (fuelled by a perceived widening gap between rich and poor) and the advent of 'yuppie' culture: rich urban elites engaged in the profitable service sectors of banking, insurance and advertising.

British straight photography was dominated in the 1980s by the increased use of colour for documentary purposes, which lent a satirical and even jarring quality to the acerbic vision of Martin Parr (b.1952), Anna Fox (b.1961), Tom Wood (b.1951) and Paul Reas (b.1955), who variously explored class, taste, work, leisure and consumerism. Paul Graham (b.1956), also working in colour, used a cooler documentary approach informed by conceptualism, to examine Northern Ireland against the background of the Troubles or the British social security system. Meanwhile, working in black and white, Chris Killip (b.1946), Graham Smith (b.1947) and John Davies (b.1949), turned their gaze upon a blasted semi-industrialized landscape and the bleak lives of those Britons shut out from the Thatcher

141 CHRIS KILLIP
Bever, Skinningrove 1981
Silver gelatin print
50.8 × 61 (20 × 24)

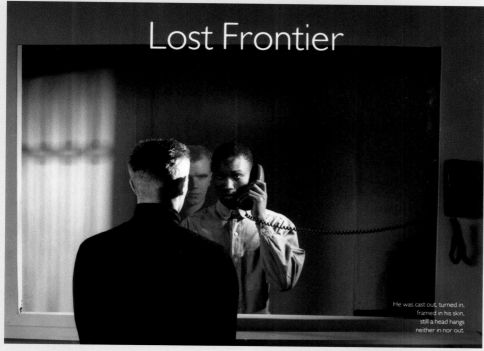

Lost Frontier

He was cast out, turned in, framed in his skin, still a head hangs neither in nor out.

142 MITRA TABRIZIAN
Lost Frontier
from *The Blues* (1986–87)
Kodak C print
121.9 × 152.4 (48 × 60)
Collection of the artist

revolution (fig.141). In Birmingham, the black photographer Vanley Burke (b.1951) was creating an important documentary portrait of the Afro-Caribbean community during these times.

The 1980s also saw the emergence of artist/ photographers who used the camera to make works influenced by conceptualism's use of image and text, as well as reflecting other disciplines such as psychoanalysis, feminism and Marxism. Examining themes such as identity, power, gender and wealth, artists attempted to subvert the traditional power of the male gaze as articulated in conventional advertising and magazines, as could be seen in the glossy colour tableaux of Mitra Tabrizian, which borrowed the aesthetics of film advertising to examine questions of identity and race (fig.142). Willie Doherty (b.1959) and Paul Seawright (b.1965) used text and photo to reveal the hidden histories of the still bitter conflict in Northern Ireland and to suggest a society continually under surveillance. Artists used photo-text to reveal power structures: from Karen Knorr (b.1954), with her coruscating portraits of the rich of Belgravia, to Oliver Richon, with his highly artificial still lifes suggestive of coded symbolic systems. Sunil Gupta (b.1953) added captions to his images of gay men in India in his Exiles series of 1985, a body of work that aimed to reveal the dangers and realities of these hidden lives. Many artists used their own experience in making work: Donald Rodney (1961–98), who suffered from sickle cell disease, recycled hospital X-rays in his large collages that eviscerated race, politics and the politics of health in 1980s Britain.

Jo Spence (1934–92), a feminist and socialist photographer, developed a form of photo-therapy, based upon her own self-image, combined with text, which was a disarmingly honest meditation on family, class, society, gender and power (see Stallabrass, p.144).

The decade also saw the rise of New British Sculpture (see Wallis pp.196–7). In parallel with this, constructed studio photography that blurred the boundaries between photography and sculpture and that had a strong narrative quality was widely exhibited, with works by Boyd Webb (b.1947), Mari Mahr (b.1941) and Calum Colvin (b.1961) regularly appearing in group exhibitions alongside conventional sculptural works. In *Ego Geometria Sum* 1983 by Helen Chadwick (1953–96), images redolent of the artist's life from birth to age thirty, including naked self-portraits, adorn the exterior of the numerous bulky plywood structures. *Monument* 1981 by Susan Hiller (b.1940) used photography as part of a multi-layered installation that examined public and private, memory and language. At this time, the Nigerian-born Rotimi Fani-Kayode (b.1955) was making studio-based poetic imagery in both black and white and colour, creating a unique iconography exploring religion, race, spirituality and sexuality.

While Germany saw the rise of large-scale pseudo-objective and precisionist photography in the late 1980s and early 1990s, as practised by Andreas Gursky and Thomas Struth, in Britain only the work of Hannah Collins (b.1956) and Craigie Horsfield (b.1949) was of a sufficient scale and seriousness to warrant inclusion in

exhibitions examining history and objectivity in photography. Indeed, in contrast to German trends, the YBA generation exploited photography as a dumb tool for recording, just as Conceptual artists had done in the 1970s, choosing to champion what Neville Wakefield has described as 'bad' photography rather than 'good'. Rather than the technically brilliant images of their German colleagues, artists such as Gillian Wearing (b.1963), Sarah Lucas (b.1962), Sam Taylor-Wood (b.1967) and Richard Billingham (b.1970) favoured a rough and ready style that suggested immediacy, informality, popular culture and style magazine aesthetics, often using it for a variety of performative presentations in front of the camera. Another development of the 1990s saw a blurring of boundaries between the worlds of fashion photography and fine art, as photographers such as Corinne Day (b.1965), Wolfgang Tillmans (b.1968), Jurgen Teller (b.1964) and Hannah Starkey (b.1971) started using magazines as an outlet for their challenging and original vision, later becoming artists who entirely distanced themselves from fashion photography, but not before they had exerted a powerful influence on the sector.

Recent developments have seen a shift in how artists engage with their subject: Phil Collins (b.1970) lives and works with the communities of asylum seekers or refugees that he depicts, while Shizuka Yokomizo (b.1966) works collaboratively with her subjects, inviting unknown participants to appointments, and asking them to decide how they wish to be depicted. Clare Strand (b.1973) poses her models against a nineteenth-century type painted backdrop, the subject is carefully styled and posed, while revealing specially planted signs of vulnerability and stress.

FURTHER READING

S. Bright and V. Williams, *How We Are: Photographing Britain from the 1840s to the Present*, exh. cat., Tate Britain, London 2007.
M. Kozloff, *The Theatre of the Face: Portrait Photography Since 1900*, London 2007.
D.A. Mellor, *No Such Thing as Society: Photography in Britain 1967–1987*, exh. cat., Hayward Gallery, London 2008.

Painting in Britain since the mid-1970s

NEIL MULHOLLAND

The mid-1970s are remembered as the time when painting was rudely awoken following a perceived crisis in modernist confidence. Certainly, in terms of its international visibility, critical reception and market value, figurative painting was a dominant medium. In the UK, however, where many wilfully ignored contemporary art, there was little need for a 'revival'. By continuing to take centre stage in art college syllabi, painting marginalized newer media and strategies. Despite this hegemony, a sense of disgruntlement was voiced towards what many painters unduly regarded as the prominence of video, photo-based practices, performance, conceptualism and social functionalism. R.B. Kitaj was joined by a chorus of voices including David Hockney, painters associated with *Artscribe* magazine and critic Peter Fuller in proclaiming a painterly renaissance. The School of London, a group of figurative painters who had migrated to bohemian Soho, was championed

as guardian of the Great Tradition of 'British' figurative oil painting. On closer inspection the work of artists as diverse as Francis Bacon, Frank Auerbach and Leon Kossoff reveals affinities with a European existentialism that is entirely at odds with the nostalgic English bucolic it purportedly supported, a sensibility that has more to do with the Diaspora and trauma of the 'atom age' than the 1970s with its oil crises and strikes. As a cultural imaginary the 'British' qualities attributed to such painting unwittingly helped to serve as a marketing tool for a neoconservative revival led by Margaret Thatcher and as an ideological bulwark against the dominance of New York as the global art centre. Painting in the early 1980s was the field upon which Western European states would attempt to wrestle control from this centre (and one another) through a process of vernacular mobilization and critical regionalism.

In other corners of the UK painting was a means of contesting this new imperialism with a plurality of highly polarized practices. In Scotland painters such as John Bellany (b.1942) and Alexander Moffat (b.1943) rallied under the banner of 'Scottish Realism', a tendency influenced by Max Beckmann, Fernand Léger and the inimitable nationalist Marxism of poet Hugh MacDiarmid. Numerous artists contributed to mural schemes across the UK, often with the intention of giving painting an agitational purpose and expanding its remit beyond the frame of the museum. Many feminist artists rejected painting in favour of lens-based work due to painting's relations with a patriarchal canon. Just as many turned to painting precisely as a means of challenging the hegemony of this canon on feminist terms. Alexis Hunter (b.1948) showed a renewed interest in representational images of the body, with facture as an abject process and as a vessel for a mytho-poetic discourse. We can see the prevalence of this approach to painting throughout and beyond the 1980s in the impasto work of Thérèse Oulton (b.1953), Gwen Hardie (b.1962) and Jenny Saville (b.1970) among others.

Significant developments in the 1980s also included the rise of the New Glasgow Boys, a cluster of young figurative painters who emerged rapidly into international prominence. The label served more to advance the visibility and autonomy of contemporary Scottish art than to elucidate the substantial differences between practices. The paintings of Ken Currie (b.1960) are continuous with the 'Scottish Realism' and Marxist muralism of the 1970s (see Stephens, p.80). Working in New York, Steven Campbell (1953–2007) made paintings that were, in contrast, informed by a metropolitan postmodernist vocabulary that was rooted in conceptualism and performance and commensurate with the anti-Expressionism of German artists Martin Kippenberger and Albert Oehlen (fig.143). An equally rigorous post-Conceptual approach to painting as a discursive practice could also be identified in the work of Terry

143 STEVEN CAMPBELL
The Dangerous Early and Late Life of Lytton Strachey 1985
Oil on canvas 261.8 × 274.5 (103 × 108)
Tate. Presented by the Patrons of New Art through the Friends of the Tate Gallery 1986

144 GARY HUME
Incubus 1991
Alkyd house paint on Formica
238.9 × 384.6 (94 × 151 ³/₈)
Tate. Presented by Janet Wolfson
de Botton 1996

Atkinson (b.1939) and the remaining members of Art & Language, pioneers of conceptualism in 1960s Britain (see Harrison, p.62 and Wood, p.183).

The kind of painting that survived the bursting of the New York art market bubble in 1986 and the consequent rise of neo-conceptualism emphasized conceptual rigour and a non-painterly decorum rooted in a neo-modernist preoccupation with materiality, repetition and process. Such issues surface in the cerebral facture of works by Callum Innes (b.1962), Ian Davenport (b.1966) and latterly Alexis Harding (b.1973). A renewed interest in hard-edged pop was reflected in the gloss surfaces of paintings by Gary Hume (b.1962; fig.144) and Damien Hirst. While much of this work uncritically revisited aspects of painting that had been exhausted in the 1960s, it had the benefit of opening the floodgates to a more performative, post-conceptual way of painting that was less concerned with the art-historical canon.

Like the feminist painters of the 1970s, many painters now focus on their own varied and contingent cultural experiences, as is evident in the eclectic mixture of faux naïf primitivism, pornography, Blaxploitation and elephant dung in the work of Chris Ofili (b.1968). His playful and irreverent engagement with identity might benefit from oblique comparison with very different paintings by George Shaw (b.1966), who depicts the back lanes of his childhood in Humbrol enamels or by Lucy McKenzie (b.1977), who paints bespoke parochial subcultures relating to Scotland, Germany, Poland, New York and Belgium. The moot issues of Britishness, art-historical references and 'painter's painting' that preoccupied painting in the 1980s and 1990s have been conclusively overshadowed by the appreciation that painting is just one medium among many others. Few artists based in the UK now practice exclusively as painters and even fewer are concerned with old 'painting' paradigms and polemics. Those who do paint exclusively tend to have a sophisticated understanding of the benefits of studio praxis, of working with a malleable medium that allows them to dabble, make mistakes and test parameters rather than work in an instrumental project-based fashion.

FURTHER READING

P. York, *Style Wars*, London 1980.
P. Fuller, *Seeing through Berger*, London 1988.
M. Dickson, 'Polemics: Glasgow Painting Now', *Edinburgh Review*, no.73, 1986, pp.59–64.
R. Cork, *New Spirit, New Sculpture, New Money: Art in the 1980s*, vol.2, New Haven and London 2003.
D. McCorquodale, N. Siderfin and J. Stallabrass, *Occupational Hazard: Critical Writing on Recent British Art*, London 1998.
B. Schwabsky, *Vitamin P: New Perspectives in Painting*, London 2004.

Black Visual Arts Activity in the 1980s

EDDIE CHAMBERS

The 1980s was an unprecedented period of activity for Britain's black artists. The previous decade had seen a number of important visual arts initiatives involving black artists. These practitioners, such as Emmanuel Jegede (b.1943) and Ronald Moody, were immigrants who had come to Britain from countries of the British Empire/Commonwealth (see Araeen, pp.154–5 and Stephens, p.106). The 1980s, however, produced a new generation of artists, for the most part British-born, the majority of whom were, or were to become, art school graduates. The decade was significant for two reasons. Firstly, it produced many professional artists who went on to make important contributions within Britain and further afield. Sokari Douglas Camp (b.1958), Veronica Ryan (b.1956), Eugene Palmer (b.1955), Denzil Forrester (b.1956), Sonia Boyce (b.1962) and others all established reputations for themselves during the course of the decade. Secondly, the 1980s delivered many new opportunities for black artists to have their work included in the group exhibitions that frequently took place within galleries and other venues across the country.

The genesis of this activity is often traced back to the early 1980s and a series of exhibitions mounted and organized by a group of young artists and art students who had grown up in the West Midlands. Chief amongst these practitioners was Keith Piper (b.1960), who came to symbolize a new generation of younger black artists whose work was characterized by what was, in a British context at least, a new attachment to social and political narratives expressed though styles that drew heavily on the influence of Pop art, found imagery, ready-mades and the use of mechanical forms of image making, such as the photocopy (fig.145). Other artists utilized more traditional techniques of painting and drawing to comment on the black experience. These artists, Claudette Johnson (b.1959) and Donald Rodney amongst them, took as their subject matter the history, culture, tribulations and aspirations of black people throughout the world (fig.146). Piper and

others embraced and advocated the American ideology of 'Black Art' that had emerged in the late 1960s and early 1970s (that is, a socially dynamic visual art practice, closely aligned to militant political and cultural agendas of progress for black people). To this end, these artists' work touched on the experiences of black people in the United States, South Africa, and flash points of tension closer to home, such as Brixton.

Lubaina Himid (b.1954) is one of the most accomplished women artists to be identified with the 1980s emergence and development of black British artists' practice. Alongside her studio practice as a painter and creator of mixed media pieces she established a reputation as an advocate and a curator of black artists' work, both gender and non-gender specific. In 1983 Himid organized the first of several widely acclaimed exhibitions of work by black women artists. *Five Black Women* at the Africa Centre was followed by other such exhibitions, the most high profile of which was *The Thin Black Line* at London's ICA in 1985.

Meanwhile, Creation for Liberation, a group of cultural activists based in Brixton, took a pronounced interest in black artists' work and

organized a series of open exhibitions that attracted the work of a great many artists. The first such exhibition was held in 1983 and other exhibitions followed throughout the course of the decade. Within these open submission exhibitions, the work of lesser-known and newly emerging artists was hung and shown alongside professional and established painters, print-makers and sculptors, giving many artists important exposure that had traditionally been denied to them by many of the country's art galleries. The profile of black British artists received a further and major boost with the opening (again, in 1983) of The Black-Art Gallery in Finsbury Park, north London. The gallery, under the director-ship of Shakka Dedi (b.1954), was run by a group calling themselves the Organisation for Black Arts Advancement and Leisure (later changed to Learning) Activities – OBAALA. The Black-Art Gallery was the first publicly funded art gallery dedicated to promoting the work of the country's black artists. To this end, a significant number of artists were able to exhibit in a supportive professional environment, where they were provided with exhibition paraphernalia such as posters, opening view cards and critically important catalogues.

146 DONALD RODNEY
In the House of my Father 1996–7
Photograph on paper on aluminium
122 × 153 (48⅛ × 60¼)
Tate. Presented by the Patrons of
New Art (Special Purchase Fund) 2001

145 KEITH PIPER
Go West Young Man 1987
14 panels, photographs on
paper mounted on board
84 × 56 (33⅛ × 22⅛)
Tate. Purchased 2008

Black artists were able to open up another front of important activity when a number of the country's municipal museums and independent galleries took an interest in their work, exhibiting it in often large-scale group exhibitions. The first such exhibition was *Into the Open*, held at Mappin Art Gallery, Sheffield, in 1984. A mix of artists, some familiar, some less so, were exhibited together in what was to be become one of the landmark exhibitions of the decade. Many other such exhibitions were to follow, the most high profile of which was *From Two Worlds*, held at the Whitechapel Art Gallery just over two years later.

Fittingly perhaps, the decade ended with a substantial exhibition curated by Rasheed Araeen and hosted by London's Hayward Gallery. Araeen had conceived the idea for *The Other Story* a number of years earlier, but it was not until the late 1980s that he was able to realize the project. *The Other Story* showcased the work of African, Asian and Caribbean artists working in post-war Britain. The exhibition generated unprecedented levels of press attention and did much to give credibility to the notion of a tangible history of Black British artists' practice.

FURTHER READING

R. Araeen, *The Other Story: Afro-Asian Artists in Post-War Britain*, exh. cat., South Bank Centre, London 1989.

D.A. Bailey, I. Baucom and S. Boyce (eds.), *Shades of Black: Assembling Black Arts in 1980s Britain*, Durham, NC 2005.

K. Mercer, *Keith Piper: Relocating the Remains*, London 1997.

Installations and Exploding Homes

GILL PERRY

Loosely defined as an arrangement of objects and/or architecture that the spectator can enter and walk around, 'installation art' often includes a wide range of materials, and can be sited in a particular urban or rural location, or can be moved between gallery spaces. Installations often employ industrial or everyday materials, sculptural or ready-made and found objects, natural or organic sources and may include various forms of technology such as film, video, sound or even smells. The term 'installation' was first used to distinguish some of the experimental practices of Minimal art of the early 1960s from the 'environments' and 'happenings' of the preceding period, and by the 1970s and 1980s it had become a versatile, hybrid medium, which made possible the display of a range of seemingly incompatible media and styles. During this period the term was often used to describe an art form that encouraged a critical awareness of cultural, ideological and physical contexts and relationships between viewers and objects.

Several British artists working in the 1980s, including Richard Wentworth, Tony Cragg, Bill Woodrow, Alison Wilding and Richard Deacon explored installation art as a means of transforming and reframing found objects and everyday materials, and their sculptural possibilities (see Wallis, pp.196–7). During the 1980s and '90s artists such as Helen Chadwick and Susan Hiller developed the sensory and experiential possibilities of the medium. While Chadwick used bodily waste, meat and organic matter in her works, Hiller's installations often included sound, interlocking video projectors and coloured light (fig.147).

A recurring theme within British installation art of the last few decades is the iconography of the house or home. Rachel Whiteread and Richard Wilson (b.1953) have both used and demolished the architectural form of the house, exploiting its uncanny possibilities. Whiteread's notorious, short-lived negative cast of a terraced house in Bow, east London, in 1993 had a strange, monumental quality, which reminds us of the slippery boundary between installation and sculpture. Wilson's *She Came in through the Bathroom Window* of 1996, where the artist removed an entire wall of windows from Matt's Gallery, London, and suspended it within the gallery space, undermined the viewer's expectations of particular spaces, whether domestic or public. Similarly, Wilson's *Jamming Gears*, a builder's cabin partially sunk at an angle into the floor of the Serpentine Gallery in 1996, provoked viewers and critics to muse on the mutability of both the gallery space and the shelter offered by cabins and sheds.

Sheds and huts, replete with their associations of intimate homes or retreats from the world, have been the objects of both destruction and aesthetic reconstruction in some recent British works. The beach huts of Tracey Emin (b.1963), found on beaches and reassembled in gallery spaces, along with the reconstructed boat house *Shedboatshed* by Simon Starling (b.1967), winner of the 2005 Turner Prize, have revealed some of the temporal, transformative possibilities that can be embraced by the broad label of installation art. Such possibilities are also represented in *Cold Dark Matter: An Exploded View* 1991 by Cornelia Parker (b.1956) (fig.148). This began as a garden shed, filled with gardening tools, old toys, disgarded household

147 SUSAN HILLER
Belshazzar's Feast, the Writing on Your Wall 1983–4
Video installation
each: 50.9 × 40.9 (20 × 16)
duration: 21min, 52 sec
Tate. Purchased 1984

junk and a collection of books. First installed at the Chisenhale Gallery in East London in 1991, it was removed to an outdoor site and blown up by the British Army School of Ammunition. The charred pieces of debris were then collected up and reassembled, suspended from the gallery ceiling around a 200-watt light bulb, creating a glistening and gently moving display of hanging fragments, which 'like a flashback or memory trace, projects an extraordinary play of shadows on the gallery walls and floors, such that the interplay of chance and necessity becomes one of the things the work's about' (Interview with Lisa Tickner, 2004). In *Cold Dark Matter* artistic process and performance – in the form of a controlled explosion and subsequent reconstruction – are intrinsic to the immediate history of the installation. And despite the ambiguous title, for Parker 'the shed also represented the home. The project had to do with living in Leytonstone when houses were being knocked down to build the M11 link road, which made me think about transience and ephemerality. I really wanted them to blow up a house, but I felt that was going too far.' (Tickner 2004.) As an exploded home, reassembled as a seductive aesthetic object that the viewer can experience from many angles, *Cold Dark Matter* raises many pertinent questions about the relationship with sculpture, and the roles of embodied viewing, transience, memory and performance in recent installation art.

FURTHER READING

C. Bishop, *Installation Art*, London 2005.
G. Perry and P. Wood (eds.), *Themes in Contemporary Art*, London and New Haven 2004.
A. Searle, *Cornelia Parker: Cold Dark Matter: An Exploded View*, exh. cat., Chisenhale Gallery, London 1991.
L. Tickner, 'A Strange Alchemy: Interview with Cornelia Parker', in G. Perry (ed.), *Difference and Excess in Contemporary Art: The Visibility of Women's Practice*, Oxford 2004.

148 CORNELIA PARKER
Cold Dark Matter: An Exploded View
1991
Mixed media
400 × 500 × 500 (157½ × 197 × 197)
Tate. Presented by the Patrons of New Art (Special Purchase Fund) through the Tate Gallery Foundation 1995

British Art in the 1990s

ANN GALLAGHER

London in the 1980s seemed an unlikely location for the emerging centre of contemporary art that it was to become in the following decade. New York and Cologne boasted museums devoted to modern and contemporary art, high profile commercial galleries and influential art magazines promoting critical debate. In London, by comparison, contemporary art had a limited presence. Public sector exhibition spaces struggled to represent adequately the best of international contemporary art in a political climate more inclined towards heritage than innovation. A handful of galleries existed with an international profile, but these were heavily reliant on collectors from outside Britain. Young artists graduating from British art schools at this time had few opportunities to exhibit their work or to support themselves by selling their art.

The climate was beginning to change, however. The international success of the group of young sculptors associated with the Lisson Gallery (see Wallis, pp.196–7) had helped engender a greater confidence and younger commercial galleries were beginning to emerge to provide a wider platform for new art. Artist-run spaces in London and other British cities were establishing their reputations and gradually increasing in number. In 1985, the same year that the renovated Whitechapel gallery re-opened its doors, the high profile collector Charles Saatchi opened a museum-sized gallery space in a converted factory in north London. Initial displays from his collection included work by Andy Warhol, the American Minimalists and a younger generation of American artists including Jeff Koons. Inspired by the display methods of the Saatchi Gallery, in 1988 Damien Hirst and other students from London's Goldsmiths College staged an ambitious series of exhibitions of their work, collectively titled *Freeze*, in an

empty building in Surrey Docks. This three-part exhibition has been viewed as a seminal event in the evolution of British contemporary art as much for the entrepreneurial spirit with which it was organized as for the careers it launched. Other exhibitions followed in the disused factories and warehouses that were readily available in London's depressed industrial areas. In 1989 Slade graduate Rachel Whiteread showed her first large-scale cast room, *Ghost*, at Chisenhale Gallery (fig.150). While a significant number of artists had profited from influential teachers and a radical interdisciplinary structure at Goldsmiths college, it was by no means the only source of talented and enterprising artists to emerge at this time.

London-based *Artscribe* magazine had done much to promote the visibility in Britain of international contemporary art throughout the 1980s but failed to survive the worsening

149 DAMIEN HIRST
The Acquired Inability to Escape
1991
Mixed media
221 × 304.9 × 213.7
(87 × 120 × 84⅛)
Tate. Presented by the artist 2007

economic climate, releasing its final issue in early 1992 (fig.151). *Frieze* magazine emerged in its place, the pilot edition having appeared in the summer of 1991. This issue included an interview with Hirst and an article on new British art entitled 'A New Internationalism' (fig.152). Its publisher and editor Matthew Slotover was invited to select work for the Aperto section of the 1993 Venice Biennale, in which Hirst, Mat Collishaw (b.1966) and Simon Patterson (b.1967) were included from the original *Freeze* shows, as well as Laotian artist Vong Phaophanit and Scottish artist Christine Borland (b.1965). Fellow Scot Douglas Gordon (b.1966), as well as Jake and Dinos Chapman (b.1966 and 1962), Ceal Floyer (b.1968), Gary Hume and Cerith Wyn Evans (b.1958), were included in an exhibition devoted to young British artists, *General Release*, at the following Venice Biennale.

From this point museums and galleries throughout the world sought to profile an expanding and varied group of young British artists, by then frequently referred to by the acronym YBA or yBa. Of these, the most prominent exhibitions were *Brilliant!* held in 1995 at the Walker Art Gallery in Minneapolis and *Life/Live* in 1996 at the Musée d'Art Moderne de la Ville de Paris, while the most comprehensive in scope was *Pictura Britannica* at the Museum of Contemporary Art Sydney held in 1997. Also in 1997 London's Royal Academy showed Saatchi's by now substantial collection of young British art in the much publicized exhibition, *Sensation*. Few of the works included were in fact as shock-inducing as the title and the marketing strategy suggested, but Academicians resigned in protest and controversy was engendered in the media over a painting by Marcus Harvey (b.1963) of the child murderer Myra Hindley. Further controversy ensued when the exhibition toured to the Brooklyn Museum. New York mayor Rudolph Giuliani attempted to withhold public funding from the museum, apparently in protest at the inclusion of a painting of a black Madonna, *The Holy Virgin Mary*, by Chris Ofili, on the grounds that it was sacrilegious. Whether the work of

this generation of artists (which included Hirst, known for suspending dead animals in formaldehyde and Sarah Lucas, associated with the use of tabloid imagery) was characterized as provocative or just about real life, no unifying theme could encompass such a diverse range of production.

The Tate Gallery's Turner Prize, initiated in 1984 along the lines of the Booker prize for literature, had re-launched in 1991, with nominations limited to artists under fifty years of age. The winner was announced on national television and a younger generation of artists were given even greater national and international prominence. Winners included Whiteread in 1993, Hirst in 1995, Gordon in 1996, Wearing in 1997 and Ofili in 1998. Comparisons were frequently drawn between British art in the 1990s and that of its most recent heyday in the 1960s. Galleries and spaces devoted to contemporary art were being initiated or renovated, with the aid of funding from the Heritage Lottery Fund. Though new art was still largely being sold outside the country, the number of British-based collectors gradually began to increase. When the new Labour government came to power in 1997, it was initially keen to be associated with the international success of young British artists as a means of promoting a new youthful image of Britain. In 2000 London finally opened a museum dedicated to modern and contemporary art, in the form of Tate Modern, where British art was viewed within an international context by unprecedented numbers of visitors.

FURTHER READING

R. Araeen, 'The Other Story: Afro-Asian Artists', in V. Button, *The Turner Prize: A History*, London 2006.
Brilliant!, exh. cat., Walker Art Gallery, Minneapolis 1995.
Sensation: Young British Artists from the Saatchi Collection, exh. cat., Royal Academy, London 1997.

151 Cover of *Artscribe*
No.90, February/March 1992

152 Cover of *Frieze*
Pilot issue, Summer 1991

The Glasgow Scene

SARAH LOWNDES

In the late 1980s a succession of internationally acclaimed artists began to emerge from the Environmental Art Department at Glasgow School of Art. Students in the department were encouraged by Head of Department David Harding, and tutors Sam Ainsley, Brian Kelly and Stan Bonner, to undertake comprehensive research and to produce art outside studios and galleries ('with or through people'). Crucially, they were also expected to seek permission to install their work in the public domain, breeding a confidence that was evident in their post-graduation projects, perhaps the most signifi-cant of which was the 1991 *Windfall* exhibition, held in the disused Seaman's Mission by the Clyde. The neo-conceptual work of Claire Barclay (b.1968), Martin Boyce (b.1967), Roderick Buchanan (b.1965), Nathan Coley (b.1967), Douglas Gordon (b.1966), Craig Richardson (b.1966), and Julie Roberts (b.1963) was positively reviewed in the inaugural issue

of *Frieze* magazine, introducing their work to an audience beyond Glasgow.

Legitimate parallels may be drawn between Glasgow's Environmental Art Department and Goldsmiths College, London, and further comparisons made between *Windfall* and the 1988 Docklands exhibition *Freeze*, which precipitated the beginning of the YBA phenomenon (see Gallagher, pp.230–1). However, such compar-isons elide the significant differences between the London scene and Glasgow's developing arts infrastructure. The situation of being outsiders was something that many Glasgow-based artists turned to their advantage, a strategy reflected in works such as Douglas Gordon's *Letters* 1991–, sent to various members of the art world (many of whom he did not know person-ally). Messages such as 'I am aware of who you are and what you do' and 'I forgive you' provoked reactions that ranged from unease and anger to amusement in the various recipients. Gordon's

non-hierarchical *List of Names* (1990–; fig.153), an attempt to record the names of every person he could recall meeting, ranked the names of influential artists, curators and critics alongside lesser known individuals of his acquaintance such as neighbours, family friends and children, implying that his local allegiances were as significant as his growing international connections.

Despite the evident confidence and ability of Gordon and his associates, collectors of contemporary art in Glasgow were few, and the city certainly had no equal to London gallerist Charles Saatchi, so often credited with creating much of the hype around the YBAs in the early 1990s. The establishment of the Modern Institute by Will Bradley, Charles Esche and Toby Webster in 1998 and, more recently, the young commercial galleries Sorcha Dallas and Mary Mary has changed that situation to a certain extent, but Glasgow remains a city in

153 DOUGLAS GORDON
List of Names (Random)
1990-ongoing
Wall text, typeface variable
Dimensions variable
Scottish National Gallery of
Modern Art, Edinburgh

which many artists make work that they do not expect to sell.

During the 1980s numerous independent working structures and models of practice developed in Glasgow, amongst them, discussion forum the Free University, radical arts magazine *Variant*, the Women's Library and the artist-led Transmission Gallery. Late in the decade, around the time that artists such as Dave Allen (b.1963), Christine Borland (b.1965), Martin Boyce, Douglas Gordon and Craig Richardson began to involve themselves with Transmission, the gallery began to forge alliances and exchanges with like-minded artists and galleries in Belfast, London, Chicago and Cologne. Interest in the work of these artists was further stimulated by artist-led projects within the city such as *Windfall* and by shows by high profile artists such as Lawrence Weiner (b.1942) and London-based contemporaries like Simon Patterson at Transmission.

In the 1990s, as Glasgow developed a more established scene, people moved to the city from elsewhere, introducing different influences and a new kind of work. Jonathan Monk (b.1969), David Shrigley (b.1968), Hayley Tompkins (b.1971), Jim Lambie (b.1964), Cathy Wilkes (b.1966) and Richard Wright (b.1960) were making work that was playful, tactile, and reinstated a concern with material and its poetry. The scene continued to be grounded in actual bodies and social sites, as evidenced by Wright's elaborate, site-specific wall paintings, often extant only for the duration of an exhibition. For Wilkes's solo installation *Our Misfortune* (Transmission, 2001) she turned over part of the gallery's floorboards as a stage for her sculptural works, paintings and assemblages, physically revealing a history that permeated, even engendered, the work itself. Similarly, Jim Lambie's *Zobop* 1999 (fig.154), a psychedelic floor installation made using vinyl tape for Transmission, can be viewed as a celebration of a specific cultural identity, expressing Lambie's involvement in the local independent music scene (as a onetime member of the Boy Hairdressers and sometime DJ), his blue-collar background, and his twisting of the rubric of modernist painting. Works such as these are hard to realize, and only arise 'with and through people': the same has been true of the Glasgow scene.

FURTHER READING

K. Brown and R. Tufnell (eds.), *Here + Now: Scottish Art 1990–2001*, Dundee 2001.

M. Hamilton and J. Schmidt (eds.), *Synth: Ten Artists from Glasgow*, exh. cat., Kunstraum B/2, Leipzig 2004.

S. Lowndes, *Social Sculpture: Art, Performance and Music in Glasgow, A Social History of Independent Practice, Exhibitions and Events since 1971*, London 2004.

A. McLauchlan and C. Stephenson (eds.), *Transmission*, London 2002.

154 JIM LAMBIE
Zobop 1999, remade on installation
Vinyl tape. Dimensions variable
Tate. Presented by
Tate Members 2006

After the Millennium

NICOLAS BOURRIAUD

The dawn of the new millennium is synonymous in the UK art scene with the opening of Tate Modern; it inaugurated a spectacular decade during which London increasingly came to occupy the centre of the European art market. This economic boom brought about a profound – and astonishingly rapid – transformation of the modes of reception, distribution and presentation of contemporary art in Great Britain, a transformation also reflected in artistic practices. In 2000 the international success enjoyed by the 'Young British Artists' (YBAs) was still resonating through the arts scene. *Sensation*, an exhibition mounted by the Royal Academy of Arts in 1997, seems to have set new standards of communication for both artists and media alike in its quest for visual impact and in the spectacular dimensions of works and their gestures (see Gallagher, pp.230–1). The heroic scale of the conceptual in Damien Hirst's sombre romanticism or the provocative autobiographical works of Tracey Emin or Sarah Lucas testify to a desire to communicate with the wider public and combine great visual efficacy with a mastery of the codes of popular culture. This latter aspect underpins many works produced in the UK and can perhaps be traced to the time of William Hogarth.

No surprise, then, that video soon became the dominant medium. Televisual formats, notably documentary, allowed artists to register the fact of globalization and the transformation of London into a multicultural city (though here we might single out Yinka Shonibare's installations, with their ironic take on post-colonial imagery). Thus the work of Steve McQueen (b.1969) explores our relation to history through subtly staged scenes of daily life, as does that of Rosalind Nashashibi (b.1973), who works in documentary, or Runa Islam (b.1970), who filters her vision through film history. This planetary nomadism is also manifest in the works of Tacita Dean (b.1965); her fragile film works, based on meticulous research, evoke both the imagery of amateur film and the history of conceptual art.

In reaction to the pop imagery of the YBAs, many artists have taken an analytic look at the protocols of the art system, focusing particularly on the means and media of exhibition. One such is Liam Gillick (b.1964), who interrogates the structure of the working world and the framework of our daily life through a constant oscillation between narrative and form – the latter borrowed, for the most part, from the vocabulary of minimalism. Simon Starling is

an archaeologist of the relations between modernism and nature, an artist who foregrounds the traceability of the things around us and of industrial objects in particular. In a work that celebrates metamorphosis, he disassembles a shed and makes a boat of it, which he then sails down the Rhine (*Shedboatshed*, fig.155). Crossing a Spanish desert on a motorbike whose engine's exhaust-product is water, he uses the latter to paint a watercolour showing a cactus. Another nomad, Jeremy Deller, mounts veritable expeditions to different cultural worlds, collecting clues and evidence and assembling them into an archaeology of the present; the *Battle of Orgreave* 2001 (fig.156) is a meticulous reconstruction of an episode from the UK Miners' Strike of 1984. Also informed by Minimalism and Conceptual art is the work of Martin Creed (b.1968), who uses elementary forms (the balloon), monochrome surfaces or very simple devices (the light of an exhibition room going on and off) to question our relation to art.

Another theme that holds a central place in British art in the first decade of the new millennium is gender. According to the artist Cornelia Parker, installation as a medium is inherently orientated toward feminism: 'It's a feminine art form because it's inclusive and you walk into it,

155 SIMON STARLING
Shedboatshed (Mobile Architecture No.2) 2005
Mixed media
400 × 600 × 600
(157½ × 236¼ × 236¼)
Kunstmuseum Basel
Installation view, *Turner Prize* 2005

156 JEREMY DELLER
Battle of Orgreave 2001
Film still
Commissioned and produced
by Artangel

it's not going to the centre just to look at this lump in the middle ... It's always this anti-centre thing.' Aspiring in her own works to an 'atmospheric sense of ... relations and exchanges', Parker perfectly describes the video-works of Sam Taylor-Wood, with their multiple points of view on stormy emotional scenes. The notion of escaping the centre might indeed underpin a new reassertion of artistic autonomy. Thus Keith Tyson (b.1969) develops a mythology of the studio as a laboratory sealed away from the world, whence come the results of his research on the structure of the physical world, transcribed into pictures resembling the pages of a notebook.

But fiction affords another way of attaining autonomy. In the neo-Victorian paintings and theatrical performances of Spartacus Chetwynd (b.1973), the past and the present embrace. Charles Avery (b.1973), meanwhile, meticulously constructs a fictive universe in the form of a circular island inhabited by incarnations of philosophy. The imaginary world is also the province of Paul Noble (b.1963), the archaeolo-gist of a long-vanished civilization that he surveys with immense pencil drawings (fig.157). Though relations with the past are a focus for certain artists, for others time itself has become a medium; one might almost, in reference to the 'site-specific' art of the 1960s, speak of the 'time-specific' art of the 2000s. Consider Ryan Gander's *Time Capsule* 2006, which takes the form of a legal document comprising a certain number of instructions together with details of the secure deposit of a sum sufficient to execute the directions for Gander's project 'New Adventures in ...' – but only in 2056.

FURTHER READING

V. Button, *The Turner Prize*, London 2007.
Keep On Onnin': Contemporary Art at Tate Britain, Art Now 2004–7, London 2007.
B. Ruf and C. Wallis, *Tate Triennial 2006: New British Art*, exh. cat., Tate Britain, London 2006.

157 PAUL NOBLE
Paul's Palace 1996
Graphite on paper
167.6 × 149.8 (66 × 59)
The Cranford Collection, London

Notes

INTRODUCTION TO THE HISTORY OF
BRITISH ART: 1870–NOW pp.17–29

1 See for example Mellor 1987; Corbett 1997;
Tickner 2000; Corbett and Perry 2000; Corbett,
Holt and Russell 2002.
2 Hubbard 1951; Bertram 1951.
3 See, for example, Barringer 1998 and P. Barlow,
'Millais, Manet, modernity', in Corbett and Perry
2000, pp.49–63.
4 See E. Prettejohn, 'The modernism of Frederic
Leighton' in Corbett and Perry 2000, pp.31–48.
5 Foster 2004.
6 Eliot 1922; Francis Bacon in Sylvester 1975.

1 GOING MODERN pp.39–65

1 My previous attempts to address this question
have been greeted with a measure both of hostility
and of misrepresentation by scholars with a more
exclusive investment than mine in the history of
art made in Britain. A conspicuous instance is to
be found in the introduction to Corbett and Perry
2000, where I am held responsible for arguing
'that the category of the modern does not pertain
to the art of England and that English art has little
claim on our attention'; further, 'Harrison's attack
on any claims for the modernity of English art is
only the latest of a long series of dismissals which
deny the importance of English art to any history
of modernism'. These are strange accusations to
level at the author of a book on *English Art and
Modernism* and of over twenty subsequent articles
on art and artists in Britain, leaving aside my
engagement with and publications on the practice
of Art and Language over the past thirty-five years.
In the article that seems particularly to have
irritated Corbett and Perry, what I actually argued
was this: 'It is from modernity in the practise of art
that motivation to intellectual work most fruitfully
comes . . . The intelligibility of art or of anything else
is a matter of its being continually thought about
in a manner productive of self-consciousness –
of its being reflected upon and reflected from. The
necessity and continuity of this self-consciousness
is . . . what modernism means. It is not to be fore-
closed – in the name of "Englishness" or anything
else [and a fortiori of "Britishness"] – without a loss
of critical and cognitive vitality.' ('"Englishness"
and "Modernism" revisited', *Modernism/modernity*,
January 1999.)
 In the writing of the present text, as in all my
previous contributions to the subject, my concern
has simply been to ensure that sentimental or
professional investment in the products of the
national culture neither privileges nor insulates
those products where it is their modernism that
is at issue.
2 *Weekend Review*, 12 March 1932.
3 From the introduction to Read 1963, p.xxv.
4 The signatories were Roy Ascott, Peter Blake,
Anthony Caro, Bernard Cohen, Harold Cohen,
Robyn Denny, R.B. Kitaj, Richard Smith, William
Turnbull, Brian Wall, Eduardo Paolozzi and
Anthony Benjamin. They wrote to assert the
requirement of professionalism in response to
an article by David Sylvester proposing 'the
hypothetical purity of the amateur'.
5 Thornton 1938.
6 Sickert 1910a.

7 As reported in Baron 1973, p.109, Fred Brown
wrote to Sickert to the effect that 'the sordid nature
of his pictures since the Camden Town Murder
series made it impossible for there to be any
friendship between them.' A former friend and
colleague at the NEAC, Brown was then principal
of the Slade School.
8 Bell, C. 1914, p.207.
9 Fry 1961, p.191.
10 In December 1913 an exhibition of paintings
and drawings by 'English Post-Impressionists,
Cubists and Others' was held in Brighton under
the auspices of the Camden Town Group. Lewis,
Etchells, Cuthbert Hamilton, Wadsworth,
Nevinson, Bomberg and Epstein exhibited in
a segregated 'Cubist Room', for which Lewis
provided a separate catalogue introduction.
11 Lewis 1915, p.23.
12 As reported in the *Daily Express*, 25 February 1915.
13 From a statement published in *Partisan Review*,
March–April 1947.
14 Read 1934a.
15 From a review in the *The Scotsman*, 28 Oct. 1933.
16 See his notice of the exhibition in the *Weekend
Review*, 17 June 1933.
17 See, for example, the discussion of the exhibition
by J.M. Richards in 'London Shows', *Axis*, 4,
Nov. 1934.
18 Moore, H. 1937.
19 From a statement published in Read 1952.
20 Ibid.
21 I offered an extended argument in support of
this assertion in the paper 'England's Climate',
included in Allen 1995.
22 Read 1935.
23 Moore, Sutherland and Piper were all appointed
as official war artists. The War Artists
Advisory Committee was under the direction
of Kenneth Clark.
24 Ironside 1947. Cf. Francis Klingender's pamphlet
Marxism and Modern Art, London 1942, which
contains a comparable condemnation of abstract
art and a celebration of the 'blitz paintings of
1940–1' (painted by Piper and Sutherland) as
demonstrations of the artists' capacity to give
'imaginative form' to the experience of 'the people'.
25 Meyric Hughes and van Tuyl 2002.
26 Biederman's *Art as the Evolution of Visual
Knowledge* was published in 1948 and was widely
read among the English Constructionists.
27 The phrase is Hepworth's, from a statement
published in Gabo, Nicholson, Martin 1937.
28 In a letter to the *New York Times*, 8 July 1945.
29 Newman, 'The New Sense of Fate', unpublished
typescript quoted in Hess 1972.
30 The occasion was an exhibition of work by Heron,
Hilton and Bryan Wynter at the Waddington
Galleries, London, in May 1959.
31 Heron 1956. The occasion was the exhibition
Modern Art in the United States. See below,
n.35.
32 'For an abstract painter there are two ways out
or on: he must give up painting and take to
architecture, or he must reinvent figuration.'
Hilton, 'Remarks about Painting', originally
published in the catalogue of an exhibition at the
Galerie Lienhard, Zurich, in June 1961; reprinted
in Harrison, C. and Wood 2003, p.773.
33 The phrase is taken from Richard Hamilton's 'For
the Finest Art, Try Pop', *Gazette*, no. 1, London,

1961; reprinted in Harrison, C. and Wood 2003,
p.743. The relevant passage is concerned with the
legacies of Dada and Futurism.
34 Alloway, 'The Arts and the Mass Media',
Architectural Design, London, Feb. 1958; reprinted
in Harrison, C. and Wood 2003, p.717.
35 *Modern Art in the United States* was organized
by the Museum of Modern Art, New York. It was
toured to several European centres in 1955–6, and
was shown at the Tate Gallery in Jan.–Feb. 1956.
The concluding room included three paintings
by De Kooning, two each by Pollock, Rothko
and Motherwell, and one each by Kline and Still.
Newman was not represented, though he featured
in *New American Painting* shown at the Tate Gallery
three years later.
36 'The School of Paris remains the creative fountain-
head of modern art, and its every move is decisive
for advanced artists everywhere else – who are
advanced precisely because they show the capacity
to absorb and extend the preoccupations of that
nerve-center and farthest nerve-end of the modern
consciousness which is French art.' (Greenberg
in 'Review of an Exhibition of School of Paris
Painters', *The Nation*, 29 June 1946.) Within less
than two years Greenberg had drastically revised
this judgement. Perceiving a grievous decline in the
work of Picasso, Braque and Léger, he concluded
(in 'The Decline of Cubism', *Partisan Review*, March
1948) that 'the main premises of Western art have
at last migrated to the United States, along with
the center of gravity of industrial production and
political power'.
37 From the introduction to the catalogue of the
exhibition, written by Roger Coleman. The other
members of the organizing committee were Alloway,
Bernard Cohen, Robyn Denny, Gordon House,
Henry Mundy, Hugh Shaw and William Turnbull.
38 Alloway 1960.
39 Though there was a considerable representation
of American sculpture in the exhibition *Modern
Art in the United States*, no work by Smith was
included. Until the Museum of Modern Art's
touring retrospective came to the Tate Gallery in
1966 (the year of Smith's death), his reputation in
England was established largely through Caro's
advocacy and through reproductions. A statement
by Smith and illustrations of his work were repro-
duced from the American journal *Arts* (Feb. 1960)
in *First 2*, a magazine published in the St Martin's
Sculpture Department in 1961.
40 In his introduction to *Sculpture in the Open Air*,
Greater London Council, Battersea Park, 1966.
Shortly to become Director of the Tate Gallery,
Bowness was at the time a lecturer in modern art
history at the Courtauld Institute.
41 Lucie-Smith 1968.
42 Fried 1968, p.25.
43 See the verdict of Donald Judd, delivered in 1965:
'Half or more of the best new work in the last few
years has been neither painting nor sculpture'
(Judd 1965, p.74). A decisive moment was reached
with the exhibition *Primary Structures: Younger
American and British Sculptors*, staged at the
Jewish Museum, New York, in the following year.
A large but incoherent selection, it served to make
clear just how wide a gap separated the English
sculpture of King, Tucker and others from the
'three-dimensional work' of the Americans Judd,
Robert Morris, Sol LeWitt and Carl Andre.

44 Fried, 'Art and Objecthood', LeWitt, 'Paragraphs on Conceptual Art', in *Artforum*, June 1967. The issue was timed to coincide with an exhibition of American sculpture at the Los Angeles County Museum; the inclusion of Caro's work in this show was a sign of his conscription to the canon of American high modernism.

45 The Art and Language work *Index 01* was credited to Atkinson, Bainbridge, Baldwin, Burn, Harrison, Graham Howard, Hurrell, Kosuth, Philip Pilkington and David Rushton. Though each of these had contributed to the written materials included in the display, not all had worked on the design and installation of the indexing system.

46 The classic modernist argument for a critical distinction between avant-garde and kitsch was mounted in Clement Greenberg's article of that name, originally published in *Partisan Review*, Fall 1939. During the 1980s and 1990s a self-conscious erosion of the grounds of this distinction was a tactic adopted by certain artists bidding for post-modernist status in New York (Jeff Koons, Haim Steimbach, Meier Vaisman) and subsequently in London (Damien Hirst, Tracey Emin, Sarah Lucas, Jake and Dinos Chapman).

2 MAPPING BRITISH ART pp.77–107

1 Stuart Hall, 'A Question of Identity (II)', the *Observer*, 15 Oct. 2000.
http://www.guardian.co.uk/britain/article/0,2763,382791,00.html#article_continue

2 See Robins and Thomson 2005.
3 Buchloh 1990, pp.85–105.
4 Heron 1949.
5 Dakers 1999.
6 Read 1962, pp.536–8.
7 Cited by Richard Dorment in MacDonald, M.F. 1994, p.122.
8 Sickert 1910b.
9 Kitaj 1976; the School of London has generally come to include Michael Andrews, Frank Auerbach, Francis Bacon, Lucien Freud, R.B. Kitaj and Leon Kossoff, as demonstrated, for example, in the British Council exhibition, *A School of London: Six Figurative Painters*, 1987–8. See also Hyman 2002, pp.255–86.
10 Orton and Pollock 1980, pp.314–44.
11 Lübbren 2001, p.1.
12 Quoted in Farr 1978, p.34.
13 Harrison, C. 1981, p.200.
14 Fry 1920.
15 In the late 1940s and early 1950s the chief promoter of the St Ives artists was Patrick Heron, a painter himself and then a summer visitor to the town and art critic of the *New Statesman and Nation*.
16 Fry 1920.
17 McCannell 1976.
18 Tickner 2000, pp.142–83.
19 For these quotations and a further discussion of the issues raised see Janet Wolff, 'The "Jewish Mark" in English Painting: Cultural Identity and Modern Art', in Corbett and Perry 2000, pp.180–94.
20 Janke Adler, 'Memories of Paul Klee', *Horizon*, vol.6, no.34, Oct. 1942, pp.264–7.

3 CONSERVATISM AND CLASS DIFFERENCE IN TWENTIETH-CENTURY BRITISH ART pp.121–51

1 Lewis 1914, p.11.
2 Jonquet 2004, p.314.
3 See Remy 1999, pp.156–7.
4 Dangerfield 1996; Wheatcroft 2006.
5 For the slump, see Stephenson 1991, p.44; for 'young British art', see Stallabrass 2006.
6 On the issue of the slow and uneven adoption of photography by museums in Britain, see Moschovi 2004.
7 McKibbin 2000, p.46.
8 The central account here is Perkin 2002. We can, I think, use the very valuable empirical work in this account without subscribing to the view (unevenly held to) that the professional class overwrites rather than intersects existing class stratification.
9 McKibbin 2000, pp. 91–2.
10 McKibbin 2000, pp. 530–1.
11 McKibbin 2000, pp.96–8. McKibbin's remarkable account of class in Britain is central to my account here.
12 W. Sickert, 'Walter Bayes', preface to an 'Exhibition of Paintings by Walter Bayes', exh. cat., Leicester Galleries, Leicester 1918; in Sickert 2000, p.422.
13 Fuller 1987, p.263.
14 See Anderson 1992, particularly the chapter 'Origins of the Present Crisis', originally published in 1964; Nairn 1977. Various critiques of this view have been published, notably Thompson 1965, pp.311–62. Anderson replied in Anderson 1980.
15 Wiener 2004, p.7.
16 Wiener 2004, pp.20–1.
17 The influential account reacted against here is Harrison, C. 1981. For an example of the former, see Corbett 1997; for the latter, much of the work of Peter Fuller provides an anti-modernist history of English art. In particular, see Fuller 1988.
18 Anderson 1984, pp.104–5.
19 Lewis 1914, p.8.
20 McKibbin 2000, p.7.
21 McKibbin 2000, p.13.
22 McKibbin 2000, pp.23, 26.
23 McKibbin 2000, p.33.
24 McKibbin 2000, p.42.
25 Wiener 2004, pp.43–4. The debate about the character and extent of that decline is summarized in Crafts 2004, pp.11–17, concluding that the economy did not fail and that US overtaking of the UK economy could not have been prevented.
26 Wiener 2004, pp.6, 100.
27 Wiener 2004, p.101; citing Addison 1975, p.27.
28 Lloyd 2002, p.175.
29 Crafts 2004, p.18.
30 Wiener 2004, p.15.
31 Skeaping 1977, pp.96–7.
32 On the insecurities of the profession of artist, see Abbing 2002.
33 Wright 2004, pp.17, 194–6.
34 Wright 2004, p.29. Though, as we shall see below, there are doubts about how specialist this criticism was in language and outlook.
35 Wright 2004, p.28.
36 Williams, R. 1980, pp.159–60.
37 Williams, R. 1980, pp.152–3.
38 Williams, R. 1980, p.155.

39 See Collins 2000, pp.76–8.
40 Woolf 1996, pp.57–60.
41 Williams, R. 1980, pp.164–5.
42 Williams, R. 1980, p.167.
43 Stephenson 1991, p.41.
44 Stephenson 1991, p.42, citing Nash 1932, p.100.
45 Dangerfield 1996. On syndicalism, see especially pp.190–1.
46 Dangerfield 1996, p.294.
47 Tickner 2000, p.190.
48 Dangerfield 1996 cites Charles Booth's *Life and Labour in London* (1889), B. Seebohm Rowntree's *Poverty* (1901), and Mona Wilson and E.G. Hawarth's *West Ham* (1907) as works read by slum-dwellers. See p.212.
49 John Ruskin, *Lectures on Art*. 'Lecture I: Inaugural', 8 Feb. 1870, in Ruskin 1903–12, xx, p.43.
50 See Wiener 2004, p. 38, citing Ruskin 1903–12, xvii, p.16.
51 Ruskin, *Sesame and Lilies* (1865), in Ruskin 1903–12, xviii, p.97.
52 Wiener 2004, p.59; Morris, W. 1894.
53 Benjamin 1999.
54 Morris, W. 'Art and Labour' (1884), in Lemire 1969, p.115.
55 For an analysis of Morris's account of the path to communism and its unique place in Marxist thinking, see Anderson 1980, chap.7.
56 L. Johnson, review in *Academy*, no.39, 23 May 1891, pp.483–4; reprinted in Faulkner 1973, p.340.
57 Anderson 1980, p.171.
58 Fuller 1988, p.101–42.
59 Dangerfield 1996, p.345.
60 Wiener 2004, p.62.
61 Tickner 2000, p.77.
62 Williams, R. 1973; cited in Wiener 2004, p. 48.
63 See Wiener 2004, pp.48–9.
64 Wiener 2004, p.72.
65 W. Sickert, 'A Stone Ginger', *The New Age*, 19 March 1914; in Sickert 2000, p.344.
66 Baron and Shone 1992, p.216.
67 W. Sickert, 'The Study of Drawing', *The New Age*, 16 June 1910; in Sickert 2000, p.247.
68 Richard Shone, 'Walter Sickert, the Dispassionate Observer', in Baron and Stone 1992, p.7.
69 Among a number of contributions, Shone wrote an essay in an exhibition Damien Hirst curated, *Some Went Mad, Some Ran Away . . .*, exh. cat., Serpentine Gallery, London 1994, and 'From "Freeze" to *House*: 1988–94', in *Sensations*, exh. cat., Royal Academy of Arts, London 1997, pp.12–24.
70 Shone 1988, p.8.
71 W. Sickert, 'On Swiftness', *The New Age*, 26 March 1914, in Sickert 2000, p.346. Sickert means George Santayana, of course.
72 Bacon said that he viewed social injustice as part of the 'texture of life' and that the suffering it caused was what made great art. See 'Interview 4' in Sylvester 1975, p.125.
73 Tickner 2000, p.82.
74 Tickner 2000, p.95; Lewis 1914, p.145.
75 Lewis 1914, p.18.
76 Lewis 1917, pp.3–4.
77 Edwards 2000a, p.133.
78 This is also the interpretation of Normand, who sees the painting as 'an impeachment of the crowd'. See Normand 1992, p.7.
79 Lewis 1914, p.7.
80 Lewis 1915, p.98.

81 Rutter 1922, pp.54–5.

82 Read 1933, p.13.

83 Rothenstein 1952, p.20.

84 Berenson 1958, p.77.

85 Newton 1962, p.182.

86 McKibbin 2000, pp.88f.

87 Lloyd 2002, pp.62–3.

88 Lloyd 2002, pp.93–4.

89 This is a point made by Wheatcroft, who notes that it was a powerful pillar of Tory support. See Wheatcroft 2006, ch.3.

90 McKibbin 2000, p.528.

91 McKibbin 2000, p.50.

92 McKibbin 2000, p.54.

93 McKibbin 2000, p.71.

94 McKibbin 2000, pp.56–7.

95 McKibbin 2000, p.58.

96 Lloyd 2002, p.94.

97 Wiener 2004, p.58.

98 Lloyd 2002, p.106.

99 McKibbin 2000, p.96.

100 Morphet 1982, p.11. The timing of the Tate's retrospective of Frampton showed, as Morphet pointed out, the waning of 'too exclusive an emphasis of the avant-garde of those [inter-war] years' under the impact of postmodernism.

101 Morphet 1982, p.20.

102 McKibbin 2000, p.529.

103 This is in part the argument of Corbett 1997, chap.5.

104 On that European tendency, see Cowling, E. and Mundy 1990; and for France, Silver 1989.

105 Morphet 1982, p.14.

106 Schapiro 1999.

107 Stephenson 1991, pp.31–2.

108 Stephenson 1991, p.32, 35.

109 Lloyd 2002, p. 164.

110 McKibbin 2000, pp. 60–1.

111 See Paul Oliver, 'Introduction', in Oliver, Davis, Bentley 1994, pp.13ç14.

112 McKibbin 2000, p.77.

113 McKibbin 2000, p.81.

114 McKibbin 2000, pp.87–8, 90.

115 See Stephenson 1991, p. 40.

116 See Stephenson 1991, pp.37–8, who cites Fry 1926, p.141.

117 Stephenson 1991.

118 Stephenson 1991, p.46.

119 Berger 1958. For Peri as a model, see Radford 1987, p.75.

120 For the French figures, see Mortimer 1984, p.251.

121 See Radford 1987, pp.66–7; Rea 1935.

122 Rea 1935, p.14.

123 Rea 1935, p.15.

124 Rea 1935, p.43.

125 This point is made by John Roberts in the introduction to his edited collection, *Art Has No History! The Making and Unmaking of Modern Art*, London 1994, pp.6–7.

126 Thompson 1995, p.309.

127 Thompson 1995, p.316.

128 Caudwell 1938, p.69; cited in Thompson 1995, p.346.

129 Thompson 1995, p.347, citing Caudwell 1949, p.72. This theme is an important element of the analysis of the avant-garde in Bourdieu 1996; I apply it to the realm of contemporary art in my book, *Art Incorporated* (Stallabrass 2004).

130 Thompson 1995, p.329, citing Caudwell 1938, p.54, 50.

131 E.P. Thompson's important piece was an attempt to rehabilitate Caudwell's reputation (Thompson 1995). It originally appeared in *The Socialist Register*, 1977.

132 Alfred Durus, review in *International Literature* (Moscow), August 1937, pp.109–10; cited in Roth 1977.

133 The piece was published in *Left Review* in July 1936. Paul Hogarth in one of the few catalogues devoted to Boswell's work notes that this neglect was due in large part to prominent radical critics, such as Read, abjuring anything that was 'low' or propagandist. See Hogarth, P. 1976, p.10.

134 Lloyd 2002, p.176.

135 This is pointed out by Mark Haworth-Booth in Brandt 1985, p.14.

136 Delany 2004, p.115.

137 Raymond Mortimer, 'Introduction' in Brandt 1936, p.3.

138 Brandt 1936, p.7.

139 Brandt 1936, p.8.

140 Sander 1986.

141 Mulford 1978, pp.7–8; cited in Frizzell 1997, p.28.

142 Harrison, T. 1937; see the account in Varley 1987, p.7.

143 Varley 1987, p.11.

144 Varley 1987, p.11.

145 Frizzell 1997, p.28.

146 See, for example, Malinowski 1926.

147 Frizzell 1997, p.29. She also provides an account of the publication of Spender's work from the 1970s, pp.9–10.

148 Madge and Harrisson 1939; Varley 1987, p.17.

149 Trevelyan 1957, pp.100–1.

150 Varley 1987, p.18.

151 Wiener 2004, p.77.

152 Lloyd 2002, p.233. Keynes 1936.

153 Lloyd 2002, p.307.

154 McKibbin 2000, pp.63–4.

155 McKibbin 2000, p.535.

156 Tomlinson 1944, p.30.

157 Richards 1973; the first edition was published in 1946.

158 For an account of these developments, see Garlake 1998, p.17f.

159 McKibbin 2000, pp.48–9.

160 Anon., 'Mr. Moore's "Family Group". Work Commissioned for New Town', *The Times*, 18 May 1956. For an account of Moore's quasi-official place in British art at this time, see my essay 'The Mother and Child Theme in the Work of Henry Moore', in Henry Moore Foundation, *Henry Moore: Mutter und Kind/Mother and Child*, Much Hadham 1992, pp.13–39.

161 A table of British military interventions between 1949 and 1970 may be found in Van Wingen and Tillema 1980, p.294.

162 Lloyd 2002, p.275.

163 Lloyd 2002, p.315. Lloyd details these changes and notes that the provision of state services in the post-war period makes the raw figures misleading.

164 Hoggart 1957; Williams, R. 1958.

165 See Perkin 2002, pp.xii–xiii.

166 R. Hamilton, 'An Exposition of $he', in Hamilton 1982, p.35; originally published in *Architectural Design*, Oct 1962, pp.485–6.

167 Hamilton 1982, p. 36.

168 For an analysis of Hamilton's depiction of the effects of consumerism, see Kaizen 2000, pp.113–28.

169 McKibbin 2000, p.65.

170 Lloyd 2002, p.385.

171 Wiener 2004, p.164.

172 For Perkin, this is the fundamental distinction of such professionals from the entrepreneur whose competence is of course tested against the market. See Perkin 2002, p.xxiii. For an analysis of university-generated art in the US, see Singerman 1999.

173 The translations of works by European Marxists such as Benjamin, Gramsci and Lukács, appearing first in *New Left Review* from 1966 and then in editions by New Left Books, had a huge impact on the development of Marxism in Britain. For an account of these developments, see Chun 1993.

174 Baldwin, Harrison, Ramsden 1999, p.199.

175 The quoted passage is from Benjamin Buchloh's justly renowned essay, 'Conceptual Art 1962–1969: From the Aesthetic of Administration to the Critique of Institutions', in *October*, no.55, Winter 1990, p.142.

176 Spence, J. and Dennett 1995, p.77.

177 Spence, J. and Dennett 1995, p.78.

178 Spence, J. and Dennett 1995, pp.84–5.

179 Spence, J. and Dennett 1995, p.86.

180 McKibbin 2000, p.536.

181 Lloyd 2002, p.416.

182 Cowling, M. 1971, p.427; cited in Wiener 2004, p.101.

183 Stuart Hall, 'Postscript: Gramsci and Us', in Simon 1991, p.118. See also Hall 1988.

184 This combination of radicalism masked by conservatism is analysed brilliantly by Raphael Samuel, 'Mrs Thatcher and Victorian Values', in Light 1998.

185 Wheatcroft 2006, pp.154–5.

186 Wheatcroft 2006, p.155. Note, though, the defence of his legacy in the light of these revelations by Christopher Hitchens (Hitchens 1993, pp.161–72).

187 Jonquet 2006, pp.312–13.

188 This point is made by Wheatcroft 2006, p.160.

189 Wheatcroft 2006, p.161.

190 Jonquet 2004, p.312.

191 Rosenblum 2004, p.119. Quote from 1981.

192 Jonquet 2004, p.131.

193 Wheatcroft 2006, p.272.

194 See Susan Watkins's review of Wheatcroft: 'Toryism After Blair', *New Left Review*, new series, no. 38, March-April 2006, pp.128–35. While Major was still in power, the journal also published a prescient analysis of the deep structural problems facing the Conservatives: Gamble 1995, pp.3–25.

195 See Perkin 2002, pp.xvi–xvii.

196 See Mair 2006, pp.25–51.

197 In an interview with Rick Poynter, *Twice* magazine, summer 2001; cited in Williams, V. 2002, p.275.

198 See the introduction to Gramsci 1957, p.15.

199 For an account of 'Woodwork', see J. Stallabrass, 'A Place of Pleasure: *Woodwork*, Vauxhall Spring Gardens and Making Audiences for Art', in McCorquodale, Siderfin and Stallabrass 1988, pp.170–207.

200 There is naturally little literature on Hinchliffe. The artist-run space Beaconsfield showed a retrospective of his work in 1998: *Estate: The Ian Hinchliffe Retrospective*, London 1998.

4 BETWEEN GOD AND THE SAUCEPAN: SOME ASPECTS OF ART EDUCATION IN ENGLAND FROM THE MID-NINETEENTH CENTURY UNTIL TODAY pp.163–87

1 Rushton and Wood 1979a.
2 In his detailed study of *The History and Philosophy of Art Education* (London 1970), Stuart Macdonald begins from the premise that 'art education is a branch of the subject education rather than of the history of art' (p.5). I have followed a different approach, relating developments in art education to changing paradigms of art. Accordingly, though I have derived much of my overall picture of developments, especially as regards the nineteenth century, from his book, I seldom cite Macdonald's arguments. I have however made use of the invaluable documentary source material his book provides. Citations are given as they arise, followed by the format 'Quoted Macdonald, S. 1970'.
3 Reynolds, J. 1992, p.79. A taste of the debates preceding the foundation of the Academy can be gleaned from Hogarth, W. 2000, pp.635–8.
4 Haydon 1926, vol.2, p.525. Quoted Macdonald, S. 1970, p.70.
5 Cole 1884, vol.2, pp.295–6. Quoted Macdonald, S. 1970, p.140.
6 Ruskin 1857, p.xiv.
7 The *National Course of Instruction for Government Schools of Art*, Stage 2. Quoted Macdonald, S. 1970, p.388.
8 From a Parliamentary debate of 1858 discussed in the *Art Journal* 1860. Quoted Macdonald, S. 1970, p.175.
9 Sir Charles Eastlake, *Sessional Papers* of the 1864 Select Committee on the Schools of Art, p.181. Quoted Macdonald, S. 1970, p.193.
10 Circular Letter of 27 Feb. 1858, in the Minutes of the Committee of Council on Education 1857–8, p.27. Quoted Macdonald, S. 1970, p.168.
11 Redgrave 1876, p.163. Quoted Macdonald, S. 1970, p.241.
12 Moore, G. 1893, pp.65–6. It is perhaps worth registering that Moore's incipient modernism, technically so at odds with the contemporary academy was in other respects entirely at home in its supporting culture: "Woman's nature is more facile and fluent than man's. Women do things more easily than men, but they do not penetrate below the surface . . . in the higher arts, in painting, in music and literature, their achievements are slight indeed." (Ibid., p.220.)
13 Steadman 1979, p.96.
14 Ibid., p.86.
15 Ruskin 1877, vol.7, p.192. It is perhaps worth noting that, in the words of his biographer, Ruskin's *Fors Clavigera* represents "a noble mind evidently distraught" (Hilton 2002, p.468). The fierce criticism of Cole appears in the same letter as Ruskin's denunciation of Whistler, which led to the famous court case.
16 This and succeeding quotations from Poynter 1885, pp.94–114.
17 Hind 1906, pp.2, 8.
18 Ibid., pp.56–7.
19 Ibid., p.61.
20 Fry 1960, pp.166–70.
21 Report of the Royal Commission on Technical Instruction, 1884. Quoted Macdonald, S. 1970, pp.293–4.

22 William Morris, evidence to the Royal Commission on Technical Instruction, 17 March 1882, reprinted in Morris, M. 1936, vol.1, pp.205–25; quoted passages from pp.222, 211.
23 Ibid., p.212.
24 Ibid., p.210.
25 W. Morris, 'Art Under Plutocracy', quoted in Thompson 1976, p.642.
26 H. Muthesius, quoted in Pevsner 1973, p.265.
27 Pevsner, ibid. The final phrase is quoted by Pevsner from C.R. Ashbee, whom he describes as 'the most intelligent and consistent of Morris's followers' (p.264).
28 Lord Gorell, Report of his Committee on the Production and Exhibition of Articles of Good Design and Everyday Use (1932). Quoted Macdonald, S. 1970, p.302.
29 Gorell Report, quoted ibid.
30 Pevsner 1973, pp.293–4.
31 Pevsner 1937, p.219.
32 Ibid., pp.220–1.
33 Read 1934b, pp.7, 10.
34 Ibid., pp.167–70.
35 Pevsner 1937, p.137.
36 Ibid., p.155.
37 Ibid., p.215.
38 Quoted Rushton and Wood 1979a, p.8.
39 Ibid., p.9.
40 Sweet 1992, p.3.
41 Quoted Rushton and Wood 1979a, p.9.
42 Hamilton 1982, p.173.
43 ibid., p.177.
44 Thistlewood 1981, pp.22ff.
45 Quoted Rushton and Wood 1979a, p.14.
46 Ibid., p.13.
47 Hamilton 1982, p.175.
48 ibid., p.177.
49 ibid., p.174.
50 Butler 1962, p.11.
51 Ibid., p.69.
52 A detailed analysis of this process is provided in Rushton and Wood 1979a, pp.18–19.
53 The vocational/honours distinction has once again emerged as an issue in the early twenty-first century with government sponsorship of the two-year 'Foundation Degree', principally aimed at preparing students for employment in what have come to be called the 'creative industries', while providing them with degree-type camouflage in an increasingly qualification-hungry market.
54 Rushton and Wood 1979a, p.11.
55 L. Tickner, 'The Gestetner Revolution', unpublished paper, delivered at the Courtauld Institute, London, 7 Nov. 2006. Subsequently expanded into book form. See Tickner 2008.
56 *Document 11*, issued by the Association of Members of the Hornsey College of Art, 3 June 1968. Subsequent quotations all from this document.
57 A detailed analysis of this process is provided in Rushton and Wood 1979a, pp.21–4.
58 A highly visible symptom of the clash was the painter Patrick Heron's famous essay 'Murder of the Art Schools', which was published in *The Guardian*, 12 October 1971. Its concern about the baleful impact of polytechnicization was entirely justified; its starry-eyed celebration of the modernist status quo was largely fatuous (notwithstanding the contribution of the art school ethos to British popular culture of the period).

59 C. Greenberg, 'Modernist Painting' (1960/5), reprinted in Harrison, C. and Wood 2003, pp.773–9 (passage quoted from p.778).
60 De Ville 2002, pp.297–301 (passage quoted from p.300). The 'locked room' educational experiment conducted on first-year students at St Martins at the start of the new academic year in autumn 1969 has been documented in an exhibition at Tate Britain, Feb.–Aug. 2007. See also Westley 2007, pp.56–9.
61 Harrison, C. 1993, p.204.
62 Atkinson and Baldwin 1971, pp.25–50.
63 Harrison, C. 2004, pp.45–86; passage quoted from p.77.
64 Letter from E.E. Pullee, Chief Officer of the NCDAD to Sir Alan Richmond, Director of Lanchester Polytechnic, 29 July 1971. Dave Rushton archive, Edinburgh.
65 Contemporary discussion of these disputes may be found in Pilkington et al. 1971, pp.120–2; Morris, L., Jacks, Harrison 1971, pp.169–70; Everitt 1972, pp.176–8; Berry, Wood, Wright 1972, pp.179–81. Work relating to the Coventry course appeared in *Statements*, Jan. and Nov.1970, and *Analytical Art*, no.1, July 1971, and no.2, June 1972. Work from Newport appeared in *Number 1*, *Numbers 1A–1D*, 1970–1971, and *Papers Read at Leeds Polytechnic*, 1972. The goings-on at Newport were documented in an exhibition, *Art: Education Matters*, shown at California Institute of Arts in 1973.
66 Quoted in Rushton and Wood 1979a, p.33.
67 See Rushton and Wood 1975, pp.96–101.
68 Rushton and Wood 1979b.
69 See Pateman 1972.
70 Perry 2004, p.11.
71 All quotations from de Ville 2002, p.300.
72 V. Burgin, 'The Absence of Presence' (1984), reprinted in Harrison, C. and Wood 2003, pp.1068–72 (quoted passages from p.1072, 1070).
73 Jon Thompson, in Singerman 2001. Quoted in de Ville 2002, p.30.
74 de Ville 2002, p.301.
75 Sweet 1992, p.1.
76 V. Burgin, 'The Artist's Responsibility', at *Contemporary Art and Globalisation*, European Symposium of the Institut Nationale d'histoire de l'art, Paris, 3 Dec. 2005. There can be no clearer statement of the priorities governing official thinking on the role of art in society than that essayed by the Department of Culture, Media and Sport in its 'Creative Industries [sic] Mapping Document' of 2001: 'those industries which have their origin in individual creativity, skill and talent and which have the potential for wealth and job creation through the generation and exploitation of intellectual property'. Further comment would be superfluous.
77 Andrew Stonyer, Professor of Fine Art at the University of Gloucestershire, communication to the author, Aug. 2006.
78 David Ryan, 'Emptiness, Openness and Instrumentality', unpublished lecture on the occasion of the exhibition, *Starting At Zero: Black Mountain College 1933–1957*, Kettle's Yard, Cambridge, April 2006. Ryan is Senior Research Fellow at Chelsea College of Art and Design, and Head of Fine Art at Anglia Ruskin University, Cambridge.
79 Rogoff 2006, pp.142–7.
80 Rushton and Wood 1979a, p.7.

5 THE SPACES OF BRITISH ART:
PATRONAGE, INSTITUTIONS,
AUDIENCES pp.199–221

1 Bernice Murphy writes in the catalogue
Pictura Britannica that 'to deny all reference to
structures through which nations engage with
each other culturally, and through which many
international projects are directly funded, would
be to dissemble on crucial issues of analysis
concerning the social resourcing of many
cultural encounters'. Murphy 1997, p.15.
2 See Garlake 1991, p.19.
3 Taylor 1999, p.xiv.
4 Pearson 1982.
5 Taylor 1999, p.202.
6 Hatton and Walker 2003.
7 Much was finding its way to the United States
where newly enriched industrialists were
acquiring major European works of art as 'a
sign of culture as well as a token of success and
riches', but works by artists hitherto present in
British collections such as Fra Angelico, Botticelli
and Van Eyck had gone to the Kaiser-Wilhelm
Museum in Berlin opened in 1904. Witt 1911,
p.16.
8 For example, the Society for the Protection of
Ancient Buildings was founded by William Morris
and others in 1877; the National Trust was set
up in 1894 although its origins date back to
1884. See Mandler 1999, pp.160 and 171. The
Museums Association was established in 1889.
Witt 1911, p.53.
9 4 Sept. 1916, T.1.12587, the National Archive.
10 Poynter, TS, 1 Aug. 1917, T.1.12587, the
National Archive.
11 Report of the Committee of Trustees of the
National Gallery, Appointed by the Trustees to
Enquire into the Retention of Important Pictures
in this Country, and Other Matters Connected
with the National Art Collections: Report and
Appendices, London 1915, p.26.
12 See, for example, *Pall Mall Gazette*, 12 March 1892.
13 See Meslay 1999, pp.40–9, and Reynolds, S. 1980,
pp.459–61.
14 See Sharp 2003.
15 Quoted in Kelly 2004, p.92.
16 Because of an unwitnessed codicil to his will, the
Lane bequest was subject to a protracted dispute
with Dublin that was only settled in the 1950s.
See Kelly 2004.
17 Taylor 1999, pp.150–3.
18 Press Release, n.d. TG 14/5/1 TGA.
19 See Newall 1995, p.34; and Stephenson 2000,
p.193.
20 The Grosvenor had a ladies' drawing room and
reading room, and women artists were well
represented. See Stephenson 2000, p.198. About
a quarter of the artists in the Grosvenor's summer
shows were women, although they showed fewer
works, which were less prominently displayed.
Newall 1995, p.23.
21 Stephenson 2000, p.198.
22 As argued by both Cork 1994, and Harries and
Harries 1983.
23 See Malvern 2004. Muirhead Bone, one of
the advisers on the commissioning of the large
canvases, imagined a 'Great Memorial Gallery' to
house them, but no designs were ever produced.
See p.81.

24 See TG 4/8/1 'Tate Public Records: Loans in date
range 1910–1938'. TGA.
25 'The Transformation of the Tate', *Sunday Times*,
3 Sept. 1922.
26 Taylor 1999, p.xiv.
27 See Malvern 2003, p.79.
28 Members paid a subscription for the right to show
five works in a jury-free exhibition, which for demo-
cratic reasons was hung in an order determined
by a ballot. See Rutter 1927, pp.180–99.
29 See Lewison 1982, pp.11–19.
30 Herbert Read, one of the organizers, refused to
hang Kokoschka's *Robert Freund (Lacerated by the
Police of Vienna)*, because he said it was too political.
See Frowein 1991, pp.45–56, especially p.50.
31 In 1945 the Tate, its Millbank building still mostly
closed and bomb-damaged, hosted an exhibition
of Paul Klee's work at the National Gallery.
32 Taylor 1999, p.174, and the Arts Enquiry, *The Visual
Arts: A Report Sponsored by the Dartington Hall
Trustees*, London 1946, p.113.
33 Report of the Committee on the functions of
the National Gallery and Tate Gallery and, in
respect of paintings, of the Victoria and Albert
Museum together with a memorandum thereon
by the Standing Commission on Museums and
Galleries, London 1946, p.8.
34 In Spalding 1998, p.50.
35 Barr 1943, p.3.
36 Barr 1943, p.6.
37 Heron 1968, pp.63–4.
38 Anon., 'Should Britain Have a Ministry of Fine
Arts?,' *Studio*, vol.125, no.599, 1943, p.57.
39 *Henry Moore, Early Carvings 1920–1940:
A Catalogue with Three Essays*, Leeds 1982, p.33.
40 Morris, L. and Radford 1983, pp.53–4, 58.
41 Cox and Williams 1983, p.14
42 Cox and Williams 1983, p.10.
43 Pearson 1982, p.47.
44 Crane, Kawashima, Kawasaki 2002, p.29.
45 Crane, Kawashima, Kawasaki 2002, p.42.
Minihan makes the same point about Britain
(Minihan 1977).
46 CEMA (Council for the Encouragement of Music
and Art), *A Selection from the Tate Gallery's
Wartime Acquisitions*, London 1942, p.2.
47 Alley notes 189 British works purchased and 14
foreign between 1938 and 1948. Alley 1981, p.2.
48 TGA 806/6/5, 'Writings by JBM', c.1939, TGA.
49 *Tate Gallery Annual Report*, 1961–2, p.1.
50 The Paris museums were reorganized in 1938 but
only opened in 1947 because of the occupation.
See Lawless 1986, p.37, and *Tate Gallery Annual
Report*, 1964–5, p.1.
51 It is known as the 'white cube' and was analysed
in Brian O'Doherty's 1976 series of essays for the
American journal *Artforum*. O'Doherty 1986.
52 *Painting and Sculpture of a Decade, '54–'64*,
London 1964, p.20.
53 *Guardian*, 21 April 1964, quoted in Searing 2004,
p.45.
54 Kosinski 2001, p.24.
55 Kosinski 2001, p.25.
56 The first time that the pavilion was government
sponsored was in 1930 and before the war this
came under the Department of Overseas Trade.
See Bowness and Phillpot 1995.
57 *Britain and the São Paulo Bienal 1951–1991*, 1991,
p.32.
58 Taylor 1999, pp.188–91.

59 Taylor 1999, p.190.
60 Yule 2001, p.104. 'A Place for Living Art': The
Whitechapel Art Gallery 1952–1968,' in *Artists
and Patrons in Post-War Britain: Essays by post-
graduate students at the Courtauld Institute of Art*,
edited by Margaret Garlake, Aldershot 2001.
61 Ibid., p.114.
62 Bryan Robertson, John Russell and Antony
Armstrong-Jones Snowdon, *Private View*, London
1965, p.14.
63 Sadler 1935.
64 Khan 1976, p.17.
65 Hall 2002, p.2. Key sources include Araeen 1989;
Deliss 1995; Baucom, Boyce, Bailey 2005.
66 Khan 2005, p.119.
67 David Medalla, who came to London from Manila
via New York and Paris, set up 'Exploding Galaxy',
an artists' collective, in Dalston in 1967.
68 The original founders were Kevin Goldstein-
Jackson, Tom Goodman, Jonathan Harvey,
Rosemary Harvey, David Panton, Claire Smith
and Susan Sauerbrun.
69 See ACME's website, http://www.artistsineast-
london.org/frameset.htm (accessed 23 May 2006,
website still being built), including the essay
commissioned from Michael Archer, on the history
of art in the East End, 'Oranges and Lemons and
Oranges and Bananas: Artists in East London'.
70 See Tickner 2000, chap.5.
71 Ford and Davies, 1998. Also available at
http://www.infopool.org.uk/artcap.htm,
accessed 26 May 2006. S. Ford and A. Davies,
'Art Capital,' *Art Monthly*, vol.213, 1998.
72 Chin-Tao Wu 2002, p.78.
73 See http://www.tate.org.uk/supportus/corporate/
sponsorship.htm (accessed 13 July 2006).
74 Masterplan Report, June 1992, TG 12/1/1/2, TGA.
75 *The Glory of the Garden: The Development of the Arts
in England: A Strategy for a Decade*, London 1984.
76 See for example 'The Way Through the Woods'
Masterplan Report, June 1992, TG 12/1/1/2, TGA.
77 See http://www.wolff-olins.com/tate.htm
(accessed 13 July 2006), and Wolff Olins, *Tate:
Look again, Think again*, brochure.
78 See http://www.tate.org.uk/about/marketresearch/
(accessed 13 July 2006).
79 Report of a PR consultant for Stuyvesant, quoted
in Yule 2001, p.111.
80 Cox and Williams 1983, p.14.
81 Chin-Tao 2002, p.11.
82 Thompson, J. 2002, p.209.
83 Hatton and Walker 2003, p.21.
84 M. Davidson quoted in ibid., p.22.
85 Button 2007, p.17.
86 Bickers quoted in Hatton and Walker 2003, p.178.
87 In 2008 the Saatchi Gallery will reopen in Chelsea.
88 The title of an article by Michael Corris; Corris
1992, p.106–11. See also Murphy 1997, p.66, and
Legge 2000, pp.1–24.
89 Harris 2004, p.45.

Bibliography

This is not intended as a definitive list of books on the art of this period, but has been compiled from references in the long essays in this volume combined with additional selected further reading.

ABBING 2002
H. Abbing, *Why Are Artists Poor? The Exceptional Economy of the Arts*, Amsterdam 2002.

ADDISON 1975
P. Addison, *The Road to 1945: British Politics and the Second World War*, London 1975.

AGAR 1988
E. Agar, *Eileen Agar: A Look at my Life*, London 1988.

ALLEN 1995
B. Allen (ed.), *Towards a Modern Art World (Studies in British Art I)*, New Haven and London 1995.

ALLEY 1982
R. Alley, *Graham Sutherland*, exh. cat., Tate Gallery, London 1982.

ALLEY 1981
R. Alley, *Catalogue of the Tate Gallery's Collection of Modern Art, other than works by British Artists*, London 1981.

ALLOWAY 1954
L. Alloway, *Nine Abstract Artists*, London 1954.

ALLOWAY 1960
L. Alloway, 'Size Wise', *Art News and Review*, Sept. 1960.

ANDERSON 1980
P. Anderson, *Arguments Within English Marxism*, London 1980.

ANDERSON 1984
P. Anderson, 'Modernity and Revolution', *New Left Review*, no.144, March–April 1984.

ANDERSON 1992
P. Anderson, *English Questions*, London 1992.

ARAEEN 1989
R. Araeen, *The Other Story: Afro-Asian Artists in Post-War Britain*, London 1989.

ARCHER 1997
M. Archer, *Art Since 1960*, London 1997.

ATKINSON AND BALDWIN 1971
T. Atkinson and M. Baldwin, 'Art Teaching', *Art-Language*, vol.1, no.4, Nov. 1971.

BALDWIN, HARRISON AND RAMSDEN 1999
M. Baldwin, C. Harrison and M. Ramsden, *Art & Language in Practice*, 2 vols., exh. cat., Fundació Antoni Tàpies, Barcelona 1999.

BANHAM AND HILLIER 1976
M. Banham and B. Hillier, *A Tonic to the Nation: the Festival of Britain*, London 1976.

BARKER 2004
I. Barker, *Anthony Caro: Quest for the New Sculpture*, Aldershot 2004.

BARON 1979
W. Baron, *The Camden Town Group*, London 1979.

BARON AND SHONE 1992
W. Baron and R. Shone, *Sickert: paintings*, exh. cat., Royal Academy, London 1992.

BARR 1943
A.H. Barr, *What is Modern Painting?*, New York 1943.

BARRINGER 1998
T. Barringer, *The Pre-Raphaelites*, London 1998.

BAUCOM, BOYCE AND BAILEY 2005
I. Baucom, S. Boyce and D.A. Bailey (eds.), *Shades of Black: Assembling Black Arts in 1980s Britain*, Durham 2005.

BEATTIE 1983
S. Beattie, *The New Sculpture*, New Haven 1983.

BELL, C. 1914
C. Bell, *Art*, London 1914.

BELL, K. 1999
K. Bell, *Stanley Spencer*, London 1999.

BENJAMIN 1999
W. Benjamin, *The Arcades Project*, trans. H. Eiland and K. McLaughlin, Cambridge 1999.

BERENSON 1958
B. Berenson, *Essays in Appreciation*, London 1958.

BERGER 1958
J. Berger, *A Painter of Our Time*, London 1958.

BERNARD AND BIRDSALL 1996
B. Bernard and D. Birdsall, *Lucien Freud*, London 1996.

BERRY, WOOD AND WRIGHT 1972
P. Berry, P. Wood and K. Wright, 'Remarks on Art Education', *Studio International*, Nov. 1972.

BERTRAM 1951
A. Bertram, *A Century of British Painting 1851-1951*, London and New York 1951.

BILLS AND KNIGHT 2007
M. Bills and V. Knight, *William Powell Frith*, exh. cat., Guildhall Art Gallery, London 2007.

BLACK 2005
J. Black, *Edward Wadsworth: Form, Feeling and Calculations: The Complete Paintings and Drawings*, London 2005.

BOURDIEU 1996
P. Bourdieu, *The Rules of Art: Genesis and Structure of the Literary Field*, Cambridge 1996.

BOWNESS AND LAMBERTINI 1980
A. Bowness and L. Lambertini, *Victor Pasmore*, London 1980.

BOWNESS AND PHILLPOT 1995
S. Bowness and C. Phillpot, *Britain at the Venice Biennale, 1895-1995*, London 1995.

BRANDT 1936
B. Brandt, *The English at Home*, London 1936.

BRANDT 1985
B. Brandt, *Behind the Camera: Photographs, 1928-1983*, Oxford 1985.

BRITISH COUNCIL 1976
British Council, *Arte inglese oggi, 1960-76*, exh. cat, Palazzo Reale di Milano, Milan 1976.

BROWN, D. 1985
D. Brown (ed.), *St Ives: Twenty-Five Years of Painting, Sculpture and Pottery*, exh. cat., Tate Gallery, London 1985.

BROWN, N. 2006
N. Brown, *Tracey Emin*, London 2006.

BURN 2001
G. Burn, *Damien Hirst: On the Way to Work*, London 2001.

BUTLER 1962
R. Butler, *Creative Development: Five Lectures to Art Students*, London 1962.

BUTTON 2003
V. Button, *Christopher Wood*, London 2003.

BUTTON 2007
V. Button, *The Turner Prize*, London 2007.

CAUDWELL 1938
C. Caudwell, *Studies in a Dying Culture*, London 1938.

CAUDWELL 1949
C. Caudwell, *Further Studies in a Dying Culture*, London 1949.

CAUSEY 1980
A. Causey, *Paul Nash*, Oxford 1980.

CAUSEY 1985
A. Causey, *Edward Burra: Complete Catalogue*, Oxford 1985.

CHAMOT 1937
M. Chamot, *Modern Painting in England*, London 1937.

CHIN-TAO 2002
W. Chin-Tao, *Privatising Culture: Corporate Art Intervention since the 1980s*, London 2002.

CHUN 1993
L. Chun, *The British New Left*, Edinburgh 1993.

COLE 1884
H. Cole, *Fifty Years of Public Work*, 2 vols., London 1884.

COLLINS 1998
J. Collins, *Eric Gill: The Sculpture*, London 1998.

COMPTON, A. 2004
A. Compton, *The Sculpture of Charles Sergeant Jagger*, Aldershot 2004.

COMPTON, M. 1988
M. Compton, *David Hockney: A Retrospective*, exh. cat., Tate Gallery, London 1988.

COMPTON, S. 1987
S. Compton (ed.), *British Art in the 20th Century*, exh. cat., Royal Academy, London 1987.

CORBETT 1997
D.P. Corbett, *The Modernity of English Art 1914-30*, Manchester and New York 1997.

CORBETT 2004
D.P. Corbett, *The World in Paint: Modern Art and Visuality in England 1848-1914*, Manchester 2004.

CORBETT, HOLT AND RUSSELL 2002
D.P. Corbett, Y. Holt and F. Russell, *The Geographies of Englishness: Landscape and the National Past 1880-1940*, New Haven and London 2002.

CORBETT AND PERRY 2000
D.P. Corbett and L. Perry, *English Art 1860-1914: Modern Artists and Identity*, Manchester 2000.

CORK 1974
R. Cork, *Vorticism and its Allies*, exh. cat., Hayward Gallery, London 1974.

CORK 1976
R. Cork, *Vorticism and Abstract Art in the First Machine Age*, 2 vols, London 1976.

CORK 1985
R. Cork, *Art beyond the Gallery in Early 20th Century England*, New Haven and London 1985.

CORK 1987
R. Cork, *David Bomberg*, New Haven and London 1987.

CORK 1994
R. Cork, *A Bitter Truth, Avant-Garde art and the Great War*, New Haven and London 1994.

CORK 2006
R. Cork, *Michael Craig-Martin*, London and Dublin 2006.

CORRIS 1992
M. Corris, 'British? Young? Invisible? With Attitude?', *Artforum*, vol.30, no.9, 1992.

COWLING, M. 1971
M. Cowling, *The Impact of Labour, 1920-1924: The Beginning of Modern British Politics*, Cambridge 1971.

COWLING, E. AND MUNDY 1990
E. Cowling and J. Mundy, *On Classic Ground: Picasso, Léger, De Chirico and the New Classicism*, London 1990.

COX AND WILLIAMS 1983
B. Cox and R. Williams, *The Arts Council: Politics and Policies*, London 1983.

CRAFTS 2004
N. Crafts, 'Long-run Growth', in R. Floud and P. Johnson (eds.), *The Cambridge Economic History of Modern Britain: Volume III: Structural Change and Growth, 1939-2000*, Cambridge 2004.

CRANE, KAWASHIMA AND KAWASAKI 2002
D. Crane, N. Kawashima and K. Kawasaki (eds.), *Global Culture: Media, Arts, Policy, and Globalization*, New York and London 2002.

CRONE 2008
R. Crone, *Anish Kapoor to Darkness: Svayambh*, London 2008.

CROW 1996
T. Crow, *The Rise of the Sixties*, London 1996.

CURTIS, D. 2007
D. Curtis, *History of Artists' Film and Video in Britain 1897–2004*, London 2007.

CURTIS, P. 2003
P. Curtis (ed.), *Sculpture in 20th Century Britain*, 2 vols, Leeds 2003.

DAKERS 1999
C. Dakers, *The Holland Park Set: Artists and Victorian Society*, New Haven and London 1999.

DANGERFIELD 1996
G. Dangerfield, *The Strange Death of Liberal England*, London 1936, repr. 1996.

DAVIDSON 2005
A.A. Davidson, *The Sculpture of William Turnbull*, Aldershot 2005.

DAVIES ET AL. 2007
C. Davies et al., *Kenneth and Mary Martin: Constructed Works*, exh. cat., Camden Art Centre, London 2007.

DEBBAUT 2007
J. Debbaut, *Gilbert & George: Major Exhibition*, exh. cat., Tate Modern, London 2007.

DE VILLE 2002
N. de Ville, 'British Art Schools, and the influence of art education in the twentieth century', in Meryric Hughes and van Tuyl 2002.

DELANY 2004
P. Delany, *Bill Brandt*, London 2004.

DELISS 1995
C. Deliss, *Seven Stories about Modern Art from Africa*, exh. cat., Whitechapel Art Gallery, London 1995.

EDWARDS 2000a
P. Edwards, *Wyndham Lewis: Painter and Writer*, New Haven and London, 2000.

EDWARDS 2000b
P. Edwards (ed.), *Blast: Vorticism 1914–18*, Aldershot 2000.

ELIOT 1922
T.S. Eliot, *The Waste Land*, 1922.

EVERITT 1972
A. Everitt, 'Four Midland Polytechnic Fine Art Departments', *Studio International*, Nov. 1972.

FARR 1978
D. Farr, *English Art 1870–1940*, Oxford 1978.

FAULKNER 1973
P. Faulkner (ed.), *William Morris: The Critical Heritage*, London 1973.

FORD AND DAVIES 1998
S. Ford and A. Davies, 'Art Capital', *Art Monthly*, vol.213, 1998.

FOSTER 2004
H. Foster, *Prosthetic Gods*, Cambridge and London 2004.

FRANCES AND GRIFFITHS 1990
C. Frances and A. Griffiths, *Avant-garde British Printmaking 1914–60*, exh. cat., British Museum, London 1990.

FRIED 1968
M. Fried, 'Two Sculptures by Anthony Caro', *Artforum*, Feb. 1968.

FRIZZELL 1997
D. Frizzell, *Humphrey Spender's Humanist Landscapes: Photo-Documents, 1932–1942*, New Haven 1997.

FROWEIN 1991
C. Frowein, 'German Artists in War-Time Britain', *Third Text*, vol.35, 1991.

FRY 1920
R. Fry, *Vision and Design*, London 1920.

FRY 1926
R. Fry, *Transformations: Critical and Speculative Essays on Art*, London 1926.

FRY 1961
R. Fry, 'The French Impressionists', introduction to the French section of the 1912 *Second Post-Impressionist Exhibition*; repr. in Fry 1920, repr. Harmondsworth 1961.

FULLER 1987
P. Fuller, 'British Art in the Twentieth Century: Royal Academy', *Burlington Magazine*, vol.129, no.1009, April 1987.

FULLER 1988
P. Fuller, *Seeing Through Berger*, London 1988.

GABO, NICHOLSON AND MARTIN 1937
N. Gabo, B. Nicholson and J.L. Martin (eds.), *Circle – International Survey of Constructive Art*, London 1937.

GALE 1998
M. Gale, *Alfred Wallis*, London 1998.

GAMBLE 1995
A. Gamble, 'The Crisis of Conservatism', *New Left Review*, no.214, Nov.–Dec. 1995.

GARLAKE 1991
M. Garlake, *Britain and the São Paulo Bienal 1951–1991*, London 1991.

GARLAKE 1998
M. Garlake, *New Art, New World: British Art in Postwar Society*, New Haven 1998.

GOODING 1994
M. Gooding, *Patrick Heron*, London 1994.

GOODING 2001
M. Gooding, *Gillian Ayres*, London 2001.

GRAMSCI 1957
A. Gramsci, *The Modern Prince and Other Writings*, trans. L. Marks, London 1957.

GREEN 1999
C. Green (ed.), *Art Made Modern: Roger Fry's Vision of Art*, exh. cat., Courtauld Galleries, London 1999.

GRESTY 1984
H. Gresty (ed.), *When Attitudes Became Form*, exh. cat., Kettles Yard, Cambridge 1984.

GRUNENBERG AND BARSON 2006
C. Grunenberg and T. Barson (eds.), *Jake & Dinos Chapman: Bad Art for Bad People*, exh. cat., Tate Liverpool 2006.

GUILBAUT 1990
S. Guilbaut (ed.), *Reconstructing Modernism: Art in New York, Paris, and Montreal 1945–1964*, Cambridge 1990.

HALL, D. AND TUCKER 1992
D. Hall and M. Tucker, *Alan Davie*, London 1992.

HALL, S. 1988
S. Hall, *The Hard Road to Renewal: Thatcherism and the Crisis of the Left*, London 1988.

HALL, S. 2005
S. Hall, 'Assembling the 1980s: The Deluge – and After', in Baucom, Boyce and Bailey 2005.

HAMILTON 1982
R. Hamilton, *Collected Words, 1953–1982*, London 1982.

HAMMACHER 1987
A.M. Hammacher, *Barbara Hepworth*, London 1987.

HARRIES AND HARRIES 1983
S. and M. Harries, *The War Artists*, London 1983.

HARRIS 2004
J. Harris (ed.), *Art, Money, Parties: New Institutions in the Political Economy of Modern Art*, Liverpool 2004.

HARRISON, C. 1981
C. Harrison, *English Art and Modernism 1900–1939*, London and Bloomington 1981.

HARRISON, C. 1993
C. Harrrison, '1967–1972: New Avant-Gardes', in P. Wood et al., *Modernism in Dispute: Art Since the Forties*, New Haven 1993.

HARRISON, C. 2004
C. Harrison, 'Conceptual Art, the aesthetic and the end(s) of art', in G. Perry and P. Wood (eds.), *Themes in Contemporary Art*, New Haven 2004.

HARRISON, C. 2001
C. Harrison, *Essays on Art & Language*, Cambridge 2001.

HARRISON, C. AND SZEEMAN 1969
C. Harrison and H. Szeeman (eds.), *Live in Your Head: When Attitudes Become Form: Works, Concepts, Processes, Situation, Information*, exh. cat., ICA, London 1969.

HARRISON, C. AND WOOD 2003
C. Harrison and P. Wood (eds.), *Art in Theory 1900–2000*, Oxford 2003.

HARRISON, M. 2002
M. Harrison, *Transition: The London Art Scene in the Fifties*, exh. cat., Barbican Gallery, London 2002.

HARRISON, T. 1937
T. Harrison, *Savage Civilisation*, London 1937.

HARTLEY 1990
K. Hartley, *Scottish Art Since 1900*, Edinburgh 1990.

HATTON AND WALKER 2003
R. Hatton, and J.A Walker, *Supercollector: A critique of Charles Saatchi*, London 2003.

HAWKINGS AND HOLLIS 1979
J. Hawkins and M. Hollis (eds.), *Thirties: British Art and Design Before the War*, exh. cat., Hayward Gallery, London 1979.

HAYDON 1926
B.R. Haydon, *Autobiography*, 2 vols., London/New York 1853/1926.

HERON 1949
P. Heron, 'The School of London', *New Statesman and Nation*, 9 April 1949.

HERON 1956
P. Heron, 'The Americans at the Tate Gallery', *Arts*, March 1956.

HERON 1968
P. Heron, 'A Kind of Cultural Imperialism?', *Studio International*, vol.175, no.897, 1968.

HESS 1972
T. Hess, *Barnett Newman*, exh. cat., Tate Gallery, London 1972.

HEWISON 1977
R. Hewison, *Under Siege: Literary Life in London 1939–45*, London 1977.

HEWISON 1981
R. Hewison, *In Anger: Culture in the Cold War 1945–60*, London 1981.

HEWISON 1986
R. Hewison, *Too Much: Art and Society 1960–75*, London 1986.

HEWISON 1995
R. Hewison, *Cultural Consensus: England, Art & Politics Since 1940*, London 1995.

HILTON 2002
T. Hilton, *John Ruskin*, New Haven 2002.

HIND 1906
C.L. Hind, *The Education of an Artist*, London 1906.

HITCHENS 1993
C. Hitchens, 'Something about the Poems: Larkin and "Sensitivity"', *New Left Review*, no.200, July-Aug 1993.

HOGARTH, P. 1976
P. Hogarth, 'James Boswell: Eyewitness of the Thirties', in *James Boswell, 1906–71*, exh. cat., Nottingham University Art Gallery, Nottingham 1976.

HOGARTH, W. 2000
W. Hogarth, 'Of Academies' (c.1760-1), reprinted in C. Harrison and P. Wood (eds.), *Art in Theory 1648-1815*, Oxford 2000.

HOGGART 1957
R. Hoggart, *The Uses of Literacy: Aspects of Working-Class Life, with Special Reference to Publications and Entertainments*, London 1957.

HUBBARD 1951
H. Hubbard, *A 100 Years of British Painitng 1851-1951*, London 1951.

HUTCHINSON ET AL. 2000
J. Hutchinson et al., *Antony Gormley*, London 2000.

HYMAN 2001
J. Hyman, *The Battle for Realism*, New Haven and London 2001.

HYMAN 2002
J. Hyman, 'The Persistence of Painting Contexts for British Figurative Painting, 1975-90' in Meyric Hughes and van Tuyl 2002.

HYNES 1990
S. Hynes, *A War Imagined: The First World War and English Culture*, London 1990.

IRONSIDE 1947
R. Ironside, *Painting since 1939*, London 1947.

JENKINS AND STEPHENS 2004
D.F. Jenkins and C. Stephens (eds.), *Gwen John and Augustus John*, exh. cat., Tate Britain, London 2004.

JONES ET AL. 1996
S. Jones et al., *Frederick Lord Leighton 1830-1896*, exh. cat., Royal Academy, London 1996.

JONQUET 2004
F. Jonquet, *Gilbert & George: Intimate Conversations with François Jonquet*, London 2004.

JUDD 1965
D. Judd, 'Specific Objects', *Arts Yearbook*, vol.8, 1965.

JUNCOSA 2006
E. Juncosa (ed.), *Barry Flanagan: Sculpture 1965-2005*, exh. cat., Irish Museum of Modern Art, Dublin 2006.

KAIZEN 2000
W.R. Kaizen, 'Richard Hamilton's Tabular Image', *October*, no.94, Autumn 2000.

KELLY 2004
A. Kelly, 'The Lane Bequest', *Journal of the History of Collections*, vol.16, no.1, 2004.

KEYNES 1936
J.M. Keynes, *The General Theory of Employment, Interest and Money*, London 1936.

KHAN 1976
N. Khan, *The Arts Britain Ignores: The Arts of Ethnic Minorities in Britain*, London 1976.

KHAN 2005
N. Khan, 'Choices for Black Arts in Britain over Thirty Years', in Baucom, Boyce and Bailey 2005.

KHOROCHE 2007
P. Khoroche, *Ivon Hitchens*, Aldershot 2007.

KITAJ 1976
R.B. Kitaj, 'School of London' in *The Human Clay: An Exhibition Selected by R.B. Kitaj*, London 1976.

KOSINSKI 2001
D. Kosinski (ed.), *Henry Moore. Sculpting the 20th Century*, Dallas 2001.

LAMBIRTH 2006
A. Lambirth, *Roger Hilton*, London 2006.

LAMPERT ET AL. 2001
C. Lampert et al., *Frank Auerbach: Painitngs and Drawings 1954-2001*, exh. cat., Royal Academy of Art, London 2001.

LAUGHTON 1986
B. Laughton, *The Euston Road School: A Study in Objective Painting*, Aldershot 1986.

LAUGHTON 2004
B. Laughton, *William Coldstream*, New Haven and London 2004.

LAWLESS 1986
C. Lawless, *Musée national d'art moderne. Historique et mode d'emploi*, Paris 1986.

LEGGE 2000
E. Legge, 'Reinventing Derivation: Roles, Stereotypes, and "Young British Art"', *Representations*, vol.71, 2000.

LEMIRE 1969
E.D. Lemire (ed.), *The Unpublished Lectures of William Morris*, Detroit 1969.

LEWIS 1914
W. Lewis, *Blast*, no.1, 20 June 1914.

LEWIS 1915
W. Lewis, *Blast*, no.2, July 1915.

LEWIS 1917
W. Lewis, 'Inferior Religions', *Little Review*, Sept. 1917.

LEWIS 1969
W. Lewis, *Wyndham Lewis on Art: Collected Writings 1913-1956*, London 1969.

LEWISON 1982
J. Lewison (ed.), *Circle: Constructive Art in Britain 1934-40*, exh. cat., Kettle's Yard, Cambridge 1982.

LEWISON 1993
J. Lewison, *Ben Nicholson*, exh. cat., Tate Gallery, London 1993.

LIGHT 1998
A. Light (ed.), *Theatres of Memory, Volume II: Island Stories, Unravelling Britain*, London 1998.

LINGWOOD 2004
J. Lingwood, *Susan Hiller: Selected Works 1969-2004*, Gateshead 2004.

LLOYD 2002
T.O. Lloyd, *Empire, Welfare State, Europe: History of the United Kingdom 1906-2001*, Oxford 2002.

LÜBBREN 2001
N. Lübbren, *Rural Artists' Colonies in Europe 1870-1910*, Manchester 2001.

LUCIE-SMITH 1968
E. Lucie-Smith (ed.), 'An Interview with Clement Greenberg', *Studio International*, vol.175, no. 896, Jan. 1968.

LYNTON 2004
N. Lynton, *William Scott/Norbert Lynton*, London 2004.

MCCANNELL 1976
D. McCannell, *The Tourist: A New Theory of the Leisure Class*, London and New York 1976.

MCCONKEY 1993
K. McConkey, *Sir John Lavery*, Edinburgh 1993.

MCCORQUODALE, SIDERFIN AND STALLABRASS 1988
D. McCorquodale, N. Siderfin and J. Stallabrass (eds.), *Occupational Hazard: Critical Writing on Recent British Art*, London 1998.

MACDONALD, M.F. 1994
M.F. MacDonald (ed.), *Whistler*, exh. cat., Tate Gallery, London 1994.

MACDONALD, S. 1970
S. Macdonald, *The History and Philosophy of Art Education*, London 1970.

MCEWAN 2006
J. McEwan, *Paula Rego*, London 2006.

MCKIBBIN 2000
R. McKibbin, *Classes and Cultures: England 1918-1951*, Oxford 2000.

MADGE AND HARRISSON 1939
C. Madge and T.H. Harrisson, *Britain by Mass-Observation*, Harmondsworth 1939.

MAIR 2006
P. Mair, 'Ruling the Void? The Hollowing of Western Democracy', *New Left Review*, second series, no.42, Nov.-Dec. 2006.

MALINOWSKI 1926
B. Malinowski, *Crime and Custom in Savage Society*, London 1926.

MALVERN 2003
S. Malvern, 'The Identity of the Sculptor 1925-1950', in Curtis 2003.

MALVERN 2004
S. Malvern, *Modern Art, Britain and the Great War*, New Haven and London 2004.

MANDLER 1999
P. Mandler, *The Fall and Rise of the Stately Home*, New Haven and London 1999.

MELLOR 1987
D. Mellor, *A Paradise Lost: The Neo-Romantic Imagination in Britain 1935-55*, exh. cat., Barbican Art Gallery, London 1987.

MELLOR 1993a
D. Mellor, 'Existentialism and post-war British Art' in F. Morris (ed.), *Paris Post-War: Art and Existentialism 1945-55*, exh. cat., Tate Gallery, London 1993.

MELLOR 1993b
D. Mellor, *The Sixties Art Scene in London*, London 1993.

MELLOR 2002
D. Mellor, *The Art of Robyn Denny*, London 2002.

MESLAY 1999
O. Meslay, 'La collection de Sir Edmund Davis,' *48/14 The Musée d'Orsay Review*, vol.8, 1999.

MEYRIC HUGHES AND VAN TUYL 2002
H. Meyric Hughes and G. van Tuyl, *Blast to Freeze: British Art in the 20th Century*, exh. cat., Wolfsburg Kunstmuseum, Wolfsburg 2002.

MINIHAN 1977
J. Minihan, *The Nationalization of Culture: The Development of State Subsidies to the Arts in Great Britain*, London 1977.

MOORE, G. 1893
G. Moore, *Modern Painting*, London 1893.

MOORE, H. 1937
H. Moore, 'The Sculptor Speaks', *The Listener*, 18 Aug. 1937.

MORPHET 1982
R. Morphet, *Meredith Frampton*, London 1982.

MORPHET 1992
R. Morphet (ed.), *Richard Hamilton*, exh. cat., Tate Gallery, London 1992.

MORRIS, M. 1936
M. Morris, *William Morris, Artist, Writer, Socialist*, 2 vols., London 1936.

MORRIS, W. 1894
W. Morris, *News from Nowhere, or An Epoch of Rest*, London 1894.

MORRIS, W. 1976
W. Morris, 'Art Under Plutocracy', quoted in E.P. Thompson, *William Morris, Romantic to Revolutionary*, London 1976.

MORRIS, L. JACKS AND HARRISON 1971
L. Morris, Jacks and C. Harrison, 'Some Concerns in Fine Art Education II', *Studio International*, Nov. 1971.

MORRIS, L. AND RADFORD 1983
L. Morris and R. Radford, *AIA: the Story of the Artists' International Association 1933-53*, exh. cat., Modern Art Oxford, Oxford 1983.

MORTIMER 1984
E. Mortimer, *The Rise of the French Communist Party, 1920-1947*, London 1984.

MOSCHOVI 2004
A. Moschovi, *Photo-phobia and Photo-philia: the Neglect and Accommodation of Photography in British Art Institutions in the Postmodern Era*, PhD thesis, Courtauld Institute of Art, London 2004.

MULFORD 1978
J. Mulford (ed.), *Worktown People: Photographs from Northern England, 1937–1938, by Humphrey Spender*, Bristol 1978.

MURPHY 1997
B. Murphy, 'Pictura Britannica: Scenes, fictions and constructions in contemporary British art' in *Pictura Britannica: Art from Britain*, Sydney 1997.

NAIRN, T. 1977
T. Nairn, *The Break-Up of Britain*, London 1977.

NAIRNE, S. AND SEROTA 1981
S. Nairne and N. Serota (eds.), *British Sculpture in the Twentieth Century*, London 1981.

NASH 1932
P. Nash, 'The Artist and the Community', *Listener*, 20 Jan. 1932.

NEFF 1987
T. A. Neff (ed.), *A Quiet Revolution: British Sculpture Since 1965*, Chicago and San Francisco 1987.

NEWALL 1995
C. Newall, *The Grosvenor Gallery Exhibitions: Change and Continuity in the Victorian Art World*, Cambridge 1995.

NEWTON 1962
E. Newton, *The Meaning of Beauty*, Harmondsworth 1962.

NORMAND 1992
T. Normand, *Wyndham Lewis the Artist: Holding the Mirror up to Politics*, Cambridge 1992.

O'DOHERTY 1986
B. O'Doherty, *Inside the White Cube: the Ideology of the Gallery Space*, Santa Monica 1986.

OLIVER, DAVIS AND BENTLEY 1994
P. Oliver, I. Davis and I. Bentley, *Dunroamin: The Suburban Semi and its Enemies*, London 1994.

ORMOND AND KILMURRY 1998–2006
R. Ormond and E. Kilmurry, *John Singer Sargent: Complete Paintings*, 4 vols., London 1998–2006.

ORTON AND POLLOCK 1980
F. Orton and G. Pollock, 'Les Données Bretonnantes: La Prairie de Representation', *Art History*, vol.3, no.3, 1980.

PATEMAN 1972
T. Pateman (ed.), *Counter Course: A Handbook for Course Criticism*, Harmondsworth 1972.

PEARSON 1982
N.M. Pearson, *The State and the Visual Arts: A Discussion of State Intervention in the Visual Arts in Britain, 1760–1981*, Milton Keynes 1982.

PENROSE AND MILLER 2001
The Surrealist and the Photographer: Roland Penrose, Lee Miller, exh. cat., Scottish National Gallery of Modern Art, Edinburgh 2001.

PERKIN 2002
H. Perkin, *The Rise of Professional Society: England Since 1880*, London 2002.

PERRY 2004
G. Perry (ed.), *Difference and Excess in Contemporary Art. The Visibility of Women's Practice*, Oxford 2004.

PEVSNER 1937
N. Pevsner, *An Enquiry into Industrial Art in England*, Cambridge 1937.

PEVSNER 1973
N. Pevsner, *Academies of Art, Past and Present*, Cambridge 1940, New York repr. 1973.

PHILLPOT AND TARSIA 2000
C. Phillpot and A. Tarsia, *Live in Your Head: Concept and Experiment in Britain 1965–75*, exh. cat., Whitechapel Art Gallery, London 2000.

PILKINGTON ET AL. 1971
P. Pilkington, D. Rushton, K. Lole and C. Harrison, 'Some Concerns in Fine Art Education', *Studio International*, October 1971.

POYNTER 1885
E.J. Poynter, 'Systems of Art Education', *Lectures on Art*, London 1885.

PRATESI 2007
L. Pratesi, *Tony Cragg: Material Thoughts*, Milan 2007.

PRETTEJOHN 1999
E. Prettejohn (ed.), *After the Pre-Raphaelites*, Manchester 1999.

PRINZHORN ET AL. 2006
M. Prinzhorn et al., *Sarah Lucas: Exhibitions and Catalogue Raisonné 1989–2005*, exh. cat., Tate Liverpool 2006.

RADFORD 1987
R. Radford, *Art for a Purpose: The Artists' International Association, 1933–1953*, Winchester 1987.

RANKIN ET AL. 2006
I. Rankin et al., *Douglas Gordon: Superhumanatural*, exh. cat., Scottish National Galleries, Edinburgh 2006.

REA 1935
B. Rea, *5 on Revolutionary Art*, London 1935.

READ 1933
H. Read, Art Now: An Introduction to the Theory of Modern Painting and Sculpture, London 1933.

READ 1934a
H. Read, *Unit 1: The Modern Movement in English Architecture, Painting and Sculpture*, London 1934.

READ 1934b
H. Read, *Art and Industry. The Principles of Industrial Design*, London 1934.

READ 1935
H. Read, 'What is Revolutionary Art?', in Rea 1935.

READ 1952
H. Read, *Barbara Hepworth: Carvings and Drawings*, London 1952.

READ 1962
H. Read, 'A Nest of Gentle Artists', *Apollo*, vol.77, new series no.7, Sept. 1962.

READ 1963
H. Read, *To Hell with Culture*, London, 1963.

READ 1965
H. Read, *Henry Moore: A Study of His Life and Work*, London 1965

REDGRAVE 1876
R. Redgrave, *Manual of Design*, London 1876.

REMY 1999
M. Remy, *Surrealism in Britain*, Aldershot 1999.

RENTON AND GILLICK 1991
A. Renton and L. Gillick (eds.), *Technique Anglaise: Current Trends in British Art*, London 1991.

REYNOLDS, J. 1992
J. Reynolds, *Discourses*, ed. P. Rogers, Harmondsworth 1992.

REYNOLDS, S. 1980
S. Reynolds, 'Sir Edmund Davis, Collector and Patron of the Arts,' *Apollo*, vol.CXI, June 1980.

RICHARDS 1973
J.M. Richards, *The Castles on the Ground: The Anatomy of Suburbia*, illus. John Piper, London 1973.

ROBBINS 1990
D. Robbins (ed.), *The Independent Group: Post-War Britain and the Aesthetics of Plenty*, Cambridge and London 1990.

ROBERTSON ET AL. 1986
A. Robertson et al., *Surrealism in Britain in the Thirties, Angels of Anarchy and Machines for Making Clouds*, exh. cat., Leeds City Art Gallery 1986.

ROBERTSON, RUSSELL AND SNOWDON 1965
B. Robertson, J. Russell and Snowdon, *Private View: The Lively World of British Art*, London 1965.

ROBINS 1997
A. G. Robins, *Modern Art in Britain 1910–1914*, London 1997.

ROBINS AND THOMSON 2005
A.G. Robins and R. Thomson, *Degas, Sickert and Toulouse-Lautrec: London and Paris 1870–1910*, exh. cat., Tate Britain, London 2005.

ROGOFF 2006
I. Rogoff, contribution to 'Schools of Thought', *Frieze*, no.101, Sept. 2006.

ROSENBLUM 2004
R. Rosenblum, *Introducing Gilbert & George*, London 2004.

ROSENTHAL ET AL. 1998
N. Rosenthal et al., *Sensation: Young British Artists from the Saatchi Collection*, exh. cat., Royal Academy, London 1998.

ROTH 1977
H. Roth, 'James Boswell: A New Zealand Artist in London', *Auckland City Art Gallery Quarterly*, no.65, Dec. 1977.

ROTHENSTEIN 1952
J. Rothenstein, *Modern English Painters: Sickert to Smith*, London 1952.

ROYOUX 2006
J. Royoux, *Tacita Dean*, London 2006.

RUDD 2003
N. Rudd, *Peter Blake*, London 2003.

RUSHTON AND WOOD 1975
D. Rushton and P. Wood, 'Education Bankrupts', *The Fox*, vol.1, no.1, New York 1975.

RUSHTON AND WOOD 1979a
D. Rushton and P. Wood (eds.), *Politics of Art Education*, London and Edinburgh 1979.

RUSHTON AND WOOD 1979b
D. Rushton and P. Wood (eds), *The Noises Within...*, Edinburgh 1979.

RUSKIN 1857
J. Ruskin, *The Elements of Drawing*, London 1857, repr. 1892.

RUSKIN 1877
J. Ruskin, *Fors Clavigera: Letters to the Workmen and Labourers of Great Britain*, Letter LXXIX, 18 June 1877, in Ruskin 1903–12, vols.27–9.

RUSKIN 1903–12
J. Ruskin, *The Works of John Ruskin*, 39 vols., London 1903–12.

RUSSELL 1993
J. Russell, *Francis Bacon*, London 1971, rev. ed. 1993.

RUTTER 1922
F. Rutter, *Some Contemporary Artists*, London 1922.

RUTTER 1927
F. Rutter, *Since I Was Twenty-Five*, London 1927.

SADLER 1935
M.E. Sadler (ed.), *Arts of West Africa (Excluding Music)*, London 1935.

SANDER 1986
A. Sander, *Citizens of the Twentieth Century: Portrait Photographs 1892–1952*, Cambridge 1986.

SCHAPIRO 1999
M. Schapiro, 'The Social Bases of Art' (1936), in *Worldview in Painting – Art and Society*, New York 1999.

SEARING 2004
H. Searing, *Art Spaces: The Architecture of the Four Tates*, London 2004.

SEARLE ET AL. 2003
A. Searle et al., *Chris Ofili: Within Reach*, London 2003.

SHARPE 2003
N. Sharpe, 'The Wrong Twigs for an Eagle's Nest?
Architecture, Nationalism and Sir Hugh Lane's Scheme
for a Gallery of Modern Art, Dublin, 1904–1913,' in
M. Giebelhausen (ed.) *The Architecture of the Museum:
Symbolic Structures, Urban Contexts*, Manchester 2003.

SHONE 1976
R. Shone, *Bloomsbury Portraits*, London 1976.

SHONE 1988
R. Shone, *Walter Sickert*, Oxford 1988.

SICKERT 1910a
W. Sickert, 'The New English and After', *New Age*, 2 June 1910.

SICKERT 1910b
W. Sickert, 'Idealism', *Art News*, 12 May 1910.

SICKERT 2000
W. Sickert, *The Complete Writings on Art*, ed. A. Gruetzner
Robins, Oxford 2000.

SILBER 1986
E. Silber, *The Sculpture of Epstein*, Oxford 1986.

SILBER 1996
E. Silber, *Henri Gaudier-Brzeska*, London 1996.

SILVER 1989
K.E. Silver, *Esprit de Corps: the Art of the Parisian
Avant-Garde and the First World War, 1914–1925*,
London 1989.

SIMISTER 2001
K. Simister, *J.D. Fergusson 1974–1961*, Edinburgh 2001.

SIMON 1991
R. Simon, *Gramsci's Political Thought: An Introduction*,
London 1991.

SINGERMAN 1999
H. Singerman, *Art Subjects: Making Artists in the American
University*, Berkeley 1999.

SINGERMAN 2001
H. Singerman (ed.), *Public Offerings*, exh. cat., Museum of
Contemporary Art, Los Angeles 2001.

SKEAPING 1977
J. Skeaping, *Drawn from Life: An Autobiography*,
London 1977.

SLEEMAN 2007
J. Sleeman, *The Sculpture of William Tucker*,
Aldershot 2007.

SPALDING, F. 1986
F. Spalding, *British Art Since 1900*, London 1986.

SPALDING, F. 1998
F. Spalding, *The Tate: A History*, London 1998.

SPALDING, J. 1984
J. Spalding, *The Forgotten Fifties*, exh. cat., Sheffield City
Art Gallery, Sheffield 1984.

SPENCE, R. 2000
R. Spence, *Eduardo Paolozzi: Writings and Interviews*,
Oxford 2000.

SPENCE, J. AND DENNETT 1995
J. Spence and T. Dennett, 'Remodelling Photo-History',
in J. Spence, *Cultural Sniping: The Art of Transgression*,
ed. J. Stanley, London 1995.

STALLABRASS 2004
J. Stallabrass, *Art Incorporated*, Oxford 2004.

STALLABRASS 2006
J. Stallabrass, *High Art Lite: The Rise and Fall of Young
British Art*, London 2006.

STEADMAN 1979
P. Steadman, *The Evolution of Designs*, Cambridge 1979.

STEPHENS 2000a
C. Stephens, *Terry Frost*, London 2000.

STEPHENS 2000b
C. Stephens, *Peter Lanyon: At the Edge of Landscape*,
London 2000.

STEPHENS 2002
C. Stephens, 'We are the Masters Now: Modernism and
Reconstruction in Post-war Britain', in Meyric Hughes
and van Tuyl 2002.

STEPHENS AND STOUT 2004
C. Stephens and K. Stout, *This Was Tomorrow: Art &
The 60s*, exh. cat., Tate Britain, London 2004.

STEPHENSON 1991
A. Stephenson, '"Strategies of Situation": British
Modernism and the Slump c.1929–1934', *Oxford Art
Journal*, vol.14, no.3, 1991.

STEPHENSON 2000
A. Stephenson, '"Anxious Performances": Aestheticism,
the Art Gallery and the Ambulatory Geographies of Late
Nineteenth-Century London', in F. Lloyd and C. O'Brian
(eds.), *Secret Spaces, Forbidden Places: Rethinking Culture*,
New York and Oxford 2000.

STEYN AND CAUSEY 1992
J. Steyn and A. Causey, *Mark Gertler*, exh. cat., Camden
Art Centre, London 1992.

SWEET 1992
D. Sweet, *Towards a Militant Academy*, Manchester 1992.

SYLVESTER 1975
D. Sylvester, *Interviews with Francis Bacon*, London 1975.

TAYLOR 1999
B. Taylor, *Art for the Nation: Exhibitions and the London
Public 1747–2001*, Manchester 1999.

THISTLEWOOD 1981
D. Thistlewood, *A Continuing Process: The New
Creativity in British Art Education 1955–65*, exh. cat.,
Institute of Contemporary Arts, London 1981.

THOMPSON, E.P. 1965
E.P. Thompson, 'The Peculiarities of the English',
The Socialist Register, 1965.

THOMPSON, E.P. 1995
E.P. Thompson, 'Christopher Caudwell', *Critical Inquiry*,
vol.21, no.2, Winter 1995.

THOMPSON 2002
Thompson in Z. Felix, B. Hentschel, and D. Luckow (eds.),
Art and Economy, Ostfildern-Ruit 2002.

THOMPSON, J. ET AL. 2000
J. Thompson et al., *Richard Deacon*, London 2000.

THORNTON 1938
A. Thornton, *The Diary of an Art Student of the Nineties*,
London 1938.

TICKNER 2000
L. Tickner, *Modern Life and Modern Subjects: British
Art in the Early Twentieth Century*, London and
New Haven 2000.

TICKNER 2008
L. Tickner, *Hornsey 1968: The Art School Revolution*,
London 2008.

TILLYARD 1988
S.K. Tillyard, *The Impact of Modernism: Early Modernism
and the Arts and Crafts Movement in Edwardian England*,
London and New York 1988.

TOMLINSON 1944
R.R. Tomlinson, *Children as Artists*, London 1944.

TOWNSEND, C. 2004
C. Townsend (ed.), *The Art of Rachel Whiteread*, London 2004.

TREUHERZ ET AL. 2003
J. Treuherz et al., *Dante Gabriel Rossetti*, exh. cat.,
Walker Art Gallery, Liverpool 2003.

TREVELYAN 1957
J. Trevelyan, *Indigo Days*, London 1957.

TRODD AND BROWN 2004
C. Trodd and S. Brown (eds.), *Representations of G.F. Watts:
Art Making in Victorian Culture*, Aldershot 2004.

TUFNELL 2007
B. Tufnell, *Richard Long: Selected Statements and
Interviews*, London 2007.

UPSTONE 2005
R. Upstone, *William Orpen: Politics, Sex, Death*,
exh. cat., Imperial War Museum, London 2005.

VAN WINGEN AND TILLEMA 1980
J. Van Wingen and H.K. Tillema, 'British Military
Interventions after World War II: Militance in a
Second-Rank Power', *Journal of Peace Research*, vol.17,
no.4, 1980.

VARLEY 1987
R. Varley, *Mass-Observation, 1937–1987*, Brentford 1987.

WAGNER 2005
A.M. Wagner, *Mother Stone: The Vitality of Modern British
Sculpture*, New Haven and London 2005.

WALKER 1998
J.A. Walker, *Cultural Offensive: America's Impact on
British Art Since 1945*, London and Sterling 1998.

WALKER ART CENTER 1995
Brilliant: New Art from London, exh. cat., Walker Art Center,
Minneapolis 1995.

WALSH 2002
M. Walsh, *C.R.W. Nevinson: This Cult of Violence*,
New Haven and London 2002.

WESTLEY 2007
H. Westley, 'The Year of the Locked Room', *Tate ETC*,
no.9, Spring 2007.

WHEATCROFT 2005
G. Wheatcroft, *The Strange Death of Tory England*,
London 2005.

WIENER 2004
M.J. Wiener, *English Culture and the Decline of the
Industrial Spirit, 1850–1980*, Cambridge, 2nd ed., 2004.

WILDMAN AND CHRISTIAN 1998
S. Wildman and J. Christian, *Edward Burne-Jones: Victorian
artist-dreamer*, exh. cat., Metropolitan Museum of Art,
New York 1998.

WILLIAMS, R. 1958
R. Williams, *Culture and Society, 1780–1950*, London 1958.

WILLIAMS, R. 1973
R. Williams, *The Country and the City*, London 1973.

WILLIAMS, R. 1980
R. Williams, *Problems in Materialism and Culture: Selected
Essays*, London 1980.

WILLIAMS, V. 2002
V. Williams, *Martin Parr*, London 2002.

WITT 1911
R.C. Witt, *The Nation and its Art Treasures*, London 1911.

WOOLF 1996
J. Woolf, 'The Failure of a Hard Sponge: Class, Ethnicity
and the Art of Mark Gertler', *New Formations*, no.28,
Spring 1996.

WRIGHT 2004
B. Wright, *Modern Art and the Professionalisation of Culture:
The Development of Modern Painting in England at the
Beginning of the Twentieth Century*, PhD thesis, Courtauld
Institute of Art, 2004.

YOUNG, MACDONALD AND SPENCER 1980
A. M. Young, M. MacDonald and R. Spencer,
The Paintings of James McNeill Whistler, New Haven
and London 1980.

YULE 2001
M. Yule, 'A Place for Living Art: The Whitechapel Art Gallery
1952–1968', in M. Garlake (ed.), *Artists and Patrons in
Post-War Britain: Essays by Postgraduate Students at the
Courtauld Institute of Art*, Aldershot 2001.

Timeline 1870–Now

Social and political events
Cultural events

1870–99

1870	Elementary Education Act.
1871	George Eliot publishes *Middlemarch*.
	Slade School of Art, London founded.
1874	*First Impressionist Exhibition*, Paris.
1877	Grosvenor Gallery, London opens.
	Society for the Preservation of Ancient Buildings founded.
	Frederic Leighton, *Athlete Wrestling with a Python*, considered first New Sculpture piece.
	James McNeill Whistler, *Nocturne: Blue and Gold – Old Battersea Bridge*.
1878	First electric street lighting in London.
	Ruskin/Whistler trial: Whistler sues Ruskin for libel after Ruskin's attack on Whistler's *Nocturne in Black and Gold: The Falling Rocket* (c.1874).
1879	First telephone exchange in London.
	Public granted unlimited access to British Museum.
1880	Edward Burne-Jones, *The Golden Stairs*.
1881	Population of London 3.3 million (Paris 2.2 million and New York 1.2 million).
1882	Society for Psychical Research founded.
1884	Alfred Gilbert, *Icarus*.
	Edward Burne-Jones, *King Cophetua and the Beggar Maid*.
1885	Walter Pater publishes *Marius the Epicurean*.
1886	Robert Louis Stevenson publishes *Dr Jekyll and Mr Hyde*.
	G.F. Watts, *Hope*.
	Frederic Leighton, *Needless Alarms* and *Sluggard*.
	New English Art Club, London founded.
1887	Bloody Sunday socialist demonstration in Trafalgar Square.
1888	Arts and Crafts Exhibition Society, London founded.
	Frederic Leighton, *Captive Andromache*.
	J.W. Waterhouse, *The Lady of Shallott*.
1890	William Booth publishes *In Darkest England and the Way Out*.
1891	Oscar Wilde publishes *The Picture of Dorian Gray*.
1894	*Yellow Book* first published, with Aubrey Beardsley as editor.
	Rudyard Kipling publishes *The Jungle Book*.
	William Morris publishes *News from Nowhere*.
1895	National Trust founded.
	Marconi invents wireless telegraphy.
	H G Wells publishes *The Time Machine*.
	Frederic Leighton, *Flaming June*.
	Lumière brothers invent cinematograph.
1896	First cinema opens in London.
	Central School of Arts and Crafts, London founded.
	National Art Workshops, London renamed Royal College of Arts.
1897	Tate Gallery opens as a branch of the National Gallery, London.
1899	Magnetic recording of sound invented. Start of Boer War.

1900–49

1900	Sigmund Freud publishes *Interpretation of Dreams*.
	Queen Victoria dies.
	Accession of Edward VII.
	UK population 41.4 million (USA 75.9 million).
1903	National Art Collections founded to prevent works of art leaving Britain.
	Wright brothers make first aeroplane flight.
1905	Les Fauves (Paris) and Die Brücke (Dresden) painters groups formed.
c.1906	Walter Sickert, *La Hollandaise*.
	C.L. Hind publishes *The Education of an Artist*.
1907	Origins of Cubism in Paris.
	Pablo Picasso, *Les Demoiselles d'Avignon*.
1909	F T Marinetti publishes Futurist Manifesto in Paris.
	Lawrence Alma-Tadema, *A Favourite Custom*.
	William Orpen, *Homage to Manet*.
1909–10	Gwen John, *Nude Girl* and *Girl with Bare Shoulders*.
1910	Accession of George V.
	Contemporary Art Society founded to purchase modern works for the nation.
	Manet and the Post-Impressionists exhibition, curated by Roger Fry.
1911	National Insurance Act.
	Der Blaue Reiter group of abstract and expressionist painters, Munich founded.
	Walter Sickert forms the Camden Town Group.
	Walter Sickert, *Off to the Pub*.
	Stanley Spencer, *John Donne Arriving in Heaven*.
	Henri Matisse, *Red Studio*.
1912	*Second Post-Impressionist Exhibition*, London.
	Futurist Exhibition, London.
1913	Omega Workshops and Rebel Art Centre, London founded.
c.1913	Henri Gaudier-Brzeska, *Red Stone Dancer*.
1914	*Blast* No. 1 published.
	David Bomberg, *Mud Bath*.
1914	First World War starts.
1915	Wyndham Lewis, *The Crowd* shown at Second London Group exhibition.
	Blast No. 2 – the 'War number' – published.
1916	Dada Movement, Zurich founded.
	Mark Gertler, *The Merry Go-Round*.
1917	Russian Revolution.
	Jacob Epstein, *Venus*.
1918	First World War ends.
	Paul Nash, *We Are Making a New World*.
	Women over the age of 30 granted the right to vote .
1919	Treaty of Versailles.
	Bauhaus, Weimar modernist art, architecture and design school founded.
	The Seven and Five Society – later 7 & 5 – formed in London.
	Stanley Spencer, *Travoys with Wounded Soldiers Arriving at a Dressing Station at Smol (1916)*
1919–20	*The Nation's War Paintings* exhibition, Royal Academy, London.
1920	Winifred Knight, *The Deluge*.
	Roger Fry publishes *Vision and Design*.
1922	BBC founded.
	T.S. Eliot publishes *The Waste Land*.
	James Joyce publishes *Ulysses*.
	Mussolini comes to power in Italy.
1924	André Breton publishes *Manifesto of Surrealism*.
1924–7	Stanley Spencer, *The Resurrection, Cookham*.
1925–6	Frank Brangwyn designs British Empire panels for the House of Lords.
1926	General Strike in Britain.
	Council for Preservation of Rural England formed.
	Fritz Lang's film *Metropolis* released.
1927	Virginia Woolf publishes *To the Lighthouse*.
	Experiment, an avant-garde magazine, published by the Cambridge University group of the same name.
1928	Representation of the People Act – women granted electoral equality to vote.
1929	World financial crash.
	Museum of Modern Art, New York founded.
	First 7 & 5 exhibition.
	Paul Nash, *Landscape at Iden*.
1930	Wyndham Lewis, *Apes of God*.
1932	*Room and Book* exhibition, Zwemmer Gallery, London.
1933	Unit One group formed by Paul Nash; members included Henry Moore, Ben Nicholson, Barbara Hepworth, Edward Burra, Wells Coates, Colin Lucas.
	Artists' International Association founded.
	British Film Institute founded.
	Herbert Read publishes *Art Now*.
	Hitler comes to power in Germany.
1934	Edward Burra, *Harlem*.
	James Boswell, *The Means Test*.
	Unit One group exhibition, Mayor Gallery, London; *Unit 1* book of statements and catalogues published to coincide.

1935	Sidney and Beatrice Webb publish *Soviet Communism: A New Civilization*. Artists' International Association publishes *5 on Revolutionary Art*.
1936	Accession and abdication of Edward VIII. Accession of George VI. A.J. Ayer publishes *Language, Truth and Logic*. *International Exhibition of Surrealism*, New Burlington Galleries, London. Naum Gabo arrives in London from Russia, via Germany and Paris. Bill Brandt publishes *The English at Home*.
1937	Euston Road School founded. Mass Observation group founded. *Degenerate Art* exhibition, Munich. *Circle* published to promote international modernism. Stanley Spencer, *Leg of Mutton Nude* and *Hilda, Unity and Dolls*. Oscar Kokoscha, *Self Portrait as a Degenerate Artist*. Meredith Frampton, *A Game of Patience*. Humphrey Spender, *Dominoes in the Pub*.
1938	Munich Crisis. *Twentieth Century German Art* exhibition, New Burlington Galleries, London. Henry Moore, *Recumbent Figure* – first Moore work acquired by Tate.
1939	Second World War starts. *Unity of Artists for Peace, Democracy and Cultural Development* (known as *Art for the People*) exhibition, Whitechapel Gallery, London. C. Madge and T.H. Harrisson publish *Britain by Mass-Observation*.
1939–40	Graham Sutherland, *Black Landscape*.
1940	Beginning of Blitz (–1941). Council for Encouragement of Music and Arts founded; becomes Arts Council at end of war. Henry Moore, *Grey Tube Shelter*.
1941	John Piper, *Seaton Delaval*. Graham Sutherland, *Devastation 1941: East End Street*. Henry Moore, *Tube Shelter Perspective*.
1943	Alberto Cavalcanti's propaganda film *Went the Day Well?* released.
1944	R.A. Butler's Education Act. T.S. Eliot publishes *Four Quarters*. Francis Bacon, *Three Studies for Figures at the Base of a Crucifixion*. Graham Sutherland, *Horned Forms*.
1945	Dropping of first atom bombs on Hiroshima and Nagasaki ends the Second World War. Karl Popper publishes *The Open Society and its Enemies*.

Evelyn Waugh publishes *Brideshead Revisited*. Labour landslide victory at General Election.

1946	Institute of Contemporary Arts (ICA), London founded.
1947	Robin Ironside publishes *Painting since 1939*. Le Corbusier builds 'Unité d'habitation', Marseilles. Nationalisation of coal and other industries in Britain.
1948	West Indian immigrants begin to arrive in Britain. National Health Service founded. Henry Moore, *Family Group*. George Orwell publishes *Nineteen Eighty-Four*.

1950–99

1950	Papal decree against existential philosophy. Jean Cocteau's film *Orphée* released. Outbreak of Korean War.
1951	UK population 50 million (USA 153 million). Festival of Britain on South Bank, London.
1951–3	Competition for a monument to *The Unknown Political Prisoner*, organised by the ICA; entries exhibited at Tate Gallery, London.
1952	Accession of Queen Elizabeth II. First hydrogen bomb exploded. Independent Group formed at ICA, London. First American abstract expressionist paintings exhibited in London.
1953	Coronation of Queen Elizabeth II. Peter Lanyon, *St Just*. *Parallel of Life and Art* exhibition, ICA, London, designed by Eduardo Paolozzi.
1954	Publication of *Nine Abstract Artists*, introduced by Lawrence Alloway. Dylan Thomas's *Under Milk Wood* broadcast. Federico Fellini's film *La Strada* released. Bill Haley and the Comets single *Rock Around the Clock* released. Richard Hamilton, *Trainsitions*. Eduardo Paolozzi, *Automobile Head*.
1955	Samuel Beckett's play *Waiting for Godot* first performed.
1956	Suez Crisis. John Osborne's play *Look Back in Anger* first performed. Nikolaus Pevsner publishes *The Englishness of English Art*. *This is Tomorrow* exhibition, Whitechapel Gallery, London.

Modern Art in the United States: A Selection from the Collections of The Museum of Modern Art, New York exhibition, Tate Gallery, London. Nigel Henderson, *Head of a Man*.

1957	USSR launches 'Sputnik I'. Richard Hoggart publishes *The Uses of Literacy*. Raymond Williams publishes *Culture and Society*.
1958–61	Richard Hamilton, *$he*.
1959	*New American Painting* exhibition, Tate Gallery, London. C.P. Snow gives lecture titled *The Two Cultures*.
1960	Alfred Hitchcock's film *Psycho* released. First *Situation* exhibition of abstract art, Royal Society of British Artists Galleries, London. Scottish National Gallery of Modern Art, Edinburgh opened.
1961	*Private Eye* satirical magazine first published. *New London Situation* exhibition, New London Gallery, London. Arnolfini Gallery, Bristol established.
1962	Anthony Sampson publishes *The Anatomy of Britain*. Cuban Missile Crisis causes serious international tension and fear of nuclear war. Commonwealth Immigrants Act limits immigration to Britain.
1963	Profumo Affair contributes to downfall of Conservative government. US President John F. Kennedy assassinated. *New Generation* sculpture exhibition, Whitechapel Art Gallery, London. Kasmin Gallery, London opens. Robert Fraser Gallery, London opens.
1964	Harold Wilson Prime Minister of new Labour government. Concern about 'brain drain' of scientists and academics to USA. *54–64: Painting and Sculpture of a Decade* exhibition, Tate Gallery, London.
1965	*International Poetry Incarnation*, Royal Albert Hall, London. Post Office Tower built by Ministry of Public Building and Works.
1966	Cultural Revolution in China. Arte Povera in Italy. Michelangelo Antonioni's film *Blow Up* released.
1967	Beatles album *Sergeant Pepper* released. Anthony Caro, *Prairie* exhibited at Kasmin's Gallery, New York.
1968	SPACE founded in London by Bridget Riley and Peter Sedgley. Student riots in Paris. Lindsay Anderson's film *If…* released.

1969	First moon landing.
	Kenneth Clark *Civilisation* and first *Monty Python* series on television.
	Student protests in British universities and art colleges.
	Ulster Troubles begin.
	When Attitudes Become Form exhibition, ICA.
1970	Victor Burgin publishes *All Criteria*.
	Nicholas Roeg film *Performance* released.
1971	Decimal currency introduced in Britain.
	Stanley Kubrick's film *A Clockwork Orange* released.
	Keith Arnatt, *Is It Possible for Me to Do Nothing as My Contribution to this Exhibition?*
1972	John Berger publishes *Ways of Seeing* to accompany influential TV series.
1973	UK enters European Community.
	USA withdraws from Vietnam.
	Death of Pablo Picasso.
1974	Richard Nixon resigns.
1975	Art & Language, *Dialectical Materialism (Dark Green)*.
1976	*The Human Clay* exhibition, Hayward Gallery, London curated by R.B. Kitaj.
1977	First mass-produced Apple computers for sale.
	The Sex Pistols album *Never Mind the Bollocks* released.
1978	Dennis Farr publishes *English Art 1870–1940*.
	Conservative government elected, Margaret Thatcher the first female and longest serving Prime Minister in 150 years.
1980	John Lennon killed.
1981	Charles Harrison, *English Art and Modernism 1900–1939*.
	Object and Sculpture exhibitions, ICA, London and Arnolfini, Bristol.
	Bill Woodrow, *Twin Tub with Guitar*.
	Thames Barrier opens.
1982	Tony Cragg, *New Stones – Newton's Tones* exhibited.
	Jo Spence & Terry Dennett, *The History Lesson*.
1983	*Five Black Women* exhibition, Africa Centre, London.
	The Black-Art Gallery, London opens.
1984	Turner Prize established.
	Prince of Wales attacks modern architecture.
	Miner's strike in Britain.
	Richard Deacon, *If the Shoe Fits*.

1985	*The Thin Black Line* exhibition, ICA, London.
	Saatchi Collection, London opens.
1986	*From Two Worlds* exhibition, Whitechapel Gallery, London.
	Gilbert & George, *Class War, Militant, Gateway*.
	Derek Jarman's film *Caravaggio* released.
	Lloyd's Building, London built by Richard Rogers.
1987	*British Art in the 20th Century: The Modern Movement* exhibition, Royal Academy, London.
	Christie's sells Van Gogh's *Sunflowers* for £30million, a world record.
	Sonia Boyce, *From Tarzan to Rambo*.
1988	*Freeze* exhibition of Goldsmith Art College students' work in Docklands, London marks inauguration of Young British Artists movement.
	Sotheby's sells Jasper Johns *False Start* for $17million, a world record for a contemporary artist.
	The Other Story exhibition, Hayward Gallery, London.
	Rachel Whiteread, *Ghost*.
1989	Tiananmen Square Protests.
1990	Gulf War starts.
	Douglas Gordon, *List of Names*.
1991	Douglas Gordon, *Letters*.
	Cornelia Parker, *Cold Dark Matter: An Exploded View*.
	Frieze magazine inaugural issue.
	Turner Prize restricts entries to those by British artists under fifty.
1992	Charles Saatchi holds first Young British Artists exhibition at Saatchi Gallery, London.
	Francis Fukayama publishes *The End of History and the Last Man*.
1993	Jake and Dinos Chapman, *Disasters of War*.
	Rachel Whiteread, *House*.
	Sarah Lucas, *Self Portrait with Mug of Tea*.
	'Woodwork' art event held at Vauxhall Spring Gardens, London.
	Jay Jopling opens White Cube Gallery on Duke Street, London .
	Transmission Gallery, Glasgow founded.
1994	Church of England ordains first women priests.
	Gillian Wearing, *Dancing in Peckham*.
1995	Michael Landy, *Scrapheap Services*.
1996	Richard Wilson, *She Came in through the Bathroom Window* and *Jamming Gears*.

1997	Labour Government elected.
	Princess Diana dies in car crash in Paris.
	Sensation exhibition of Young British Artists, Royal Academy, London.
1998	The Modern Institute, Glasgow founded.
	Antony Gormley, *Angel of the North*.
	Good Friday Agreement establishes a devolved Northern Ireland assembly.
1999	Jim Lambie, *Zobop*.

2000–

2000	'Millenium bug' fears prove unfounded.
	Millenium Dome opens.
	Tate Modern opens.
	Stuckists' first demonstration at the Turner Prize.
	Martin Parr publishes *Think of England*.
2001	UK population 59.6 million (USA 275 million).
	Cathy Wilkinson, *Our Misfortune*
	Martin Creed wins Turner Prize with *The Lights Going On and Off*.
	Jeremy Deller, *The Battle of Orgreave*.
	Queen Mother dies at the age of 101.
	Terrorist attacks on New York and Washington; George W Bush calls for War on Terror.
2002	BALTIC Centre for Contemporary Art, Gateshead opens.
2003	Saddam Hussein's regime crumbles after invasion of Iraq by US and UK troops.
	Damien Hirst's exhibition *Romance in the Age of Uncertainty*, White Cube Gallery.
2004	30 St Mary Axe ('the Gherkin') built by Norman Foster.
	Momart Warehouse fire sees over 100 artworks from the collection of Charles Saatchi destroyed.
2005	Terrorist attacks on London.
	Simon Starling, *Shedboatshed*.
2006	Tomma Abts wins Turner Prize.
	Saddam Hussein executed.
2007	Mark Wallinger wins Turner Prize for his installation *State Britain*.
	Tracey Emin represents Britain at the Venice Biennale.
	Tony Blair steps down as Prime Minister.
	Doris Lessing wins Nobel Prize.
2008	China hosts Olympic Games.
	Serpentine Gallery Pavilion designed by Frank Gehry.

Index

First published in North America by the Yale Center for British Art
P. O. Box 208280
1080 Chapel Street
New Haven, CT 06520-8280
www.yale.edu/ycba

in association with Tate Britain

Distributed in North America by Yale University Press
www.yalebooks.com

© Tate 2008

ISBN 978-0-300-11672-4
ISBN 978-0-300-14304-1 (three-volume set)

Library of Congress Control Numbers:
2008933922
2008933920 (three-volume set)

General Editor: David Bindman
Designed by LewisHallam
Color reproduction by DL Interactive, London
Printed and bound in China by C&C Offset Printing Co., Ltd

JACKET
FRONT: Tracey Emin, *Everyone I Have Ever Slept With 1963–1995* 1995 (detail of fig.41, p.65)
BACK: *(from left to right)*: Mark Boyle, *Holland Park Avenue Study* 1967 (detail of fig.124, p.193); Jacob Epstein, *Torso in Metal from 'The Rock Drill'* 1913–14 (fig.23, p.46); Francis Bacon, *Study after Velázquez's Portrait of Pope Innocent X* 1953 (detail of fig.7, p.25); Rachel Whiteread, *Ghost* 1990 (fig.150, p.231); Sarah Lucas, *Self Portrait with Mug of Tea* 1993 (detail of fig.94, p.148)

FRONTISPIECE: Lucian Freud, *Standing by the Rags* 1988–9
Oil on canvas 181 × 150.5 (71¼ × 59¼). Tate. Purchased with assistance from The Art Fund, the Friends of the Tate Gallery and anonymous donors 1990.

pp.4–5: Paul Nash, *Landscape at Iden* 1929 (detail of fig.60, p.90)
 p.16: Francis Bacon, *Study after Velázquez's Portrait of Pope Innocent X* 1953 (detail of fig.7, p.25)
 p.38: Jacob Epstein, *Torso in Metal from 'The Rock Drill'* 1913–14 (detail of fig.23, p.46)
 p.76: Frank Auerbach, *Oxford Street Building Site I* 1959–60 (detail of fig.56, p.86)
 p.120: Walter Sickert, *Off to the Pub* c.1912 (detail of fig.82, p.127)
 p.162: Ben Pimlott Building, Goldsmiths College, University of London (detail of fig.118, p.185)
 p.162: Anon., *Freearm drawing*, 1901 (detail of fig.111, p.169)
 p.198: Installation view of *Painting and Sculpture of a Decade, '54–'64* 1964 (detail of fig.136, p.213)
 p.263: Gillian Ayres, *Lure* 1963 (detail of fig.38, p.61)

Measurements of artworks are given in centimetres, height before width, followed by inches in brackets.